SO-AIV-567

Multimedia

A Hands-On Introduction

Online Services

Delmar Online
To access a wide variety of Delmar products and services on the World Wide Web,
point your browser to:
> **http://www.delmar.com**
> or email: info@delmar.com

thomson.com
To access International Thomson Publishing's
home site for information on more than 34 publishers
and 20,000 products, point your browser to:
> **http://www.thomson.com**
> or email: findit@kiosk.thomson.com

A service of **I**(**T**)**P**®

Multimedia

A Hands-On Introduction

Dave D. Peck

Delmar Publishers

an International Thomson Publishing company

Albany • Bonn • Boston • Cincinnati • Detroit • London • Madrid
Melbourne • Mexico City • New York • Pacific Grove • Paris • San Francisco
Singapore • Tokyo • Toronto • Washington

NOTICE TO THE READER

Publisher does not warrant or guarantee any of the products described herein or perform any independent analysis in connection with any of the product information contained herein. Publisher does not assume, and expressly disclaims, any obligation to obtain and include information other than that provided to it by the manufacturer.

The reader is expressly warned to consider and adopt all safety precautions that might be indicated by the activities described herein and to avoid all potential hazards. By following the instructions contained herein, the reader willingly assumes all risks in connection with such instructions.

The publisher makes no representation or warranties of any kind, including but not limited to, the warranties of fitness for particular purpose or merchantability, nor are any such representations implied with respect to the material set forth herein, and the publisher takes no responsibility with respect to such material. The publisher shall not be liable for any special, consequential or exemplary damages resulting, in whole or in part, from the readers' use of, or reliance upon, this material.

Cover design: Mick Brady

Delmar Staff
Publisher: Alar Elken
Developmental Editor: Michelle Ruelos Cannistraci
COPYRIGHT © 1998

Editorial Assistant: John Fisher
Production Manager: Larry Main
Art and Design Coordinator: Nicole Reamer

By Delmar Publishers
a division of International Thomson Publishing Inc.

The ITP logo is a trademark under license.
Printed in the United States of America

For more information, contact:
Delmar Publishers
3 Columbia Circle, Box 15015
Albany, New York 12212-5015

International Thomson Editores
Campos Eliseos 385, Piso 7
Col Polanco
11560 Mexico D F Mexico

International Thomson Publishing Europe
Berkshire House 168-173
High Holborn
London, WC1V 7AA
England

International Thomson Publishing GmbH
Königswinterer Strasse 418
53227 Bonn
Germany

Thomas Nelson Australia
102 Dodds Street
South Melbourne, 3205
Victoria, Australia

International Thomson Publishing Asia
221 Henderson Road
#05-10 Henderson Building
Singapore 0315

Nelson Canada
1120 Birchmont Road
Scarborough, Ontario
Canada M1K 5G4

International Thomson Publishing—Japan
Hirakawacho Kyowa Building, 3F
2-2-1 Hirakawacho
Chiyoda-ku, Tokyo 102
Japan

Dedication

This book is dedicated to my family. Their contributions, though not technical, have made this project a reality.

Thank You,
Trish, Lauren, Chad, Chris and Dria

Carl, Charlotte, Paul and Pam

Contents

Part II • Media Preparation

Preface

This book is designed to take the novice multimedia explorer to a quick understanding of what took me many months of research, trial, error, and energy to discover. In my personal quest, I have learned what to do and what not to do, and hopefully can convey this process to you. Let me stress that what I have communicated in this text is only a small sampling of what is becoming an extremely wide and diverse area of communication. This field is growing so quickly! There is much to learn and much to enjoy by being involved in multimedia. Everyone will approach this field with different areas of interest and with different needs. I sincerely hope that this introduction will help launch many successful endeavors.

Perhaps the disappointing aspect of writing a book based on technology is the fact that by the time it gets to you, so much of the "currentness" will be history. Though new products come and go, my intention is to introduce some core concepts that will endure for a while, even though the products and technologies will transition rapidly.

I have tried my best to provide helpful hints and shortcuts to help you come to an understanding of what multimedia is and how to quickly get your feet wet and put this exciting technology to use.

Enjoy!

Dave

Acknowledgments

Developing a project like this book/CD is no small undertaking. I would like to acknowledge the contributions of the following individuals and companies.

Adobe Systems	Patricia Pane
	Therese Bruno
	Janice Reese
Macromedia	Suzanne Porta
	Jane Chuey
	Rachael Schindler
Multimedia Design Corporation	Tom Wheeler
	Rob Yarmey
	Annessa Warehime
	Greg Sobieski
Image Club Graphics	Tammy Wing
Allanti Cycling Company Brentwood, TN	Robert Todd Nordmeyer
	Kerry Roberts
METATEC Corporation	Sharon Kissner
Sanctuary Woods	
Instant Buttons and Controls	Kelly Walker

The Delmar Staff: John Anderson, Michelle Cannistracci, Nicole Reamer, Larry Main, John Fisher, David Mosher, Sean Lowery, and Carolyn Soika.

The Auburn Crew	Chad Peck
	Steve Strandburg
	Chris Phillips

I would like to give a special thanks to Barbara Riedell for her support, her contagious enthusiasm, and vision for this project.

I wish to acknowledge and thank the following reviewers whose comments and criticisms were invaluable during the development of this project:

Jeffrey R. Brown, Montana State University College of Technology, Great Falls, MT

Richard Brown, Los Angeles Trade & Technical College, Los Angeles, CA

Steve Romaniello, Pima Community College, Tucson, AZ

Dr. Thomas Schildgen, Arizona State University, Tempe, AZ

Part I

Multimedia Concepts

- [] Chapter 1 Multimedia Overview
- [] Chapter 2 Getting Involved
- [] Chapter 3 Developing a Project
- [] Chapter 4 Choosing Hardware
- [] Chapter 5 Choosing Software
- [] Chapter 6 Peripherals

Multimedia Overview

This chapter introduces you to the concepts behind multimedia, and clarifies the term multimedia as outlined by this book and the accompanying CD-ROM. This chapter will also give you the background as well as the current state of multimedia computing.

Chapter 1 provides a guide for what you can do with multimedia, how to get involved, and how it can help you. You will be grounded in fundamentals which will support your endeavors and explain the balance of this book/CD-ROM package.

Multimedia Defined

Let's begin this book in a straightforward manner. Let's define what multimedia is! In our attempt to do so, perhaps we should first consider the following question: What constitutes media? Some examples of media are:

- Animation
- Graphics
- Photography
- Sound
- Text
- Video

If any one of the above constitutes a singular form of media, then what constitutes multimedia?

Multimedia: the combination of two or more media types, to effectively create a sequence of events that will communicate an idea usually with both sound and visual support. Typically, multimedia productions are developed and controlled by computer.

Now that I have defined multimedia, perhaps I should differentiate multimedia from the word *media*. When you think of media, what is the first thing that comes to mind? If you think media is a magnetic tape or a floppy disk, a videotape or CD-ROM, you are right. If you think of media as a television broadcast, a computer-based production, or an audio/visual presentation, you are right again! To clarify the position of this book, I am talking specifically about electronic, computer-controlled multimedia, using a variety of media elements to produce a visual presentation.

When I speak of multimedia, many things may come to mind, such as highly technical presentations, computer-based applications, a slide show, or simply a transparency on an overhead projector with narration provided by the presenter. Any one of these elements is a form of multimedia presentation. Multimedia involves the use of more than one media type to communicate an idea or enhance a message. Today, multimedia typically involves the use of personal computers to create and control these media productions. Since the general perception revolves around this theme, so does the nature of this text.

As a practitioner, trainer, and multimedia consultant, I occasionally produce or participate in multimedia seminars. I remember vividly the first seminar that I produced to evangelize the multimedia process. Because it was a small group I always kept the floor open for discussion. In my mind, and in the organization of the seminar, I planned a comprehensive presentation of the entire process, from multimedia history to software choices, from graphic design to the production of CD-ROMS. To my surprise, I discovered that the attendees all came to the seminar with a different opinion of what multimedia was and what they expected to get from the meeting. As with most scripts and presentation materials, I had to make on-the-fly modifications to my presentation and address the issues at hand. Luckily, the medium itself lent perfectly to that type of impromptu customization.

In the early days of presenting, the presentation relied heavily on skillfully designed support devices, such as drawings, charts, graphics, and actual products. Today, the art of presenting is still the same. However, the method of presenting and the new support products have ushered in a new era of sight and sound that add a variety of stimulus to contemporary presentations.

This brings to mind the perception of multimedia in today's marketplace. Many think of multimedia as a huge conglomerate of high-powered corporations controlling the way information is being sent between earth and a satellite for media broadcasting. Others think of it as an over-used technical word to describe a personal computer or

Multimedia: the combination of two or more media types, to effectively create a sequence of events that will communicate an idea usually with both sound and visual support. Typically, multimedia productions are developed and controlled by computer.

another electronic device sold through a local retail store. When a customer walks into a computer store and sees a computer labeled "multimedia ready" what does that mean? In general, the term "multimedia" is being pasted onto many new products and services. Because there are so many products and services defined as multimedia, no wonder the term is so hard to define.

The History of Multimedia

The previously mentioned definition of multimedia states that it is made up of more than one form of media. When we think about multimedia today, we think it is created from new technology. However, several elements of multimedia have been around for quite some time. One example of an enduring media type is the slide (see Figure 1.1). The slide presentation has been the cornerstone of family, educational, and business presentations for decades. The process of mixing two forms of communication, the slide and the narration from the presenter, constitutes a form of multimedia. This form has been perhaps the most popular formula in the business world for decades. Not only has it been successful, it is still successful.

Some of the technology that affects how slides are made and projected may change, but this tried and true formula will continue to exist for quite a while.

In the 1970s, the slide show format was introduced to the computer. This introduction was not to the PC as you know it today, but rather specialized computers, designed just to control slide shows. This technology allowed the computer to control numerous projectors, coordinating them in a manner that produced fast-paced dissolves and effects, creating truly spectacular visual presentations. Totally separate from the visuals was the sound track. The taped soundtrack would contain cues that triggered the slide projector(s) to do what it was programmed to do. These projects were very effective and impressive, but took a highly skilled person or team to organize and develop them.

In the 1980s, personal computers were designed to "cut" a graphic element and then "paste" it into another document. Since that time, software and hardware developers have been scrambling to integrate various forms of media into the personal computer. This is evident today with the plethora of peripheral devices that can be connected to our computers to increase functioning.

Some external devices that have been introduced allow the computer to communicate beyond itself. For example, when the computer

Figure 1.1
The slide has been around for decades, and will continue to be an important form of presentation.

Though the personal computer was born in the 1970s, it learned to walk in the 1980s.

Figure 1.2 Multimedia processes come from various combinations of devices.

needs more storage space an external drive is added to meet the need. When the computer monitor is too small, larger monitors are attached to enhance viewing. To share information with a large audience, connections to a video projector and external sound amplification sources are available. Figure 1.2 illustrates some external devices.

In the 1990s computer manufacturers made their systems more accessible to third-party developers who were anxious to design and distribute their wares to the marketplace. The result of this "open architecture" approach was an explosion of third-party devices. As far as the birth of computer-controlled multimedia was concerned, the industry rolled to the launching pad during this phase.

The Future of Multimedia

Being on the launching pad means that a lot of work and planning have gone into a product or project. Even though multimedia has been around a while in a variety of formats its impact is just beginning in the arena of computerized development and delivery.

Because a big portion of multimedia activity is channeled through computers, one thing is certain: rapid change. Computer models have a shelf life between three and twelve months. They are often replaced with newer, faster, more powerful units. These new units must contain new features in order for them to sell, and selling is what keeps the manufacturer alive.

Along with the change that happens to the computer itself, the peripheral devices that connect to the computer are forced to change. You may be seeing a domino effect starting here. As these hardware elements begin to change, software products must also change. An example of this was the introduction of the Power Macintosh in early 1994. These new systems propelled the performance of existing Mac-

Remember this formula: Contemporary Computing = Rapid Change

intosh models into a new dimension. However, when this new hardware was introduced, existing software did not run much faster. Therefore, software developers were forced to adjust their applications, to make them compatible with the new products, and to take advantage of the speed from this newer technology.

What does this mean? Hardware, peripherals, software, and other products, will be in a constant state of flux from here to eternity (see Figure 1.3). By the time this book is published and in your hands, the specific hardware and software issues will have changed or be in the process of changing. The best way to handle this is to learn how to investigate what is next in line and learn how to integrate it into your current mode of operation. The challenge for companies in the business of publishing technology-based books and distributing CD-ROM-based media, is to get the information to the marketplace while it is current.

Multimedia Products

Evidence of the popularity of multimedia is the abundance of CD-ROM titles being released by companies such as Microsoft Corporation. Microsoft is a dominant player in the area of multimedia title development. Microsoft offers a variety of multimedia titles including: *Encarta Encyclopedia, Bookshelf, Cinemania, Musical Instruments, Art Gallery, Fine Artist, Dinosaurs,* and many other titles (see Figure 1.4). CD-ROM or electronic publishing will continue to flourish in the future. Although personal computer sales have traditionally been higher in the work place, the home market currently dominates total PC sales.

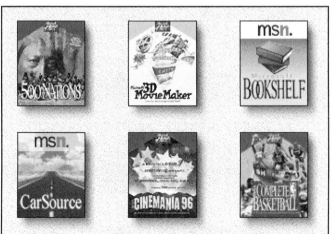

1984–1987
Simple slide shows
Basic interactivity
1988–1992
Faster processors
Sophisticated graphical interface
Interactive environments grow
1993–1997
CD quality sound
3-D animation
Presentation software enhanced
Sophisticated authoring environments
Connection to externals
Cross platform development

Figure 1.3 Computer capabilities are constantly changing. Personal computers have evolved gradually to include multimedia capabilities.

Figure 1.4 Various multimedia titles from Microsoft Corporation.

Multimedia processes allow you to:
- Entertain
- Educate
- Engage
- Inform
- Instruct
- Learn
- Motivate

Another company involved in paving the multimedia highway is Philips Consumer Electronics. Philips was one of the pioneers in the development of CD-ROM technologies. Around 1992, Philips introduced Compact Disk Interactive (CD-i) (see Figure 1.5). This product looked somewhat like a typical audio CD player, but it contained some sophisticated features and it allowed the user to control or interact with the contents of the CD. This was one of the first attempts to gain entry into the home market with a "multimedia" product. The concept and design of the product was good. Many software titles were developed initially with the promise of more in the near future. The initial offering went over only fairly well. The price for a consumer product was initially high, but as with most consumer electronics, within a few months the price began to drop.

Price is not always the selling point for consumer electronics. With products like the CD-i, software availability is critical to its success. Once this type of technology is developed, and proven to be viable and in demand, competitors will emerge to claim their share of the market. As other companies began to develop similar CD-i products and applications, Philips went back to the drawing board to recreate their product and came out with a reduced priced unit and new software releases.

The success of the product, based on total sales, never did meet original expectations. The CD-i player had mass appeal but the software, expandability, and marketing of the device, did not keep it afloat for long. One reason was the linearity of the device. The CD-i format is good but to be able to take the format and apply it for use in a personal computer, with enhanced capabilities is even better. An example of how CD-ROM technology used through a personal computer is a better solution is as follows: An encyclopedia on a CD-i player would only allow you to view the contents on a television. If you wanted to copy information to use in a report, the format did not allow you to do so. In contrast, an encyclopedia for use on a multimedia personal computer will allow you to use the information in other capacities, such as copying data or pictures into a word processor for embellishment.

Figure 1.5
The Philips CD-I player brought interactive multimedia into the home.

Becoming Involved in Multimedia

Becoming involved in multimedia does not require a high level of expertise. Most become involved in this process through the need to present, typically to an audience. In the past, presenting to an audience meant the utilization of slides, charts, marker boards, overhead projectors, and other methods. Today, with most information being created and stored on our personal or business computers, the logical step is to take this existing information and display it directly from the computer.

Taking information on your computer and presenting it to an audience may require additional hardware and software. The information you are presenting does not need to be attractive or colorful to communicate what you are trying to say, but using good design has its obvious advantages.

The occasional user, one who needs to make presentations and wants to take these presentations to a higher level, should not be intimidated. Most of us have a personal computer at our disposal. Most of these systems either have the capability to develop graphics, sound, and other types of media, or can be upgraded to do so. If not, the basic system cost is fairly reasonable. If your goal or job description entails the development and presentation of computer-based information, the basic products are easily accessible, either through purchasing or renting.

Multimedia Presentation Tips

If you have a need to present in front of an audience, here are some helpful tips that could save you some time, energy, and even embarrassment.

Presentation Preparation

If you have prepared a presentation on your computer and plan to present it using another computer, perhaps at a different location or meeting site, be aware of potential problems. It is critical that testing be performed on the exact computer that will be used on presentation day. Here are some items, however, that you could use as a checklist when presenting on another computer system.

- Make sure that the proper software is installed. This includes the version that you used to prepare your presentation.

Multimedia productions may be viewed on a variety of equipment.

- Having the proper fonts that are used in your presentation is mandatory. Without matching fonts, your presentation text will not conform to your original design.

- Computer Compatibility: If you designed your presentation on a desktop computer that has a fast Central Processing Unit (CPU) and your final presentation will be on a slower system, you may not achieve the same results during playback for the transitions, animation, movies, and other elements that you are planning on using in the presentation. Presentation design should be done with various systems in mind.

- Sound quality will differ from system to system. It is critical that sound hardware be compatible. Also important is the number of people you are presenting to and the room in which the presentation will take place. If sound output is a critical part of your message, make sure that you have the necessary external sound support in order for the sound to be heard.

- Screen colors will vary from monitor to monitor. Screen colors can also change, often dramatically, when projected via an LCD (liquid crystal display) panel or projector, or other projection devices. The application of color should be given serious consideration in the overall presentation, especially related to the device that will be used to present to the audience.

- Color depth can also be an issue. You may have designed a presentation in the "thousands of colors" mode, and your current settings may be at "256 colors." This can be fixed within the system utilities on your computer.

Expectations

The responsibility of preparing presentations has usually been an in-house procedure with most of the responsibility resting on the presenter. In comparison, the desktop publishing revolution of the mid-eighties ushered in a new level of expectation as to what the typical document looks like today. Now we expect near typeset-quality documents from our desktop printers. Likewise, presentation software and hardware is becoming a must. We are also in an era demanding polished audio/visual presentations. We are accustomed to fast-paced information thrown at us via the television and are becoming used to visually stimulating images and sound from our personal computers. When we attend a lecture or a presentation, we expect some form of visual that will keep us entertained and stimulate our thinking. We are so accustomed to entertaining presentations that old technology just will not suffice.

We face competition as we deliver information.

Time and Resources

Learning about hardware and software for developing media presentations does not necessarily need to be a full-time job. Your requirements will vary based on your direct involvement with a project. If you have the support of an MIS or graphics department, then your main concern may be with content and delivery. If you are dependent on yourself to conceptualize, develop, produce, and present, then be prepared to learn about the selected hardware and software products involved. It is not only important to know how to use the individual products, but also how they interact with each other.

Having access to the proper resources is also a key issue. You may have a computer and presentation software, but do you have a projection device that is compatible with your computer? If you must present to a large audience, what is the best presentation method? Do you connect to a television? Do you use an LCD panel with an overhead projector? Do you rent a video projector? Are you even familiar with these products and options?

There are numerous options and each is designed for a specific purpose. Once you establish what your purpose is, the output device or process will be obvious. It is important to know how these various options work, where you can obtain them, and what product will work best for your particular audience. Usually, these issues are not complex to resolve but all of these issues will require forethought and resourcefulness.

Doing Multimedia

If you are going to be a presenter or multimedia user, then you need to have a strong knowledge of what hardware and software products are going to work for you. Learning a versatile presentation program that can incorporate all of the elements that you will ever use is a wise move. When the need arises to give a presentation, usually the conditions will change form for each. When you have plenty of time to prepare your presentation you can be a bit sloppy initially and still have time to perfect your show prior to the presentation date. However, usually the time is very brief between the notification and the actual presentation.

Therefore, be prepared by knowing your software. Stay ahead of the game. When you have to make the impromptu presentation, your focus should be on the actual presentation content, not software issues. If your choice is to use a computer-based presentation pro-

With the sophistication of current software programs, and the graphical user interface, it is easy to enter into multimedia development.

Figure 1.6 Many computer-based presentations use LCD panels for projecting with an overhead projector.

Figure 1.7 Another method of projecting computer-based presentations is through self-contained projection units.

gram, such as Adobe Persuasion, you can use the predesigned templates that will allow you to quickly enter your data and proceed. If you have used this or a similar software product you will know how to take advantage of the templates, artwork, sound, and other features that these programs have to offer. Remember that these programs are tools and should support the creative processes that go into your presentation, not dominate the process with a hard-to-use interface.

Contemporary multimedia presentations have many useful support products that enhance the visual sophistication of your materials such as LCD panels for projecting computer screens through overhead projectors for big screen viewing, and projectors that provide excellent color and clarity in a large format (see Figures 1.6 and 1.7). Another relatively new concept in presentation support devices are remote-controlled presentation devices. These units function somewhat like the controller of a slide projector. With these units, you can control a computer-based presentation from across the room via the remote control. Because these technologies are closely linked to the computer industry, rapid changes will happen in this arena.

Personal Usage

As a presenter, you want to use all of the presentation elements that will prompt your audience to respond. One of the most important elements in making a presentation that is supported by multimedia processes is to know how to access the key functions of the hardware and software that you will use. There is nothing more uncomfortable than spending hours rehearsing your presentation then forgetting a command or procedure that makes your presentation perform as planned.

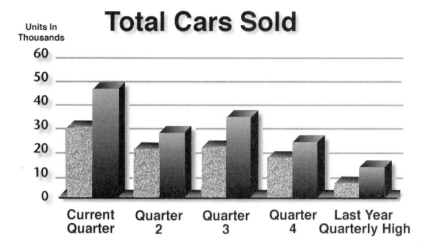

Figure 1.8 This chart is clear and precise. Just as in spoken presentation, points should be focused, clear, and to the point.

The art of professional multimedia presentations involves becoming a master of your craft. You should seriously research the software that will do the job for you and learn it well. As a computer user, you are probably experienced in the operation of at least one word processing program. You know how to use the spell checker, set tabs, find and replace words, and other features. You feel comfortable enough to open the word processing application and begin typing, giving total concentration to what you are typing. The operation of multimedia software should also be second nature, allowing you to concentrate on content, not the technical aspects of presenting. A good feature of current software product offerings is that they are becoming easier to use.

If you are a timid presenter, multimedia presentation can be frightening. For those uncomfortable in front of an audience, the perfect ice breaker is a gleaming chart, graphic, video or other media element that will dazzle your audience. Any boring statistic or presentation can really shine by using animation, sound, video, or other element.

Making Your Point

When using multimedia elements in a presentation, be sure to use discretion in your timing and implementation. The proper graphic or effect can be dazzling and really emphasize a point if used at just the right time (see Figure 1.8). These graphics should be shown long enough to get your point across but should not be left in front of your

The simpler the message, the better the retention.

audience too long. An effective presentation will allow the effect to enter, make its impact, then move to the next level.

George Lucas, director of the *Star Wars* trilogy, has perfected this art form. Some of his movie making techniques include the integration of huge sets and special effects. These sets can cost millions to develop and, as with the *Star Wars* movies, can successfully create the illusion of being in another time and place. In the past, many Hollywood directors thought that if you built these fantastic sets, they must be used throughout the entire movie. Mr. Lucas sees it quite differently. His philosophy is to build the right prop for the right effect, let it fulfill its purpose, then move on. In all of the *Star Wars* movies, you will see this technique used most effectively. A spacecraft or backdrop may have taken months to build, but may only appear on the screen for a few seconds. As you know, many films are successful due to the fact that the special effects are the stars of the show. The result is a vivid impression on your audience.

On the other hand, most of us have gone to movies that have been just the reverse. Total boredom exists when there is not enough change. Remember that we are a generation that thrives on having ever-changing, colorful images and crisp sounds presented for our entertainment. Keep these principles in mind as you contemplate the preparation and presentation process for any type of media presentation. Keep it moving, colorful, and simple. Practice your presentation and look for ways to communicate your point in a simple and straightforward manner. You may also find it helpful to borrow ideas from proven presentations or presenters.

Promoting Information and Ideas

Usually, if you are giving a presentation, either in person or via other media types, you have a message you want to communicate. Your ability to communicate can either be good or bad. As the saying goes, a picture is worth a thousand words. Therefore, if you integrate photographs, along with sounds, graphics, video, and color into a presentation, your chances of effectively communicating your message will increase. Of course this is based on tasteful selection of the elements used to support your presentation.

Presentation content must be able to grab the attention of an audience. It must be both appealing and inviting. There are many players vying for attention these days. As you promote your business ideas, your product must stand out from the others.

Why You Need Multimedia

What is multimedia good for? Multimedia, like the computer itself, is a tool. This tool will assist in the promotion of ideas, concepts, or services that you may wish to promote. There are no limits as to what it can be used for. Here are a few areas where multimedia processes are beneficial:

- Business
- Marketing
- Education
- Edutainment
- Training

Business

Today, businesses use the computer to process virtually all correspondence and internal data particular to that business. As businesses have the need to communicate with the outside world, multimedia processes offer a wide variety of options. Through the utilization of multimedia processes, typical information that is generated on a computer can be converted to dynamic charts, illustrations, and colorful graphics, therefore moving the preexisting information into a new arena.

By using multimedia processes, business presentation takes on a whole new meaning. Visual impact is enhanced with the addition of these dynamic components.

Marketing

Computer-based multimedia productions can take product marketing to a new level. Multimedia techniques can be used at trade shows, for presentations, or to give new life to older products. Electronic catalogs, similar to the illustration in Figure 1.9, allow companies to send electronic versions of their catalogs to households, increasing exposure of their products and increasing sales by making the shopping process easier.

Marketing new or existing products can be greatly enhanced by using multimedia technologies. Products can be marketed in a manner that will provide more detailed and stimulating information than printed media.

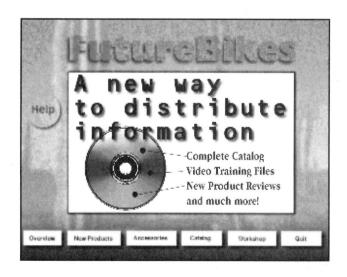

Figure 1.9 Electronic catalogs, distributed via CD-ROM or the Internet, add a great advantage over traditional print media.

Figure 1.10 The CD-ROM based Encarta Encyclopedia master screen.

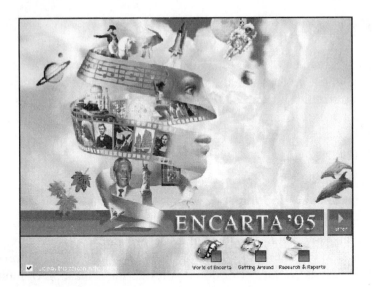

Education and Training

In corporate life, you can expect growth, downsizing, takeovers, and turnovers. The one thing that remains constant is change. In this transitional environment, it is crucial that employees are properly trained and stay up-to-date on changing trends. Today's businesses are dependent on trained personnel to perform highly specialized tasks. This requires continual exposure to new training methods.

One of the most effective uses of multimedia technologies is the conversion of existing printed information into digital format. An example of this is the information found in printed encyclopedias. As this information transfers from print to digital, the information takes on new life. Information that was once static in nature, can now be seen and heard through multimedia technologies. A perfect example of this is the Microsoft Encarta (see Figure 1.10).

Distributed on a CD-ROM, Encarta Encyclopedia brings information to life. With the capacity available on CD-ROMs, various types of information can be stored to illustrate a particular subject. Here's an example of what can be stored on a CD-ROM:

- 33,000 articles
- 8,000 pictures
- 325 detailed maps
- Hundreds of tables
- Narrated animation
- Six hours of audio and video

CD-ROMs include all of this with a simple interface that includes easy word searching and linking. As this trend continues, more topics will be developed to cover any subject matter that you wish to pursue.

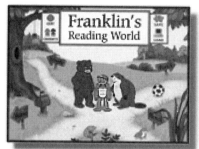 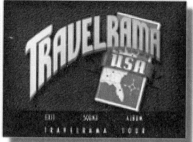 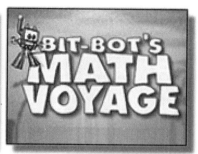

Edutainment

Exactly what is Edutainment? This hybrid term refers to multimedia titles that are part Educational- (Edu) and part Entertainment- (tainment) oriented. Such types of media are products like *Franklin's Reading World, Bit-Bot's Math Voyage,* and *Travelrama, USA,* from Sanctuary Woods (see Figure 1.11). Distribution companies, like Educorp® specialize in the distribution of CD-ROM software and offer a vast variety of Edutainment titles.

Computer-Based Training

There is currently a major shift happening in the utilization of computers in the area of training. Computer-Based Training (CBT) is beginning to gain wider acceptance due to the added advantages of the multimedia components. Companies are discovering that computer-based training allows their employees to learn faster as well as achieve better retention results compared to other training techniques. Curriculum development for in-house training is expensive and takes a long time to produce. With computer-based training, however, the individual can move at his own pace. Another plus in computer-based training is the ability to change lessons or data for certain levels of staff training. Many exercises may contain common elements. These elements may need only slight adjustments in order to create these new levels.

Another benefit of computer-based training is that the content can contain a variety of multimedia elements. As a part of the job training, the worker can perform a simulated job function in order to develop an advanced skill level without having touched the actual unit. The integration of audio and video allows this training technology to be a highly effective medium. These processes are particularly successful in the area of flight and driving simulators.

Figure 1.11 A sample of educational CD-ROM titles distributed by Sanctuary Woods.

What you can do with multimedia is still evolving.

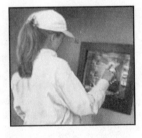

Figure 1.12 A multimedia kiosk refers to a free standing unit, usually with a touch sensitive screen.

Unique Applications

They are in shopping malls, grocery stores, pharmacies, just about everywhere! Electronic kiosks are becoming a mainstay in our day-to-day lives. The concept behind these multimedia droids is to communicate a message or gather information without requiring an attendant. The medium is an excellent method to advertise and market products and services. Perhaps you have been in a shopping mall and had surveyors approach you, asking if we have a few minutes to complete a survey about a particular product or service. The kiosk is a tireless worker, always there, giving and taking information on demand.

A kiosk is typically a computer and a touch-sensitive screen that allows the user to evoke a command or response by touching a graphic element. The hardware configuration can vary for these units (see Figure 1.12). Typically a kiosk is a stand or a booth used for point-of-purchase product sales, information handouts, or directory services.

Sometimes a laserdisk player is used to hold a vast amount of video that can be instantly accessed by the user. All of this is hidden from view in the kiosk cabinet enclosure.

Kiosks are capable of producing and gathering the same type of information that the survey teams are paid to gather yet without the intimidation to the consumer. The kiosk environment allows the customer or consumer to approach the device based on the message that the kiosk is presenting. The consumer can also take his time rather than commit to an individual. Kiosks can contain the following:

1. Display Only: Allows the viewer to look and learn without active participation.

2. Interactive Display: Allows the user to learn interactively. The user pushes a key on a keyboard or touches a button on the monitor to go to another screen or level to learn more about a product or service. This "interactive" learning is extremely valuable because the user is learning at his own pace (see Figure 1.13). The user could also control other devices such as a printer to print a copy of an on-screen instruction or presentation.

3. Information Gathering: Allows vendor to gather information about services, needs, demographics, or other information.

The use of kiosks will continue to grow due to the relatively low overall cost compared to the cost of a manned unit.

Figure 1.13 The screen on the kiosk has a simple design, allowing users to obtain information quickly.

Publishing Multimedia Projects

So far in this chapter, we have covered several areas of multimedia. You are probably beginning to see how the term came into existence. Not only are we using multiple mediums, but we are also using them in many environments and for a variety of applications. Let us take a look at using multimedia technologies in electronic publishing.

Though the term electronic publishing seems new, electronic publishing has actually been around for quite a while. Here is a brief comparison of traditional versus electronic publishing. To publish a printed book involves having the support of a publisher, who will pay for the up-front costs associated with the project. The services that the publisher provides include the design, manufacturing, distribution, and sales associated with the development of the product. With electronic publishing, once you develop the content, you are ready to distribute. If this is true, then what are the distribution options for electronic publishing? Perhaps the most visible electronic publishing vehicles are the Internet and the CD-ROM.

Electronic publishing on the Internet can be done by anyone that has access to a computer, the proper software, and a connection to an Internet provider. A basic form of electronic publishing includes processing a document to a bulletin board. A more advanced technique is to have a page published on the Internet. This is a process that allows constant exposure to your information while on the Internet.

Another popular electronic publishing medium is the CD-ROM. This technology, and the amount of information it is capable of containing, allows a wealth of information to be published and distributed. CD-ROMS can contain just about any type of presentation that is developed on a personal computer. CD-ROMS are capable of playing music, voice, animation, three-dimensional graphics, video, and other elements that make multimedia work. Electronic publishing makes multimedia work because it can successfully incorporate all of the elements that stimulate our thinking, feeling, and understanding or retaining a message that was presented using this technology.

Another trend that is becoming mainstream is multimedia magazines. These interactive CD-ROM magazines contain interactive articles, art, music, and presentations from contributing authors and performers, and often include sample software programs (see Figure 1.14).

In traditional publishing, text, photographs, layout, and design are prepared and formatted, then, sent out for printing and distribution. Obviously, the printing, production, and distribution costs are ex-

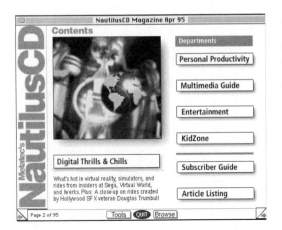

Figure 1.14 Multimedia magazines, such as Metatec's *Nautilus* CD, are becoming increasingly popular.

Figure 1.15 *From Alice To Ocean* was originally a photographic journal that was turned into an enormously successful book and CD-ROM product.

pensive. Producing a CD-ROM product is somewhat similar. You must prepare your text, graphics, photographs, layouts and design as you do in traditional publishing environments. The exception to traditional publishing is that instead of going to press at a printing plant, your electronic file goes to press at a CD-ROM reproduction facility, or on-line via the Internet.

If going the route of CD-ROM production, the initial cost of mastering a CD-ROM is fairly expensive, approximately $1,000. Once the master copy is produced, subsequent copies cost around $1. each, based on volume. Distribution on these CDs could be through the mail at a cost of under $1. Compared to the cost of printing and mailing a printed piece, the CD-ROM can offer cost savings.

When developing for on-line distribution, once the presentation is prepared in electronic format it is ready for broadcast.

Of course, most CD-ROM products also include printed support material as well as colorful designed packaging. For the amount of information as well as the type and quality of information you can distribute on CD-ROM, a new world of information technology awaits us all.

The future of CD-ROM publishing could rely somewhat on the publications of the past. The printed information that has been produced through the years is a vast storehouse waiting to be reborn in the form of a computer-based multimedia production. Nothing reflects this concept better than the move of encyclopedias from print to CD-ROM, and products like *From Alice To Ocean* (see Figure 1.15).

From Alice To Ocean is a book/CD-ROM product that chronicles Robyn Davidson's 1997 journey across the Australian outback. The CD-ROM contains narration from Davidson and outstanding photojournalism from Rick Smolan. Through the vision of Apple Computer and other sources, the product was reborn in the form of a CD-ROM, allowing us to join in the journey.

Look for similar projects to be produced from archived information. This technology will also allow the preservation of older forms of media, ensuring that the information will endure for future generations.

On the Edge of Multimedia's Impact

The creative and practical usage of multimedia development is still in its infancy. Over the next few years, expect an onslaught of multimedia titles for entertainment, instruction, and other areas. Look for innovation, not only in titles, but also in the format in which they will be presented. Probably one feature that will be refined in the next few years is the ability to use the same title on various computer systems. This is more common today due to the corroboration between hardware and software vendors, and the need to distribute information to anyone, no matter which computer he uses.

The industry has come a long way in the past ten years. When considering the current state of hardware and software technology, imagine the state-of-the-art ten years from now!

Getting Involved

You may be driven to become involved in multimedia as a result of your chosen course of educational studies, your personal interest in the medium, or because you are trying to keep up with the current trends in business communications. One thing is certain, we must stay abreast of the changes in this field.

Outlining is a critical step in multimedia planning. It can be done on paper, in a word processing program, or in presentation or authoring software.

If you are entering the multimedia arena just to find out what it is about, you will be amazed at what lies ahead. If you are being forced to learn this technology to develop a new set of presentation skills or even to begin developing a multimedia title for distribution, then you obviously have a concept or need that is driving you to become involved. This chapter will help clarify how to "get your feet wet" in the multimedia process.

The Need to Develop

No matter what your reason for joining the multimedia revolution, you will find that it is a fascinating environment, offering new ways to express any message. There is much to learn about the individual mediums and how they work cohesively to form a single product. Once the direction of your product or production is established, you can begin to assemble the pieces.

Acquiring Resources

You may find that entering the world of multimedia is very linear, requiring the mastery of only a couple of external sources. This will solely be based on what you are going to do with it. Remember the idea that a simple slide show is a form of multimedia. On the other hand, your intentions for a multimedia production may require many resources and external devices to properly produce your product.

A key element in making multimedia work is knowing what resources are available.

Each project or product that you develop will have its own process development path to follow during the preparation stages. The inter-working of all of these processes is fairly straightforward. For example, if you want to include a photograph in your production then you only have a few options to get this information into your computer. These options include: scanning, digital camera input, video camera image capture, or acquiring an image through a clip-photography resource.

Acquiring various resources requires knowledge of incorporating the various images, sound, and video files into your computer to create a cohesive production. Through the study and observation of the products and processes, the pieces should fit together easily.

If you are a novice to computing or multimedia production, consult with instructors, practitioners, or computer professionals that have expertise in this area. Find out what your limitations are in the realm of acquiring the numerous components that constitute a multimedia production. Your presentation may vary from others. Know what you want to present, then find what it takes to make it work. There are numerous books and computer-based help products that can assist you in this process. Develop a clear vision for the product you wish to develop and establish milestones to reach that goal.

Your idea may reside in a product that currently exists. Borrowing ideas from proven success stories is a great way to begin. If you have been inspired by a colorful presentation with properly applied music and graphics, then imitate. Imitation is the sincerest form of flattery. However, be careful not to imitate too much. Be original with your content and implementation and do not plagiarize.

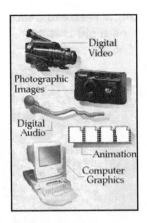

Figure 2.1
Some of the resources involved in the creation of multimedia.

Examining the Products

The products that are used in the creation of multimedia projects are numerous and varied. A close examination of what you are going to produce will dictate what external devices or products you will need. Careful planning means that you know the final outcome of your production. Therefore, knowing the end result will tell you which products are required for the production.

Video, photographs, sound, music, animation, computer graphics, and more will play a part in the make-up of your multimedia projects. It is up to you and your project requirements as to which you will have to master.

The beginner knows what he wants but knowing how to get there may be a difficult journey. If you need to produce illustrations for

your production and you are not an illustrator, how do you learn which software product is the best for printed media as well as on-screen multimedia production? For incorporating photographic images, what software will allow color adjustments and corrections to make the production look the best for on-screen presentation? For text, what is the best type style, color, and size for the presentation? This is just the beginning. There are many issues that must be addressed during production.

Determining the Audience

Knowing your audience is probably the most important factor in planning your project. After all, you do not have a need to develop unless you have an audience. The tools that you will use as well as the method you will use to develop the project will be determined by the audience.

Will your project be intended for in-house training, product marketing, or mass production and distribution to the public? Will it have to be compatible with different types of computers? These issues must be addressed before you begin development.

You can look forward to the fact that the more you learn about and are involved with multimedia, each new project will be easier, due to the experience that is gained from each. Each project will also add to your total skill set. For example, if you produce a project that incorporates photography, animation, and video, then you will be able to carry over these skills to your next project. Not only that, but with each new project, you will have better ideas on design and implementation. A refreshing part of expanding your current skill set is that with each new venture, you will have substantial experience from which to draw.

When determining your target audience, another aspect that must be addressed is funding. The time and resources that it takes to develop a multimedia presentation or product will vary with each circumstance. If a production is being developed for an in-house function, then it may be a part of your job to produce it, meaning that the production cost is buried in company overhead. If you are producing a multimedia product for distribution to the mass market, then the constraints are quite different. Developing a mass-marketed product could mean hundreds of thousands of dollars in advance. Therefore, when you predict an estimated completion time, management usually expects that the product will be finished and that the funds are sufficient to complete the job.

Each project is unique, and preplanning is essential towards reaching a finalized product as well as to effectively reach an audience.

You can carry over the skills learned from one project to another.

Figure 2.2 Clip-art samples from Image Club Graphics.

Creating It Yourself Versus Using Predesigned

There are many options to consider when producing a multimedia related product. All of the elements that make up a multimedia production can be produced with your own resources if you possess the proper skill set for creating the variety of graphic and sound related files, and if you have access the required hardware products. If you are a novice and do not have access to all of the equipment or software for production, there are other avenues that will allow you to develop your product.

In the early days of computing, placing art into a word processing document was difficult. Thus, electronic "clip art" was born. Many companies came into existence for the sole purpose of developing predesigned graphic elements for specific applications. Like traditional clip art services for producing advertising art or publication art, this clip art consisted of electronic files that were ready to copy and paste into your word processing or page layout document (see Figure 2.2). Clip art quickly became popular due to the demand for high-quality artwork for print and presentation.

Today, this concept has expanded from clip art to clip media. This is due to the fact that the concept now includes predesigned art, animation, sound, photographs, and video images, that can be purchased and used in projects. Typically, if you purchase this form of media, they are considered license free. This means that when you purchase the product, you have legal permission to use and distribute without being required to pay royalties to any party. If you choose to use a video clip from a commercial video title in your production, however, beware. This information is protected by copyright laws. Never use copyrighted material. Look for an applicable product in a royalty-free package or create your own.

Clip media includes predesigned art, sound, animation, and video.

Figure 2.3
Clip media consists of a variety of source material.

Some companies specialize in the development and distribution of clip media that include a variety of media types on CD-ROM. A typical product could include 1,000 stock photographs, 100 live-action video clips, and 1,000 sound effect and music clips. All of this information is royalty-free and prices start around $50. This media can be extremely helpful when time and creative resources are at a minimum. It is difficult to conceive how much time would go into developing or acquiring this information on your own.

Whether you use your own designs or clipmedia, most presentations contain numerous support files. Oftentimes many of these files are variations of a common file. A graphic could be used for one part of a presentation, then be slightly modified and used once again later. They often contain almost the same name and look almost identical. These files become numerous and can create confusion when trying to locate them for use in your production. Using a visual database can be very beneficial here.

Figure 2.3 demonstrates how various types of files are available for instant access. By using a program such as Adobe Fetch, you can see a thumbnail of the file for easy reference. These files can be created by the user, or can be taken from a clip-media resource. When working with multimedia projects, the external files can be numerous. Using a visual database like Fetch allows you to quickly find the file you are looking for.

One of the simplest forms of multimedia presentation is a computer-based slide show. Using computer-controlled presentations

Several software applications allow on-screen slide show capabilities.

opens up a world of advantages. Unlike traditional 35mm slides, the images used in computer-controlled presentations can be used in various formats in the future with only slight modifications.

This slide show concept can easily be turned into a desk-bound presentation by utilizing software such as ClarisWorks. This integrated software program has a slide show feature built in. This feature allows you to automatically go from page to page at a time interval that you specify. It allows you simple effects like dissolves and colored backgrounds. This gives the feel of a media presentation with very little work or even knowledge of the whole multimedia process. This is one example of how multimedia processes are slipping into the mainstream. Again, being involved in multimedia can begin quite simply, and be very effective. Keep this in mind as you start your journey.

Choosing the Complexity

As you may have noticed, there are some very exciting CD-ROM titles currently available on the market that provide excellent content and presentation. These titles are fulfilling their intended purpose by providing sophisticated sound, graphics, and spectacular integration of storytelling and interactivity. Most commercially available products are designed by experienced multimedia developers. However, since this is still a relatively new field, you may not be that far behind. As a novice, you can learn about the process of development. All it takes is time and training on the appropriate software to make it all work together. Your adaptability to these skills will rely on your creativity, time, and interest in the necessary processes.

If you have ever used a page layout program, such as Adobe PageMaker, you know that these programs are designed to receive various elements that have been prepared by other software programs. These programs are very sophisticated but are not designed as a universal solution for creating all of the elements that typically are a part of a page. Elements that are placed into these page layout programs consist of the following:

- Illustrations from a drawing/illustration program
- Text from a word processing program
- Photographs from a scanner
- Charts from charting software
- Line art from clip-art programs

These page layout programs offer sophistication in the following areas:

- Accept a variety of file formats: .pct, .tif, .eps, .bmp, .gif, and others
- Allow the resizing of graphic elements
- Provide precision text features such as leading, kerning, horizontal scale adjustment, tracking, etc.
- Adjust tone, texture, and line-screening of scanned images
- Rotate images

These are just a few of the features that these programs offer.

As previously mentioned, page layout programs typically cannot create the scan, line art, chart, or logo, but are well equipped to have various file types placed into them, and to output the file with excellent results. This is what they are designed to do (see Figure 2.4).

This concept is somewhat similar to the process of multimedia development. Programs like Macromedia Director are parallel to page layout programs. Some authoring environments do not have the capability to produce movies, scans, sound, etc., but rather accept all of these files and allow you to coordinate all of them into an orchestrated scheme to interact appropriately at the time you want them to (see Figure 2.5).

Figure 2.4 Page layout programs and multimedia screen share some common concepts.

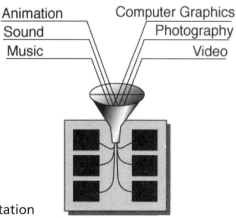

Figure 2.5
All of the elements that make up a multimedia presentation are funneled into the authoring program.

Authoring Program

Exercises 1 and 4 on the CD-ROM allow you to experience the power of Director.

Design and Your Skill Set

What you will learn in your journey into multimedia is that you must consider design. Design will apply to many phases of multimedia presentation development. Design is used in the creation of art, sound, animation, video, computer graphics, and all of the support items in a production (see Figure 2.6). Design is also used in the aspect of production. Any project must be designed from the aspect of the layout and execution of the project. Design sometimes refers to the manner in which the pieces are put together, such as the way a presentation will be displayed, on what products, and in what environment. All of these aspects reflect design considerations.

It will not take you very long to realize that there are a lot of issues to be addressed in multimedia planning and execution. This may bring you to the issue of focusing on what constitutes your current skill set. For example, you may be an excellent graphic artist, having mastered the graphic design process on the computer. Because of your skills in this discipline, you may be an excellent candidate to learn the necessary software to totally author a multimedia project. But remember, there are a lot of disciplines involved in the overall multimedia development

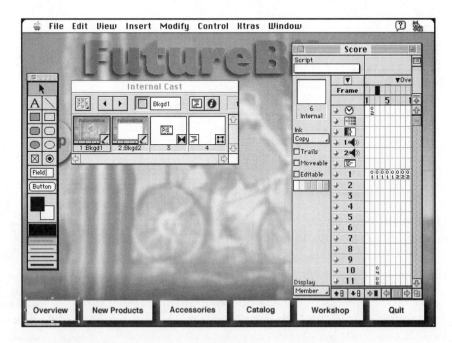

Figure 2.6 Authoring programs like Macromedia Director allow the importation of various types of files.

process other than just graphic design. On the other hand, your present job description may dictate that it is just not feasible for you to dedicate the time required to become a master of all processes.

Each situation will vary. If you are a student wishing to learn all of the disciplines, then you will need exposure to each process, and therefore develop a degree of proficiency in each. If you want to learn this technology/art form as a course of study or to develop a new business, then you will also need to expand your existing skill set.

Having hands-on experience is the best teacher. The more multimedia components you can be involved with, the better qualified you will be to create, produce, and present, using these tools.

There are companies that can produce custom media components for you.

Help from Outside Contractors

With the popularity of multimedia continuing to flourish, an increasing number of companies and individuals are playing a part in the process. One area that is rapidly growing is the number of specialty companies that produce support services. These companies can develop customized media for your productions.

Very much like the clip-media services mentioned earlier, these companies can take on the task of producing content-specific media. For example, if you need video footage of a specific sports team that you are planning to use in your production, and you do not have the equipment or expertise to acquire it on your own, these companies' services could provide the footage. This process could also apply to custom photography, sound, animation, three-dimensional graphics, graphic design, the mastering and reproduction of CD-ROMs, and other services.

Growth of these types of support companies occurred during the desktop publishing revolution. Numerous support-related industries, previously not in existence, were developed to support the explosion of this dynamic industry. Based on the fact that multimedia is still in its infancy, the same changes will apply to this fast changing industry.

Making Multimedia Meet Your Needs without Changing Your Job Description

Multimedia development is a full-time job in many instances. However, if you need media support for various forms of presentation design, how can you get it without becoming a full-time multimedia developer?

Exercise 3 on the CD-ROM allows you to develop a presentation.

Much of the answer lies in the ideas mentioned earlier about who your audience is. If you are on the road giving presentations on a regular basis a part of your job is to develop presentations. Preparing these presentations could be solely your responsibility. In that case, you must rely on the resources you have available. If your business is to present on-screen facts and statistics with charts and graphs, then a presentation program like Adobe Persuasion or Microsoft Powerpoint is a good development tool. If your presentation requires video integration, animation, and other resources that you do not have access to on the road, then you must be able to access them through a local source or from support back at the office. As you can see from this scenario, the issues at hand are knowing what your skills are and utilizing other support mechanisms to execute your presentation or project.

Another scenario would be involvement in a product for distribution on CD-ROM or the Internet. This type of production involves many disciplines and more man hours than organizing a presentation to a live audience. If you are in charge of producing this type of product, then your job description will be that of a manager, controlling the project as a whole. Few individuals are capable of creating an interactive CD-ROM, with all of its elements, by themselves. Again, knowledge of the overall process and what it takes to make it happen is crucial to the organization of such an effort.

Ongoing Development

If you are going to be the producer of the project then you must have a combination of a good imagination and the ability to think through the production processes of the project. Your responsibility is to process your ideas into a logical step-by-step production schedule, complete with all of the peripheral devices required to make the production happen. You also must consider arranging the proper personnel to perform and develop various segments.

Once you have successfully gone through all of the steps in a production, your subsequent projects will be better. This experience will give a freshness to each new project, allowing the creative process to flourish, and the mechanical aspect to become somewhat routine.

Developing a Project

Who will do it?
How much time will it take?
How much will it cost?
What system will be used?
Will it go "on the road"?

These are a few of the issues you may be facing as you begin the process of developing a multimedia project.

Development scenarios for multimedia projects are broad and will vary based on the nature of the project. As mentioned earlier, to proceed on a productive path, it is very important to know who your audience is. Multimedia projects, no matter how simple or complex, do not have to incorporate all of the resources available to be considered a true multimedia production. A combination of just one or two of these elements will constitute a multimedia project. Your particular level of expertise should not hinder you from developing what is considered a multimedia project, and your knowledge and resources will grow as you learn more about the technology and how to integrate all of the resources that are involved.

Examining the Scope of the Project

A multimedia production can be as simple as a slide show on your computer, using still images only. Sophistication can be given to your project by the addition of voice or animation to the project at a later date. Adding the proper sound at the right time can provide powerful impact, but adding the wrong sound at the wrong time could spell disaster for the message you are trying to convey in your presentation.

Project Definition

What are you producing and for whom are you producing? What is the delivery platform? What is the budget? What multimedia elements will the project include? What development software and hardware is required? When does it have to be finished? There are many questions to answer during the development cycle. Examine each area carefully and come to a solid understanding of each one. This will ensure that you are on the right track towards developing a successful project.

No matter how it will be presented, having a clear picture of the overall project is necessary to produce any type or size multimedia product. To truly capture this picture, careful examination of the project, and the development of an organizational model is important.

The following topics represent a model that will encompass almost all of the steps necessary when developing any size production. Keep in mind that this list is comprehensive and some elements will not concern smaller projects.

Outline Preparation

Outlining is absolutely necessary to produce any type of presentation. We are all used to outlining in one form or another. Some of us do it in our heads, logically organizing information so that it can be played back on demand, either verbally or mechanically. Others look at schedules and organizational tools and use them in a manner that is either most efficient or most convenient to support whatever process that has to happen.

Outlining, as a tool for preparing and organizing a multimedia project, can be performed in a variety of ways. To organize thoughts, information, and interactivity flow, writing or typing this information will work. This may be done in word processing software. Some applications, such as Microsoft Word, have an outlining mode built in. This feature allows you to input ideas and thoughts, then arrange them in a logical format.

Most presentation software programs have outlining capabilities built in. This feature allows you to type ideas into an outliner and to easily rearrange the information into a logical formation. Once this is done, the information can be converted into a slide show format, illustrating your text with backgrounds, color, transitions, and animation. This is a good way to begin, and provides a quick method of having your information displayed in a graphical format. From here, you can

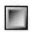

A delivery platform simply means the computer that plays your presentation.

Figure 3.1
A presentation outline as developed in Adobe Persuasion.

Exercise 3 on the CD-ROM uses Adobe Persuasion to develop a sales presentation.

progressively build a presentation or project. Figure 3.1 shows an example of an outline developed in Adobe Persuasion.

For multimedia applications, an important concept is to develop a prototype or an outline to determine if the idea that you have for your production can be translated into a workable product. This prototype would best be developed in the authoring software that you will use for your final product. The prototype will also give a feel for how the final product will be designed and operated. This is also important for developing the human interface of the product. This type of outlining is much more visual, and will take some of the in-between steps out of the traditional outlining approach. Outlining in a software environment, by creating a dummy screen, is usually for those who are very familiar with their presentation/authoring software of choice. This type of outlining crosses into the storyboarding process.

Storyboarding

A storyboard is simply a visual representation of the different frames, or screens, that will be included in your production. The purpose of a

Figure 3.2 A storyboard is critical to the creation of a coherent flow of information.

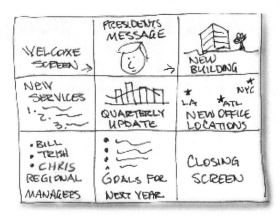

storyboard is to visualize how the story will flow, and to ensure that no vital information is left out during the sometimes confusing development process. If your product is going to be interactive, requiring that others have decisions to make, then the storyboard will be helpful for determining when and where user input can or should happen. In this situation, many options must be reviewed to make sure the flow of information reacts to the user as intended by the developer. Storyboards are helpful, if not mandatory, for even the smallest project, and are crucial for large projects involving many production team players

Before developing a storyboard, the outline process should be completed. The project developer or producer will embellish the outline even further by developing a storyboard (see Figure 3.2).

Storyboards let you know what will happen in each frame, and the content that needs to be acquired or developed for each. Storyboards can be done on paper utilizing the ever popular stick figure, or can be done in presentation software such as Persuasion or mPower, or in authoring software, such as Director. There are also specific software applications designed especially for storyboarding.

An advantage of developing the storyboard in the final authoring or presentation environment is that features such as graphics, interactivity, "hot buttons," and other integral elements can be gradually built upon. As this building process continues, and modifications and improvements are made, eventually the final product will evolve. Make sure that the authoring program supports screen printing or page printing. This will be necessary to produce a hard copy for distribution and proofing.

Each multimedia production, no matter how small, must have a design strategy.

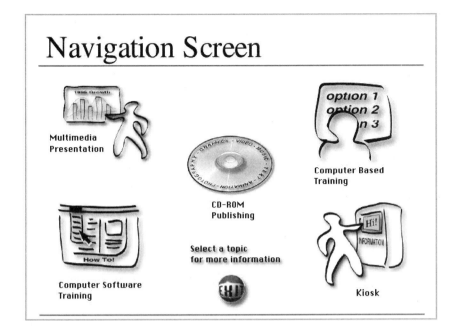

Navigation Screen

Multimedia Presentation

CD-ROM Publishing

Select a topic for more information

Computer Software Training

option 1
option 2
n 3

Computer Based Training

Hi!
INFORMATION

Kiosk

Figure 3.3
This graphic is an example of an interactive presentation interface.

Exercise 2 on the CD-ROM provides a simple, uncluttered interface that is appropriate for an electronic brochure or an electronic kiosk.

Interface Development

In multimedia terminology, the interface refers to what the user sees on a screen. In a kiosk environment, for example, the user interface is the information on the screen that is seen, heard, and touched. The same is true for an interactive presentation or computer-based training application. The interface is a person-to-screen interaction. An interface traditionally applies to one of these situations, and almost always refers to the way the user interacts with the screen.

If your multimedia project is designed for multiple users, an easy to use interface should be implemented. For example, if you are designing an interactive kiosk, requiring that the user make selections by touching a button on the screen, then the screen images should be clean and uncluttered (see Figure 3.3). If the product is an interactive presentation viewed on a computer screen then the buttons and/or options should be designed in a manner that is logical, easy to read, and visually leads the user to specific areas. If the product is a computer-based presentation being shown to a room full of people, then what they see should be designed clearly and concisely.

Interface design is critical for keeping the attention of the user and making on-screen information logical.

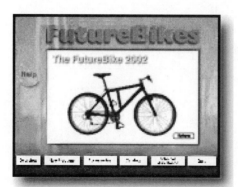

```
Date:      3/18/98
Channel: 04
On:        8:00 pm
Off:       9:00 pm
```

Figure 3.4 The interface used in Exercise 4.

Figure 3.5
The VCR has become easier to program, thanks to refinements in the interface.

Developing an interface screen usually involves creating artwork, buttons, and other elements with a drawing or painting software program. The interface art can be designed in a graphics program and the interactivity implemented in the authoring software.

The interface is important in any phase of multimedia development, but is most important when your product demands that others interact with it. Some books are easy to read and some are not, based on who is telling the story and the words they use. The same is true for computer-based presentations. If your product requires interactivity, users should be able to easily interact with it. Ease of interaction should not be based on how it works for you, but how it works for others. Testing by others will provide valuable insight as to how your product will work for a general audience. Figure 3.4 is an example of an easy to use interface.

The interface is usually not the information that you are trying to communicate, but rather the shell that allows you to approach the information. This shell can affect the outcome of retrieving information. The interface screen is what the user sees and uses to navigate through a product or presentation. If the information being communicated is good, and the interface poor, then the overall product will be negatively affected.

Early VCRs offered basic features, such as speed control, remote controls, and the ability to set a timer to record a program at a user specified time. These proved to be difficult to program. Today's VCRs provide straightforward, on-screen menus for programming. This is due to the fact that manufacturers have listened to consumer suggestions and have made this process much more user friendly (see Figure 3.5).

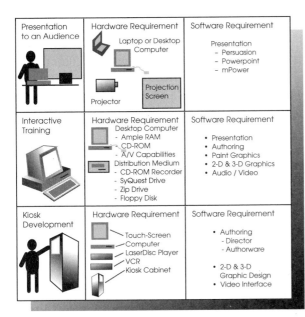

Figure 3.6 Each type of production requires different hardware and software support. This figure demonstrates some of the differences.

Interface issues have also surrounded the way we gain access to the Internet. This process is also becoming easier due to the graphical user interface that is being utilized by most Internet browsers.

Hardware and Software Decisions

There are countless hardware and software products currently on the market and more are added on a daily basis. Each new project you produce will have its own unique hardware and software requirements. Developing a presentation for a one-time showing to an audience will require different hardware and software than that required to develop a CD-ROM. Choosing hardware and software will be affected by the type of project, the budget, the time-frame, the equipment on hand, and other factors.

Figure 3.6 demonstrates some typical projects and the unique requirements of each. Note that each scenario will utilize some common equipment, but each process requires something unique. This is because each instance addresses a situation in a new venue, therefore requiring new hardware to successfully convey information.

You may be in a situation that demands that you utilize your existing equipment however inadequate you feel it may be for the job. This is when creativity and outside resources come into play. There are some

Many software programs for presentation and authoring multimedia allow files to be developed on one computer environment and played back on another.

definite requirements that must be met in order to perform certain tasks. For example, to simply use a presentation program, like Adobe Persuasion, your computer must have the following minimum configuration:

		Minimum
Minimum System	**RAM**	**Hard Disk Space**
Windows 3.1w/Intel 486	8MB	20MB
Macintosh w/System 7.0	8MB	20MB

In the realm of multimedia presentation and production, working with the minimum is like treading on thin ice. To clarify this point, consider the following scenario. Your computer has the minimum amount of random-access memory (RAM) required by the software manufacturer. This allows you to develop a presentation. But, let us say that you have a large presentation with sixty-five different screens. You work hard making your text look great. Your backgrounds are in place, you have placed numerous scanned graphics into your presentation, and all is well. As you proceed to present your masterpiece, you notice that your presentation begins to get sluggish and as you advance from frame to frame, each one takes longer to display on screen. You are presenting to an audience and you haven't rehearsed it. You find that you are stuttering and stammering while you wait for the slides to load. You have struggled through the presentation and are now ready to present your last slide. This slide contains a very large, beautiful scanned image which contains the heart of your presentation. You advance to the slide and your system crashes. You haven't backed up your file and are not sure that it is salvageable. You are embarrassed because your visual is not there to deliver the "punch" you anticipated. What happened? You needed more RAM! But, how were you to know? After all, you followed the suggested minimum that the manufacturer recommended.

What happened here is that the user was simply inexperienced. Even though manufacturers recommend a minimum configuration, it is not optimum, or even workable, when you load the program to the max. In the multimedia world, you work with large graphics, video, audio, animation, and other files, that use a great deal of RAM. Not only do these programs vie for RAM, but they love disk space as well. Beware of manufacturers' suggested minimums. They will work but you must know the minimum and maximum loads they are capable of carrying. Furthermore, pay close attention to the label which says to allot a certain amount of RAM to the application. If you have 8 MB of RAM total, be aware that the operating system will consume a certain portion of that in order to function. On the Macintosh, the operating system alone could consume as

In the development of multimedia, adequate RAM, random-access memory, is essential for successful development. The larger the production, the more RAM needed.

Figure 3.7 Knowing where you stand with your memory availability is critical as you begin to work in multimedia environments.

much as 4 MB of RAM. This leaves 4 MB for other applications. In the multimedia world, this will not produce much (see Figure 3.7).

Consideration must also be given to the amount of disk space you have available. Word processing or spreadsheet applications consume a minimum amount of space on your hard disk drive compared to the space needed for graphic, sound, and video files. Careful consideration must be given to your storage system. Prices for hard disk space, and external storage devices are very reasonable, making the cost of expanding your systems capabilities affordable.

If speed and efficiency are important and you are using an older, slower system, you should upgrade your system. Like storage devices, computer systems now offer more power and features than ever before, and high-speed systems can be integrated easier than ever before. If you are going to produce high-level media on a consistent basis, you should upgrade to newer technology. It will pay for itself in a short period just in time savings. It will also help in the sanity area, as you are trying to make all of the media components work in harmony.

This upgrading concept applies to the software arena. Acquiring the right product for specific needs is essential. Purchasing software that will allow import and export features is critical. A key element in multimedia computing is knowing the software that will make your project work and knowing your options as to where you can take your information. Is it compatible with other systems? Is it a well known program that will be around tomorrow? Can I export it into other applications? There are many issues that need to be addressed as new software products are acquired.

Output Format

A multimedia presentation designed for a one-time showing could be confined to floppy disk, a SyQuest or cartridge drive, CD-ROM, or per-

The quality and quantity of the type of media production you can produce is in direct proportion to the hardware products you use.

Exercise 4 is a prototype for the distribution of product information on CD-ROM. Take a look at this demo in the Browser.

haps an internal hard disk drive. These types of projects will probably be archived if they will fit on floppies or a cartridge drive, but if your presentation is valuable, you will not want to leave it on a hard disk drive. First, they take up a lot of space and second, the failure rate is potentially high, especially if the drive is in daily use.

Your final output format will usually be based on what your presentation is and where it has to go. For large productions you will want to store these on high-capacity media such as a SyQuest drive, a magneto-optical disk, videodisk, or on a CD-ROM.

Production Cycle

The following topics demonstrate a suggested scenario to follow for the production of a project such as a commercial CD-ROM title for mass distribution, or perhaps a site on the World Wide Web. The outline, though comprehensive, will be helpful for all projects.

Prototypes

By developing prototypes early in the design and planning stages of any project, the projected workflow and process planning will crystallize, allowing the project to come together faster. Test in small segments and on planned intervals so that you know where you are in the production stage.

Organizing a Team

Once your prototype is developed, you must consider the team players that will be involved in the overall production. This applies to almost any size project. You will need to assign various tasks to team managers. These managers will need to be responsible for specific segments of the production. Examples of such managers are designers, videographers, programmers, and artists.

Product Design

If there is a need to develop a presentation or product, then the steps to take will be logical. As architect Frank Lloyd Wright said, "Form follows function." By the time you make it to the product design stage, you may have to rethink and rework your original storyboard. At this stage, you should have a good feel as to the amount of time, resources, and cost of development your production will require. This process should become easier with future projects.

Testing for Usability

The best source of feedback on project development is user testing. Your ideas are important and critical to the overall development process, but having someone unfamiliar with the project give an objective opinion is invaluable. This usability testing should occur on a scheduled basis during the development process. One of the worst things that could happen is that you reach near completion of your project and then invite testers only to find out that you left out a critical step. Going back at this time is truly a setback. Plan ahead.

Product Redesign and Modifications

Based on the valuable input received from the previous step, you will find that you will tweak your production continuously during development, keeping in mind your original target date for completion. Make sure that your revisions are in accordance with your schedule. Redesign activities demand time management skills on behalf of the project manager. If time management is not your strong suit, then assign this task to a capable team member.

Financial Considerations

The financial consideration of developing and producing a sophisticated multimedia project is a critical part of the process. In this project, it can be costly to get to the stage of developing a prototype to demonstrate. Financial issues are also an integral part of marketing, testing, and distributing. Each of these areas require serious consideration.

Since this is still a new field, there are not a great deal of outside resources that can assist you by providing an exact cost model of what your custom project will cost. This will demand more time and consideration during the initial planning stages. All phases must be carefully calculated and one must plan for the unexpected.

Final Organization and Team Implementation

At this point, you are ready to take another look at your team and perhaps adjust the players that will assist in the preparation of your product or project. These players may or may not be people within your organization or even immediately at your disposal. Players could be resources or providers in the form of vendors, local service bureaus, or contractual support.

Media Production/Software Development

Making multimedia work really begins with the successful merging of the various media types with the proper software implementation. The media (video, graphics, scans, artwork, sound effects, audio), and the software (the authoring environment that makes the media come alive), must be developed in harmony to ensure the success of your production.

Management skills are important at this stage. The need for tight organization during the development of the various media types is required. In all projects, production deadlines are critical. Obviously, final software development and assembly cannot take place until all of the externals are completed.

Product Documentation

Products designed for distribution to a marketplace must contain documentation. As a project develops, required documentation could take on a variety of forms. With computer-based presentations designed for personal use there is traditionally no requirement for documentation. If it is, for example, a corporate presentation that others will use, then the documentation format could consist of a file or notes that are a part of the presentation preparation. This information could be a separate file, and be considered speaker's notes or other types of notes related to the presentation content. With interactive titles, games, educational titles, and more, documentation takes the shape of pertinent support material for the program. There is so much detail that goes into these products, the issue of providing the user with the necessary information to find out what they need to know, when they need to know it, is critical.

Print has been the traditional form of documentation in the past. However, in this electronic age, other methods of preparing product documentation are feasible. Many programs offer on-line help files. These files reside in the application and offer instant support. Another method of support documentation would be to provide an electronic file with the program. This file may be a text document that is shipped on the same storage media as the program. These files are traditionally called "read me" files. These files can be read by your word processing program or your program may include a basic "reader" application, allowing access without the need for additional applications.

A popular method for reading documents on a variety of platforms is a Portable Document Format file (PDF). This is a format de-

Developing the individual media components that go into a multimedia production can be a project in itself.

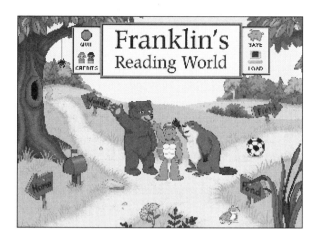

Figure 3.8
Packaging plays an important part in the marketing and distribution of commercial software.

veloped by Adobe Systems. Saving in the PDF format will ensure that anyone can read and print the documentation on any computer system, providing he has a copy of the Acrobat Reader software. The Adobe Acrobat Reader application can be freely distributed with files saved in the PDF format, allowing access to the information by the user.

Along with developing a multimedia product and bringing it to completion, preparing support documentation is critical. Support documentation is its own unique project, requiring production organization, art preparation, formation of a layout format, and the actual printing or output process. Like a multimedia project, documentation will go through many redesigns and checkpoints before the final product is ready. One good thing about producing a CD-ROM project for distribution is that much of the text traditionally printed can be on the disk, potentially eliminating the need for extensive printed materials. We have not quite reached the paperless society, but with current technologies options are available.

Packaging

For commercial projects, packaging considerations are very important. After all, the package is the first thing a consumer will see and therefore will create a positive or negative impression of your product. Packaging concerns often play a part in the mock-up phase of product development as well.

Packaging design, like most art forms, follows the wave of contemporary trends. Consider what will make your product stand out from the competition.

Today, documentation can be on-line, saving the time and expense of traditional printing.

Sample programs are an excellent advertising method, allowing the end user to see a part of the finished project.

Advertising

Advertising is imperative for commercial media products. To get your product out to the masses requires promotional literature or even a working prototype available for advanced showings. This may also require promotional packaging and documentation.

Another form of advertising is to produce demonstration versions of a product or presentation. These demo versions are a great way to allow your target audience to view a selected portion of your product before purchasing. If your product is what the marketplace is waiting for, these demo versions should generate a positive response.

Final Product and Testing

At this point, you are at the final stage of your production. Once you are here, no matter how hard you and your team have worked, be prepared to find flaws. When you do, run your product through another round of critical checks.

Feedback from industry professionals on product, packaging, and documentation is also important. These early versions that are shipped out for evaluation are considered Alpha or Beta versions of your product.

Manufacturing Your Product

You should be at this point only after rigorous testing and only after going through every possible scenario of product inconsistency. Now that you know that your product is ready to go into production, let it go. If the product is going to be pressed into a CD-ROM, the initial cost is going to be substantial. However, if you are producing in volume, your individual cost will be nominal. Remember, the nominal cost could turn out to be an enormous cost if the data copied on to the CD is flawed. Know that you have a workable product before going to press. These procedures will also apply to presentations and products intended for broadcast onto the Internet. If it goes out to the masses, they will let you know in a hurry if there are problems or flaws.

Distributing Your Product

At this point it is time to sit back and enjoy the fruits of your labor. If you have done the job properly, the product will fulfill its intended purpose.

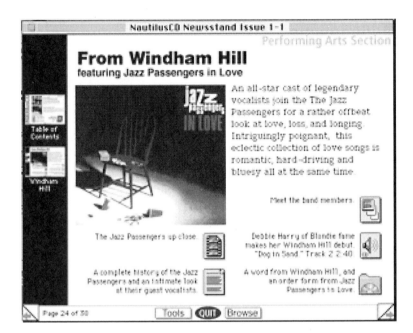

Figure 3.9 The *Nautilus* CD (category windows) allows access to movies, sounds, demos and other files.

Product Example

One example of a commercially available multimedia product is Metatec's Nautilus CD (see Figure 3.9). This is a monthly, interactive CD-ROM magazine that offers much more than a traditional printed magazine. This new form of media disbursement comes alive with the added dimensions of sound, video, photography, and animation. Though not a printed piece, specific files can be printed on demand.

This product is available at a monthly subscription rate of $6.95. This is slightly higher than many monthly magazines, but you have the added advantage of having this information presented with sound, motion, and graphics, making the information come alive. The CD-ROM also includes a number of freebies like multimedia and software resources, try-before-you-buy software, free software, software tools and utilities, and movie and music reviews. Not only does this format offer excellent resources, it is a fantastic resource to learn how multimedia publishing is done and an example of good human interface design for multimedia title development. This is just a sample of one product utilizing multimedia technology to communicate in new ways.

Exercise 4 on the CD-ROM will simulate the environment of developing multimedia content for distribution to a wide audience.

Choosing Hardware

If you are confused by the rapid growth of hardware choices in the marketplace, you are not alone. There are about as many options in computer hardware and peripheral devices as there are stars in the sky. However, in the scope of this book, we are specifically focusing on the devices and products that surround multimedia production on either Macintosh or Windows computers.

Oftentimes your choice of a multimedia development system will be based on what you are familiar with, what you currently have, or what your research tells you will work best for your desired result. Our goal is to provide an objective review of computer platforms, to discuss the requirements of multimedia computing, and to review common features.

One thing that has become prevalent recently is the convergence of computer technologies and harmony between hardware and software vendors. This is partly due to development integrity by software and peripheral developers, and the strategic alliances between Apple and IBM. This is also due to the mixed hardware environment in corporate America. There are more and more demands for the same software to be available on both platforms. There will probably never be just one platform, but the work process will become increasingly similar between systems.

Technologies Introduced through Apple's Macintosh

The Macintosh has always been a media-oriented machine. Since its introduction in 1984, it has always been pitched as a computer that works with other media types. Even though this media may have

Figure 4.1 Art placed directly into the text, as illustrated through this entire book, is a result of the groundbreaking technology introduced with the advent of the Macintosh, and the cut-and-paste process.

QuickTime is an extension that will allow your Mac or PC to play digital movies. You can find the QuickTime software on the CD-ROM.

been clip art, it was a start. Apples initial marketing campaigns illustrated the integration of graphics into text (see Figure 4.1). As far as ease of use, their marketing strategy suggested that if you can "point and click," then you can use the Macintosh.

Through the years, the Macintosh has grown and matured substantially, and has truly revolutionized the personal computer marketplace. One thing the Macintosh has accomplished is the establishment of several niche markets or industries. For example, when laser printers were introduced that included the Adobe PostScript page description language, the desktop publishing revolution was born. PostScript took the information on the computer screen and translated it to commands in the laser printer that made it print exactly what you saw on your screen, only better. This was when the term WYSIWYG (what you see is what you get) was born. This firmly set the Mac as the platform of choice for page layout and design for the printing and publishing industries. In the early 1990s, when Apple developed QuickTime, the desktop video revolution began, thus ushering in the introduction of video to desktop multimedia.

The Macintosh has always been a fun and easy to use environment. Perhaps the good thing about the Macintosh is that you do not have to know much about computer operation to set up the system and to quickly become a productive user. This environment allows you to take your existing skill set and, with the proper software, get right to work. An example of this is if you know how to type, and are accustomed to working on a typewriter, then using a word processing program on the Mac is extremely easy. Another example is if you are a skilled graphic artist, familiar with painting, drafting, free-hand sketching, and other skills, the translation of your existing skills into this computer environment will be natural. With the growth and sophistication of the Windows operating environment, this easy to use interface is carried over in the same manner.

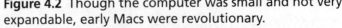

Figure 4.2 Though the computer was small and not very expandable, early Macs were revolutionary.

Figure 4.3
The evolution of the Macintosh from the original 128 to the 9500.

Running Multimedia

Minimum System for Development

What does it take for multimedia titles to run on a Mac? From a users perspective, having a color system with at least 16 MB of RAM and a 13-inch or 14-inch monitor is a basic start. A CD-ROM drive is not required for multimedia development, but is needed to view other titles and is considered a "standard" device in a multimedia computer. Sound is an important part of multimedia; therefore, speakers are critical. Either internal or external speakers will significantly enhance multimedia presentations.

Even though color and sound quality are nice, they are not necessarily required. This is based on what you are going to develop. There are a multitude of older Macintosh computers that do not have color displays or the sophistication in sound capabilities that today's computers offer. Based on the particular multimedia production you are viewing, hardware considerations are extremely important.

Figure 4.4 shows a basic multimedia development system. Keep in mind that these features are a minimum environment. You can enhance each aspect of this suggestion as far as your need and budget allow you to. You can make it as elaborate as you desire. These suggestions apply for Macintosh or PC.

Multimedia development requires more computing power than traditional software applications.

Figure 4.4
The suggested minimum for multimedia development.

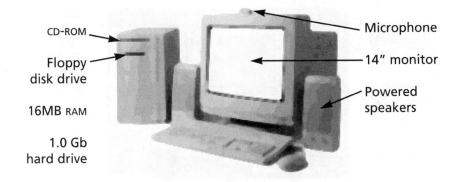

CD-ROM

Floppy disk drive

16MB RAM

1.0 Gb hard drive

Microphone

14" monitor

Powered speakers

Preferred Models for Media Development

If you are in a start-up situation, and have a liberal equipment budget, there are certain systems that will handle any job. One thing to remember is that most computers today are very expandable. They can be expanded by adding more RAM, larger hard disk drives, and peripherals to enhance functioning. Table 4.1 demonstrates some expansion options.

Hardware Considerations When Shopping for Software

If you own a computer or have the responsibility to purchase software for computers, then you are familiar with the constraints of software shopping. If you see a software title that you are considering purchasing, the first question you ask is, "Will it run on my computer?"

Table 4.1
Most computers can be upgraded in some way.

EXPANDABILITY OPTIONS TO CONSIDER FOR NEW EQUIPMENT		
Product	**Minimum**	**Expansion Options**
Memory	Minimum 16	Expandable to 256 and above
Expansion Slots	PCI	2 to 3
Microprocessor	Must be upgradeable	
Hard Drive	500 MB	2–4 Gigabyte recommended
CD-ROM	2X speed	8X + recommended

MACINTOSH
SYSTEM REQUIREMENTS
 LCIII or higher
 4 MB of RAM
 (8 recommended)
 Hard disk drive
 Speakers
 Mouse
 13" monitor or larger,
 set at 256 colors
 Printer recommended

MINIMUM WINDOWS
REQUIREMENTS
 Intel 486
 Single-speed CD-ROM
 8-bit color
 Windows 3.1
 8 MB memory
 13" monitor set at
 256 colors
 Speakers

Figure 4.5 Software compatibility requirements.

This means you must investigate to see if it is compatible with Macintosh, DOS, or Windows Multimedia Personal Computer (MPC). This is where the software issue becomes a hardware issue. However, just knowing this is not enough. Oftentimes there are many other requirements to ensure that the software will work on your machine. Software developers typically tell you exactly what is required to run their product by printing the requirements right on the box.

A typical requirement sticker on the side of a multimedia title is shown in Figure 4.5.

Today, many software products are delivered on CD-ROM. Often, both Windows and Macintosh versions are contained on the same CD-ROM, therefore, it is becoming more common to see requirements for both Windows and Macintosh computers on the same box .

Developing Multimedia

If you are developing media for distribution to the masses, you must first determine on which machines you desire to make your product compatible. You can develop a product that will work with more recent models, containing faster processors and perhaps more RAM, however, if you want to reach all computer users, you may want to consider making a version for the earlier machines as well.

If you decide to go the route of providing a version of your product that is compatible with all older systems, you will need to access other computers for testing. This could require that you have access to everything from the original Macintosh 128 to the current version of the Power Macintosh; from an old 286 system to the latest Intel-based processor. For example, if your production is to be compatible with all Mac or Windows systems ever made, much homework

and preparation must be made to ensure that the product will be compatible with the variety of screen resolutions and sizes, hardware configurations, system software versions, and storage media, just to mention a handful of considerations. This would be a monumental undertaking.

DOS/Windows Integration into the Macintosh

The Macintosh has had the capability to read DOS files for quite some time. With the introduction of the Macintosh IIx, in 1988, Apple included a new floppy disk drive called the "super-drive." This unit was revolutionary because it read the new high-density disk, which held 1.4 MB of data. This significantly aided the need to save more information on a single floppy disk. At the time, applications and file sizes were on the increase, demanding more storage space. The drive also had the capability to read disks that were formatted for Apple II systems (ProDOS) format, and disks formatted for DOS-based systems.

At this point, accessing software from different machines was not commonplace, but this technology allowed users to import files such as spreadsheet data created in a DOS based spreadsheet program directly into the Macintosh for importation into a Mac-based spreadsheet. This was also applicable to other file types, such as typed documents created in a word processor and graphic file translation.

If you are a Macintosh user and have a need to run Windows based applications, how do you do it? One option is to use a software program that allows the Macintosh to emulate the DOS, or Windows, operating system. This allows you to use DOS or Windows applications right on your Macintosh. From a hardware perspective, it is important to know that Macintosh models equipped with "super-drives" will accept DOS-formatted disks. This is required if you want to load DOS-related software disks into a Macintosh. The super-drive, which is still a Macintosh standard today, allows access to 400k single-sided disk, 800k double-sided disk, and 1.4 MB high-density disks. If your Mac is a Macintosh IIx or newer it has the super-drive built in, allowing you to read each of these disk types.

Another option for running DOS/Windows on a Macintosh is to purchase an additional hardware product. By purchasing an add-on board for your Macintosh, you can emulate the PC environment with the power of a real computer. These boards use your disk drives,

Though computer systems have had the ability to share information for many years, it is becoming more commonplace today.

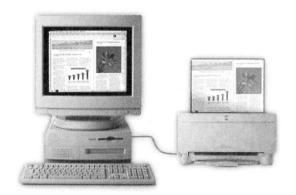

Figure 4.6
Some of us use our computer for just one reason: as a word processor, for spreadsheets, or for database information.

monitors, and printer, thus allowing you the capabilities of a full functioning DOS/Windows system right in your Macintosh. This is a good solution; however, with the price of some of these units, you could almost afford to purchase a complete Windows system.

What You Must Know

There are several things you must know about hardware. For example, you must know the significant differences in Macintosh and Windows multimedia hardware. You must know the hardware componentry that allows the integration of the various media types. You must know the peripheral devices that physically connect to a computer system to enhance its capabilities. You must have an understanding of presenting information on equipment other than a personal computer. You must have an understanding of the various array of storage devices and how they work. To actively participate in multimedia computing, this knowledge is essential.

The Technical Mindset of the User

Anyone can do multimedia, but with any process, there are varying degrees of what you can do. What you can do is based on a variety of conditions. Some of these conditions include: how much time you have to dedicate to the process, the resources you have (the computer, software, and technical assistance), and what you want to do with it. Your adeptness and willingness to learn what this is all about is also an important aspect.

Having an inquisitive mindset about the products and processes will also be beneficial. The specifics of hardware and software change

Figure 4.7
Some of us want to use the computer for all we can get out of it. Is this the vision of how AV and multimedia technologies are merged?

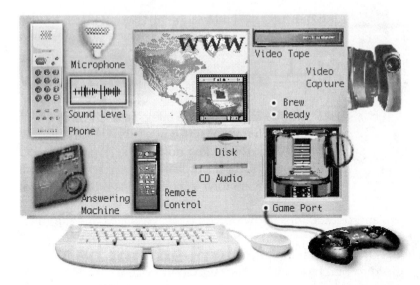

almost daily. Making an effort to keep up with the latest products and trends will enhance your involvement as you strive to stay on the cutting edge. Reading technical and trade publications are tremendously helpful to stay current.

AV Technologies

It used to be that computer owners used their computers for one specific purpose. An example of this would be the way that PC owners began to replace the typewriter as the device of choice for typing and producing letters and other forms of communication. Others used their computers primarily for spreadsheets, a database, or other specific purpose.

As the capabilities of personal computers grew in size and sophistication, they began to be used to serve as a comprehensive solution for a variety of tasks. Today, we are beginning to use our computer systems for much more than just word processing or spreadsheets, or other linear tasks. Contemporary computer systems offer a host of new capabilities from year to year.

An example of this is the way that we use our system for e-mail or to access the Internet. This allows communication to the world in a format other than the telephone using our computer as the interface device. The way this is possible is by having telephone capabilities built in the computer. By having phone capabilities built in, we are able to send and receive fax transmissions through our machines. This is fantastic technology, which allows on-screen documents to be

sent without requiring the creation of a hard copy. This also works in reverse. Fax transmissions can be received directly into the computer and printed only if needed.

NTSC, PAL, and SECAM are formats set forth from different countries as a standard for video.

Even though the connection to modems and general telecommunications has been around a while, there are new audio/video capabilities being added to personal computers. Apple calls this "AV Technologies," and they have been a part of their computer line since 1993. Since that time, it has become commonplace for computer hardware vendors to bundle such features with their computer products. As far as manufacturers of Intel-based PCs, these features come under the componentry typical to the MPC label. A system labeled as a Multimedia Personal Computer would include these features as a standard part of their hardware configuration. Following is a review of some of these features.

Telecommunications

Integrating data, fax, answering machine, and telephone into the computer is commonplace today. With the necessity to connect to voice, facsimile, and the Internet, the computer and phone are integral components. These features, being essential communication elements, add a level of sophistication to the typical computer system. These features also enhance the ability to gather and distribute media components.

Video and Graphics Input and Output (I/O)

This is the ability to capture video from a wide variety of sources such as VCRs, digital cameras, video cameras, and laserdisks, and then output it to other sources. With the proper software, such as the QuickTime extension, video can be displayed in a window on the monitor, similar to any other computer document. Like other windows, the video image can be resized, usually from the size of a postage stamp up to a full-screen image. This technology also contains the ability to capture images displayed on the screen. This can be done by using frame grabbing techniques. Frame grabbing is capturing a frame randomly during playback, or "freezing" the image, then grabbing, in order to capture specific images.

Computers with AV/MPC capabilities have the ability to send information to other peripheral devices. For instance, if you want to copy a computer presentation onto videotape, VCR-type connectors are included allowing connection to a VCR for taping. This process is also used for connection from the computer to a television, or other device, for the presentation of computer-based information. These connections

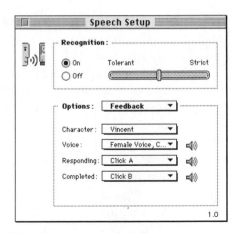

Figure 4.8 A QuickTime movie window contains the movie and offers typical controls like: play, pause, forward, and reverse.

Figure 4.9 The speech setup window from the Macintosh Control Panels menu.

conform to world wide standards like NTSC, PAL, and SECAM video signals. Traditional S-VHS connections are also included in these systems.

QuickTime™

QuickTime is an extension compatible with Macintosh- and Windows-compatible computers, that allows digital video files (or movies), to be played on your computer. QuickTime technology allows information such as sound, video, graphics, and animation to be stored, then used in a variety of applications. The introduction of QuickTime revolutionized the ability to go beyond the static images that traditional computing offered. This also ushered in a new era of enhanced multimedia processes. QuickTime not only has the ability to display video, but offers high quality audio as well.

QuickTime is available for both Macintosh and Windows environments. QuickTime is not a traditional software application, but rather an extension that allows the computer to recognize files saved in this format to be played back.

Speech Technology

Not only can your computer speak to you, you can also speak to your computer. Speech recognition software has made great strides in the past few years. Speech technology allows a document to be read to you in your choice of voices. You can also talk to your computer, giving commands that you would traditionally make with a keyboard or a mouse. Speech technology offers tremendous potential in computing. We are also beginning to see it used in other arenas as well.

AV technologies are becoming increasingly popular and are available on Macintosh and Windows environments. This type of trend will probably continue to grow in popularity, and will become increasingly affordable to purchase a system that has these features built in.

Exercise 4 on the CD-ROM incorporates a series of digital movie files to demonstrate a training scenario.

The Connection Between Hardware and Multimedia

Phone, fax, audio, video, and other processes are now a part of computing. The ability to integrate or import these processes through a computer is changing the way work and visual communication is performed. In the realm of multimedia development, better processes are available to make any type of production more dynamic. As these components evolve, the way information is produced will change, as well as who is doing the production.

Chapter 5

Choosing Software

As you begin to plan a multimedia project, there are many areas to consider such as your hardware platform, your audience, and the creation process. Perhaps the most important element to consider is the software that you will use to make it happen. Software is like the engine of an automobile: it gets you where you want to go.

Software, like hardware, is subject to change. This usually occurs through regularly scheduled updates. Through software company research, and user input, software products typically get better with each release. If the product is viable, it will enjoy a long life in the marketplace. In multimedia design and development, there are key software players and since multimedia incorporates a variety of media types, interaction with many programs is typical.

There are literally thousands of software products on the market today. One must differentiate between applications and software products. The application is the vehicle for producing a product while the software product is the result of a series of files created by one or more software applications.

An example of a software product are the files created in Adobe Premiere (see Figure 5.1). Premiere is designed to create digital video and audio files. Premiere is a software application that depends heavily on the input of files created in other application programs. Premiere combines these files in a manner that creates a finished software product. In Premiere's case the product is a QuickTime movie. There are other products that follow this pattern.

Having a software program that provides a workable multimedia authoring environment can determine the success of your end product. There are numerous software programs on the market today, each with their unique features. What may be a good solution for your development needs may not be appropriate for others. Like everything else, these choices are based on the individual and his unique vision.

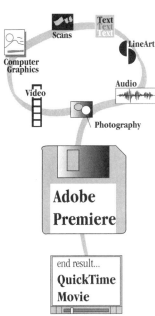

Figure 5.1
Files placed into Adobe Premiere to create a QuickTime movie.

61

Table 5.1 Software products that support the multimedia process.

Environment	Product	Publisher
Authoring	Director	Macromedia
	Authorware	Macromedia
	mPower	Multimedia Design Corp.
	Apple Media Tool	Apple Computer
	Quest	Allen Communications
Video Editing	Premiere	Adobe Systems
	Avid VideoShop	Avid Technology, Inc.
Sound Editing	Sound Edit 16	Macromedia
	Deck II	Macromedia

If your development needs are going to be fairly basic, then begin with a basic program that provides an intuitive interface, one that can deliver the goods you need without a high learning curve. On the other hand, if your needs require that you develop serious interactive content, or other features that demand considerable extendibility, then by all means invest in the best. Often it is hard to know exactly where your ventures will take you; therefore, it is important to make sure you have a vehicle that can take you wherever you want to go.

As you become involved in producing multimedia content, you may be required to assemble a team to assist in the production of your product. The team configuration will totally be based on the complexity of the particular project. However, if your focus is an in-house presentation, then you could very well pull it off yourself. You may often find yourself playing the role of the entire team. If your product will be a commercially available product, such as a CD-ROM title or a game that will have mass appeal to a vast marketplace, then you will definitely need to assemble a team to perform various tasks during project development.

As with most software products, the more you work with a particular program, the more proficient you become. In the team approach, the demands of having to know all the programs extensively is not required. You may be the idea person, while the graphic or programming person would be another part of the team. If this is your situation, you are in luck. If you are working with a staff of designers that understand the operation of media integration and the scripting process, Director will work well.

The "Browser" on the CD-ROM, is an example of a Director file saved in a Projector format.

A software product can be many things: a game, a utility, an interactive presentation, a training program, or one of many other products. These types of products are what constitute the thousands of software products that are on the market. When it comes to software applications, the products that allow the development of files and end products, the number is much smaller.

As mentioned in previous chapters, there are different products and processes that are required to develop multimedia. Along with the hardware required to capture audio, video, computer graphics, animation, and the other processes that make up multimedia, there must be a software product to support each. Table 5.1 provides an overview of some of the software products that support these processes.

Multimedia Authoring: Macromedia Director

Software Category: Authoring
Platform(s): Macintosh & Windows
Company: Macromedia
This longtime multimedia workhorse is a real industry staple. Director allows the development of a wide range of presentation types from the very basic to the extremely sophisticated. Director possesses great strength in animation and interactivity. Some authoring software products require that you pay the company a royalty for distributing pro-

Figure 5.2
Macromedia Director authoring software.

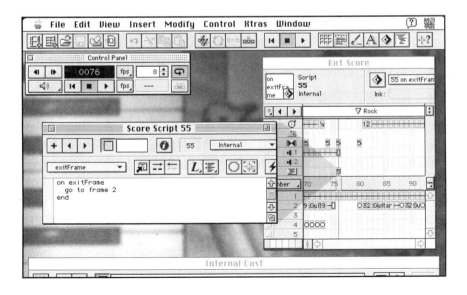

Figure 5.3 The Score window in Director allows virtually any action to happen based on information entered in the Score Script window.

grams that you have developed using their application. Director allows you to freely distribute any presentation. These presentations are saved in the form of a Projector file. A projector bundles your presentation with an engine that will play back your presentation on other computers without requiring the Director application.

There are versions of Director for both Macintosh and Windows. Files created on one system can be played on the other system. Director can also be extended through other routines referred to as XObjects. An example of an XObject would be a specific set of commands that would allow the computer to control an external peripheral such as a laserdisk player. A script would be written, perhaps by the manufacturer of the laserdisk player, that would allow Director to access the player. At the proper time, a specified video segment could be retrieved and played.

Director gives you an edge while in the development process. You have the capability to preview any portion of your program during the design process. This includes Lingo scripting. This language is fairly straightforward; however, there is a learning curve. The real advantage of Lingo is the amazing diversity it provides. When using Lingo, learning just a few lines of scripting commands will allow you to develop a wide range of interactivity. Obviously, to accomplish more interactivity and intricacy, more expertise with Lingo will be required. Director contains multiple capabilities that allow team members to use all of the great features, and to quickly pick up where others have left off.

Director also contains a complete set of painting tools to allow both the creation of a graphic object as well as the modification of imported graphics.

Multimedia Presentation Software

For many years, presentations were done mostly by utilizing the old reliable slide projector. Even though the slide projector has made a few changes through the years, the method of inserting a group of slides and advancing one by one has remained the same. This technology has been very effective and will continue to be perhaps the most used form of presentation to an audience.

The effectiveness of a presentation is based on three things:

1. The content presented

2. The quality of the image

3. The effective communication skills of the presenter

As with all presentation techniques, these qualities will waver in their level of importance, making the impact and effectiveness of each presentation unique.

Most of us were raised with the television and other media devices surrounding us. We are accustomed to having bright, colorful images and sound delivered to us through these mediums. Usually, the television can communicate important messages in a short amount of time. For example, the average length of an image displayed on the TV screen during a typical show is only about six seconds. This fast moving pace is set in order to keep our attention. Commercials can throw much more information our way in much less time.

In the world of computer-based presentations and presentation software solutions, we should keep in mind who we are presenting to and what they are expecting to see. More than likely, the intended audience is expecting to see a message delivered that has some punch.

Early versions of software for computer-based presentations were minimal to say the least. The pioneers in presentation software development offered features like slide-to-slide sequencing, transitions, pop-up text with bullets, and a handful of other effects. Now that the industry has become more sophisticated and more of us are using computer-based presentation software, these programs are fighting to add more features and special effects so that we can stimulate our audience.

Exercise 3 on the CD-ROM covers the development of a sales presentation using Adobe Persuasion. View this presentation by opening the Browser on the CD-ROM, or take a look at the printed exercise at the end of the book.

Figure 5.4 Adobe Persuasion showing the tools for creating slides.

Director uses this Projector icon for movies that are packaged for distribution.

Browser

These movies do not require the Director software in order to play back.

As seems to be the norm with most software programs, each release becomes more powerful and feature-packed. Presentation software usually experiences a revision every six months or so with a major version release perhaps every eighteen months.

What exactly do we expect to get out of a presentation program? For many people having the ability to advance from one graphic to another is just fine. All presentation programs will do that. But what about all of the elaborate effects that we see on music videos and in commercials these days? What if your audience demands these types of effects or if your message is to a group that you know will respond better to this type of presentation? Only you can be the judge of what will work best for your particular situation. Remember, you must know who your audience is. This will dictate your presentation method.

The questions above lead us to consider specific software solutions. With so many options out there, where do you begin to qualify what will work best for your situation? It is important to determine what types of presentations you will create and present. Be careful not to purchase a program that will just meet your immediate needs. Keep in mind that the more you learn about the functioning of these programs, the more you will probably do to make your presentations more appealing. An exception to this is if your business is linear, requiring that only a certain procedure be followed with each production. In this case, buy only the essentials that meet your needs.

If you are interested in getting all of the sophisticated features in a presentation program beware of using all of the features in a single presentation. Use good judgment and tasteful design when assembling your production. Too much activity can be distracting to your content.

Most of the software programs contain a host of pre-packaged accessories. These include, but are not limited to auto templates (pre-designed backgrounds), context-sensitive help systems, and clip-art file libraries. The more sophisticated programs contain these features as well as: three-dimensional chart creation, video integration, interactivity, animation, and branching. Some of these programs also provide an electronic marker utility. This feature allows the presenter to mark up the computer or presentation screen similar to the way it would be done on an overhead projector with an acetate overlay and color markers.

A new dimension to many presentation programs is the capability to save presentations in a Player format. Like the Projector file mentioned earlier for Director, player files contain enough of the application program to make your presentation play only. This is useful for sending projects to other locations for viewing when they do not

own a copy of the original software. A great feature of many of these player files is that they can be authored on the Macintosh and distributed as a Windows compatible file, and vice versa. This capability is becoming standard for most high-end presentation software applications.

Multimedia Necessities

There are certain things that are absolute necessities in multimedia presentation software. These include the ability to accept the following external files:

- Digital Movies—Multimedia presentation software must have the ability to accept movie and sound files that are saved in Apple QuickTime or AVI file format. The integration of digital movie files provides variety and interest to any presentation.

- Sound—Adding background music or narration adds interest and clarification to the message of your presentation. These sound files could be in the form of a voice, music, or sound effect file.

- Animation—Animation can capture and emphasize a point with colorful images and motion. Animation can make the unreal happen and make it believable.

- Charting—Charting is a feature that is used in almost all presentation programs. The most frequent type of presentation given relates to numbers and translates to charted information on dates, growth, and financial issues.

- Interactivity—In early presentation software, about the only form of interactivity was the ability to click the mouse and have the program advance to the next slide. In current programs, much more can happen with your presentation if you choose to make it happen. Hypertext or "hot buttons" can be assigned to various graphics, allowing other actions to happen based on assigned functions. An example of this would be the importation of a digital movie and establishing a command in the program to have the movie play automatically or upon a click of the mouse or other user prompt.

Many so-called presentation software programs offer enough interactive sophistication to function in a kiosk environment. Programs, such as mPower, from Multimedia Design Corporation, offer "hot buttons" for interactive control and "hooks" to external peripherals such as VCRs and laserdisk players. This functioning rivals some of the features found in high-end multimedia authoring environments.

Some programs allow the integration of many file types. A very important consideration in presentation software is the ability to import the file types that you currently use on a regular basis as well as options for other types that you may use in the future.

As presentation software progresses, look for even more features, easier file integration, and more straightforward point-and-click functions. Another consideration in this arena will also be hardware changes and support for better image and sound quality as well as an improved appearance on screen.

Presentation software should be easy to use and conform to your work style. The ideal presentation software allows the user to concentrate on content development rather than on the mechanical aspects of making it work.

Multimedia Presentation: Adobe Persuasion

Software Category: Presentation
Platform(s): Macintosh & Windows
Company: Adobe Systems
One of the earliest entries into the presentation software market was Adobe Persuasion. This versatile product offers an easy to use presentation creation environment for the beginner while offering the sophistication needed for experienced presentation designers. Persuasion offers a high level of precision, flexibility, and end-user control. Many support elements are a part of the Persuasion package that are designed to make the development of any type of presentation easy. Some of the key support elements that are a part of Persuasion include versatile type controls, custom-designed background art, an integrated three-dimensional charting program, and rich color control. Persuasion can accept externally prepared files, such as illustrations, movies, charts, text, data, and audio files.

As far as finished projects, you can output the files as a Player document. Creating a Player file will allow the presentation to be viewed on other computers (Macintosh or Windows) without requiring the Persuasion program. When this is done, sounds, video, and multimedia effects transfer. Player presentations also have the ability to be annotated on screen. This means you can draw on the slide with the mouse to emphasize or highlight a specific point. This proves to be an excellent feedback and review tool.

Persuasion allows you to give live presentations, produce 35mm slides, overheads, printed speaker notes, even publish formatted presentations on the Internet. Some of Persuasion's built-in multimedia features allow you to add animation, sound, branching, and video clips, which add excitement and sustain audience interest. There is also an auto-animation feature that helps emphasize points through the power of animation. Autojumping is another tool that will allow you to branch to other slides, files or applications from anywhere within a presentation. Persuasion provides an excellent charting module that can produce dynamic three-dimensional charts. Such media elements are capable of conveying a message that would be difficult to convey with plain text. A full set of drawing tools, including line, arc, rectangle, circle, polygon, freeform sketching, are also a part of Persuasion, allowing custom illustrations to be added from within the program.

The full retail version of mPower is on the CD-ROM.

Multimedia Presentation/Authoring: mPower

Software Category: Multimedia Presentation/Authoring
Platform(s): Development on Macintosh
 Playback on Macintosh and Windows
Company: Multimedia Design Corporation
mPower is an innovative product that is part authoring and part presentation software. Since the two are so closely connected, they are combined in this software so your presentation can become what you want it to be. If you want to develop a simple slide presentation, mPower lets you do so with very little knowledge or hands-on experience with the product. It works with a familiar slide metaphor and relies on a simple push-button interface. These features are beneficial to the occasional user. The on-screen menus and options are very simple, eliminating the confusion of finding an answer once a decision is in the project development phase. This interface and ease of use is what makes mPower redefine the word intuitive.

For those who want to take it farther, mPower provides an impressive array of features and connectivity that will suit a high-end, professional approach. mPower has the built-in capabilities to create QuickTime movies, capture still images, and digitize audio from CDs or microphones. It also has the capability to control CD players, laserdisk players, and other external devices without digitizing the sound or video first.

Figure 5.5
mPower, from
Multimedia Design
Corporation, allows
you to assign hot
buttons over specific
graphics to cause an
action to happen
when selected.

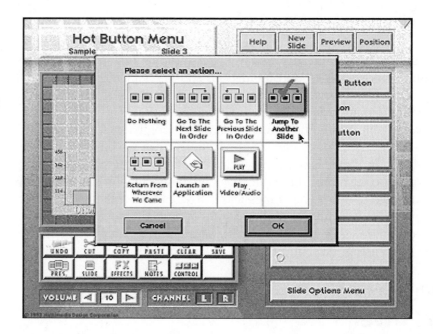

For interactive control, mPower allows the creation of hot buttons that can branch to other slides, play audio/video content, or even launch another application program. Internet playback is possible via a Netscape™ Plug-In (see Figure 5.5).

Software File Preparation

An important task in producing a multimedia presentation is the preparation of all of the files that will go into the production. This phase is somewhat similar to file preparation in a page layout program. In a page layout program, such as Adobe PageMaker, elements that are a part of a document are prepared in other applications. For instance, type may be done in a word processing program, photographs are scanned or captured from a digital camera, line art may be produced in an illustration program, and original art may be produced from a paint program. Once these files are prepared and saved in a compatible format, they are ready to be placed into the page layout program. Once the files are imported they are placed in position on the page based on the designer's preference.

This scenario is similar to the preparation of files that will be used in a multimedia environment. Some of the file types are exactly the same as mentioned above, while others have additional functions. For instance, a multimedia presentation will contain backgrounds,

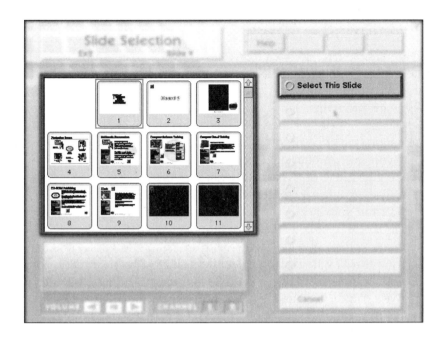

Figure 5.6 The mPower screen allows various slides to be developed with the ability to incorporate various media elements.

type, photographs, illustrations, and other file types mentioned above. They will also contain files like sounds, animation, movies, music, computer graphics, and much more. All of these files must be saved in the proper format for importation into the authoring environment. Often times just saving the file in the proper format is not enough. With multimedia, issues like color look-up tables, sound quality, resolution, and other factors should be considered.

Modern-day Software Shopping

In the past, software was usually purchased through your local computer retailer. While at the store, you could obtain professional assistance and advice as to which software worked with which hardware and other pertinent information relative to the program. Originally, the computer retailer was the only place to buy software products. Not long after the desktop computer revolution began, specialty software stores began to open everywhere. Next, mail-order companies began to get into the act by offering a wide variety of titles for all areas of interest. This type of software distribution has really become popular due to the fact that the consumer is more computer and application savvy than ever before. Another reason that mail order is so popular is that you can usually order a product one evening and have it delivered to your doorstep the next morning.

Use a variety of "save-disabled" software products in the TRIAL-SW folder on the enclosed CD-ROM.

Test-driving Software

There are several sources that offer software that can be taken on a "test-drive" without purchasing the product. There are options, such as downloading demos through the Internet, which allow you to try software programs. This concept is fantastic because many software applications look good on the spec sheet but may not meet your expectations as a real product. By trying it before you buy it, you know that you are purchasing exactly what you want, and know in advance that it will do what you want it to do.

The great feature of test-drive CD-ROMS is that the full working version of the software is often on the CD as well as a demo of the application. Of course, you do not automatically have access to the real software without paying the price. Here is how it works: Usually, the CD-ROM is free. When you receive the disk, you get instructions on operating the program as well as an 800 number. By calling the 800 number, you can provide a credit card number in exchange for a code that will allow you to instantly download the actual software you wish to purchase. The software usually contains an electronic manual or documentation.

The CD-ROM

In the old days, when software was distributed exclusively on floppy disks, the only product that came on the disk was the application program and perhaps some demo files or tutorials that illustrated how a project should look in that application. Early programs were small, their files were small, and their RAM requirements were small.

The 1990s have ushered in an era of more power, more storage, bigger monitors, and faster processing speed. As a result storage requirements have grown in direct proportion. The first Mac came with 128k RAM and no hard disk drive. The disk drive was a single sided, 400k unit. Optional external 400k drives were available, and were priced in the $500 range. Today there are many media-storage options such as the CD-ROM. As with technology-based products, the CD-ROM dropped in price during the 1990s and distribution to the masses became extremely practical. With the cost of mastering a CD-ROM dropping to approximately $1 each, software product distribution began to be commonplace in this medium.

The real demand for more space for application programs and support files happened gradually over a period of years. As software developers continued to upgrade, their products experienced growth

in the amount of disk space and RAM required. Naturally, competition demanded that products contain all of the latest features and what the competitors were putting in their product. As these products grew in size, the distribution methods began to change. First, the software was shipped on numerous floppy disks. Next, they were shipped on numerous disks and the data files were compacted using a compression program. After a while, it became quite a project to purchase new software and load floppy after floppy into your Mac while the installer program decompressed and rejoined all the segments.

With the advent of the CD-ROM, a new avenue of data storage and distribution was born. CD-ROM technology introduced the capability to store the equivalent of hundreds of floppy disks on a single CD. A typical CD-ROM has a 650 MB capacity. This means that on one CD-ROM, you can place the equivalent of approximately 600 floppy disks. Does this mean the typical application program distributed on this media fills an entire CD-ROM? Not necessarily! A CD-ROM application, such as an encyclopedia or multimedia production, certainly could fill the entire disk, or more. However, most software applications will not even come close to filling 650 MB of space. What then is the importance of distributing software on CD-ROM? Here are several answers:

1. Cost is usually about $1.

2. Software companies can include support files, tutorials, and other information which add great value to the customer.

3. CD-ROM eliminates the need to swap disks.

4. All information is contained on one disk in most situations.

5. Trial versions of other software can be added.

Many CD-ROM software products come with trial versions of other software titles. Adobe Systems is a great example of a company who practices this. If you were to purchase, for example, Adobe Premiere, it would be shipped with a CD-ROM containing a full-working version of Premiere, support files, and trial versions of other Adobe products such as Photoshop, Illustrator, Dimensions, and Streamline. These trial versions usually consist of fully functional copies of the application, with the exception that you cannot save your work. This concept will allow the user to try the software, and see if it meets his needs before he buys it.

Numerous technical books are being authored that include CD-ROMs with tutorials and these trial versions of software programs that are applicable to the subject matter in the book. The good thing about these titles is that the consumer will be exposed to a variety of software applications by using these trial versions. As you shop for these books, the content of the CD-ROM is usually listed on the back of the

The CD-ROM that accompanies this book contains save-disabled software.

Figure 5.7
Macintosh- and
Windows-compatible
applications can be
stored on the same
CD-ROM. They can
even share common
data files.

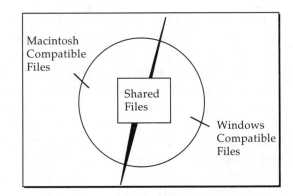

book. If you are interested in trying out a program that may be included on the CD-ROM included with the book, it will make the purchase price of the book a better value.

You will find that many software developers are creating hybrid CD-ROM titles. This means that the disk contains both Macintosh- and Windows-compatible versions of the same presentation. The CD is mastered in a way that allows the user to simply insert the disk into his CD-ROM drive and boot the proper version. A software driver is present that recognizes what to do when placed in either computer. If you are a Macintosh user, typically, the Windows files are transparent, requiring absolutely no interface. They are merely stored on the same media. This is true for Windows users; the Macintosh files are transparent. This format is becoming very commonplace with the convergence of platform technologies changing on a daily basis.

Peripherals

In the early days of desktop computing, the only items connected to the computer were the printer and perhaps a modem. Today there are numerous external devices that perform a variety of functions once connected. A computer peripheral is a device that connects to a personal computer to increase system functioning. These peripherals include digital cameras, microphones, scanners, laserdisk players, speakers, CD-recorders, hard disk drives, video cameras, and VCRs.

All of the "toys" that are a part of multimedia are quite intriguing. There are so many devices that interface with the computer that it is difficult to keep up with which does what and why! In technology-based environments, these products are constantly changing and growing in number. Knowing the products that can assist you best is important.

Probably the best way to keep up with new products and services is to subscribe to a trade publication that addresses issues surrounding your particular computer system. These publications provide fresh articles and reviews on the latest products and trends in this changing marketplace. These publications also cover specific computer and peripheral devices when they are introduced and let you know how the products perform. Subscribing to a publication that is user friendly is a good investment.

You do not have to be an expert to know what is going on in the computer peripheral market. Once you become involved in multimedia computing and are familiar with all of the componentry you will constantly be on the lookout for the latest and greatest device to assist your project. One thing you can always count on in this area is by the time you finally decide that the product is something you must have and get budget approval to make the purchase the price will drop. This is a typical scenario with technology-based equipment.

Approximately every six months you will see major shifts in product introductions and pricing strategies. If you haven't experi-

Connectivity to external peripheral devices is what makes your computer versatile.

75

Figure 6.1
Multimedia
computing requires
numerous peripheral
devices.

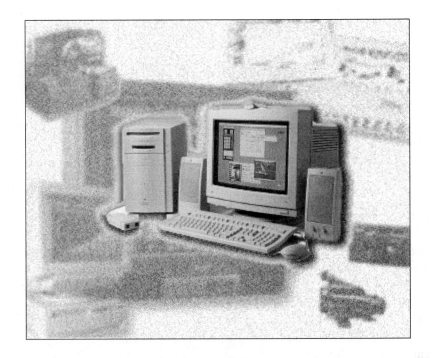

enced this yet, you soon will. It is all a part of a game that manufacturers play that is somewhat dictated by the consumer. As consumers, we are always looking for the next level of product or service. Manufacturers cater to us by constantly offering upgrades. In the arena of computer peripherals, the next level is always where we want to be. There are so many products that allow us to elevate the performance and capabilities of our core computer system. Most of us will never satisfy our hunger for new products and capabilities.

Necessary Peripherals

There are some components that are mandatory to the multimedia computing process. These items include but are not limited to monitors, keyboards, disk drives, and printers. Other additions allow you to make your system perform and function according to what your job or work style demands. For instance, if you are involved in desktop publishing, you need a large monitor to display a two-page spread, a large hard drive to store color graphic scans, and a high-resolution printer or image setter for high-quality image output. These are some of the basics for this environment.

For multimedia production, your needs will vary. Although helpful, a large monitor may not be required. Most multimedia presenta-

tions are designed to be played on a 13-inch or 14-inch monitor. You may find that you will need a large capacity hard disk drive or a disk array for storing large files and for retrieving movies and sound files. A disk array is a series of hard drives that can transfer large amounts of information almost instantaneously. With multimedia production you may also need devices like VCRs, camcorders, CD-ROM recorders, microphones, and video digitizing cards.

With most peripheral devices, you will find that the same type of product is manufactured by a variety of vendors. These products are usually offered in a variety of price ranges. If you need to purchase a product and are unfamiliar with a vendor's reputation, you need to do your homework before you make your purchase. If you have searched for solutions on your own and are still confused, you need to consult a professional for further input. These professionals can be located by contacting computer retail stores, computer consultants, multimedia service bureaus, professional organizations, or users' associations.

When you are seeking this advice, make sure you have a relationship with these sources and that you trust their judgment and recommendations. Ask questions and take notes because there is much to learn. Another source for great advice is to consult with other professionals that are willing to share information. These users can provide excellent input because they have already gone through the selection process. Users' groups are also a great source of information. There are many users' groups that support different types of computer-related functions. Check in your area for computer or multimedia users' groups. If you do not know where to start, call a local computer retail store for advice.

Unnecessary Peripherals

You may wonder how you can have unnecessary peripheral devices. It is actually fairly common. You must have enough knowledge of the whole process to know exactly what is needed to develop the type of media presentation you are seeking to achieve. There is a plethora of peripheral devices that can be added to enhance your computer's functioning. If you are on a strict budget that demands wise purchasing decisions, do your homework. To make wise decisions on selecting a device, think through the process you need to achieve and then seek advice from industry professionals.

If you need to purchase a CD-ROM drive, do not go through a mail-order catalog and buy the cheapest drive you can find, unless you

Make sure that the peripheral adds real value to your system.

Products should be flexible allowing you to share with others if needed.

have done your research, and can prove that it is the best for your needs. Part of ensuring that a product is the best overall value includes making sure that the company you buy it from will be there to support you in the future. Look at the entire range of drives and find the highest and lowest cost units. Ask professionals and users what the best brand name is. You probably bought your car based on the reputation first and then the deal you got on it during the shopping process. Make sure that the peripheral you need is the best you can possibly buy, then, if price is an issue, do your bargaining to get the best possible price.

When considering the purchase of any peripheral think about the future. If you buy through mail order, how will they support you? Even if you buy locally, make sure they can and will support you. Remember that all mechanical devices will have some form of failure in time. Look for companies that have been around a while and have established a great reputation for customer support.

Another consideration that needs to be made when selecting peripheral devices is the variation of the product. What is meant by variation? Consider this example. You need a large capacity storage device for archiving your multimedia projects. You make a decision that a SyQuest storage device will meet your needs. As you are researching the variation you need you discover that there are several capacity formats of SyQuest cartridges available, 44MB, 88MB, 200MB and more. The obvious solution is to purchase the 200MB drive because it meets your immediate budget and storage needs. You purchase the 200MB drive. A few weeks later you have a need to send your files to a company to review a presentation that you are preparing for them. The company gives you a call to inform you that your 200MB cartridge is not compatible with their 44MB drive. This puts you into a reactionary mode, perhaps requiring that you purchase a 44MB cartridge and send your presentation to them once again. This may cause even more confusion and cost. What if your presentation will not fit on a 44MB cartridge and it takes a total of three cartridges to handle all of the data? This may not be a big deal but it certainly would be convenient to have thought through this entire process before it happened. If cost is not an issue then the frustration and deadline issues may be.

This scenario could apply to a number of products and situations. The key issue here is to make sure that your work patterns are thoroughly considered before purchasing a peripheral device. If you are working solo, then your needs alone are paramount. If you must distribute information to other workers or out to the rest of the world then you need to consider what products they use and how you can adapt.

Multimedia Support Products

Graphics, photographs, text, animation, and video—each of these elements has a source of origin. Each source of origin has its unique product and methods of development. When considering products for producing these images, you have to consider what your final production will be. Proper consideration for these products will include wise purchasing and appropriate training for each. This will ensure that as you compile all of your elements into a single multimedia production and utilize a smartly crafted script your production will come alive.

Video cameras and VCRs connect to the computer through a video digitizing board.

Input Device

You have several ways to input information with a computer. In word processing, you can either type your information in word for word or you may choose to scan in a typed document, using optical character recognition (OCR). This allows you to enter text in a short period of time. With multimedia, many types of information are used to prepare your project. For a fully customized production, you will use tools to capture images and information to your liking. To do this, you must consider several input devices to assist with your production. These include the following:

Digital Camera

With digital image capture technology, your photographs can be copied directly onto disk then into your computer for incorporation into your productions. There are many models of cameras available today ranging widely in quality and price. Digital cameras are designed to store a specific number of digital images. These devices offer instant image capture and are perfect for projects demanding a quick turnaround.

Video Camera

Your choice of a video camera for use in your multimedia productions will be based on what type of productions you will be doing, what your final product will be, and who your audience is. For low- to medium-end productions, a high-quality consumer level video camera will suit your needs. If your plans are to go to the mass market with a commercial product, you will need the best quality original video product you can produce. Digital cameras are an excellent solution; however, if you are on a strict budget, this technology may be an expensive alternative. Make a purchasing decision based on your immediate as well as anticipated needs.

Figure 6.2 Digital cameras are the wave of the future—but are available now.

Figure 6.3 New digital video cameras offer excellent resolution, new features, and communicate well with computers.

Figure 6.4 Videotape units are important for capturing video images and "printing video to tape."

Videotape Unit

Like the video camera, VCRs come in various price ranges, qualities, and formats. These formats include VHS, S-VHS, 8mm, and Hi-8. For average multimedia usage S-VHS and Hi-8 offer exceptional results. There are also video decks that can be controlled by your computer. The quality of your equipment should be determined in part by the quality of your final product. When placing video footage into your computer for editing, your video images can be enhanced with various software effects. Sometimes, you can compensate problems in your videotape by using these software techniques.

Sound Input Devices

Have you ever pressed the "mute" button on your TV remote control and just watched the screen with no sound? Images are good, but moving images without sound are not as effective as combining the two. Sound, whether narration, sound effects, or music, is vital to the full implementation of a multimedia production.

There are several ways to get sound into your computer. Many computers come with a hand-held microphone for voice annotation or recording. Sound can also be obtained through clip resources, like clip art. These files can range from effect sounds to music clips that are especially prepared for the computer and multimedia productions.

Sound can also be created by connecting musical instruments to your computer. This process is called Musical Instrument Digital Interface (MIDI). This format converts the sound into a digital signal. Being digital means that the sound file will be clear, equal to CD audio quality, and ready for instant playback, at specified locations in your production.

Sound can be captured into your computer if it is equipped with a sound card, or if it is an A/V or MPC model. The sound quality will only be as good as the quality of the microphone and equipment.

Figure 6.5
A sound file as displayed on the computer.

All four exercises on the CD-ROM allow you to work with the placing and execution of sound files.

Scanner

There are enough scanners on the market today to really confuse a potential buyer. Before purchasing a scanner, it is imperative that you do your homework. Following are some questions you should consider in a scanner purchase.

- Does it have a color preview feature?

- Does the scanner save images to RAM or disk? Scanning to RAM is a faster process. If you have a low amount of RAM your file will be saved to disk. This is slower, but nonetheless a workable solution.

- In what file format does the scanner save the file? Make sure it is a common format such as TIFF, PICT, .pct, .bmp, or .tif.

- At what resolution does the scanner capture information? The higher the dots per inch (dpi), the better the image will be.

- If software is bundled with the scanner, is it something you will use and is it a good value as a bundled package?

If color fidelity is vital to your work, buy the best scanner you can. Some manufacturers have a better reputation with optics and color systems than others. For serious media work, a hand-held scanner is not really a viable option. You may also want to consider the Optical Character Recognition (OCR) capabilities of the scanner. This probably has nothing to do with multimedia but as long as you are buying a scanner, see if it has the capability. Many desktop scanners bundle OCR software with the scanner.

Figure 6.6 A typical flatbed desktop scanner.

There are numerous storage devices on the market today. Capacity, as well as speed, are critical for multimedia development.

Hard Drive/External Storage Devices

When you first began computing, you may have started with a word processing program. As you know, you can get a lot of documents on a single floppy disk. This is not true with multimedia computing. Digital photographs consume a great deal of disk space. Moving pictures with sound, animation, special effects, and numerous support files require even more space. Not only is more space required but speed becomes an important consideration. High-capacity drives, 1 gigabyte or more, usually offer fast access times and transfer rates. This performance is necessary for multimedia computing. You will have to pay more for drives with more capacity and faster access times, but it is worth it. There are also special drives designed to handle the demands of transferring the enormous amount of information associated with multimedia. These are called audio/video (AV) drives. They are constructed to handle the rapid retrieval and display of full-motion video and audio, which can be around 1MB of information per second.

A Review of Media Storage Devices

Laserdisk

Laserdisks are to video what CD is to audio. With the CD, the audio quality is superior to audiotape. With a laserdisk, the video and audio quality are superior to videotape. Videodisks are used in many kiosk applications that require large amounts of data demanding superior image quality. Another advantage of videodisk is that the access time to a particular segment on the disk is very fast. For other multimedia applications, certain laserdisk units offer the ability to be controlled by your computer. If this is a consideration in your multimedia future, purchase wisely and make sure that this capability is a part of the unit.

One second of digital video and audio can consume over 1MB of disk space.

Media	Size	Capacity
Floppy Disk	800k	200 typewritten pages
Floppy Disk	1.4MB	300 typewritten pages
Hard Disk	20MB	5,000 typewritten pages
Hard Disk	40MB	10,000 typewritten pages
Hard Disk	100MB	25,000 typewritten pages
Hard Disk	1 Gigabyte	250,000 typewritten pages

Table 6.1 Storage capacities of various media types.

CD-ROM **Recorder**

The CD-ROM has become a mainstream product. Having the ability to read them is a requirement, and having the ability to make them is becoming more and more popular. As a multimedia producer, you will eventually find the CD-ROM recorder essential.

Figure 6.7 CD-ROM recording device.

A CD-ROM recorder allows you to record CD-ROMs. These recordable disks cost anywhere from around ten dollars to thirty dollars based on the quality and source. This format is excellent for copying multimedia presentations because of their large capacity. Each disk can hold up to 650 MB. They are durable, inexpensive, and have a very long shelf life.

One of the differences between CD-ROM recording and recording to a hard disk drive, a SyQuest drive, or other format is that once you record, or burn, a CD-ROM the information is permanently recorded. If you want to modify the disk in any way you simply must start over. This is not a major concern, just the process that you have to get used to.

With the advent of the newer Digital Versatile Disk (DVD), this process will be similar. The exception is that the DVD will hold much more information than the traditional CD-ROM.

Part II

Media Preparation

- Chapter 7 Developing Your Graphic Images
- Chapter 8 Sound
- Chapter 9 Video
- Chapter 10 Animation

Chapter 7

Developing Your Graphic Images

The creation of graphic images for multimedia is critically important, due to the fact that in any multimedia production, there are a variety of images. These images can be static, animated, or full motion. Remember that a picture is worth a thousand words; therefore, each graphic element should be the best it can be in content and quality. These images may be in the form of a photograph, interactive button, a computer illustration, or video footage from your camcorder.

The good thing about working on a computer and developing computerized graphic images is that your work can be saved and modified to easily create variations. All of this is done without having to recreate the product from scratch. If you have ever worked with pen and ink, watercolor, oil paint, or other medium, you know that once the project is completed, it is final. To modify the piece would require recreating, touching up, or even starting from scratch.

Traditional art forms can be recreated in digital format for use on your computer. Microsoft offers a variety of classic art pieces on CD-ROM that can be viewed on your computer screen. Not only are the classics available in this technology, but you too can have your creations in digital format for manipulation or viewing on your computer system.

By utilizing digital cameras, scanners, and other input devices, any art form can be captured and turned into a computer graphic. These images in digital format can be used for a variety of purposes. They can also be enhanced and reworked to form entirely new creations as illustrated in Figure 7.2. You can even capture screen images and use them in your productions.

Figure 7.1 Microsoft is creating new CD-ROM titles by repurposing existing works of art into digital format.

87

Figure 7.2 An original piece of art, scanned into the computer and transformed into a new art form for use as a logo.

Figure 7.3 is a screen shot from *Travelrama, USA,* from Sanctuary Woods. This screen demonstrates several multimedia screen elements. Of course, each production will vary in the type of graphic as well as the quantity. Remember that this is an art form, and implementation of techniques and style will vary with each project.

On-screen graphics are the backbone of multimedia, but the addition of sound and video add a different level of direct communication.

Producing the Art Form Needed for the Project

Backgrounds

Any presentation you are involved with will contain a background. Most of us prefer to have some creative control over what the background will look like. Most presentation and authoring software programs contain a variety of predesigned backgrounds.

Multimedia projects are very much like works of art. Each one will have a different style, color palette, and feel. What makes these projects unique is the content and the creative direction given to the creator. Unique background selections can truly provide individualism and character to any project.

Figure 7.3
A screen from *Travelrama, USA,* from Sanctuary Woods. This screen demonstrates many of the elements that must be designed or procured for production. Some of the elements include: Photography, line art, scanned images, buttons, text, and original computer graphics.

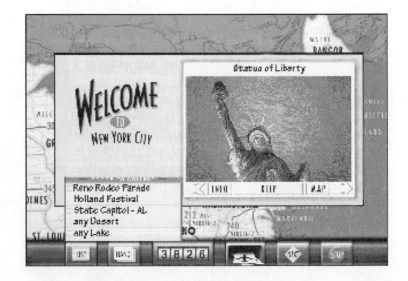

Solid **Texture** **Photograph**

In multimedia development, a background usually adds mood or supports a theme or message.

Figure 7.4 Backgrounds used in multimedia productions can be almost anything.

Solids, which can contain up to 16.7 million color variations, are the old standby. Textures can add a different feel to a presentation, and often are available to support various themes such as nautical, outdoor, weather, etc. There are a wide selection of textures that can be obtained through existing clip-art sources (see Figure 7.4).

Photographs can offer specific content and theme development, creating a very focused enhancement to any presentation. The variety of historical, thematic, and contemporary topics, currently available on CD-ROM, are virtually endless. This, combined with the ability to capture your own images, will provide total control of graphic production for background materials.

All of the exercises on the CD-ROM contain background art files such as this bicycle. These are essential to communicate the content of your presentation.

Buttons

One thing you typically see on the screen of an interactive presentation is the presence of some form of button. Traditionally, to respond to an interactive CD-ROM or other form of presentation, you must click a button. Buttons are used to start, stop, go forward or reverse, return, play, or to perform various other forms of interactive control. For the most part, buttons are just a small representation of what we are used to in real life (see Figures 7.5 and 7.6).

Figure 7.5 Any piece of art can be made into a button. They are as customizable as that artist wants them to be.

Figure 7.6 Buttons can be very spartan in design. These buttons are straightforward, making their function simple and direct.

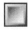

Buttons should allow the user to immediately recognize where he is and to understand their function.

Figure 7.7 Some screens contain buttons that are activated upon a click or touch. In this example, objects come to life with sound and animation.

Figure 7.8 In this example, a graphic functions as a button.

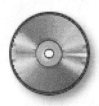

Exercise 1 on the CD-ROM demonstrates a creative use of objects that function as buttons.

Often, however, what functions as a button is not our traditional vision of what a button should look like. Figure 7.7 demonstrates a creative use of interactivity. The demo suggests that the user click one of the labeled keys on the keyboard. By clicking on one of these keys, an action will occur in response to what the key has been programmed to do. An example of this would be that when a key is selected, you will go to another screen, or begin a soundtrack, or animated sequence.

In this example, we have designated a specific graphic area as the button. This is identical to the selection of a rectangular or round button, with the exception that the selectable area conforms to the specific graphic, no matter what shape it is. The button will maintain its function no matter where it is selected.

Buttons can be created in a variety of software applications. Vectorized programs, such as Adobe Illustrator, Macromedia FreeHand, or other drawing programs, work fine. Bitmapped programs such as Adobe Photoshop also offer a design option. Figure 7.8 is an example of a bitmapped button.

Figure 7.9 Predesigned button set from Instant Buttons & Controls, from Stat Media.

An alternative to creating your own buttons is to let someone do it for you. There are companies that specialize in the development of such products. Stat Media, Inc., creates a program called Instant Buttons & Controls. This product contains over 1,000 buttons and controls (see Figure 7.9). These predesigned elements are not only graphic files, but also contain code to control interactivity when used with Macro-

media Director. They can be copied and pasted into a Director production and are ready for instant use.

Logos/Line Art

Logos and line art files can be created in a variety of methods. Logos, like Figure 7.10, could be created in a drawing program, like Adobe Illustrator or Macromedia FreeHand. Once the art is prepared, it can be turned into a bitmapped image for placement or integration into a specific art file or can become a part of a composite image. Often times, if a particular font is not available to produce the desired image, it can be drawn and can be an art file.

On-screen graphics are usually displayed at 72 dots per inch (dpi). This is a much lower resolution than graphics used for print.

Producing a graphic this way is very practical. The image may be difficult to manipulate as a bitmapped graphic, but easily modified if saved as a vector graphic. Remember that vector graphics can be saved and exported from Illustrator or FreeHand into paint programs such as Photoshop.

There are also numerous clip-art sources to obtain lineart files. These electronic files can be manipulated to reflect the desired effect you are after. After a period of working between vector and bitmapped graphics, you can learn what works best for various situations.

Remember that lineart can be placed directly into a multimedia production. Sometimes it will function better as a bitmap image.

Photography

Photography has been around for well over a century and, in this high-tech world, the photograph is still the driving force in graphic communication. A benefit of photography is that it is accessible to everyone

Figure 7.10 Lineart graphics can be used for signage or a variety of graphics. Vectorized art, from programs like Adobe Illustrator and Macromedia FreeHand, allow you great creative freedom and easy control of lineart.

Figure 7.11
Photography is
accessible to everyone.

(see Figure 7.11). Of course, there are varying degrees of quality in both cameras and processing, as well as with the photographer, but photography is everywhere. Since photography has been around so long, there are plenty of existing images that can be integrated into a multimedia presentation. By using a scanner, these images can have new life as electronic media. Through the use of digital cameras, images can be shot and captured by the computer almost instantly.

The application and growth of products and services in this area has grown tremendously in the past few years. This is evidenced by the number of stock photography services that are available in both printed and digital photography. There are even photo services available on the Internet that allow you to subscribe, browse a photo library, then download images on demand.

PhotoCD

A big technology break in the past few years is the introduction of the PhotoCD. This technology allows you to take your 35mm film to a photo lab and have your photos converted into digital files on a CD. Once converted, you can insert the CD into your computer's CD-ROM drive and have access to your photographs as digital graphic files. The images are typically stored in five different resolutions. For screen display, you use a lower resolution image. For a printed product, you use a higher resolution image for the best print quality.

This product, originally introduced as a consumer-level product with commercial overtones, is proving to be an extremely viable technology. Though the consumer applications have not been a boon to

the industry, graphic artists and multimedia users are finding this to be a product with many avenues of usage.

As more and more options are opening up to enhance computer imaging and multimedia production, presentations are becoming increasingly larger, requiring more storage space and heftier hardware and processing speed. Images used in multimedia projects must be of excellent quality and oftentimes large enough to be used as a background. Images stored on PhotoCDs provide excellent quality, and CDs can store around 100 images.

PhotoCDs, like traditional CD-ROMs, allow up to 650 megabytes of data per disk. That is the equivalent of 200,000 typewritten pages or around 500 floppy disks. For multimedia development, the CD-ROM drive is a necessary peripheral device, if for nothing else, just to access PhotoCD technology.

The PhotoCD process allows you to have your film processed onto a CD rather than to traditional film. This process is extremely useful in the realm of multimedia. One of the advantages is that it allows the user to work with a pure image at a choice of resolutions. The image is processed digitally onto the CD, giving a perfect image over and over again. No additional scanning or capturing is required. It also serves as an excellent archival device.

Consideration should be given to resolutions based on what your use of the product will be. If you plan to go to print with your image, then you may consider the Pro PhotoCD format. However, if your application for the images is strictly on-screen multimedia production or presentation, then lower resolutions will work just fine. Remember that the typical monitor used in a multimedia application will not display all of the information that is contained in a high-resolution image such as 4,096 by 6,144. Be aware also that with higher resolution graphics, more disk space will be required.

PhotoCDs capture your film onto the CD in five resolutions, the highest being 2,048 by 3,072. There is also a professional level PhotoCD. This is called the Pro PhotoCD. This format allows a total of six resolutions with the highest at 4,096 by 6,144 (See Table 7.1).

Stock Photography on PhotoCD

Utilizing stock photography is a great way to enhance or develop a presentation in a timesaving and economical manner. You can instantly capture photos, movies, animation, and other graphic file types in a tremendous time and cost saving process. Companies such as

Table 7.1 Photocd resolutions and their applications.

Resolution	Usage
192 x 128	Thumbnails
384 x 256	General Purpose
768 x 512	Monitor Display
1536 x 1024	TV Output
3072 x 2048	Printing

Image Club offer a Photocd product line that features numerous photos on a variety of subject matter such as space, business, industry, textures, backgrounds, and lifestyles. These Photocds contain a browser file that allows you to view the contents without requiring additional software applications. As with all Photocds, these digital images come in five resolutions. These photographs are compiled by well known photographers and are high quality. Use for this medium includes newsletters, multimedia presentations, brochures, ads, and more.

Using Photocd technology is an excellent way to save time and money in the preparation of images for multimedia production. Much time can be saved over the traditional process of taking photographs, having them processed and then scanning. Consideration must be given, however, to the fact that Photocds are not a one-hour, instant processing situation. Many processing labs have this work sent out for production. Make sure that proper planning and time is allowed.

Video Capture

You can record video images and sound directly to your computer using one of several movie capture software applications currently on the market. These applications are quickly becoming very sophisticated. To record video into an application such as Adobe Premiere you need a video digitizing card with video digitizing component software which is supplied by the manufacturer of the digitizer card. If you want to record sound as well as images, you need a computer with a sound input port or a sound digitizing device with input software.

Acquiring video images/footage from a VCR, camcorder or laserdisc unit into your computer requires a large amount of hard disk space and sufficient amount of RAM. Also required is a video capture board and a software program that is capable of "grabbing" the

Video capture cards run the gamut in price variations. Typically, better quality equals more cost.

video frames that you want to save as a digital movie on your computer. After you have acquired the video files, you will also need software that allows you to edit the movie.

Another tremendous advantage of capturing video on your computer is the fact that this video is made up of numerous still pictures. Based on the resolution and quality of these images, individual frames can be selected for use as a static graphic. If the quality level is not good enough for your use, these images can be great for FPO (for position only) shots for storyboarding scenes for a production. See Chapter 9 for more information about capturing video.

Computer graphics can be just about anything. The biker watch shown here was scanned, then traced, then filled with gradients. This was a three step process. This graphic is used in Exercise 4 on the CD-ROM.

Computer Graphics

Computer graphics can be developed in a variety of ways. A computer graphic can be a simple lineart drawing or a scanned photograph. It can be an illustration created in a three-dimensional drawing program, or an image compiled from a variety of original sources. Once an image enters the computer it becomes a computer art form. Once repurposed, it becomes a product of digital technology.

All images used in a multimedia production will become computer graphics no matter if they are created, captured, scanned, or created by clip art. What makes computer-based multimedia production so attractive and feasible, is the fact that the computer is the logical device to capture, manipulate, and integrate all of these elements into a cohesive product or production.

In multimedia, any image can become a suitable graphic for on-screen display. Authoring programs like Director accept a wide variety of file formats making it easy to incorporate images into a production.

Type

Type, like graphics, can take on different forms in multimedia. A very important consideration when using type is that in many instances, the type that is seen on screen is actually a graphic image. If you are producing a presentation for use on your computer only, or for an in-house function, then all the support elements that you utilize are built into your computer, ensuring that screen displays of graphics and type are workable. However, if you are producing a product that will be sent to others you must make sure that what you distribute will work on other machines. In order for your presentation to display correctly on other computers, those systems must contain the same type style. If

Figure 7.12 In this partial screen from Exercise 2 on the CD-ROM, the text becomes integrated into the overall graphic.

they do not, the type may be substituted with a different typeface causing an undesirable or unreadable visual effect on their screen.

How do you work around the previously mentioned scenario? One way is to ensure that the user has that particular font on his system. Another way is to send a copy of the font with your production and have the user install that font in his computer. However, fonts are a copyrighted software product. An alternative is to use public domain typefaces and avoid licensing and copyright infringements.

What works best is to make your typeface a part of the screen image. If the type is to be constantly displayed on the screen, for example as a part of the background, then it can be just that. If the text is to appear randomly, then it can be a smaller graphic, being introduced to the presentation as needed. The real benefit of having your text as a graphic is that it is not subject to dependence on a specific type family being present on the computer in order for it to display well on the screen.

Creation

When you cannot find a piece of art that suits your needs for a particular project, what do you do? You create it yourself. Today, there are plenty of sophisticated drawing programs that will allow you to design anything you can imagine. Programs like Adobe Photoshop, Adobe Illustrator, Macromedia FreeHand, and Fractal Design Painter allow amazing productions from your desktop computer.

Creating art that is acceptable for a particular project is totally up to the artist. One real advantage of creating electronic art is the fact that you can borrow from other images or sources to create an original art form. For instance, you may want to use a part of a scan that you have captured as the base for a new creation. Once this image is in your computer, you can enhance it and give it a new appearance. You could also merge a piece of clip art into your production to add further enhancements.

Sound

Hi-Fi, stereo, split channel, digital audio, CD-ROM-quality. These are some of the terms relative to sound that we have become accustomed to in this sophisticated, technological age. We forget that in the early days of radio any type of sound at all was good enough. When television came along it too had sound. That was also good enough. Volume adjustment was great but tone adjustment was even better. Just as most technology improves with time, so does sound, especially in the products and processes that make it happen. Determining what is "good enough" sound has changed.

Sound Technology

There have been some significant breakthroughs in sound quality over the years. Great strides have been made not only in the area of delivery, but also in the method in which sound is produced, transmitted, and even stored.

From a consumer standpoint, High-Fidelity, or hi-fi, sound was a major innovation. Stereo sound truly added a new dimension to a presentation, allowing sounds to be split and become more lifelike. In the 1970s, quadraphonic sound was added to the existing stereo systems allowing sound to come from four sources. This was supposed to be the rave, but never caught on. The quadraphonic format died almost overnight.

The next major sensation in sound was the advent of compact disk technology. This innovation set new standards for sound clarity and delivery. The CD-ROM format allows sound to be recorded to and stored in metal pits on a 5-inch plastic disk in a digital format. Storing sound or music in a digital format means that the sound information is converted from a continuous flow of sound, or an analog format, to

We are less tolerant of poor sound quality due to the sophistication level we have experienced in the last two decades.

Figure 8.1 The technology contrast between vinyl LPs and CD-ROMS.

numbers. These numbers are ones and zeros, which turn on and off as they are read by the laser in the CD-ROM player. This digital information is then processed and amplified, providing excellent sound quality with little or no distortion. With the advent of digital recording, sound can be reproduced consistently, over and over again, with the last copy sounding as good as the first.

Digital recording technology is quite different from the way a record player worked. Each time the needle was placed in a groove on the vinyl record, the quality of the sound diminished a bit due to the direct contact. Even though the LP is still around the CD-ROM format is the dominant distribution medium of choice for audio. With CD-ROM technology, information is stored in small metal pits and read by a laser. Therefore, the disk is never touched giving a long life span to the disk format (see Figure 8.1).

Next to visual images, sound is the most important part of multimedia. Properly executed sound files can communicate exactly what you want to say when you want to say it. This is critical when you are trying to communicate the same message to the masses. Proper sound editing, concise wording, and well implemented timing is what makes sound so important in multimedia presentations.

Without question, multimedia productions have much more impact with the addition of sound. As with any type of visual presentation, sound provides a dimension that assists in clear communication and provides gripping emotional impact. Consider watching the evening news with the volume turned off. Think about watching a cartoon without all of those crazy sound effects, or how about watching a sci-fi space epic without the spectacular sound effects that we all enjoy. These just would not be the same.

As you view a multimedia presentation that possesses excellent sound quality, you receive the benefits of a more dynamic experience. As with good visuals, good sound can drastically enhance any production.

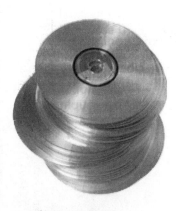

Figure 8.2 The CD is the preferred distribution medium for high-quality sound reproduction.

Sound Types in Multimedia

Types of sound typically required in various areas of multimedia development and presentation consist of the following.

Narration is a voice recording for specific use at a predetermined time or "on demand" in an interactive environment. Narration says what you want to say, and by using multimedia technologies, when you want to say it. If demonstrating a process or procedure, it can be repeated, on demand, at the user's discretion.

Sound effect is a particular sound used for impact during a slide transition, animated sequence, or in conjunction with a special visual effect. In Computer-Based Training (CBT), sound effects can be extremely useful by providing a positive or negative response.

Music is used for background sound, to create mood, to demonstrate specific music tracks as a point of interest or sale, and to set the pace of a presentation.

Each of these elements can work independently, or can be used in combination to meet specific production criteria.

With the proper computer hardware and software, you can capture, or create any type of sound.

Obtaining Sound

Obtaining narration, sound effects, and music for inclusion in multimedia projects can be simple or complicated. This process is based upon two things: what you are trying to obtain and your level of understanding of the resources needed to acquire them.

The next section will review how each sound source is obtained.

Narration

Narration for multimedia projects is usually information specific to your presentation or message. Therefore, the information must be created specifically for each production. The developer creates the narrative sound track himself or has it done by an outside source. Some of the considerations are:

- Can I do it myself?
- Is my voice quality sufficient for the job?
- Do I have the equipment to do the recording?
- If I use an outside source, where do I go?
- Does my project have the funds to pay for outside sources?

Exercise 4 on the CD-ROM makes extensive use of narration to explain graphics and processes.

Figure 8.3 Capturing voice recording directly into the computer.

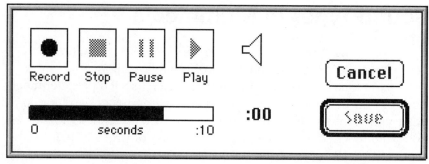

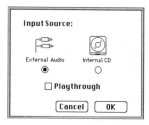

Figure 8.4 Computer systems with sound capture capabilities provide options for sound source.

Digital sounds are measured by kilohertz sampling rates. The higher the rate, the larger the sound file will be.

Of course, each project will have its own set of demands and constraints; therefore, be prepared to do what it takes to make it happen.

Some scenarios require that you give a presentation to an audience requiring visuals with you providing the narration live. If you are developing an interactive project designed for mass distribution, a decision must be made as to how to do it. For professional quality narration, time and money are almost always considerations. Careful preplanning and experimentation will guide you through the process. Experience is an excellent teacher, providing real-world knowledge as to what works best. Also, do not forget to seek the wisdom of those who have gone down the road before you. Stay ahead of the game by learning from their successes and failures.

Another method is to use a microphone, perhaps the one that came with your computer, as an input source. Many computers come with sound recording capability built in. More recent Macintosh models and MPCs have this feature. Some multimedia monitors have microphones and speakers built into them. This will work for starters. One way to get voice recording into the computer is to take a recording, from an audiotape or other source, and connect the device to an audio (or audio/video) board in the computer and capture the sound track into a program designed to convert the file to digital information.

To simply record a sound, for example for a voice annotation, a control panel is available that allows the recording process to happen. Figure 8.3, taken from the Macintosh operating system, reflects the familiar controls that are universal for record, stop, pause, and play. These buttons are similar to VCRs, laserdisk players, and CD-ROM audio players. By pressing the record button, you can record the voice or sound of your choice. Once saved, this file can be used for a variety of applications, such as for inclusion into a media presentation or as a system sound.

The aforementioned scenario represents the easiest, most direct method for capturing a sound into the computer. However, there are other methods that will add more sophistication to this process. For higher quality output the proper microphone, sound capture software, and knowledge of how to process the sound information is required.

Sound Effects

Sound effects are perhaps the most commonly used sound format in the development of multimedia productions. Properly used sound effects can be very effective at getting a point across and grabbing the attention of an audience. This type of audio file is also one of the easiest formats to obtain.

Typically, sound effects can be obtained from companies that specialize in producing sound effects for distribution. These effects are usually distributed on CD-ROM due to the size of the individual files, the number of sound files, and the format in which they are stored. A sound effects CD-ROM could include anywhere from 50 to 2,000 sound files, stored in a variety of formats. These formats include .AIF, .WAV, and others, and are compatible with Macintosh and Windows applications. These files can also be saved in a format that is compatible with specific sound recording software, such as Macromedia's SoundEdit 16. You can also expect to find an assortment of canned sound files with the purchase of sound editing software programs. Some multimedia authoring programs also offer a collection of sound effects as a part of their program.

Clip media sound files are typically prepared at a different sampling rate. That is, the lower the sampling rate, the smaller the file size. For example, simple sound effects, like a "boing" or "crash" will probably be saved at a low kilohertz (kHz), thus yielding a smaller file. On the other hand, a music file with high-quality stereo sound, will be made available in a choice of sizes, such as 22 or 44 kHz. This option will allow the user to determine the quality needed based on the impact needed or the storage space available.

Music

Like sound effects, music files can be obtained through various clip media vendors. There are music clips to support any musical taste and to accompany any style graphic or video.

Digital sound files provide clear, clean sound with virtually no background noise.

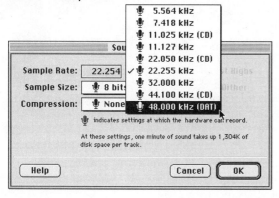

Sample Rate: 22.254
- 5.564 kHz
- 7.418 kHz
- 11.025 kHz (CD)
- 11.127 kHz
- 22.050 kHz (CD)
- ✓ 22.255 kHz
- 32.000 kHz
- 44.100 kHz (CD)
- 48.000 kHz (DAT)

Sample Size: 8 bits

Compression: None

indicates settings at which the hardware can record.

At these settings, one minute of sound takes up 1,304K of disk space per track.

Help Cancel OK

Figure 8.5 This screen is from SoundEdit 16, from Macromedia. This sound editing program lists sample sizes in kilohertz, or thousand of samples per second. CD quality audio is captured at an interval of approximately 1/44,100 second apart, as shown.

Basic Sound

These days it seems as though computers are capable of managing and running almost anything. One element that the computer manages quite well is sound. Following is some information that will help you understand computerized sound.

Sound is typically an analog process. That is, sound is a continuous flow of sound information or sound waves. This is the method an audiotape employs to handle the sound recording process. The information on the tape plays in a sequence providing a continuous flow of information.

Computers manage and process digital information. Sounds created on the computer are digital from the beginning. When importing sounds into the computer, for example from an analog tape player, the computer must convert this information into a digital format. Once the file is converted, it can read the digital information and play it back with precision.

The process of converting analog sound into digital sound is called sampling. The computer captures many samples from the original sound source and converts the information into digits that a computer can read. Sampling sound rates will vary. For instance sampling can be done anywhere from 11 kHz to 44 kHz. These numbers, eleven or forty-four, represent the number of times that a sample is taken per second. Therefore, an 11 kHz sampling rate would be only one-fourth of the quality of a sample taken at 44 kHz . This also means that the size of the file created is proportional to the sampling rate used. The word Hertz means "per second," so 22 hertz would be 22 samples taken per second. Kilo means "thousands," therefore 22 kilohertz would equal 22,000 samples per second.

CD-quality sound is 44 kHz.

Figure 8.6 Sound waves as they appear in a digital format utilizing Macromedia's SoundEdit 16.

Twenty-two kHz seems to be an average size for a sound file and is a typical sample rate for sound used in multimedia productions. The quality can be even better by sampling at 44 kHz, but based on your production requirements you may not need the higher quality sound. Sound, like other files, takes up disk space based on quality. Better quality sound equals a larger data file.

How sounds are used in multimedia productions will vary greatly. Like many other aspects of this technology, study closely and learn from successful titles currently on the market. Do not let the technicalities cloud your creative spirit.

Advanced Sound

A popular form of sound used in multimedia is called sampled sound or digital audio. Another format, Musical Instrument Digital Interface (MIDI), is a much more efficient and desirable way to deliver sound in a multimedia presentation.

There are numerous software programs dedicated to sound capture, playback, and modification. These programs allow this information to be converted to digital files that can be manipulated on the computer. Once the file is digital, it can be saved, stored, and played back in multiple formats.

If sounds had a look, the look would be similar to Figure 8.6. Like other types of computer files, this information can be edited from its original form. Sound digitizing and editing programs, such as SoundEdit 16 allow you to edit the sound in many ways.

To add an effect, such as reverb for an echo, all you have to do is to add this effect to your original sound file. The list of special effects is large, giving you great access to creative sound effects. With most

Figure 8.7 Some of the available sound effects used in editing digital sound files.

Figure 8.8
Sound is projected from the computer in a variety of ways, some yielding better results than others.

multimedia computer systems, the ability to capture sound is built into the unit in the form of a microphone. With older systems, the addition of a sound processing card will give you the ability to capture and edit sound files.

As with color graphic scans, sound files take up a considerable amount of disk space. Scans of course are based upon the physical size and the color depth to determine their size. Sound files grow larger in size the longer they are, and the higher level of quality in which they are recorded. As you develop a production, keep these factors in mind.

Sound Playback

Amplified external speakers are the typical sound device for most computers; however, many monitors are now equipped with built-in speakers.

Like other elements of multimedia preparation, sound deserves careful consideration as to the method and location that your presentation will be viewed. Most computers these days are equipped with at least a basic speaker system to handle voice and music. Those that do not, have at least a basic speaker built into the computer or the monitor. If the computer system is an MPC then sound hardware and software have been integrated into the system. This is usually done by allowing connections, through a video card or external sound connector, to a pair of external speakers. Based on the configuration, these speakers can be freestanding or can be mounted on the side of the monitor. In other scenarios, speakers are built directly into the monitor itself.

Using Sound Files Effectively in Productions

Like the many graphic files it takes to make a production, sound files can consist of many different files. If the production is narrated, the sound files will usually be a series of small narrations. These narrations, once interwoven into the production, will appear to be a part of a coherent message. In the authoring software environment, smaller files work better by being turned on and off as needed. The scripting portion of the authoring software will play the sound file at the appropriate time. The coordination of the sound file and the graphic is extremely important.

Some projects may be designed to provide continuous narration with background visuals and music. In situations like these, a continuous sound file, containing music as well as the narration, could be developed. A presentation of this type will become a large data file in just a short period of time. Keep this in mind if this method of delivery is chosen. This will impact the storage space required and will dictate from which type of device the presentation will be played.

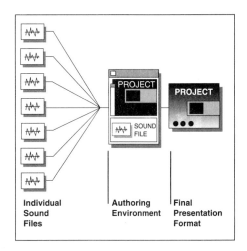

Figure 8.9
Individual sound files saved for playback as programmed or on demand.

Sound for Portable Computers

If you want to add expanded sound capability to a portable computer, one way to do so is to add a sound card. PC Cards, previously called PCMCIA cards, provide a method of expanding the audio capability of laptop computers. Some of these cards offer the older FM synthesizers as the method of processing sound. Newer options include wavetable synthesis for sound processing. The wavetable hardware option is a better alternative towards achieving higher quality sound than that of the FM synthesizer technology. These cards allow many of the sound capabilities of desk-bound systems on portables for use anywhere.

Exercise 3 on the CD-ROM uses a variety of sound files for transitions and backgrounds to create mood and impact.

Video

Multimedia, the integration of numerous elements, is enhancing presentation design like never before. Perhaps the most stimulating of all of the elements involved in multimedia is the integration of video. Various developers and companies are making video quality better and accessible to everyone, and we are enjoying the benefits of this exciting technology today. Why is video at the forefront of all the other media types? Perhaps it is due to the fact that we are visually oriented, and therefore relate to images that move.

We relate to what we see and are capable of interpreting messages visually, even without the addition of audio support. In our media-based society, especially through the venue of television programming, our visuals are not just pictures, they consist of composite graphic information. This includes full-motion photography combined with titles and graphics that are capable of telling us or selling us just about anything. When this is combined with audio, the medium becomes even more powerful.

In the realm of computer-based multimedia development and presentation, acquiring video into a personal computer is a relatively new capability. The fact that this technology exists is a technological marvel. Nonetheless, changes and capabilities in this arena continue to grow by leaps and bounds, and we can expect many changes in the future.

So, where do you begin to learn about how to capture video and integrate video into your computer? How is it handled in video editing software? How is it stored once converted into digital information? What are the Mac/PC issues? These, and other topics, will be addressed in this chapter.

Using video in multimedia productions is the ultimate visual. Communication is through real-time motion graphics.

QuickTime

A new form of video was introduced to the computer screen in 1991 through a revolutionary process called QuickTime by Apple Computer. QuickTime introduced the excitement of video to our personal computers, and ushered in yet another avenue in which we could use our computers. Before QuickTime there was text, graphics, sound, animation, and other basics that would allow development of a variety of media presentations. With the advent of QuickTime, the dimension of video was introduced, providing much greater depth and content-rich material to ordinary presentations.

QuickTime's revolutionary technology allows multiple images to be stored and played back at a speed that brings the image to life on the computer screen. QuickTime did for digital pictures what movie film did for movies. As you know, movie film is made up of many individual pictures that, when played back at the proper speed, appear to be lifelike. QuickTime controls the timing associated with many digital images, allowing them to appear in a movie format when played. Animation also works in this manner. Proper timing applied to the artwork or photograph yields a realistic presentation.

QuickTime was originally developed for the Macintosh, but the technology has since been expanded to allow Windows and other operating environments to use this format to play video files. With the advent of this technology, many software and hardware products have been introduced that assist in the capture, playback, and editing of video footage.

As we discussed in Chapter 8, sound files begin in an analog format. In order for these files to be used as computer files, they must be converted into a digital file format. Doing this allows the file to be saved and manipulated for future use. This same concept applies to video. Video captured, say from a camcorder, is analog information, or a continuous flow of information. It, like sound, must be converted into a digital file in order for it to be used and played back on the computer. Another comparison is the scanning process. When scanning a photograph on a flat bed scanner, you place the photo face down on the scanner. As it scans, a light passes over the picture capturing the image and converting it into a digital file. Once the image is converted into a digital format, it can be manipulated on the computer by a variety of painting or photo retouching software programs, or perhaps placed directly into a page layout or authoring program. Once videotape is converted into a digital file, it too can be manipulated in numerous ways through a variety of software applications.

QuickTime is a software extension. This means that it extends the capabilities of your computer to allow graphics, sounds, animation, and video to specific documents.

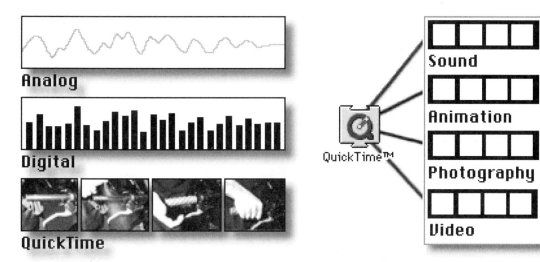

Figure 9.1 The videotape conversion from analog to digital.

Figure 9.2 QuickTime can accept these formats and play them back on Macintosh and Windows systems.

In Figure 9.1, the illustration on top demonstrates how videotape stores magnetic signals, as analog signals. The second illustration shows the analog file converted to a digital format. The image on the bottom represents the digital file displayed on the computer screen in the form of a QuickTime Movie. The digital files appear as a series of individual pictures, which when played at the proper speed appear to be a movie.

The QuickTime extension allows Macintosh and Windows users to integrate high-quality graphics, sounds, video, and animation into various documents. The QuickTime software includes utilities that allow you to play, edit, and create movies on the Macintosh, as well as save them in a format that will play on systems running Windows. Your projects can consist of video only, audio only, still images with sound, or a combination of options.

QuickTime movies are becoming a mainstay in desktop computing. Many applications, including word processing, databases, and authoring software, will accept QuickTime movie integration.

QuickTime is compatible with all Macintosh computers with the exception of the original 128k Macintosh. QuickTime movies are also compatible with Windows systems by adding the QuickTime for Windows extension. To use this extension you must have a hard disk and a minimum of 4MB of free memory. Refer to Figures 9.3, 9.4, and 9.5.

QuickTime video is an important part of Exercise 4 on the CD-ROM.

WORKSHOP

Figure 9.4 A QuickTime movie can be a "sound only" movie. These sound files have all of the QuickTime features with the exception of no picture.

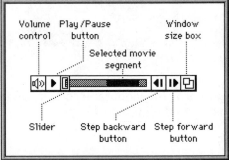

Figure 9.3 A QuickTime movie can be various sizes. This example is 160 x 120 pixels.

Figure 9.5 The QuickTime movie window control bar provides many of the features that your VCR may have.

QuickTime Reference Movies

QuickTime reference movies contain no video or sound of their own, but rather have pointers or links to the original movie file. One advantage of this format is that new movies can be made using parts from existing movies without modifying the contents of the original. This is helpful because it allows sharing of files, and conservation of storage space. If you choose to make these reference movies, it is important to remember that you must not rename the original movie or move it to another location, such as another folder on the hard drive. The movies and names must remain intact in order for these references to access the necessary files.

Disk access time, or the time it takes to read information from another movie and place it into a new movie, is affected by the proximity of all of the files that make up the movie. The optimum location for all files is the same folder, or directory, on your hard drive. A decrease in time will take place if the source information is spread out in other drives or buried in other directories or folders. Any changes done to a

A Reference Movie relies on other files to operate.

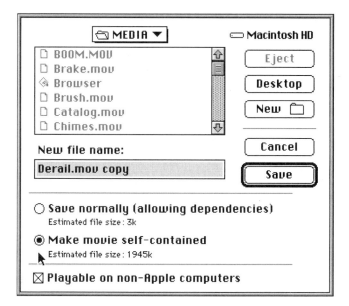

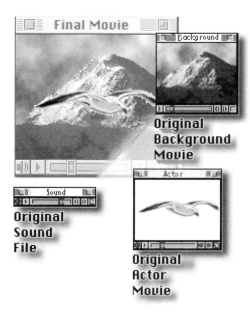

Figure 9.6 QuickTime movies can be self-contained or can depend on other files in order to function properly. This decision is up to the user.

Figure 9.7 A QuickTime reference movie uses other video and sound files in order to play back the movie.

QuickTime reference movie must be done with careful planning. A domino effect will happen if any component is removed or renamed in the structure of the movie (see Figure 9.7).

If you plan to use a QuickTime reference movie that includes linking to a file that is located on a CD-ROM drive, and your drive is single-speed and perhaps an older model, your access time will decrease significantly when pulling information from a movie or sound file located on that drive. Once again, this is not an optimal environment for maximum performance. Consider this as you manage your files and presentations.

QuickTime for Macintosh and AVI Tools for Windows

When we think of multimedia these days, we almost always think of video as a focal point. In desktop video creation, there are two major players. For the Macintosh Operating System, there is QuickTime, and as previously mentioned, QuickTime for Windows. For the Windows environment, there is also Video for Windows. Video for Windows cre-

For better performance, a QuickTime movie should be self-contained. Reference movies must access other files which slows the process.

Figure 9.8
A QuickTime
movie
created in
Adobe
Premiere.

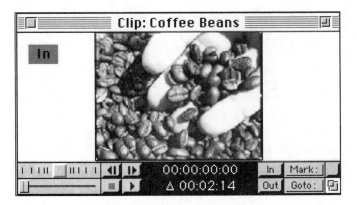

ates a file extension called AVI, or Audio Video Interleave. This format, which was developed by Microsoft, provides similar functions to QuickTime on Windows compatible systems.

Apple has always maintained a close relationship with their software developers, thus ensuring that software products are compliant and will operate with the broad range of Macintosh CPUs that exist. This has been the case with QuickTime. QuickTime has proven to be a versatile format, allowing easy playback capabilities on almost all Macintosh models. Also, because QuickTime will also allow playback on Windows compatible systems, its popularity will flourish.

The fact that these formats exist and offer compatibility between platforms is an exciting side effect of the convergence of this technology. The distinction between which product will work on which platform is beginning to diminish, allowing the user to benefit from more simplified industry standards.

Creating QuickTime Movies

Acquiring video images and footage in your computer requires a large amount of hard disk space and sufficient amount of RAM. Also required is a video capture board and a software program that is capable of grabbing the video frames you want to save as a digital movie on your computer. After you have acquired the video files, you will need software that allows you to edit the movie. Such software includes Adobe Premiere.

Remember that when you are considering jumping into video production and editing, you must have ample hardware to make it work. Working with video requires adequate RAM and hard disk storage. This can be a part of your front-end purchase or can be easily

Working with video
requires a fast
computer with large
capacities of RAM
and hard disk space.

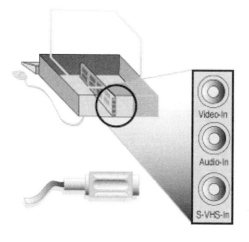

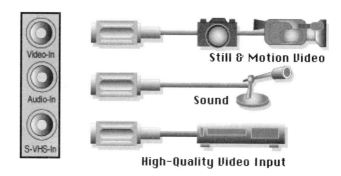

Figure 9.9 Once a digitizing board is added to the computer, audio and video can be captured.

Figure 9.10 External devices can plug into the computer through simple connectors.

added later. However, the initial addition is a good idea. The recommended minimum RAM is 32 MB and recommended minimum hard drive is 1 Gb.

An application comes with the QuickTime Starter Kit called Movie Recorder. It allows you to capture a video clip into Quick-Time. The key elements you will need to capture video include a compatible video digitizing board, the proper software for making the board compatible with QuickTime, and a video source such as a video camera, still-video camera, VCR, or laserdisk.

If your video source also contains sound, you will need a computer with a built-in sound input port. The Movie Recorder software should work with most software that is compatible with QuickTime. To capture video to the QuickTime MovieRecorder you must first make sure that your video and sound hardware is set up according to manufacturer's specifications (see Figures 9.9 and 9.10).

Keep in mind that the quality of video and sound input will vary depending on the manufacturer of the board that you use. Also be aware that the quality of your source materials is very important. If you are importing video stored on a laserdisk with a high-quality video digitizing board, then the results of your imported video should be sharp and crisp and display excellent resolution. On the other hand, if you are using a second generation videotape as your source with a high-quality video input board, your final input resolution will not be enhanced further by having a higher quality board. Remember the old saying, "Garbage in, garbage out."

If you are using equipment that has been acquired over a period of time, make sure you check the software versions listed on the products. Most peripherals refer to software version numbers that they are compatible with.

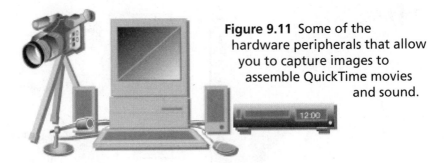

Figure 9.11 Some of the hardware peripherals that allow you to capture images to assemble QuickTime movies and sound.

Equipment Requirements

Acquiring the proper components to capture the various media types and to implement them into a usable format may require a rather substantial purchase for the occasional video user. On the other hand, a serious user making his living in this arena will need to invest in the proper quality equipment for the job.

Live video can be brought into the computer through a number of digitizing cards, manufactured by a variety of vendors. Computers with built-in A/V componentry have the ability to input and output video. Your level of involvement will play a key role in equipment decisions.

QuickTime presentations also have the capability to be copied onto videotape if your hardware supports the output of video. Keep in mind that the quality of your QuickTime video will probably be lower than your traditional video footage. At some point you will have to make the call on what is adequate video. QuickTime is capable of handling full screen images at 30 frames per second (fps) which is broadcast quality. Your hardware will definitely play a prime role here.

In order to make broadcast quality video, you will need a computer with a fast processor, a large hard drive, and good utilization of compression techniques and perhaps compression boards. To be a serious producer of QuickTime movies you should consider the biggest, best, and fastest hardware on the market. This will make your job as a producer easier.

Based on what your requirement for video footage might be, you have a couple of options. You can shoot your own video with either an industrial or consumer quality video camera, or you can have a professional videographer do the work for you. The general use of QuickTime has proven that a high-quality consumer video camera works well for a variety of requirements. Keep in mind your end product. Save the bucks you would have spent on a more expensive

Video Compression can be used with large video clips to make the file consume less disk space.

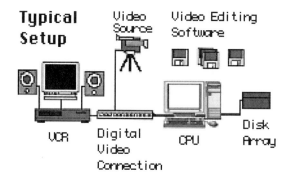

Figure 9.12 Developing and capturing broadcast-quality video requires the right equipment.

camera and invest it in more RAM. On the other hand, if you are going to produce corporate video and interactive presentations, then this issue may require reevaluation.

Another option for video acquisition is to purchase clip media. Like clip-art services and digital photo images that are available for your publishing programs, there are clip-media resources available for multimedia producers. These images often are arranged by categories and can offer much value and time savings if the product is applicable.

A/V or MPC Compatible Computers

Personal computers have changed with the times. In the past, a display, keyboard, and letter quality printer were sufficient for most jobs. Things are different today. The personal computer is capable of producing anything from a pie chart to broadcast quality video.

Current products provide many options, especially in the realm of multimedia. With the variety of elements involved in multimedia production, the computer must be capable of bringing these elements in as well as sending them back out in one form or another.

As you know, there are dozens of companies that manufacture computers today. If you are relatively new to computing, the choices can be absolutely puzzling. One trend in computer choices today is the emergence of systems that contain more than just the CPU, monitor, and keyboard. Computer manufacturers are addressing the need for systems to include not only larger hard drives and faster processors, but also sound quality, video connectivity, and ability to interface with a variety of external devices.

One of the drawbacks of buying a system piece by piece is that you have an abundance of equipment to deal with. You may even find yourself at the office furniture store buying additional furniture items to support your ongoing computer peripheral purchases. On the other

hand, buying piece by piece may be a good idea due to the need to connect each piece to another computer system. These independent components could also be compatible with laptop computers, providing expansion capabilities to these portable systems.

The hardware associated with the production of digital video and the rest of the total multimedia development process includes, but is not limited to the following:

- Computer
- Monitor
- CD-ROM drive
- CD-R (CD-ROM recorder)
- VCR (V-HS, S-VHS, 8mm, Hi 8)
- Speakers
- Tape backup system
- External AV drive
- Disk array
- Television monitor
- Video or Audio capture card
- Graphic or three-dimensional accelerator cards

As you can see, there are many devices that are a part of the desktop video process. What you need will vary based on to what extent you wish to go in your production.

If you are looking for simplicity in a computer system and would like to combine as many products and features as possible, an A/V or MPC system is worth investigating. A computer referred to an A/V unit would incorporate several basic audio/visual features in addition to the existing base computer configuration. In 1993, Apple Computer introduced their first A/V line, which consisted of the Quadra 840AV and the Centris/Quadra 660AV. As these machines were introduced, they immediately set new standards in integrated multimedia hardware technology and availability. These systems were a launching pad for several areas of technology in addition to audio and video features.

One good thing about the A/V computers is that they house many exciting technologies for the multimedia author or enthusiast. These systems also contain exciting features for the average business user, allowing them to have the functions of an office full of equipment contained in one computer system.

There is a harmonic convergence of a variety of products due to digital technology. TVs, VCRs, CD Audio, and other products are appearing under the control of the personal computer.

A/V computers also allow you to connect the computer to a television, camcorder, or VCR to record taped information or to capture live events. Though these early versions did a relatively poor job of exporting a clear video signal for television display, it still offered the capability. Other solutions such as third-party video card vendors, however, worked exceptionally well. This process works because of the compatibility between the Macintosh and traditional television sets. This capability alone is worth plenty if you are a casual or serious multimedia user or developer. After all, your productions may not always be viewed just on a computer screen. Occasionally you must present to a larger audience or output to videotape.

The inclusion of A/V technologies is not limited to Apple systems. Most major manufacturers, including IBM, Compaq, NEC, have chosen to integrate these technologies into some of their systems. These products have primarily been developed and marketed to enhance the value of their systems by offering components that are needed for a variety of purposes. These systems are primarily marketed to the small business and home arenas. A/V technology is good and certainly worth consideration. It is probably a good guess that this packaging of technologies will become more mainstream as time goes by.

These machines are a great value due to the amount of built-in features. You should, however, consider your budget and the quality of output before you purchase one of these units. If your primary need is for high-powered audio/visual output and input consider a powerful machine and an equally powerful video capture card. Your work environment may supply the extras mentioned as features in A/V machines and you would not need to clutter your system with many extras that you do not need. For example, if you are capturing and editing video as your primary job, you should not need a fax machine in your computer. You will want to conserve the horsepower and storage space that your system has to offer expressly for video work.

MPC Standards

As previously mentioned, an MPC is a standard group of components on IBM and compatible systems designed for multimedia use. Many software programs indicate that they require your system meet certain MPC standards in order to operate properly, or perhaps to gain the maximum impact from the program. See Table 9.1 for MPC minimum standards.

Table 9.1

MPC minimum standards may include:	
CPU:	25 mHz 486sx (or compatible)
RAM:	4 MB minimum (8 recommended)
Hard Disk Drive:	160 MB or above
CD-ROM Drive:	Double Speed (300k/sec sustained transfer rate)
	XZ ready/multi-session capable
	Enhanced drivers for better audio support
Audio:	16-bit audio card
	Music synthesizer
	On-board analog mixing
Video:	640 x 480 screen (minimum 13-inch screen)
	64k colors
I/O:	Serial and parallel ports
	MIDI in/out
	Joystick
Operating System:	Windows 3.0 (or higher)

Video Digitizing Cards

With the advent of the technologies described above, numerous hardware products are being introduced to support and improve the process. Perhaps the most significant piece of hardware to do this is the video capture card. Video capture devices run from $200 to $20,000. For $200, you can buy a product like the "Snappy" frame grabber that allows you to capture still images into your system with up to 16.8 million colors on your PC. For $20,000, you can have a board that will do it all. For the average user interested in obtaining quality video, the price tag is a bit more reasonable. For between $500 to $1,000, you can get a good board, capable of providing 16-bit color, with a frame rate of 30 frames per second.

The more expensive the board is, the more features you will get and better frame rate can be achieved. A 24-bit color and full-screen display, at 30 frames per second, is possible with boards in the $2,000 range. Something to consider in any video capture card is built-in compression. Compression takes the overall image file and reduces the information it has to process and then replaces it at the time it is being displayed. Having compression capabilities on the card means that the compression feature is a piece of hardware. This will provide better re-

Figure 9.13 A video digitizing board allows your computer to expand its capabilities to accept the importation of live or taped video information.

sults than software-based compression. These better results are reflected through improvements in speed and image quality.

Another consideration for boards is Peripheral Component Interconnect (PCI) architecture compatibility. PCI is a high-performance expansion bus architecture developed by Intel. This hardware interface technology allows manufacturers to develop boards, such as video capture boards, that will work in either a Windows or Macintosh system (see Figure 9.13). A major benefit of the PCI bus is speed improvements in every area associated with throughput. There are more than 200 vendors producing PCI cards, and over 500 cards are available that are compatible with the PCI bus architecture.

Like most computer products, video digitizing cards offer many variations in options and features. They also cover a wide spectrum of price ranges. They can be as low as $400 or as expensive as $5,000. As with most products, you get what you pay for. The $400 boards offer low-end capabilities, offering some of the same features of the more expensive boards, but lacking the quality components and interface that the better boards offer. The more expensive boards are capable of capturing full-motion video, rendering broadcast quality images.

It is probably not a good idea to purchase a video board based on what you read alone. If you have a chance, try it before you buy it, or at least have your local dealer or other professional advise you on your decision. Thoroughly examine your needs and what your final project will be. Know in advance what your end product is going to be, then take steps to get there.

Something to look for in a video card is its ability to handle future expansion. Many cards do not offer any type of expandability, outside of purchasing another card. On the other hand, some cards will allow you to expand them through a daughter-card addition. Often times, the warranty of the card will indicate if upgrades are available. Based on the model and company, you could be eligible for a free or reasonably priced upgrade Another area to consider is the life expectancy of the card. Is it current technology? Will it fit a computer that runs at 133mHz? 150mHz? 200mHz? Make sure that it is compatible with a va-

riety of system configurations. After all, you may be upgrading your system, and you want your card to grow with you.

Video Editing Software

Some features that video editing software might contain include:
- Special effects
- Dissolves
- Transitions
- Flying titles
- Animated logos
- Blue-screen
- Fade-in and fade-out

You are no doubt aware of the many competitors that offer solutions for word processing, drawing, spreadsheets, graphics, and other areas. When it comes to video editing software, there are also many companies that produce products for this task. As in other disciplines, there are companies that produce low-end as well as high-end solutions. Getting into this arena is based on what you plan to do, your budget, and your level of involvement.

From its introduction, the Macintosh has been a graphic-based computer. It is no surprise that it emerged early on as a logical choice to excel in the area of digital video. With the software development ties that Apple integrated early on in the development of QuickTime, the software and hardware products always worked in harmony. Due to this early lead, software companies also developed products for the Mac platform to support video editing processes. The PC on the other hand is growing at a phenomenal pace in the processes related to digital video. Today it is up to the user to decide his platform of choice and go from there.

To become involved in basic video capture and editing, you can begin with very basic software. Typical video editing software will allow you to capture video directly into the program. Some computers come with bundled software that includes a very basic video capture application. This software will provide the ability to capture video but lacks additional options such as sophisticated editing features.

Video editing software will also allow the implementation of other media types in order to create a digital movie (see Figure 9.14). These media types can be virtually anything as long as they are able to be saved in an acceptable format. Scanned images, computer graphics,

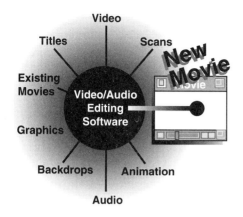

Figure 9.14 Various media types can be integrated into video/audio editing software, allowing the creation of digital movies.

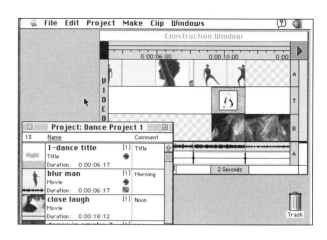

Figure 9.15 Adobe Premiere is an easy to use tool for creating video on the Macintosh.

titles, background art, animation, sound, new video, and existing digital movies are all pieces that are able to be utilized to create new digital movies. Better editing software programs will accept these types of media. As this new field evolves, new and more sophisticated software will be offered.

Capturing Video

To capture video, you must first have a source that provides video such as a VCR, camcorder, laserdisk, or still video camera.

You can record video images and sound directly to your computer using the proper hardware and software components. Software programs that support this process include Adobe Premiere. Premiere's software is specifically designed to create QuickTime movies. It has sophisticated editing tools and supports the importation of video and sound through its movie and audio capture commands.

To record video from within Adobe Premiere, you need a video digitizing card with VDIG component software which is supplied by the manufacturer of the digitizer card, or an A/V or MPC system with this feature built in. If you want to record sound as well as images, you need a computer with a sound input port, or a sound digitizing device with input software such as the Audio Media board for IBM and compatibles. Macintoshes with A/V capabilities allow sound-in and sound-out options.

Setting the frame rate higher than the frame rate of the original clips in the movie will not increase the rate of the original clips; frames will be replicated if the frame rate is higher than the original rate.

Table 9.2

Image Size	Frame Rate
320 x 240	8–10 fps
240 x 180	10–15 fps
160 x 120	15–30 fps

Frame Rates

The rate option determines the maximum speed of the movie in frames per second (fps). The playback rate you actually achieve depends on the speed of your computer and hard disk and display card you are using. The higher the frame rate, the more lifelike the movement will appear. Table 9.2 contains guidelines for setting video frame rates. Image size is measured in pixels and frame rates in frames per second.

Compression

Compression is important to desktop video from the aspect of file size and replay on the screen. Motion J-PEG, or M-JPEG, is the most commonly used hardware compression format. SCSI-1 is fast, but SCSI-2 is faster. Fast and Wide SCSI-2 is currently the fastest mode of data transfer. Data transfer rates relate to compression because the faster the transfer rate from the storage device, the less the video file needs to be compressed.

NTSC

If you are going to be involved in multimedia, then you will need to know what NTSC is all about. NTSC is an acronym for National Television Systems Committee. This committee formulated the standards for United States color television systems. NTSC is the dominant broadcast standard in the United States and Japan, but is not used as commonly throughout the rest of the world. Phase Alternating Line (PAL) is the primary standard for most of Europe and Australia. Sequential Color and Memory (SECAM) is used in Eastern Europe, France, and the former Soviet Union.

When working with software and video cards, you will find that NTSC and PAL are typically supported. Many cards support SECAM as a standard and some offer it as an option. However most cards also accept other variations of NTSC video signals. For example, Compos-

ite mixes together the chrominance and luminance parts of the signal into one channel. S-Video is a two-channel video signal dealing with color and luminescence produced by high-end consumer and professional-level cameras such as S-VHS and Hi-8. RGB is a signal made up of three separate channels: red, green, and blue. There is a channel for each color plus a separate channel to synchronize each channel.

The A/V computers and video capture cards typically have NTSC output and input capabilities allowing the capture of video from domestic VCRs and camcorders as well as output to these units.

If you are working with software configuration that offer NTSC, PAL, and SECAM options, select the various options and observe the changes in the format as it appears on screen.

Digital still cameras are similar to other digital technology products: the better the quality, the more expensive the product.

Capturing Still Images

Still images are transported into the computer in the same way that live video is. The only difference is that digital still cameras process static images. Static images are much smaller files than video images. A typical digital camera might store 32 standard-resolution images, or 16 high-resolution images in 24-bit color. They could also include both a Macintosh and Windows connecting kits. Digital still camera technology captures images to disk rather than to film. The images are stored on the disk until connected to the computer for image transfer.

Digital cameras start at approximately $400. They are innovative because the images can go directly to the computer for editing or for immediate use with no processing required. All you have to do is connect the camera to your computer and download the digital photo images. This type of product has been very effective in the area of real estate, insurance, and police investigation.

Digital Video Storage

Where and how to store your digital video files is an issue to be seriously investigated. In an environment where one second of digital video can consume more than the capacity of a single high-density floppy disk, other alternatives must be addressed to meet the storage demand.

When you work with digital video, you are working with many color pictures. These individual images can consume great amounts of disk space based on their size and image resolution. Producing a

video clip that lasts only ten seconds may consume disk space in excess of five or ten megabytes.

As you research system configurations for desktop video, your computer should have a minimum 1 Gb hard disk drive on board. This will allow you to enter basic multimedia planning and design. The speed of the disk is also very important. Your unit should run at least 15–20 miliseconds. The transfer rate should be several MB per second. Serious users and producers will consider the purchase of a 2- to 5-Gb drive. This size will offer ample size and fast access speeds.

Storage Technology Types

SyQuest

Having auxiliary external storage devices is very important and often mandatory. Historically, one of the most popular external storage devices has been the SyQuest drive. SyQuest technology basically took the hard disk concept and made the disk removable, allowing subsequent disks to be used and removed at will. With the desktop publishing revolution of the 1980s, the need for additional storage grew rapidly due to the storage requirements of scanned images and the complexity of some documents. During this time, the SyQuest became a popular alternative because it was not a "fixed" storage solution. Because the media was modular, there were no limitations. Many service bureaus and trade shops have SyQuest drives, ensuring compatibility for just about everyone. This technology has grown in capacity. Earlier systems held 44 MB of data. The progression grew to 88, 105, 200, and then to 270 MB. This technology has served well through the years and is still a viable alternative.

Digital Tape

Digital tape is the most economical of the storage mediums. However, it is also the slowest. The advantage of digital tape is its high amount of storage capability. Examples of tape formats include 8mm and Digital Audio Tape (DAT). DAT is currently the most popular and interchangable, making it a good alternative.

ZIP Drive

If you are on a budget and are producing smaller multimedia projects, the Iomega ZIP drive is an excellent alternative. With a storage capacity

of almost 100 MB per cartridge, it offers a great low-cost solution. The disks are magnetic and are about the size of a floppy disk. The unit costs under $20. and offers 100-MB cartridges. The 100-MB disks cost under $20 and are great for multimedia presentations. The drive is not the fastest for multimedia work, but it certainly has a variety of uses and you cannot beat the price.

JAZ Drive

The JAZ drive is related to the ZIP Drive. Basically, the Jaz Drive is the same product as the ZIP with the exception of the capacity. The Jaz Drive cartridge holds 1 gigabyte of information. This is equal to 10 ZIP Disks.

Magneto Optical

Magneto Optical (MO) drives have been on the market for several years and continue to grow in popularity, primarily because they offer the lowest cost per megabyte of storage currently available, usually just a few cents per megabyte. Since their introduction, these devices have proven to be dependable storage devices. Many vendors promise their media has a shelf life of 100 years. Perhaps the drawback related to MO storage is that the access time is not as fast as other technologies such as Winchester. This aspect is improving continually to keep up with the demands that video requires for speed.

Magneto Optical drives offer many advantages. The 3.5-inch disk can hold from 128 MB to 254 MB. These drives begin at around $1,000 and the disks are around $30 each.

RAID

Redundant Array of Inexpensive Disks (RAID) are becoming very commonplace for professional digital video producers. RAID is interesting technology and has been pushed to sophistication because of the demands that video places on computer and storage systems. Video, as mentioned earlier, is intensive data, requiring that a lot of information be retrieved and processed for viewing virtually immediately. RAID systems work effectively because they store information in segments on the various drives and then the information is processed in a continuous manner. The result is a continuous flow of information to the computer screen.

An example of disk array configuration is as follows:

Storage device speeds, capacities, and specifics will constantly change, due to the fact that they are driven to support computers that often evolve.

- Raid levels 0, 1, and 5
- Up to 30 MB per second transfer rate
- Plug-and-play convenience
- 8 Gb capacity
- Approximate selling price: $2,900

Technology Changes

Keeping up with technological changes in the computer field makes you continually search for what has been introduced or upgraded. Changes in screen displays, drive mechanisms, CD technology, peripherals, output devices, and the amazing amount of software will make your purchasing decisions even harder.

However, changes in technology are good for all of us. One good side effect is that usually the task we are learning today can be performed easier and faster tomorrow due to the constant improvements to technology.

The consumer video camera of the 1980s was a two-piece VCR that allowed the tape mechanism to be removed and taken into the field for use with a camera that was heavy and offered mediocre image quality. In contrast, the camcorder of today not only incorporates all of the features of this bulky equipment in a single lightweight unit, but some units offer near professional-quality video capabilities with worlds of special effects. With the advent of the digital camcorder, giant steps towards professional quality images are being achieved at a consumer level.

Today's computer technology continues at a fast rate of change. The Macintosh of 1984 was indeed revolutionary. It was compact and had a mouse, point-and-click simplicity, graphical interface, and many of the concepts that we are using today. However, current systems are many times faster and more colorful. They offer CD technology, can be used as fax machines, and incorporate voice recognition. They have excellent sound quality and you can output documents to various peripheral devices, making them revolutionary pieces of equipment. When you examine these changes, aren't you excited about the future of computing?

Chapter 10

Animation

Making things move on your computer can be very simple, if you know which software makes it work. Establishing a reason for why something should move is important. Animation is a powerful medium if used at the proper time to communicate a point or message. Animation can be as simple as a two-dimensional logo entering and exiting from a presentation program, or as complex as a three-dimensional model with shading and rendering.

Animation carries unusual powers that allow the unreal, or even the unimaginable, to happen. The power of this medium is truly fantastic. The use of animation is also widely accepted by society as a whole. The fact that the Disney empire was built around animated characters is one testament to this. In the 1960s through the 1980s, the Disney studios significantly cut back on the number of animated features it produced because of the astronomical cost of producing a feature length animated movie. In the 1990s, Disney experienced a rebirth into the animation arena because of technological advances. What resulted was the emergence of several very popular animated films. This proves that the public has an interest in the powers of animation.

How does all of this impact what you will produce on your computer? In the realm of multimedia computing, animation is crucial. Remember that we are a part of the "TV Generation." We expect fast-paced movement, bright and colorful graphics, clear sound, and multiple images flashed before us in harmony. Lots of information in a short amount of time has become what we are accustomed to receiving.

Animation is any movement on the screen. It can be as simple as a title entering and exiting.

Animation in Multimedia Computing

Animation in a major Hollywood movie studio is a major production. However, in its simplest form, animation is any movement on your computer screen. A title entering the screen from the right or left is a form of animation. A transition from one screen to another, utilizing a dissolve or curtain effect is a form of animation. Animation is simply movement. The following are three levels of animation used in multimedia presentations.

Level 1: Beginner

The beginner level requires no graphic experience. Perhaps the simplest and most commonly used form of computer-based animation comes in the form of presentation software. Programs such as Adobe Persuasion, Microsoft PowerPoint, and Multimedia Design Corporation's mPower, provide an excellent platform for creating great looking presentations. These software applications also provide the capability to produce basic animated effects. These effects are crude in comparison to three-dimensional modeling software and programs like Macromedia Director, but nonetheless, any movement on the screen is still animation. Some of the effects you can expect from presentation software include:

Flying Titles
Titles and graphics enter from one location, pause, and then exit to another location.

Fade
Picture fade-in, fade-out, and movement.

Exercise 1 on the CD-ROM allows you to experience some basic animation techniques by setting the gull illustrations in motion.

Movement
Graphic objects can be set in motion by following a path that is invisible during the presentation mode.

Importation
Animated files can be imported into your presentation for playback at the user's discretion.

Another dynamic product that can effectively be used in the realm of animation is Apple's QuickTime. QuickTime is very effective because once graphics are produced, they can be placed in frames in Quick-

Time format and played back as a movie, providing an animated sequence. As QuickTime plays a movie file, it is actually playing a series still images, at a predetermined frame rate, to achieve full motion. This works very effectively with computer illustrations and graphics as well. All of the timing and size controls are easily controlled by the user.

Level 2: Moderate

Moderate level requires an understanding of animation techniques and software. To create animation that is convincing and allows more sophistication than merely having a flying title move across a screen, you must be able to have an understanding of cell animation techniques (see Figures 10.1 and 10.2). Cell animation refers to the various frames or individual pieces of artwork that make up an animated sequence.

Macromedia Director allows you to import a graphic and control where it is placed on the screen by using a timeline approach to animation. This form of sequencing a piece of art is very effective in creating animation with a single object. Objects can move from one screen location to another, and can also change size and shape along the way. Notice the space between the objects. This is normal in animation. When a series of graphic objects are played back at a proper speed, the movement appears to be smooth. The reason for this is even though the object has spatial gaps, when put in motion, the object appears to move fluidly. The reason for this is a phenomenon called perceived motion. This means that we anticipate that the character is moving, and therefore, we look beyond the small discrepancies between one position and the next.

This effect works differently based on the object. For example, if we see a cartoon of a character walking down the street, it is impractical to totally draw each minuscule movement to fully demonstrate the process. So, if the character is in a walking motion, then we are going to think that walking is what he is going to do, not fly or jump, but walk. Therefore, as the character proceeds, only certain steps are needed to ensure that the motion is that of walking.

The concept of perceived motion also applies to the utilization of QuickTime movies. A QuickTime movie is made up of individual cells containing snapshots from a video clip or other source of imagery. In the case of a QuickTime file consisting of digitized videotape, the play back via QuickTime is a series of images with gaps between each frame. Notice the differences between the sequential frames. The real trick is to play back these images at the required frame rate to ensure that the motion is perceived to be real.

Figure 10.1 Using Apple's QuickTime for the playback of an animated sequence.

Figure 10.2 A series of images representing cell animation.

Figure 10.3 This robot from the *Journeyman Project,* is imaged at intervals that create the illusion of fluid movement.

Figure 10.4
A screen from the *Journeyman Project,* demonstrating excellent three-dimensional animation techniques.

If you are planning to import an animated file from one program to another, you will need to save the file in the proper format.

Level 3: Advanced

The advanced level of animation requires a full understanding and experience with modeling, graphic, and animation programs. This includes the ability to create two-dimensional and three-dimensional graphics, and understand how to put them in a sequence that allows them to perform as a believable character or event. There are numerous programs on the market today to support the creation of any character or scene imaginable. To become involved in this arena, you often need more creativity than software proficiency. These programs are becoming easier to use and they support the idea process in an easy to use manner. Keep this in mind when considering the purchase of modeling software!

Multimedia titles like *The Journeyman Project* use realistic three-dimensional models and futuristic background images to transport the user into an entirely new environment (see Figure 10.4). We can go anywhere with the proper use of this technology and a little imagination.

Planning

Planning is an essential part of using animation in a multimedia production. As mentioned in Chapter 2, storyboarding is a requirement for any production. It is especially important when considering the insertion of an animated sequence.

File Formats

Animated files, like any other computer file, must be saved in various formats to be used in other applications. A single file can be saved as a PICT or .pct file. These images contain a smaller amount of information than normal. By utilizing several PICT or .pct files in an application such

Figure 10.5 The morphing process must have a different start and end image.

Figure 10.6 As the morphing software generates the sequence, numerous "in-between" images are created.

as QuickTime, an animated sequence or scene can be created. PICS files save graphic images in a series and allow playback in a sequence.

Morphing

Morphing is a phenomenon that continues to be popular in the presentation arena. Morphing has been used in Hollywood for many years to show the transformation from one image to another. This was one of the early special effects used in the movie industry. In reference to computer-based multimedia production, morphing has been around since the late 1980s and early 1990s. The morphing process allows the user to combine two images through an animated sequence that subtly changes the in-between images to simulate a gradual change from one to the other.

If you are familiar with the morphing process, you may not have thought of it as a form of animation. What makes it fit this category is the fact that there are numerous images that create the "in-between" sequence, which when played back at the proper speed, simulate real motion and a dynamic effect of reality. This form of animation is quite effective in showing a before and after scenario. Rather than merely showing the before image and then the after image, the first image gradually turns into the second (see Figure 10.5). This creates a dynamic effect.

The number of in-between images are specified by the user. The more in-between images that are specified, the better the transition appears. The boy to girl morph, shown in Figure 10.6, contains a total of 24 in-between images. The sequence shown here indicates in-between frames, numbers 6, 12, and 18.

Exercise 1 on the CD-ROM contains animated effects using techniques in Director.

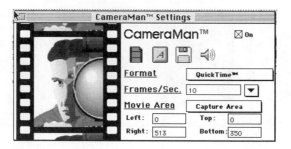

Figure 10.7
CameraMan records your screen movements to a QuickTime file.

Like all special effects, morphing should be used wisely and at the appropriate time. Using an effect like morphing over and over in a presentation could be serious overkill. Excessive use of morphing reduces its impact. Morphing, like other special effects, has its place. Use good taste and judgment when integrating into a presentation.

Animating the Computer Screen

Sometimes in the course of communicating your ideas, you will want to share a procedure that you have created on your computer. By far, the easiest way to do this is by using a product called CameraMan by MotionWorks software (see Figure 10.7). CameraMan is a screen recording utility that captures exactly what is happening on your screen to a QuickTime movie. By assigning a key to start, stop, and pause, you can capture an on-screen process. CameraMan also has the ability to record voice narration and mouse clicks along with the screen movements in real time.

These QuickTime movies can be saved in various size formats, depending on how much memory is available. This process is invaluable for anyone interested in providing computer-based training.

The "Country" section, in Exercise 1 on the CD-ROM, gives the illusion that the boots are moving across the screen (see Figure 10.8). As you place these individual graphics on the screen, it is very obvious that they are individual graphic images. Once they are placed in a proper sequence, and put to motion with proper timing and background music, the screen will come alive.

There are other animation techniques used in the exercises. Explore these and you will develop an understanding of this process.

Exercise 1 on the CD-ROM utilizes some unique animation processes.

Figure 10.8 In Exercise 1, the screen becomes animated using effects generated in Director.

Part III

Producing/ Authoring/ Presenting

- Chapter 11 Authoring Software
- Chapter 12 Interactivity
- Chapter 13 Presentations To Go
- Chapter 14 Coming Up

Authoring Software

If you have ever had the responsibility to author any type of article or publication, then you are well aware of the challenges associated with putting together a group of words, sentences, and paragraphs that form a cohesive thought. As you contemplate the quest to become multimedia-literate, be prepared to broaden your present skill set.

As discussed in previous chapters, multimedia development involves the incorporation of many forms of media types. These media types only become a harmonious production when properly orchestrated. The way these files become properly orchestrated is through authoring software. As the word authoring suggests, you are the one telling the story.

Authoring software is a product that allows the development of a multimedia production by coordinating the various media types into a production. Instead of writing text for a book or publication, you are writing, composing, and assembling files for presentation on computers, televisions, VCRs, or perhaps a presentation to an audience. If you are a novice, then the thought of working in this type of environment may be intimidating. You may be an excellent illustrator or page layout designer but when it comes to making many elements work in harmony in the dynamic world of multimedia, you will find a series of new challenges.

How Does It Work?

If you are new at multimedia, and are confused about the buzzwords do not worry. Authoring software is very straightforward. Basically, authoring software allows you to take previously prepared graphics,

Trial versions of Macromedia Director, and Adobe Persuasion are located in the TrialSW folder on the CD-ROM. Director is classified as authoring software while Persuasion is classified as presentation software.

A full working version of mPower is included on the CD-ROM. mPower is a cross between authoring and presentation software.

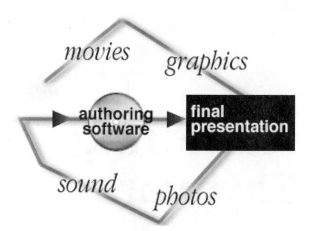

Figure 11.1 Previously prepared files are placed into authoring software to develop a media production.

sounds, animation, and movies, and place them under the control of one software program. Once they are connected by the authoring environment, the software allows you to take control, commanding the elements. In order for this to happen, the software must accept and execute your instructions.

Your external files do not necessarily become a part of the authoring software, but rather are controlled by the authoring software. For example, digital movies are traditionally very large files. When a movie is placed into the authoring program, it is usually linked to the original file, not recreated. Therefore, when you are copying a presentation or media production for distribution, the file created in the authoring software as well as the movie file must be together. When it comes time for the movie to be played, the software will look for the file for playback. Some programs, however, allow the option to place the entire movie file into the program.

Authoring software offers tremendous flexibility in the scope of what it can accomplish. Numerous products can be developed with authoring software. Some of these include multimedia presentations, CD-ROM titles, kiosks, computer-based training, artistic visualizations, and web pages.

Authoring programs are somewhat hybrid products: a cross between presentation programs and a programming language. The programming process varies in complexity based on the aptitude of the user and the type of end product that will be developed. The programming aspects related to multimedia authoring software usually refer to simple commands, or visual elements that allow you to tell your previously prepared files what to do, and when to do it.

As you will discover in your research, authoring programs usually offer either scripting options in a timeline format, or icon-based inter-

Authoring software allows development of the very basic to the very complex multimedia project.

faces. When you look at a program that relies on scripting, you get the feeling that you are involved in programming. This is because the program relies exclusively on your input to tell objects what to do and when to do it. Though you must become proficient with all of the scripting language, you eventually will understand.

Authoring Software Categories

In this section, we are going to examine a variety of software applications that allow development of interactive presentations and products. These applications include both presentation and traditional authoring software. A conscious decision has been made to add presentation software to this section. Traditionally, these products are grouped separately.

Presentation software has grown to the point of including some rather sophisticated features, including interactivity, branching, and acceptance of a variety of media types. These advances have elevated the capabilities of these programs making them much more than mere slide show applications.

Figure 11.2 Different presentation and authoring environments listed by product class.

Minimum Production Requirements

You can enter the authoring process in its most basic form by developing a project in a presentation program. Even though you may not create a high level of interactivity and may not use a variety of media types, presentation programs have a place in the multimedia process and support the authoring mind-set.

If you have been involved in computing for a while, then you remember when word processing programs were used only to produce typed pages. Today, word processing programs have grown in sophistication to incorporate graphic design tools, page layout capabilities, charting, and even the importation of multimedia elements such as digital movies. Now that presentation programs have been around for a while, they too are growing in capabilities. These programs now incorporate linking, animation, interactivity, Web page design, and much more. In fact, some of these programs rival what used to be considered sophisticated authoring environments.

Figure 11.3 This screen represents scripting in Macromedia Director. Director is an example of an authoring software environment that uses a timeline format.

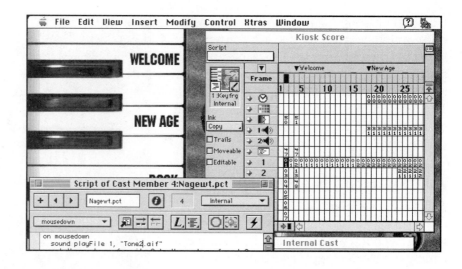

The Browser on the CD-ROM is an example of how a presentation prepared in Director allows other file types to be opened and viewed.

Some presentation programs have the ability to launch other applications from within a presentation. Traditional slide-show software and interactive applications have merged somewhat over time, providing greatly enhanced features. The extendibility of these programs is growing, in some cases rivaling full-blown authoring programs, and increasing in sophistication with each new release.

Another great feature of these programs is their ease of use. If you need to get up and running in a short period of time, the typical presentation program will allow you to quickly develop an above average presentation. These programs usually contain a wide assortment of pre-designed background art as well as a variety of clip-art files that will assist in the assembly of a presentation. This is a great feature, especially if you do not have the time or resources to develop these elements yourself.

Another tremendous advantage is the ability to make your presentation compatible with other systems. Through the utilization of player technology, presentations can be saved, and made playable on both Macintosh and Windows systems. A player is basically the part of the software that allows playback only. Players do not include the ability to create presentations. This feature has been around for a while on high-end authoring software and is becoming a standard process for presentation software as well.

Better Production Requirements

Timeline-based authoring solutions, as shown in Figure 11.3, allow for extremely flexible functioning in an authoring software. Many of these

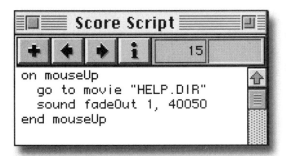

Figure 11.4 An example of a script using the Lingo scripting language in Macromedia Director.

Exercise 3 on the CD-ROM uses Adobe Persuasion to generate a sales presentation. The presentation includes many media processes, including video.

programs offer features that allow the creation and control of many external devices, such as laserdisk, VCR, and audio equipment.

Typically, these environments offer the ability to be controlled through means of a script. These scripts tell the variety of external elements exactly what to do and when to do it (see Figure 11.4).

Such programs should have the ability to create, integrate, and synchronize the wide assortment of production elements. These elements include text, still graphics, animated graphics, video, and sound files. This class of software should also support the development of dynamic presentations, which include interactive marketing productions, entertainment media, demo disks, educational CD-ROM titles, information kiosks, technical visualizations, and the ability to print, or output, to videotape. This level of authoring has the capability to develop pages for the World Wide Web. The advantage of this technology is that the Web page can contain sound, animation, and interactivity, allowing the user to benefit from multimedia technology. The ability to link and control external devices, such as VCRs, laserdisk, and audio compact-disk players is also a feature that should be in this class of authoring software.

Ultimate Production Requirements

Ultimate authoring software includes all the features listed thus far and more. Additional features include the ability to create computer-based training programs. These programs would allow the user to save a training session at any point and would contain the capability to capture or to track user responses and progress.

Enhanced capabilities in kiosk settings are also a feature of high-end authoring environments. Through advanced capabilities, kiosk interfaces can collect information about demographics, personality profiles, age, and other information and store it in a database.

Cross-platform development and connectivity to a vast array of external devices is also integral to high-end solutions.

A Closer Look

Before we go in depth, let us take a look at some specific products, their general classification, and compatibility. The product selection represents a broad category of products that offer similar features and functioning. The selected products give a good overview of features that comparable products offer.

Product	Persuasion
Company	Adobe Systems
Platform	Macintosh/Windows
Class	Presentation/Interactivity
Special Features	Can produce player files for distribution of the presentation without the application
	Web-page authoring
Product	mPower
Company	Multimedia Design Co.
Platform	Macintosh/Power Macintosh/Windows 95
Class	Presentation/Authoring/Interactivity
Special Features	Produces player files for Windows systems
	Can digitize audio and video
	Controls externals: CD-Audio and VCRs

Table 11.1 Presentation Software

Product	Director
Company	Macromedia
Platform	Macintosh/Power Macintosh/Windows/Windows 95
Class	Authoring/Interactivity/Computer-Based Training
Special Features	Excellent animation control, timeline interface
Product	Authorware
Company	Macromedia
Platform	Macintosh/Power Macintosh/Windows/Windows 95
Class	Authoring/Interactivity/Computer-Based Training/Course Development
Special Features	Icon-driven interface, control of external devices, Computer-Based Training design

Table 11.2 Authoring Software

Specific Product Overview

Presentation Software • Persuasion

Persuasion is a presentation graphics software for producing or delivering conceptual and data-intensive presentations. Persuasion can automatically generate 35mm color slide output, overheads and on-screen presentations, audience handouts, and overhead transparencies.

Persuasion is available for Macintosh, Power Macintosh, Microsoft Windows 3.1, and Windows 95. It contains charting features, with rotation, skewing, scaling, and perspective controls, plus mathematical functions; on-screen presentation capabilities, including branching, animation, sound imports, highlighted builds, and audio transitions. Features include nudge controls, ruler guides, snap-to controls, automatic pair kerning, and four standard color models.

A Player is provided for distributing and playing back a presentation on any Macintosh or Windows computer. With the Player file, presentations can be played with or without Persuasion software. Persuasion is also designed for use in multimedia Web authoring for the Internet or corporate intranets.

Figure 11.5 The Adobe Persuasion screen with various windows identified.

Presentation Software • mPower

mPower is one of those rare products that newcomers to presentation and multimedia development will be happy to discover. This unique application creates an environment that removes the intimidation from the development process. Multimedia Design Corporation took the point-and-click metaphor that is predominant with the graphical user interface (GUI) and applied it to this presentation/authoring solution. mPower is presently a Macintosh-only product. By using the mPower Player application, presentations can be saved in a format that will play on Macintosh and Windows systems.

Exercise 2 on the CD-ROM uses mPower. This is for Macintosh only.

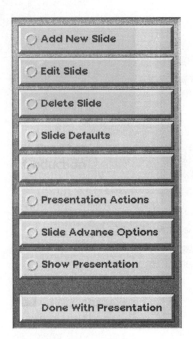

Figure 11.6 The mPower menu is made up of simple buttons that link to other options.

Creating a new presentation, adding a background, sound or graphic, and creating a player file are all done by merely clicking a button. This program offers much power and is perhaps underrated when it comes to its visibility in the marketplace. mPower has the sophistication to capture audio and video components from within the application. Also included is the ability to control externals, such as CD players, laserdisk players, and VCRs. The ability to launch other applications from within mPower also exists. This is done by attaching a hot button which will open the application or document of your choice.

Some features that are found in mPower include:

- Digitize sound and video from VCRs, laserdisk, and video cameras (providing the computer is equipped with a digitizing card)
- Control of various external media devices, such as CD players, VCRs, and laserdisk players
- Create digital movies
- Play video clips from external VCRs
- Integrate audio from CDs, microphones, or external sound files
- Import or launch Powerpoint or Persuasion files
- Import PICT, PICS, PCX, Kodak PhotoCD, and EPS files
- Integrate charting
- Branching capability through hot buttons
- Video chalk for highlighting during presentation
- Royalty-free Player distribution

Authoring Software • Director

The first product on the market was Macromedia Director. The company was previously called MacroMind and the product was called VideoWorks. Around 1985, this product burst onto the market, offering an array of features for creating and controlling animation that was very unique. At that time, we were not accustomed to having much more on our computer screens than word processing, database, spreadsheet, or simple graphic software applications. Since that time, Macromedia has grown into the leading software company producing

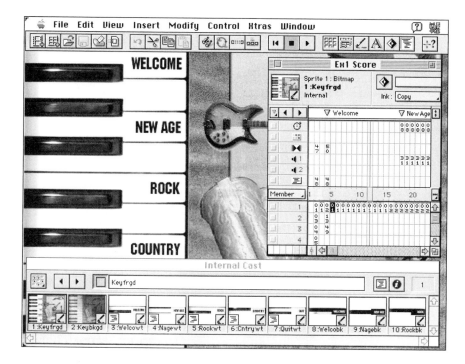

Figure 11.7
Director offers a scripting language called Lingo, which controls the variety of multimedia elements.

multimedia and related software products. VideoWorks has evolved into Director and is available for both Macintosh and Windows compatible computer systems.

Director is one of the most powerful authoring, design, and animation products available. Some of the features include a painting program, transitions, special effects, and digital video importation and control. There are also two sound channels for either music or narration. Director contains an object-oriented scripting language called Lingo. This language allows for custom control without requiring the extensive knowledge of a programming language.

Director can be used for Corporate presentations, CD-ROM titles, kiosk, visualizations, training disk, and even simple slide shows.

Macromedia has developed the concept of "author once and playback anywhere." This concept goes beyond Macintosh and Windows compatible to other areas that include the Internet, corporate intranets, set-top players, and other operating systems. Director is 100 percent binary compatible format, allowing productions developed on one computer to be played on another platform.

Figure 11.8 The icon-based interface for Authorware Professional.

Authoring Software • Authorware

Macromedia Authorware Professional maintains a leadership standard much like its sibling Director. Authorware Professional offers an iconic interface that controls complex applications and interfaces without the need for scripting. The icons are placed along a flowline so that events happen in a logical sequence (see Figure 11.8). This controls various events like audio, video, interaction, and transitions. You click and drag icons as opposed to using a programming language such as Lingo in Director.

When you choose to run a program, you are prompted to link the appropriate file that you desire to play or display and the files are properly linked. Authorware also has the ability to play interactive movies that were created in Director. This type of compatibility is one advantage of the same company developing related products. Authorware excels at CBT applications due to the fact that it allows a high level of sophistication in the area of interactive branching and managing user feedback information (see Figure 11.9).

Authorware also contains the ability to control externals such as laserdisk players, CD audio players, and VCRs.

Authorware allows a high level of sophistication in computer-based training environments.

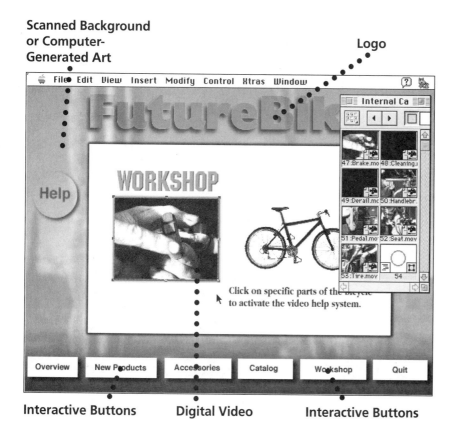

Scanned Background or Computer-Generated Art

Logo

Interactive Buttons Digital Video Interactive Buttons

Figure 11.9
In authoring software, previously prepared components can be orchestrated to present and playback on demand.

Authoring Software Functioning

Authoring software, by its very nature, must be able to not only accept outside files and put them into some form of action or organization, but it must also be extendible, performing functions beyond its typical self-contained features. Many of these programs will contain the capability to go beyond the limits of accepting what you have placed in them, and controlling what they do, and when they do it. The more serious applications will contain the ability to access and control video from a VCR or a laserdisk, open an external application, or be used as a reliable solution for a touch-screen kiosk environment.

The more sophisticated authoring programs typically incorporate additional functioning above and beyond the ability to just control a presentation. Many have the capability to edit existing files or to create externals from within the program. mPower, for example, allows

Figure 11.10 A video source is selected from the "attached components" menu.

Figure 11.11 Peripherals and ports selected.

Figure 11.12 The movie image size is selected.

Figure 11.13 Options are available allowing you to choose what to do with the video.

the user to capture video or sound from external sources, save the file, and use it within the program, or with other programs. Director has a built-in painting program and Persuasion has the capability to create Web presentations. All of these products contain the ability to extend beyond their core functioning.

These features will vary from program to program. Often the more sophisticated the features and add-ons are, the more the program will cost. Keep this in mind when considering what authoring environment is best for your application. Typically, built-in programs, such as the painting program in Director, are not powerful, full-featured applications, but are extremely useful when the need arises to perform a quick graphic touch-up in a presentation.

Enhanced Functioning Example

Figures 11.10 through 11.13 explain how mPower allows the capture of video from within the application. This type of built-in feature gives the user a fairly comprehensive tool to do more than just assemble the traditional elements normally included in a presentation. When reviewing an authoring program, look for maximum functioning. Make sure the features will handle your immediate requirements as well as allow future growth.

Software products that contain the ability to link to external devices such as this are good examples of how the authoring environment can add additional functioning to its original purpose. Often, features such as the ability to capture video and audio are provided by external software applications. Having these capabilities built in to one program is a real benefit. Ensure, however, that the functioning of these added features is up to the quality level to support the quality of work you must accomplish. These additional features will assist in the decision making process of what authoring software will do the job for you.

File Formats

Even though authoring programs are capable of producing various types of files from within the program, traditionally, they are intended to accept files prepared previously in other applications. In order to incorporate these files into the authoring environment, they must be saved in a format that the authoring program can recognize.

Back in the old days, software developers introduced a product with basic save formats. In the mid 1980s, there were not as many options or as much need to integrate one file format into another as there are today. Valuable software products typically endured long enough to go through several version upgrades. These products usually have the need to be integrated with other products. The longer a product stays on the market, the more other products will grow around it, and will want to take advantage of the ability to import or export information.

This concept became quite evident during the desktop publishing revolution. Early versions of page layout programs would accept only limited file formats such as Bitmap, PICT, TIFF, and so on. In order for other application files to be placed directly into these layout programs, they had to offer the specific formats that the page layout program would accept. Figure 11.14 demonstrates this point.

Figure 11.14 Page layout programs can accept externally prepared files saved in an acceptable file format.

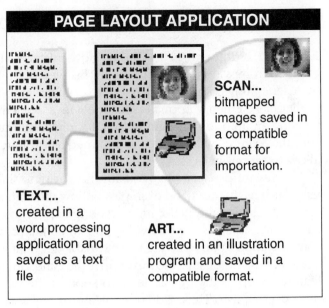

This same concept holds true for multimedia authoring software. This concept, however, continues to grow in scope with the addition of new products and peripherals. In an authoring environment, numerous file types will be imported from a variety of software applications. Some examples are listed in Table 11.3. Table 11.4 provides a brief description of file formats, their function, and their abbreviated names.

Authoring on One System for Distribution on Another

As mentioned earlier in the book, a convergence of technologies is taking place. Just a few years ago, the very thought that you could develop a multimedia presentation on a Macintosh and be able to play it on an IBM or compatible machine was absurd. However, thanks to hardware and software advances and vendor agreements and co-development endeavors, this capability has become a reality.

Player technology is changing the method of delivery for the presentations we are churning out these days. Often times these player files are referred to as "players" or "projectors." A player file allows the presentation to be "packaged" with enough of your program devel-

FILE TYPE	FILE EXTENSION
Art/Graphic	.bmp, .pct, .eps, .cdr, .gif, .il5, PICT, PICT2, EPS, TIFF, GIF, RIFF
Animation	PICS
Sound	.AIF, .WAV
Movie	.mov, .avi
Portable Document	.pdf
Compression	.jpg, .mpg
Web Page	.gif

Table 11.3 File types that can be imported into authoring software environments.

EXTENSION	FUNCTION
.pct or PICT	Line or bitmapped art files
PICT2	Line or bitmapped art files—a wider variety
.eps	PostScript line art files from Adobe Illustrator or Macromedia Freehand, or bitmapped art files from Adobe Photoshop
.tif or TIFF	Files saved in this format can be placed into a page layout program
.gif	The standard graphic file format for on-line services
pics	A series of graphics, often in sequence, that can be imported for playback in an animated sequence
.aif	An audio file format
MIDI	Musical Instrument Digital Interface—allows instrument sounds to be captured digitally directly into the computer
.jpg	Joint Photographers Experts Group—A format for compressing the size of graphics files
.mpg or MPEG	Motion Picture Experts Group—A standard for the compression and playback of digital movies
MPEG 2	Motion Picture Experts Group—An advanced standard for the compression and playback of digital movies capable of making the images appear more lifelike, with greater resolution and image clarity
.mov	QuickTime files for Macintosh and Windows
.pcx	PC bitmap file format—Old format, no compression
.bmp	PC bitmap file format—Introduced with the advent of Windows. They are not compressed—easily opened with Windows Paint and PC Paintbrush. BMP will easily integrate with Mac programs.
.avi	Audio/Video Interleave—Allows video to be played back by QuickTime for Windows.
.bin	Uncompressed Movie
.mci	Media Control Interleaves—Allows IBM and compatibles to control VCRs, laserdisk, CD players, etc.

Table 11.4 Various file extensions and their functions.

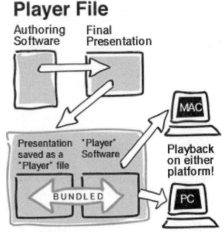

Figure 11.15 The ability to develop on one platform and play back on another allows wide distribution.

Figure 11.16 This illustration demonstrates how a presentation is saved as a "player."

Director's application icon looks like a director's chair while the player file is an icon of a projector.

Application Icon

Projector Icon

opment code to be played back on other machines. Machines that the player file is distributed to are not required to own the software in which your presentation was developed. Projector is the metaphor that Macromedia uses for Director files. These projectors typically have an icon that looks like a projector. Since the Macintosh and Windows operating systems are icon-driven interfaces, the projector typically indicates that this is a self-running presentation.

Since we have come this far in technology and in partnerships, you can look forward to even easier delivery of your products on multiple platforms in the future. The next step in this evolution is for software developers to produce authoring programs that will allow you to develop a production once that can be read by either Macintosh or IBM compatibles without developing a "player" file format.

Another consideration with player files is that some companies require that you pay a royalty for files that you prepare and distribute via their player technology. This is a serious consideration if you plan to develop and distribute to a mass audience. Some software developers initially used this strategy, then opted to drop it in order to reach a wider, more profitable market with their software products instead of player licensing fees. Look for this trend to continue.

Multimedia Cross Platform

If you have been computing for a while, you will know that the term does not have the fear attached to it that it once did. With file sharing and information becoming more widespread in recent years, software and hardware developers have navigated through the once difficult task of communicating from one operating system to another.

At one time, the traditional idea of working cross-platform meant that you could transfer a data file from one system to another. Other cross-platform issues related to situations such as saving a Macintosh page as a PostScript file in order to have it opened in a PC-compatible program.

Back in the early 1990s, developing media applications for the Macintosh required Mac-specific components. The same held true for IBM and compatibles. This is not true today. More and more software applications are supporting the ability to develop a multimedia production on one system and distribute on multiple systems.

Multimedia developers are looking to use their current set of development tools to produce titles and products that have the ability to be marketed to the masses with multiple platform compatibility. The Player technology is certainly one concept that is making this happen.

Multimedia Production End Results

When you author a project, you will have a specific goal or purpose. If you are anxious to learn what direction you can take with a specific product, here are some ideas.

- Games
- Interactive laserdisk
- CD-ROM creation
- Web site/page development
- Game cartridge development
- Multimedia Network
- Simulations/Prototypes
- Computer-Based Training

An example of a cross-platform product is the CD-ROM that is included with this book. It works on both Windows and Macintosh environments.

Macromedia Director offers cross-platform integration. This means that you can author in Windows, and open the same file on the Macintosh for playback or editing.

The Best Development Platform

What is the best automobile? What is the best airline? What is the best hotel chain? What is best is up to the person using a given system or software. If you began computing or developing media on a Macintosh, then chances are that is your platform of choice. If this is true, then you may have difficulty working with Windows because you are not accustomed to the environment or may not have the opportunity to be comfortable with it. This also works in reverse.

What is happening with the convergence of hardware and software technologies is that the look and feel of software applications on either the Macintosh or IBM and compatibles is becoming somewhat identical. This allows the user, no matter what platform is being used, to work in virtually the same environment.

The Macintosh was the platform of choice for development early on due to the fact that most of the graphic and multimedia products were initially developed to take advantage of its graphic and sound capabilities. With the introduction of Windows, software and hardware developers were anxious to create products for these systems. This was a particular advantage for software developers due to the fact that there were far greater numbers of IBM and compatibles in the marketplace. The result of the available products for both platforms has assisted in the explosion of multimedia as a whole.

Interactivity

Interactivity means that the user takes control of the media and the options presented to him or her. By doing this, the user can seek specific information he desires to study, research, or review. This method of direct access allows the user to attain specific information without going through other data that may not be relevant to his information quest.

Interactivity means that the program responds to you. It asks you a question and waits until you answer. In multimedia, when you press a button, something will happen, such as:

- A background or slide will change
- An audio or video clip will play
- A transition will happen
- You can enter or exit the presentation

This chapter will review how interactivity is important to the multimedia design process.

Interactivity, in terms of computer-based multimedia, refers to an action that the user makes to control the events being viewed on the screen.

Determining the Need for Interactivity

Why is interactivity important to the multimedia process? The utilization of video has been around for many years now. Video is a part of our daily lives. We rent movies to watch on our VCRs, we create movies with our camcorders, we use videotape training movies at work, and we use videotape to create product advertising and promotion. You could say that video is a highly used form of media woven into the fabric of our daily lives.

Video is good, video is effective, video is everywhere, but there is one thing that traditional video is not. Video is not interactive!

Video is good in multimedia environments because it can be controlled upon demand by the user, thus supporting the interactive process. Exercise 4 on the CD-ROM makes use of digital video files.

Despite the many positive aspects of video, it is not an interactive medium. Most of us have had the opportunity to view a training video. Many of these videos are well done, providing pertinent information to the task at hand. But for some, the full content of the video can be totally absorbed, while for others, only a certain percent can be retained. The reason for this is that we all learn at different levels and in different ways.

A remedy for this could be to have the user rewind the tape and view it over. Or instead of reviewing the entire tape, the viewer could view just details that were missed on the first run through. This could be a problem, however, if you are a part of a group viewing the tape. There may not be the opportunity to view it again or you may not be able to find the right spot on the tape.

What is the alternative to videotape and how does interactivity come into the picture? CD-ROM-based multimedia is an excellent method for creating or distributing information that users can interact with and move at their own pace. These CD-ROMs can be in the form of a disk that is compatible with a computer, a set-top player, or even a game machine.

Our society has reached a level where users are used to instant gratification as far as quenching their desire for obtaining information when they want it. Interactivity with computer-based information is becoming the norm. To support this, look at the popularity of the Internet!

Some media visionaries are predicting that in the near future, we will be able to interact with movies, changing the story line and affecting the outcome of the plot. Many of us have been involved with interactivity since we were kids by choosing the many options found in a home video game system. We also interact with our televisions in the form of choosing what channel we will watch and if we want to record the program on our VCRs.

In the realm of multimedia, interactivity is not only critical, it is mandatory to the process. Multimedia depends on developing a user interface that has a pleasing look and intuitive feel, enticing the user to become involved. Once the user gets there, however, he needs to know where to begin and how to carry on.

The very nature of interactive multimedia means that you will constantly see a different look and feel with each product. It is important from a development standpoint, that the user interface be based upon a common sense approach, allowing the user to automatically know how to use the product at first glance.

Action/Reaction

Usually, the user takes the initiative to begin the interaction process with the computer screen. This action could be prompted by a sound, graphic, or video that may be coming from the unit.

What happens after the user responds to an on-screen prompt by clicking or touching a button or graphic? This is based on what the button or graphic is programmed to do. Some software programs offer a limited number of options that the user can choose to make an object respond to interactivity. In more sophisticated authoring programs, what you can produce is limited only by your creativity. Figure 12.1 illustrates the sequence of events to make an action respond interactively. In this scenario, the user finds a digital movie file and makes it come to the screen and play.

Another example of what happens after the button is selected is shown in Figure 12.2. When the interactive button is selected, various events happen to retrieve the file, display it, initiate a transition, and then move on to another similar sequence. These interactive buttons can be any graphic element, or area, on the screen.

Creating a button that will provide a programmed response can be simple or complex, based on what you want the response to be. The complexity is determined by the software application being used. For example, some applications use the hot button approach. The mPower software is an example of an application that uses the hot button concept. This process allows the user to cover a certain portion of a graphic with an invisible hot button. When this area is selected in playback mode, it will invoke an action that is preprogrammed by the author (see Figure 12.3).

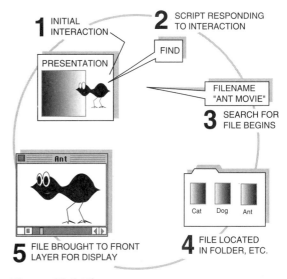

Figure 12.1 The domino effect of what happens once an interactive button is selected.

Figure 12.2 What lies behind an interactive button.

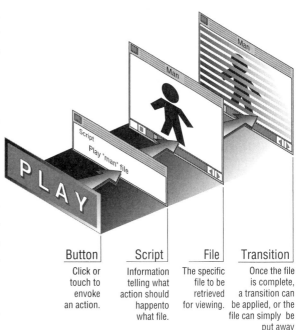

Button	Script	File	Transition
Click or touch to envoke an action.	Information telling what action should happento what file.	The specific file to be retrieved for viewing.	Once the file is complete, a transition can be applied, or the file can simply be put away

Figure 12.3 mPower offers easy to use hot buttons to execute commands. When viewed normally, these buttons are invisible.

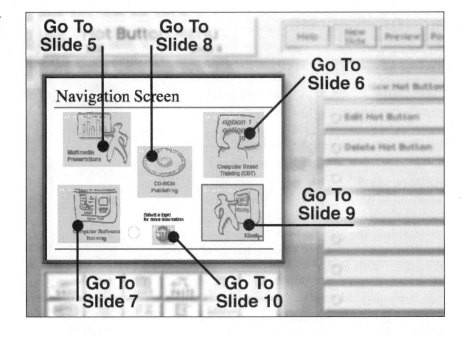

Exercise 1 on the CD-ROM contains graphics and scripts that invoke commands to perform a specific function.

Director works in a similar manner, and offers vast extendability. An excellent example of how a real interactive button works is in Exercise 1 on the CD-ROM. Figure 12.4 demonstrates that a graphic of a piano key will be used as an interactive button. A script will be written to make this key perform a specific function.

The script, in the case of Director, is what makes the interactive process begin. Any time any portion of the graphic is selected, the script immediately goes into effect. The processes described in the script can vary greatly. Functions like pauses, advances, play sounds, and others can be added to create a custom interactive function (see Figure 12.5).

When developing a multimedia production, using the proper software for the job is crucial.

Figure 12.4 In Director, any object can become a button.

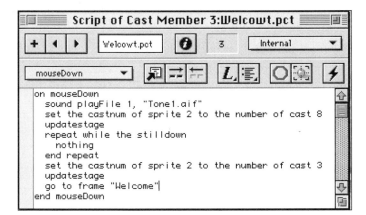

Figure 12.5 The Script, from Directors Lingo scripting language, gives instructions as to what will happen next.

How Complex Is Your Need?

If you choose software to produce a project, first determine what the project will involve. If your task is to develop a slide presentation, both presentation software and full-featured development software will accomplish this. Naturally, there are cost differences between the two. Perhaps the determining factor as to what to use will lie in what your long-term usage will be. You may find that the purchase of both will be required. Figure 12.6 demonstrates the simplicity of an interface screen with easy to use buttons.

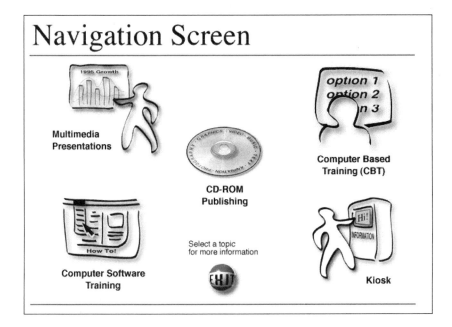

Figure 12.6 The navigation interface screen used in Exercise 2 on the CD-ROM.

Presentations To Go

The day of doing business in our local community only is long gone. We have been in the jet age for quite some time now, and doing business around the world is commonplace. Because of this, marketers, educators, instructors, and the rest of us must be able to tell our stories, present our wares, and entertain an audience in a variety of venues.

Taking a presentation on the road is nothing new. What is new and exciting is the proliferation of products entering the marketplace that make these presentations look better, sound better, and easier to use. Traditional slide presentations are great, but the only last minute modifications that can be done to them is the reorganization of the slides themselves, not the information on the slide. One of the truly great benefits of having presentation material in a computer file is that the information can be modified by the end user right up to the last minute.

Mobile Multimedia

Because so much business is done in remote locations, notebook computing has become a highly effective method of delivering quality presentations. In many cases, the actual presentation is not developed on the notebook but rather on a desktop computer. Once the project is developed and perfected, it is copied onto the notebook and then the road show begins.

Often times, we find that notebook models have limitations. They may not be as fast, able to display in higher resolutions, have better color, or integrate video as desktop units can. Earlier notebook models left a lot to be desired as far as their capability to be used as comprehensive presentation systems. They would handle simple slide-to-slide

presentations, but were not capable of more sophisticated, fully integrated multimedia action. For the average professional who does not want to learn how to integrate these elements, the quest for the all-in-one solution with plug-and-play simplicity is never ending.

The great thing about notebook computers today is that they are real computers, comparable in speed and features to many desktop models. Perhaps the only limitation is their screen display. These displays are good, and getting better all the time, but they cannot compare to an RGB monitor. Obviously, they are not designed to compete with a desk-bound monitor, but rather provide a display designed for casual or occasional use. A good feature of most notebooks is that they can connect to your desk-bound unit allowing you to view a presentation or use the full functioning of your notebook at your desktop.

Due to their sophistication, notebook computers are in great demand. As a result of this high demand, more energy has been placed in the development of better units with even more sophisticated componentry. Screen displays are getting brighter and bigger, hard disk capacity rivals desktops, and processor speeds are equally as fast as desktop counterparts. With these capabilities it only makes sense that other desktop components become an integral part of notebooks. Current notebooks contain CD-ROM drives, sound cards, speakers, and all of the necessary connectivity to external devices. With these powerful enhancements and connectivity options, notebooks are logical products for controlling mobile presentations (see Figure 13.1).

If travel is a part of your future plans, you may want to consider the following for your mobile computing needs. As mentioned before, the new generation of notebook computers are extremely powerful, containing desk-bound computer capabilities. If you plan to take a multimedia presentation on the road, you must be assured that your system is capable of delivering the content you are presenting. As you know from your research, your desk-bound computer must have lots of hard disk space, a lot of RAM, and a fast processor. These requirements will vary based on your view of a typical multimedia presentation. That is, if you need to show a simple slide show, then your requirements will be modest. If you need to create an extensive presentation with

Figure 13.1
Notebook necessities for mobile multimedia.

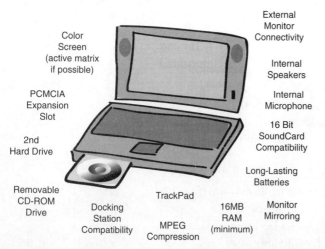

interactivity, scripting, heavy graphic usage, and digital video integration, then you need to add all the bells and whistles.

Here are three words of advice for anyone taking a presentation on the road: research, research, research! Research your products, their advantages, uses, and their connectivity options and limitations. Research thoroughly your presentation location and learn as much as possible about the physical environment of the presentation space. Research the hardware, software, connections, and peripheral devices that you will use. Experience can be the best teacher, but proper research and rehearsal will benefit you greatly.

If presentation design is going to be performed on a desktop computer with the actual presentation given from a notebook, make sure that an in-house run-through is performed on the notebook to ensure compatibility and speed consistency. If the desktop unit is a fast machine, time and energy can be spent on making sure that settings, transitions, and other features work well. However, if the notebook system has a slower processor, hard drive, and other system architecture differences, do not expect the presentation to work the same. Make sure that time is devoted to thorough testing on the system that will be used for the actual presentation. Multimedia development on a notebook may not be an ideal scenario, but being able to perfect your presentation is critical.

Following is a feature checklist and suggestions for notebook computers used for media presentations:

- 750MB hard drive minimum
- PCMCIA cards slots
- CD-ROM drive (either internal or external)
- Extra batteries
- 16MB RAM minimum
- Connectivity to external monitors
- Monitor mirroring capability
- Sound card capabilities
- Internal speakers and connections for external speakers
- Internal microphone
- Docking station connectivity

The ability to add multimedia enhancements to a notebook computer increases a system's flexibility. The addition of a docking station, which provides extras like enhanced sound features, speakers, CD-ROM drives, and enhanced external connectivity, is a real benefit. For note-

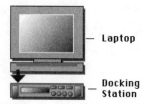

— Laptop

— Docking Station

Figure 13.2 Expanding the capability of a notebook through connectivity to a docking station.

books that do not have these features built in, this is an excellent option (see Figure 13.2).

- Motion Picture Experts Group (MPEG) compression technology is an important factor in helping the notebook become a viable factor in mobile presentations. MPEG should be hardware-based for optimum performance.

- If sound is an important part of your presentation, and you are using a PC-compatible system, SoundBlaster 16-bit compatibility is needed. This, in combination with external speakers, will produce the best audio results.

- If working from a CD-ROM drive, it should be the fastest possible. However, if your presentation can fit on a hard disk drive, you will yield better performance in speed.

- Products such as CD-ROM drives and internal hard drives should be easily upgradeable.

- Prices for multimedia equipped notebooks range from around $3,000 to $8,000 and more.

Presentation Devices

Figure 13.3 Some of the devices that connect to computers to make presentations happen.

Most equipment today is designed with portability in mind, to appeal to the user's decision to take it wherever he wants, even if there are no plans to use it in a remote setting. This technology is lighter, smaller, and better. Sales representatives are prime candidates for this technology due to their demand to present products and facts to a crowd.

Connectivity to peripheral devices is what makes presenting in a remote location work. At our office or place of work, we connect our systems into printers, network servers, speakers, and other devices. On the road, we may have the same needs. However, the needs are even more diversified. Beside having the need to connect to local devices to make the presentation happen, there are other hardware connectivity options that must be addressed. Figure 13.3 and the following demonstrate devices that are a part of mobile multimedia.

Notebook Computer

LCD Panel & Overhead Projector

LCD Projector

RGB Projector

Direct View Monitor

LCD **Panels**

LCD panels have been around for several years. They offer high-resolution display and good quality. LCD panels have become a staple in the presentation arena due to the fact that many companies own one and they are easy to obtain through audio/visual rental agencies. Also, most hotels or educational environments have an overhead projector on their premises, making it easy to deliver a presentation.

LCD **Projectors**

LCD projectors have changed recently and are setting new standards in brightness and clarity in a small, self-contained box. Early LCD projectors were very large and expensive, and only had mediocre display brightness and color density. Newer projectors weigh in the neighborhood of 10 pounds.

Features of LCD projectors should include:
- 640 x 480 pixel resolution
- 16.7 million colors
- 18-inch to 300-inch screen size
- S-Video Input
- RCA audio and video input
- Built-in speaker
- Remote control
- Compatibility with Macintosh and IBM & Compatibles
- NTSC, PAL, S-VHS compatibility

RGB (3-Gun) Data Projectors

These projectors project the biggest and brightest image currently available, due to their size and complexity. They are sometimes referred to as a 3-gun unit because they have three glass lenses on the front that project independent red, green, and blue images to form a full-color image. These units are capable of projecting either from the front or rear, from a desktop, or ceiling. This solution provides the optimum in quality, but the maximum in handling and inflexibility. These units are typically rented by the day with the base rate including a technician. The technician is required due to the temperamental nature of the unit. If your presentation requires the best, this is the way to go.

Direct View Monitors

Direct view or presentation monitors range from 27 inches to 42 inches in screen size. These monitors offer excellent resolution and color depth, making them a logical choice for smaller audiences demanding the best possible output. Prices range from $2,500 all the way up to $14,000. These monitors support traditional NTSC signals for television and movie viewing, as well as computer data input. Better monitors support NTSC and computer interfaces simultaneously. Many monitors also offer built-in speakers, but having the option to connect external speakers is a benefit.

Controlling Your Presentation from a Distance

Slide projectors have offered remote control capabilities for many years. Presenters, storytellers, and salespeople have benefited from this feature, which allows the presenter to be at a location other than that of the projection device. Contemporary presentation technologies provide products that also conform to the desire of the presenter, allowing him to give a presentation without being chained to the presentation device.

All presenters are different. Some prefer to remain at a podium because of a comfort level they feel standing behind something. Some may be required to stand by their computers due to the constraints of the presentation environment or because they are forced to stay with their machine in order to click the mouse to advance a slide in the presentation. Then there are others that want to have the freedom to move about the room, adding personal dynamics to the presentation.

Infrared and laser pointing devices are beginning to play a large part in the presentation arena (see Figure 13.4). It is possible for the presenter to mingle with the audience or roam around freely during the presentation. These remote control devices, when pointed at the projection screen, allow the user to control the function of the presentation from anywhere in the room. This action mocks the action of moving the mouse and pointer on the screen, freeing the presenter from having to be at the computer. Some hardware and software manufacturers offer products that allow the user to make annotations or to electronically mark up the presentation. This feature provides electronic interactivity that rivals handwriting on acetate overlays on an overhead projector.

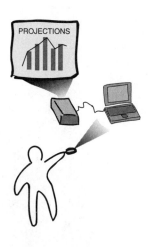

Figure 13.4 A wireless controller substitutes for a mouse.

Monitor Mirroring

Another issue mentioned earlier in this chapter is monitor mirroring. Quite simply, this means that the contents of the computer screen are mirrored to the connected projection or display device. Typically, the presenter should face the audience while giving a presentation. When using a notebook or desktop system to control a presentation, the system monitor, or

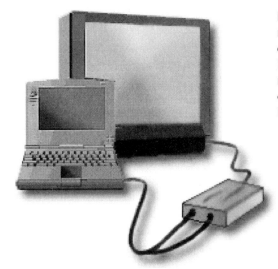

Figure 13.5 A notebook computer connected to a large screen monitor by connecting to a NTSC converter.

screen, should be facing the presenter, allowing a full view of the screen contents. This allows the presenter to make a quick reference to his presentation while maintaining eye contact with the audience.

The LCD panel, LCD projector, CRT projector, large screen monitor, or other presentation device, once connected to the computer, will project or display the presentation content exactly as it is displayed on the main screen. This display is intended for viewing by the audience while the computer display is for the presenter's eyes only.

Displaying Presentations on External Monitors

Connecting a notebook to an external computer monitor is routine. Connecting to a television is more innovative and a great way to effectively display your notebook-based presentation. However, connecting to a television set or monitor causes a different set of circumstances to arise. The resolution on a television is lower and requires a different signal interface than the computer sends to a computer monitor. Therefore a converter is required with a different transfer rate for images. These converters are priced around $200 and come with a variety of qualities and features. Consulting a user or qualified resource will be helpful when considering purchasing one of these units.

What About Videotape?

Even though notebook computers, overhead projectors, and LCD panels have been the norm in mobile presentations, there are other ways to display your productions while traveling. Digital technology in recent years has made it easier for the computer to interface with VCRs. With the connectivity between computer and video, it is now quite easy and inexpensive to copy your computer-based presentation onto video. The converter box mentioned previously will allow you to display your computer screen not only directly to a television, but also to a VCR. This will allow any information displayed on the computer screen to be captured onto videotape.

One advantage of using videotape is the fact that almost every company has a VCR and television in its conference room. Just pop the tape in and there you have it. If you are producing a video project for mass distribution, training, or product marketing, the same theory applies. Most households own a VCR.

If a videotape presentation is the medium of choice, and your plans include presentation at a remote site, investigation of on-site equipment must be considered. If the equipment is not available, then local rental or taking it with you are options. This all falls into the category of the importance of preplanning. As with all presentations stored on magnetic media, it is always a good idea to have a backup with you.

Considerations for Presentations On-the-Go

1. Prepare presentations with the presentation location in mind. If it looks good on your computer screen, will it look equally as good once projected through an LCD panel and an overhead projector?

2. When presenting at a different location, make sure that information about the room in which the presentation is to be given has been thoroughly investigated. Check for electrical supply, location and function of lighting controls, location of windows and the lighting control available at each, and acoustic details, etc.

3. Projected resolution issues are critical. Some information does not require exceptional resolution (charts, graphs, general information), while other information, such as specific training programs, require exceptional detail. Make sure the graphic

resolution of your image, and the device that will project the information is capable of presenting resolutions that work.

4. When designing a presentation for use with an LCD panel, make sure the presentation, as well as the LCD panel, have the proper resolution for the job. Likewise, make sure that the overhead projector is current enough to provide the proper projection brightness and clarity required to make the job work.

5. Look for equipment that supports "plug-and-play" ease of use. Newer equipment is easier to use in this respect. There are some areas that require technical assistance, and others that anyone can do. The best rule here is the rule of experience. The more familiar you are with the entire process, the easier success is to achieve.

6. The size of the screen is the determining factor in what size audience you can accommodate. You do not want a presentation to be too large for a small audience, or too small for a large audience. Talk to a presentation specialist for information on what size screen is appropriate for your target audience. Whatever you plan to present, it is important to ensure that it is presented as best as possible. After you have invested quality time and materials for your presentation, take the extra step to ensure that the audience sees it with the utmost quality.

Virtually everyone will have the need to communicate a message to some form of audience during the course of their career. Some possess the ability to do this without the aid of externals, while the rest of us require such support. As hardware devices offer more capabilities and we as users broaden our knowledge of how to use them, effective communication will take place naturally. With the newness of multimedia and all of the mystique surrounding it, there is no doubt that we will continually be bombarded with new products, processes, and resources. It will be our responsibility as a society dependent on technology, to pick up the tools that will support our need to communicate, and to use them to the fullest.

Chapter 14

Coming Up

The more advanced we become in technology, the faster it changes, because the technology we are developing assists in the research and development process. Where will it end?

This chapter is devoted to visions of breaking technologies and the way they will impact the multimedia process. Some of these visions are merely modifications to existing technologies, while others involve the transfer of dreams into reality. One thing is for sure: technological evolution is constant!

Digital Video Disk (DVD)

What is the future of digital storage technology? One thing is the expansion of CD technology as we know it. An enhancement to current CD technology is going to change the way these products are used. Fairly new on the scene is DVD. The DVD will take us into the future with enhanced capabilities and will no doubt revolutionize the way we store and retrieve our music, video, data, and multimedia files. This new format will hold seven to fourteen times the amount of data that the original CD held and will aim to replace the current audio CD, CD-ROM, and perhaps even videocassette.

The capacity of standard CDs is 74 minutes. This is based on MPEG-1 encoding. With DVD, the continuous video capacity will be two hours and fifteen minutes and will be based on MPEG-2 high-resolution digital video. This will roughly double the capacity of current single disk units. This new standard is exciting for multimedia producers who wish to produce longer presentations with better graphics, sound, movies, and static images on a single disk. Motion picture studios will probably take advantage of the DVD in order to distribute movies.

Vendors will also benefit from the ability to market clip media and other services due to the utilization of the additional storage. The ex-

ceptional video and audio quality will also make this product attractive. As far as multimedia applications are concerned, a quantum leap in quality and storage will happen with the advent of this new format. Some proposed details of this format are:

Compatibility Issues

- The size of the new disk format will be the same size as existing music CDs and CD-ROMs.
- New player's units will be required to play this new medium.
- These new machines will also be able to play existing CDs and CD-ROMs. New disks will not play on older CD audio players and CD-ROM players.

Resolution

- Overall picture and sound quality will be higher.
- The new player technology will be able to retrieve up to ten times as much data per second.

Figure 14.1 Just one of the new DVD disks will hold the equivalent of approximately fourteen standard CDs.

Capacity

- MPEG2 compression is being utilized on this new format. This means that four bits of information can be placed in the space that was originally occupied by one bit. A two-hour movie will easily fit on one disk.
- It is possible that these disks be made double sided. If this happens, twice the capacity will be available. Two full-length movies could fit on one disk, or several multimedia encyclopedias on one CD-ROM, or an entire boxed set of music on one disk.

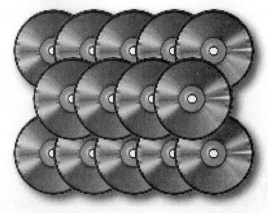

In all likelihood, the double-sided disk will be available initially with a player that will require that you manually flip the disk to retrieve both sides. Later, a unit will probably be introduced that allows both sides of the disk to be accessed on demand.

As time passes, you can count on this medium to be available as a consumer-level recording product. As compact disk-recordable (CD-RS) have dropped tremendously in price and are becoming a common peripheral, no doubt recordable DVDs will be a logical extension of this technology. The

popularity of this format could also depend on the compatibility of existing CD technology. Current CD formats are widespread and going even farther as a mainstream product.

The physical CD medium appears almost identical to the traditional CDs that we have become accustomed to over the past decade or so. The new design of the media will have a different design than previous disks. Some of the new products will hold data on both sides of the disk, yielding a capacity of 9.6 gigabytes. This equals approximately fourteen times the capacity of the original CD capacity.

Digital Still Cameras

Digital cameras have already been mentioned in this text several times, but the need to review them once more is warranted. Digital cameras are becoming an increasingly popular product for both professional and consumer use. Look forward to a widespread movement for these products to invade the mainstream, to offer more features, and to become more affordable.

Some companies producing digital cameras include Apple Computer, Casio, Chinon, Dycam, Kodak, and Logitech. Like many products, you can spend a little or a lot of money on a digital camera. Typically, the more you spend, the better the quality.

One advantage of digital technology is the quick turnaround and high-quality image output. These products will only improve with time.

Current cameras offer features such as built-in hard disk drives, connectivity to desktop computers, removable image media cards, 36-bit color, voice recording, and expanded battery operation. As the trend moves towards a totally digital world, new products will be introduced constantly that will usher in this era.

Digital Video Cameras

Digital video cameras are also becoming commonplace. These new units will include recording resolutions of around 500 lines. Editing on popular software programs such as Adobe Premiere will be available. A great feature of these video recorders is that they offer the capability to capture still images as well. This may be competition to the digital still camera. However, the still cameras cost a lot less. Speaking of cost, the new digital video cameras are being introduced around the $4,000 mark. If this sounds expensive, consider that professional systems cost around $25,000 and yield roughly the same degree of quality.

Digital video cassettes for these cameras are available in two lengths: a one-hour cassette compatible with camcorders and editing decks and a four and a half hour cassette designed to be used with an editing deck. This technology is in its infancy, but expect a boom in the late 1990s.

Multimedia Development on the Internet

Hyper Text Markup Language (HTML) began as the standard for creating pages on the Web. Now things are beginning to change, and will continue to change. Various companies and their internet solutions are rising to the forefront as providers and are out to change the images that we see at an internet site. The following is a list of manufacturers and their products for the Internet:

Adobe Systems

Adobe Acrobat saves files in a Portable Document Format (PDF). PDF is Adobe's standard document transport vehicle. It has been popular since its introduction. No doubt it will remain a steady medium for the distribution of documentation throughout various platforms.

VRML

Virtual Reality Modeling Language: three-dimensional graphics standards will provide a new dimension to sites on the World Wide Web.

Macromedia

Macromedia offers Shockwave as its entrance to provide advanced animation and player technology into the Web arena. This will provide a vehicle for the great number of Director developers to move current projects and to create new projects on the Web. This will provide the flexibility of the Director product to be moved to the Web to generate dynamic media presentations.

Apple Computer

The QuickTime Virtual Reality (VR) product will also grow to the point of providing a wealth of opportunity and utilization on the Web. QuickTime VR can produce virtual worlds, allowing individuals to navigate visually through a room, a department store, or other environment. There are unlimited uses for this product and technology.

Part IV

Exercises

- ☐ **About the Browser**

- ☐ **Exercise 1 Interactive Kiosk Design**

- ☐ **Exercise 2 Electronic Brochure**

- ☐ **Exercise 3 Sales Presentation**

- ☐ **Exercise 4 Product Support Simulation**

The Browser
Introduction

About the Browser

The Browser is an interactive presentation that allows you to take a tour of Exercises One through Four. The Browser also contains information about the contents of the disk, the author, the publisher, and more. The Browser is designed to provide a quick tour of each exercise through a simple slide show that describes the nature of each exercise. From the Browser, you can also open and view the completed exercise. This will provide information that may determine which exercise you wish to perform first.

The exercises provided on the CD-ROM consist of the following formats:
Through the Browser: Exercise Overview
 Access to a "play-only" version of the
 completed exercise
In the MEDIA Folder: The completed exercise

To just view the exercises, use the Browser. If you wish to study or more closely examine the makeup of each exercise, open the actual file stored in the MEDIA folder on the CD-ROM.

If your system has limited memory or speed and the connectivity to the exercises through the Browser is sluggish, performs poorly, or does not function at all perform one of these options:

1. Open the completed exercise located in the MEDIA folder on the CD-ROM. This will open the final exercise. From here, you can edit and playback the file.

2. Open the following "play-only" files:

Macintosh Windows

Ex1pro Ex1prow

Ex2pro Ex2prow

ex3.ppf ex3.ppf

Ex4pro Ex4prow

These files will allow the viewing of the individual exercise files. No editing can take place in these play-only files.

When the Browser main interface opens, you have the choice of selecting each of the four exercises. At this screen, click on one of the exercise icons to obtain more information. The option to exit and obtain more information and help is available from this screen also.

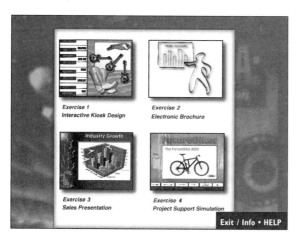

The Browser Interface Screen

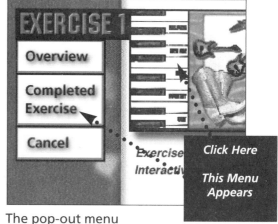

The pop-out menu selections for each exercise icon

As an exercise icon is selected, a pop-out menu will appear. From this menu, you can view the exercise overview, go to the completed exercise, or can cancel to exit the menu.

Choosing the Overview option will take you to a brief slide show overview of the exercise.

As you exit the Browser, you have the option to view the disk content layout, learn about the author, the publisher, view credits, exit, or restart the presentation.

The Browser is another example of an application of multimedia processes. Enjoy your tour and experiences as you explore *Multimedia: A Hands-On Introduction.*

The Exit Screen

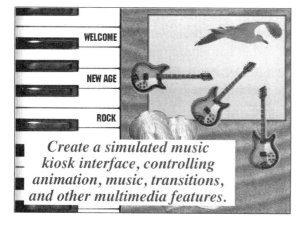

A sample of the Exercise 1 Overview screen

The What's On The Disc screen

Interactive Kiosk Design
Media Presentation for Macintosh/Windows

Exercise One will allow you to develop a simulated touch-screen kiosk environment that you may see in a mall or perhaps a music store. The concept behind this exercise is to develop an environment that would allow the user to touch a part of the computer screen to activate a brief animated sequence, then to receive additional information about a specific product. Of course, a touch screen is a special computer monitor that actually allows you to touch the screen to invoke a command. You, however, will use your mouse and the pointer to interact with this presentation.

The theory behind this project is to demonstrate how a user can obtain product information by interacting with a touch-sensitive computer screen. The interface that the user actually interacts with consists of simple, bold graphics that make the interactive decision process an easy one. The typical user of this type of product is busy. Therefore, a simple interface is used to attract end-user attention.

Predesigned data files are located on the accompanying CD-ROM. These files are located in the MEDIA folder and include finished versions of the exercise for your viewing.

What You Will Learn

This exercise will introduce you to the following concepts:

- Interface Screens
- Controlling the Tempo
- Authoring
- Graphic Importation
- Graphic Positioning
- Timing
- Scripting Language
- Transitions
- Animation
- Interactivity
- Soundtracks

Macromedia Director Save-Disabled version is available for your use on the CD-ROM as you explore multimedia development in this exercise.

You will learn the following terms:

- Castmembers
- Cells
- Frames
- Tempo
- Tool Palette
- Script Handlers
- Tool Bar
- Markers

- Sprites
- Channels
- Stage
- Resizing
- Scripting
- Playback Head
- Transitions
- Trails

This exercise is divided into three main sections, with a main screen that serves as the navigation window. If you wish, you can develop these sections individually, based on the time allocated to the exercise.

It is important that you view the completed Exercise One before performing this exercise. This completed version can be found in the MEDIA folder on the companion CD-ROM. As you view this exercise, you will notice that it is basically divided into three sections: The New Age Section, The Rock Section, and The Country Section. Based on the manner in which you approach this exercise, you may wish to perform each of these sections on an individual basis even though the exercise was designed to work as a whole.

Before You Begin

At the end of this exercise are support graphics. These can be used as guides during the development of this exercise, assuring that you are performing the exercise correctly. It is recommended that you view this section before beginning this exercise.

If you plan to perform this exercise using the Macromedia Director software contained on the enclosed CD-ROM, keep in mind that this is a save-disabled version. What this means is that the software is fully functional, with the exception that you will not be able to save your work. It is important to remember this as you perform this exercise.

If you own a copy of Director, and plan to use it for this exercise, then you will be able to save your work during the development process. This will allow you to complete the project on an incremental basis.

Remember that the final exercise is saved for your use, regardless of which version you are using. You can use it as a point of reference at any time. This file is named Ex1 and can be found in the MEDIA folder on the CD-ROM. Please note that Director will only allow one document to be open at a time.

The graphic images and figures used in this text reflect the Macintosh version of Director. If you are using the Windows version,

some screen interface details will vary slightly. However, the program details are the same.

Macromedia Director is compatible with Apple QuickTime 2.1 or above. QuickTime is on the CD-ROM. Refer to the Read Me file for instructions on installing this software and before running this exercise.

System Requirements

Macintosh

68040 Macintosh or better, System 7.1 or higher, 640 x 480 (13-inch) monitor, 8 MB of application memory dedicated to Director (more is recommended). Set monitor to thousands of colors, 20 MB of free hard disk space (minimum), double-speed CD-ROM drive.

Windows

486/66 megahertz or better system with at least 8 megabytes of memory, QuickTime for Windows, 20 MB hard disk space (minimum), double-speed CD-ROM drive, 640 x 480 (13-inch) monitor, Monitor:16-bit (high color). Note: Setting the monitors to 800 x 600 will assist in the design phase of this exercise.

Installation

Macintosh

1. Open the Demo Software folder, then open the Director 6.0 folder.
2. Double-click on the Director 6 Demo Installer icon.
3. When the Install window opens, select the Easy Install button in the upper-left corner of the window.
4. At the bottom of the screen, make your hard drive the Install Location. Note: This demo will require approximately 20MB of disk space just to install this demo. It is recommended that you have at least another 20MB of free space when building this exercise.
5. Select Install. This will install a folder on your hard drive called Director 6.0—Save Disabled.
6. To use the software, open the folder and double-click Director 6.0. When Director opens, a blank, new movie will appear. Director uses the term Movie for the multimedia project you will develop.

Windows

1. Open the Demosoft folder then the Director folder.
2. Locate the file Setup.exe. double-click on the icon to open.
3. The installation window appears. Select Next. Read the disclaimer then press Yes.
4. Select Typical setup.
5. Select Next, then create or select a folder to install the demo, as prompted.
6. Select Next, review the settings in this window. If correct, choose Next.
7. Director will begin the installation process and display a Setup Complete window.
8. Press Finish to exit Setup.
9. To use the software, open the Start menu, and select Programs. Select the following from the pop-out menus: Macromedia Director 6 Demo > Director 6 Demo. When Director opens, a blank, new movie will appear.

A Word About the Director Interface

Macromedia Director uses a theatre metaphor to describe its components. The main screen is called the Stage. This is where the movie that you are creating appears. The stage is always open and is behind other windows. The Cast window displays the castmembers. These are the files, art, sound, movies, etc., that make up your movie. The Toolbar is made up of short-cut icons. Once you become familiar with what the icons represent, this will become a quick and easy way to control your project. The Score keeps up with what castmember is on the stage in each frame of a movie. The score window is also where you control timing, transitions, sound timing, and palettes. The Control Panel is similar to the controls on a VCR. Since Director creations are called movies, the VCR control panel metaphor fits logically. The Script window is where you type instructions to create interactive links and a multitude of other functions. The Paint window is a bitmapped painting program that allows you to create graphics or to modify graphics imported from another program. The Tool Palette contains tools for creating type, graphics, buttons, lines, and colors. Review Figure E1.1.

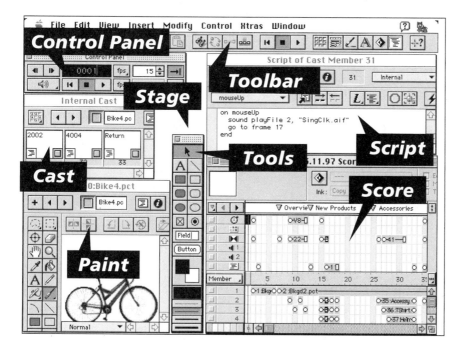

Figure E1.1 Some of Director's windows.

File Location

Prior to launching Director 6.0, the location of necessary sound files needs to be adjusted. The following are sound files that are accessed through scripts throughout this exercise.

SingClk.aif	Tone1.aif	Tone2.aif	Tone3.aif
Tone4.aif	Tone5.aif	Tone6.aif	

These sound files must be located in the same folder as the Director 6.0 application. These sound files are currently located in the MEDIA folder on the CD-ROM. Copy the above listed files to your hard drive in the Director 6 Demo folder.

Graphic Importation

Double-click on the Director icon to open and create a new document. If you are using a registered copy of Director, choose Save As from the File menu, and name the file Ex1New. Save this file in the Director 6 Demo folder.

Open the following from the Window menu.

Cast	Score	Toolbar

If you hold the pointer over icons in the Toolbar, or objects in other windows, a description will pop up letting you know the name of that feature.

Import Button

Figure E1.2 The Director Stage with the Score, Cast, and Toolbar open.

TIP
Keyboard shortcuts for opening and closing the Cast and Score windows are as shown here:

To open and close the Score window:
Macintosh
 Command + 4
Windows
 Ctrl + 4

To open and close the Cast window:
Macintosh
 Command + 3
Windows
 Ctrl + 3

A Sprite is information about a castmember. This information is contained in a cell, as shown here.

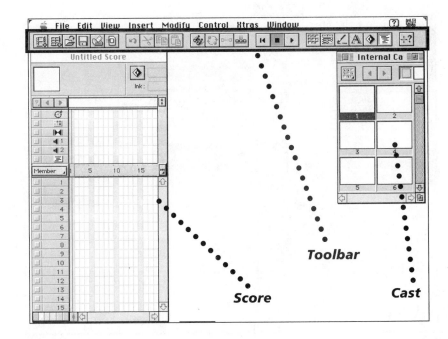

Arrange the windows as shown in Figure E1.2. In this example, Director's Toolbar is shown at the top of the screen. Make sure the Toolbar is turned on during this exercise.

Importing Files

Before anything can happen, media files must be imported for use.

1. Select the Cast window to make it the active window.

2. Choose Import from the File menu, or press the Command Key and R (Mac) or Ctrl and R (Windows). You can also use the Import icon in the Toolbar.

3. In order to place the media files in a logical order, open the MEDIA folder and import the files listed on the following page into the Cast. To import files into the Import Files window, do the following:

 • Select the specified file

 • Click the Add button

 • Continue this procedure until all files have been added. When complete, select the Import option. Doing this will bring each of the selected files into the Cast window.

Note: Some of the file names are similar. Pay close attention during the importation process. Placing the files in the improper order will adversely affect this exercise.

Figure E1.3 The Image Options window.

As you import graphic files into Director, the Image Options window will appear as seen in Figure E1.3.

For Macintosh:
Make selections as shown in Figure E1.3.

For Windows:
Select the following settings:
Color Depth: Stage (16 bits)
Palette: Dither
If importing more than one file, check the Same Settings for Remaining Images box.

Order	File	Castmember Number
1.	Keyfrgd.pct	1
2.	Keybkgd.pct	2
3.	Welcowt.pct	3
4.	Nagewt.pct	4
5.	Rockwt.pct	5
6.	Cntrywt.pct	6
7.	Quitwt.pct	7
8.	Welcobk.pct	8
9.	Nagebk.pct	9
10.	Rockbk.pct	10
11.	Cntrybk.pct	11
12.	Quitbk.pct	12
13.	Welcome.pct	13
14.	Tone1.aif	14
15.	Tone2.aif	15
16.	Tone3.aif	16
17.	Tone4.aif	17
18.	Tone5.aif	18
19.	Tone6.aif	19
20.	SingClk.aif	20

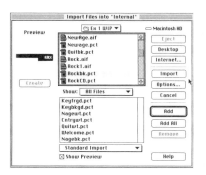

Figure E1.4 The Import Files window.

In the introduction, it was mentioned that this exercise could be divided into three sections as desired. The New Age Section would be considered the first of three sections.

To ensure that your Cast window appears as in Figures E1.5 and E1.6, make the following selections: Open the File menu and select Preferences. Next, choose Cast then Label. Next, select the Number: Name option. This will display the number and name of the Castmember under the thumbnail.

Figure E1.5 Files placed into the Cast.

Figure E1.6

When you choose the Import Files command, the window will look like the illustration in Figure E1.4. Remember: Windows screen will vary slightly.

By importing these files, you can construct the introductory phase of this project. Your Cast screen should look like the screen shown in Figure E1.5.

This phase will constitute most of the interactive portion of this exercise. It is critical that your Cast window have the files imported in the order shown in Figure E1.5. If a file is misplaced for some reason, you can Copy and Paste Castmembers in order to place in the proper position. You can also delete a Castmember and import a new file in its place.

Importing Files for the New Age Music Section

1. To begin this process, make Cast number 21 active by clicking on it once

2. To import several files at one time, choose Import from the File menu. Open the Gulls folder. Select Add All from the selections on the right, then Import.

3. When the Image option screen appears, choose the same options as before. Choose OK.

4. Next, select Cast number 30. Choose Import. Go to the MEDIA folder. Select Newage.pct and choose Import. Select the image settings as before.

5. Choose Cast 31, and select Import. When the Import window opens, change the Show/Files of Type option to Sound. Next, choose Newage.aif. Click on the Import button.

This completes the importation for the New Age files. The files just imported should be positioned as in Figure E1.6.

Importing Files for the Rock Music Section

Using the previous importing and image setting techniques, import the following files in order. When the Import window opens, make sure the Show option is set to All Files.

Figure E1.7 Cast for the Rock section.

Figure E1.8

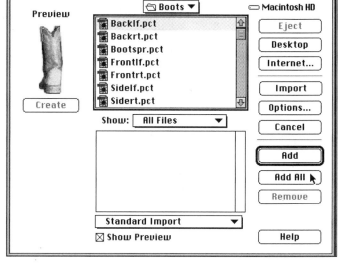

Order	File	Castmember Number
1.	Guitar.pct	32
2.	RockCD.pct	33
3.	Rock.aif	34
4.	Rock1.aif	35

This completes the importation phase for the Rock section. These files should be placed in the Cast window as shown in Figure E1.7.

Importing Files for the Country Music Section

1. Select Cast number 36. Choose the Import command. Locate the folder Boots. Select it and choose Open. Select Add All then Import. In the Image Options window that will open during the importing process, select the identical setting used previously. Cast 36 through 44 will be filled with the Boot graphics.

2. Next, select Cast 45 and choose the Import option once again. Navigate back to the MEDIA folder. Select the Slimjim.pct file and choose Import. In the Image Options window that will open during the importing process, select the identical setting used previously.

3. Select Cast 46 and choose Import. Change the Show setting to Sound. Select the file Country.aif and Import. The Cast just imported should look like Figure E1.9. This will complete the importation of files into the Cast.

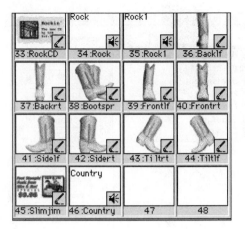

Figure E1.9

Figure E1.10

Authoring

This part of the exercise involves the authoring or scripting portion of Director. This is where the graphics, sounds, and other elements are put into a harmonious, interactive environment. This section will extensively use the Score window. You will also be introduced to the Lingo scripting language that is a part of Director. Here you will use commands to tell the presentation how and when to behave. That is what authoring is.

To begin, rearrange your computer screen to look like the one in Figure E1.10. Since you will place various components from the Cast window to the Stage and Score windows, it is important that all of these windows are open. It is also important to have the Toolbar open.

Before Castmembers are placed into the Score, make the following adjustment. Open the View menu and select Sprite Overlay, then Show Info. This feature provides information about the Sprite on the Stage. For this exercise, it should be turned off, or not checked. From the File menu, select the Preferences option. Next, select Sprite from the pop-out menu. Locate the Span Duration setting and type in "1." This will control the space that a Sprite consumes in the Score window. Finally, select the Score from the Preferences pop-out menu. Make sure Compatibility: Director 5 Style Score Display is turned off. This feature will be uitilized later in the exercise. This step is necessary because this feature may be turned on for some Mac users!

You can use keyboard shortcuts to open and close windows rapidly.

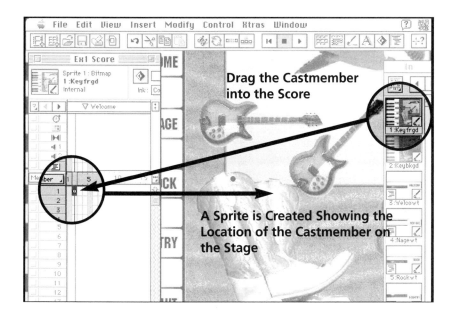

Figure E1.11

The background art is 640 x 480 pixels. This matches the settings made in the beginning.

Begin the development process by making the Cast window active.

1. Select Castmember 1. Click and hold the mouse button down and drag the Castmember directly into Channel 1, Cell 2 of the Score window. Once you release the Castmember, it will be located in the center of the Stage. It is also represented as a Sprite in the Score window in Channel 1, Cell 2. If you need to adjust the location of a graphic on the stage, the arrow keys on the keyboard will allow precision alignment.

2. To make this background remain on the Stage for a specified time, do as follows. Select Channel 1, Cell 2 and choose Copy Sprites from the Edit menu. Next, click in Channel 1/Cell 15. Choose Paste Sprites from the Edit menu. Notice as you paste the image into Cell 15 that it appears in the stage there also.

3. In order to make the graphic appear from Cell 1 to Cell 15, do the following. Click once on Cell 2, hold down the Shift key and select Cell 15. This will select both cells. Next, select Join Sprites from the Modify menu. This fills all cells between the two Sprites with the same image. See Figure E1.12.

Be aware that if a single cell or a number of cells is selected, and the image on the stage is moved in any way, that the movement will be recorded for the selected cells. With backgrounds, it is

Use the keyboard shortcuts shown in the pull-down menus. This will save time once you become familiar with them.

The Extend Sprite button located in the Toolbar.

To make multiple selections of Sprites in the Score window, here is a technique that will be very beneficial during this exercise. To select a group of Sprites, select the first Sprite in the series by clicking on it one time. Next, while holding down the Shift key, select the last Sprite. Doing this will select the first, last, and all cells in between.

Castmembers belong on the Stage, but are controlled in the Score.

The Playback Head

The Hide/Show Effects Channels icon in the Score.

Figure E1.12

easy to accidentally shift the position of the image while placing additional images on the screen. Watch carefully to ensure that the proper cells are selected for the graphic elements you want to reposition or modify.

4. Drag the pointer through the Playback Head to demonstrate how the graphic will appear in Cells 2 through 15. The background graphic should not move in any way as you drag the playback head. Notice that as you drag beyond Cell 15, that the background turns to black, or the currently selected background color.

The background that was just placed on the screen will be viewed quite a bit during this presentation, but will not consume the greatest overall placement on the screen. The three sections, yet to be added, will make use of Castmember 2 most of the time.

5. In the Cast window, select Castmember 2 and drag it into Channel 1/Cell 16. Next, press and hold down the opt (Mac) or Alt (Win) and click on the Sprite and hold the mouse button down and drag to the right. This will extend the Sprite as you drag. This Sprite should be extended to Frame 250. As you drag to the right, the Score window will automatically scroll. The auto scroll will stop around Frame 160. When this happens, release the Sprite. More frames are automatically added upon this release. Reselect the Sprite and continue to drag to the right until you reach frame 250. Now, all of these cells are filled with Castmember 2.

6. At this point, if you scroll back to reveal Frames 10 through 20, you can drag the pointer in the Playback Head between Frames 15 and 16 and see the transition from one image to another.

The next step is to build what is essentially the main screen. This is where the presentation will begin and end, and is the main point of interaction.

7. In the Score window, return to Channel 1/Cell 2. Use the Hide/Show Effects Channel button to the right of the Score window to reveal the Transition Channel. Select Cell 2 in this channel and double-click the frame to open the Set Transition screen. Select Strips on Top, Build Right. Other features should be set as shown in Figure E1.13.

Figure E1.14

Figure E1.13

After selecting these options, select OK. This will become Cast-member 47.

Next, click once in Frame 1 of the Playback Head. At this point, if you press Play, the presentation will zoom through from beginning to end unless it is told to stop. Here is where you are exposed to the Scripting portion of Director.

8. In the Script Channel, double-click in Cell 2. This will activate the Score Script. Notice the Script window opens with a command already inserted. These commands are called Script Handlers. Notice that the window is titled Score Script 48. This reflects that Cast Number 48 is automatically assigned to receive this script. This script can be used over and over again. It will always have the number 48 attached to it.

While the Score Script window is open, change it as follows.

1. Choose the Select All command from the Edit menu. Select Clear Text from the Edit menu. This will delete an existing script handler.

2. Notice the Lingo menu (the large L) on the Script window. Open this menu and select E option.

3. When a pop-up menu appears, select On EnterFrame. This will put this command in the Score Script.

4. Once in the script, type pause. Close the window and your script is complete. Rewind the presentation and press Play to view the presentation so far. This time, do not close the open windows. Notice the transition occurs, then the Playback Head stops at frame 2.

5. Press the Stop button in the Toolbar.

At this point, you will build the interactive buttons that control the presentation. Reposition the windows on the screen to look like the Fig-

Special Effects Channels in the Score Window

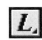

By selecting the Lingo icon, you can access the Lingo menu.

Figure E1.15

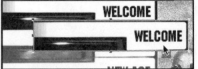

Figure E1.16

When you create a Transition, it automatically becomes a Castmember.

From the Toolbar

Rewind

Stop

Play

The Script Channel Icon.

ure E1.15. The major change is that the Cast window now reveals two columns and more options at the top of the screen. Select Channel 2/Cell 2. Next, drag Castmember 3 from the Cast Window onto the Stage until it is over the Welcome key at the top of the screen. Release the mouse button and, if needed, adjust the position of the graphic using the arrow keys on the keyboard. Using the arrow keys provides great precision in positioning graphics on the screen. This graphic will become an interactive button. Note: You may need to close the Toolbar while positioning this graphic, since it is positioned at the top of the screen.

A quick way to test for proper alignment is to move the Playback Head from Frame 2 to Frame 3 and back rapidly. This will show any misalignment and allows you to quickly make adjustments. Repeat this process mentioned above for the following. Make sure that the graphic on the stage is selected before repositioning it.

- Select Channel 3/Cell 2.

Drag Castmember 4 onto the Stage and align over the NewAge key.

- Select Channel 4/Cell 2.

Drag Castmember 5 onto the Stage and align over the Rock key.

- Select Channel 5/Cell 2.

Drag Castmember 6 onto the Stage and align over the Country key.

- Select Channel 6/Cell 2.

Drag Castmember 7 onto the Stage and align over the Quit key.

Note: Once all of these elements are in place, scripts will be added to cause a variety of effects and interaction to take place. Since these interactive activities relate to other parts of the presentation that are not in place at this point, we will focus on the development of the other areas and then return to this section to add the necessary scripting to these elements. Also, if you are using a registered copy of Director, it would be a good idea to save your work at this time.

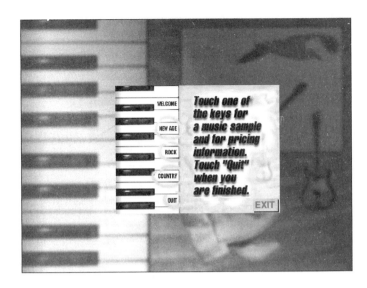

Figure E1.17

The next portion of this exercise will add a Welcome screen to the presentation.

1. With the Score window open, select Castmember 13 and drag it into Channel 2/Cell4 in the Score window. The graphic will be placed in the center of the screen. Due to the clash in the two graphics currently on the screen, we must modify, or change, the background to make the Welcome screen stand out.

2. Select Channel 1/Cell 4. Notice that the entire sequence of cells is highlighted. In order to edit a sprite within this sequence, choose Edit Sprite Frames from the Edit menu. This splits the sequence up into individual cells, allowing the selection of one sprite at a time. Now, reselect Channel 1/Cell 4 and choose Clear Sprites from the Edit menu. This will remove the current background. Select Castmember 2 and drag it directly into Channel 1/Cell 4. The new background will appear. This will create a softer appearance to the background, making the Welcome screen stand out. To preview the screen, close the Cast and Score windows.

Sprite Script Pull-Down Menu

Figure E1.18

To continue, open the Cast, Score, and Toolbar. When the Welcome screen appears, it will need to stay on the screen until a command is given to go to another location. For this to happen a Pause script must be placed. Select Cell 4 in the Script Channel. Next, go to the Sprite Script Pull-Down Menu in the upper-left corner of the Score window and select Script 48 (see Figure E.18). This will place this pause script at this location, causing the playback head to pause at this screen. Using existing Scripts saves time and does not create additional Castmembers.

To precisely reposition on-screen graphics, use the arrow keys on the keyboard.

Figure E1.19

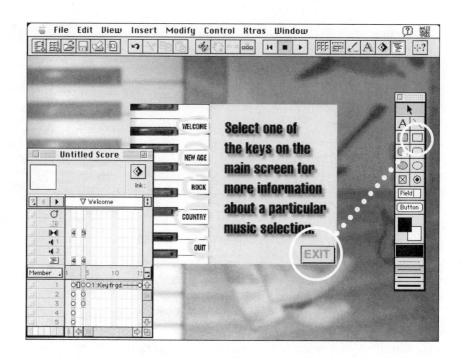

If your screen becomes cluttered with open windows that are no longer needed, close them to free your screen.

Next, an interactive button will be added to make the screen return to the main screen. To do this, make sure that your computer screen looks like the one in Figure E1.19. Open the Window menu and select the Tool Palette. Position it as shown in Figure E1.19. In the Score window, select Channel 3/Cell 4. Next, choose the hollow rectangle Tool. With this tool selected, trace over the Exit button, completely outlining it. Release the mouse button. This rectangle will become Castmember 49.

Open the Cast window and locate Castmember 49. Notice that the rectangle has appeared. This action has produced a rectangle and placed it in the next available Castmember. By double-clicking on Castmember 49 the window shown in Figure E1.20 will appear.

Figure E1.20

Name this graphic Rect 1. While at this screen, select the Script... button. Next, a script will be written to make the button interactive, playing sound files and returning to a specific location.

When the Script window appears, delete the existing script handler and change the Lingo command to on mouseDown by selecting it in the Alphabetical Lingo Menu. This command will be found on the Lingo menu under Mo to Move. With the new handler in place, type in the following script:

```
on mouseDown
    sound playFile 1, "SingClk.aif"
    sound playFile 1, "Tone6.aif"
    go to frame 2
end mouseDown
```

Close the Script window. Move the Playback Head to Frame 3. Choose Play from the Toolbar. This allows you to leave Frame 3 and enter Frame 4, which will pause until you select the Exit button. Next, press the Exit button. The script will play the click (Castmember 20) and the Tone6.aif sound effect (Castmember 19), and then return you to the main screen. Once back at the main screen, the presentation will pause again due to the Pause script that is there. Notice that when you return to Frame 2, the transition replays. This is due to the fact that upon entering this screen, the transition effect will play based on what effect is set in the Transition channel.

We also want to set a Transition for the Welcome screen. To do this, make sure that the Transition channel is viewable. Double-click in Cell 4 of the Transition channel to open the Transition settings menu. Choose the Dissolve, Pixels effect. Set the Duration option to 0.80. To apply, press OK. This will become Castmember 50.

At this stage, the Welcome screen will go to the main screen, but no interactive link or script has been written to make it return. This phase will be put in place once the other parts of the project have been designed.

Developing the New Age Portion of the Movie

In this section, we will develop the first of the three informative elements of the presentation. This phase will be developed as a somewhat independent project initially, then will link into the overall shell through interactive links added at the beginning and end of the exer-

The Hide/Show Effects Channels icon in the Score.

Figure E1.21

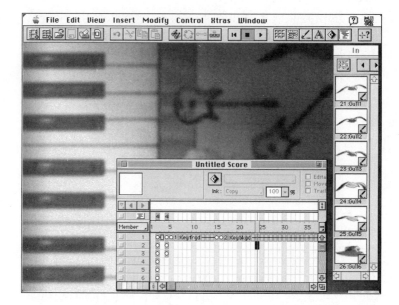

If the Castmembers placed on the Stage cannot be selected, the presentation may still be in the Play mode. Make sure the Stop button is selected after viewing the exercise.

cise. This phase will also utilize simple animation techniques to bring life to the project. To begin, reorganize your screen to look like Figure E1.21. In the Score, click on the Hide/Show Effects Channel button to temporarily close the effects and to create more room on the Stage.

The first thing to look for in graphic placement is the background. In this case, we have already placed the primary background in the Score. This needs no further attention or modification.

For clarity in placing the next few graphic files, do as follows. From the File menu, select Preferences, then select Score. Under Compatibility select Director 5 Style Score Display. Also check Allow Drag and Drop and Allow Colored Cells. This will display Castmember numbers in the cells, thus allowing easy reference to Castmember locations.

Figure E1.22
Score window preferences.

Figure E1.23

Next, a series of graphics will be placed on the Stage and in the Score. See Figure E1.23 for Stage placement and Figure E1.24 for Score placement.

1. Select Channel 2/Cell 24. Once selected, open the Cast window and select Castmember 21 and drag it onto the Stage. The graphic should be placed in the relative position as shown in Figure E1.23. Once on the Stage, and while still selected, choose the Ink option on the top of the Score window. Set the Ink option to Matte.

2. Select Channel 2/Cell 28 and drag Castmember 22 onto the Stage. The graphic should be placed in the relative position as shown in Figure E1.23. Also, select Matte from the Ink effects menu.

3. Select Channel 2/Cell 32. Drag Castmember 23 onto the Stage. Set the Ink to Matte. Place the graphic as shown in Figure E1.23.

You may find it beneficial to rearrange your windows often during this portion of the exercise.

Figure E1.24

When the first graphic is placed on the Stage, set the position and Ink settings before copying into the remaining 3 cells. Once corrected, it will not need to be changed again.

4. Select Channel 2/Cell 36. Drag Castmember 24 onto the Stage. Set the Ink to Matte. Position as shown in Figure E1.23.

5. Select Channel 2/Cell 40. Drag Castmember 25 onto the Stage. Set the Ink to Matte. Position as shown in Figure E1.23.

6. Select Channel 2/Cell 44. Drag Castmember 26 onto the Stage. Set the Ink to Matte. Position as shown in Figure E1.23.

7. Select Channel 2/Cell 48. Drag Castmember 27 onto the Stage. Set the Ink to Matte. Position as shown in Figure E1.23.

8. Select Channel 2/Cell 52. Drag Castmember 28 onto the Stage. Set the Ink to Matte. Position as shown in Figure E1.23.

Note: The gull photos do not appear on the screen at the same time. Figure E1.23 is for position only.

9. Next, in the Score window select Channel 2/Cell 24 by clicking on it once. When selected, press and hold the option key (Mac) or the Alt key (Win) and click and drag the Sprite to Channel 2/Cell 27. When in Director 5.0 Style Score Display, this creates a copy of the cell rather than creating a sequence. With the Cell in Channel 2/Cell 27 selected, press and hold the Shift key then select Channel 2/Cell 24. Doing this will select Cells 24, 25, 26, and 27.

With all of these selected, open the Modify menu and select Extend Sprite. You can also use the Extend Sprite icon located in the Toolbar. Use the process listed above to perform the same functions to the Sprites in Cells 28, 32, 36, 40, 44, 48, and 52. When completed, your Score window should look like the one in Figure E1.25. If you drag the pointer through the Playback Head, you can see the effects that were just created.

Next, the score sequence that was just created in Figure E1.25, will be duplicated twice to create more activity on the screen.

Figure E1.25

Figure E1.26

Figure E1.27

1. Insert the pointer into Channel 2/Cell 24. While this cell remains selected, press and hold the Shift key, then click Channel 2/Cell 55. This will select the entire range of Sprites. Now, choose Copy Sprites from the Edit menu. Move the pointer into Channel 3/Cell 30. Select the cell to make it active then choose Paste Sprites. The Score window should now look like the one in Figure E1.26. Since the cells just pasted are still in the Clipboard, they can be pasted into another location.

2. Select Channel 4/Cell 36 by clicking on it once to make it active. Choose Paste Sprites once more. Verify that your screen looks like the one in Figure E1.27.

The preceding process copied and pasted the gull sequence creating a total of three animated sequences. These sequences are identical, but due to the fact that the placement in the Score window is staggered, they will begin and end at different times.

3. To test this screen, close all windows, with the exception of the Score window. Move the Score window to the bottom of the screen, leaving enough room to use the playback head. Move the playback head back and forth between Frames 20 and 65. This will provide a feel for the animation effects that were just created.

Next, the placement of the second and third gull scores will be modified in order to create the feel of more activity on the screen. The next few steps will cover modifications to Sprites in Channel 3 only.

1. In Channel 3, select the four cells filled with Castmember 21. Remember that you can select them all quickly by selecting the first cell (in this case Channel 3/Cell30) then press and hold the Shift

Figure E1.28

key, then select the last cell (in this case, Channel 3/Cell 33). Notice the selected gull that is displayed on the screen.

Note: With these frames selected there are two gulls on the screen. The cells in Channel 2 are also displayed because the cells you have selected in Channel 3 are directly under them. Notice the position of the Playback Head. Remember that wherever the Playback Head is, all graphics will be displayed that are at that location or frame. It is important for you to know that the frames you have selected in the score will be reflected on the screen by selected objects. In this case, these are graphics.

2. With these cells selected, move (or temporarily close) the Score window, in order to give full view of the screen. Click on the selected gull and hold the mouse button down. Next, move the gull to the position shown in Figure E1.28. Open, or reactivate, the Score window.

3. By using the same selection process as above, select Channel 3 - Cells 34 through 37 (filled with Castmember 22). With these frames selected, once again, move the Score window out of view. Move this selected Castmember to the location shown in Figure E1.28.

4. Repeat this process for Cells 38 through 41. Move the gull to the location in Figure E1.28.

5. Reposition the gulls in 42-45. Castmembers 25, 26, 27, and 28 will remain unchanged.

At this point, a different entrance point was created for each of the gulls. The rest of the animation paths will remain the same. However, due to the fact that their timing is staggered, the movement will continue.

The next few steps will cover modifications to Sprites in Channel 4 only. Refer to Figure E1.29 for placement.

1. By using previous selection techniques, select Cells 36 through 39. Move Castmember 21 to the position shown in Figure E1.29.

2. Select Cells 40 through 43. Move the graphic Castmember 22 to the position shown in Figure E1.29.

3. Select Cells 44 through 47. Move Castmember 23 to the position shown in Figure E1.29.

4. Select Cells 48 through 51. Move Castmember 24 to the position shown in Figure E1.29.

5. Castmembers 25, 26, 27, and 28 will remain unchanged.

6. With the Score window open and out of the way, move the Playback Head to Frame 20. Open the Toolbar and press the Play button. This allows you to preview your project thus far. As you will notice, the gull images begin at different times and enter at

The position of the Playback Head displays what is on the screen at that time.

Figure E1.30

different locations. The speed of their entrance and playback will be adjusted later. To preview the gull placement, you may also click and drag through the playback head.

There is an additional graphic that needs to be included to complete the series of gull images.

1. Select Channel 2/Cell 67. With the Cast window open, select Castmember 29 and drag it onto the Stage. Temporarily close the Toolbar and move the Score window out of the way so that you can place this Castmember. Position it directly over the similar image in the upper right-hand side of the Stage, as in Figure E1.30.

 Reopen the Score window. At this point, a transition will be set for this graphic.

2. In the Transition Channel, activate Cell 67. Double-click the cell to open the Transition settings menu. Select Dissolve Pixels. Set the Duration to 0.50 seconds. Select OK. This transition will become Castmember 51.

3. Select the Sprite in Channel 2/Cell 67. Press and hold the Opt/Alt key and drag to Channel 2/Cell 75. This will create a copy of this Sprite at that location. With Channel 2/Cell 75 selected, hold the Shift key down and select Channel 2/Cell 67. Next, choose Extend Sprite from the Modify menu. This will fill the in-between cells, causing the graphic to remain displayed.

4. In the Transition Channel, copy the transition in Frame 67 and Paste a copy into Cell 68. This will cause two dissolve effects in a row. When this is completed, set the Playback Head to Frame 60, press Play, and review the results. Press Stop when complete.

5. Select Channel 4/Cell 70. Open the Cast window and drag Castmember 30 onto the Stage. Set the Ink pattern to Matte. Position it as shown in Figure E1.30. Copy Channel 4/Cell 70. Paste the Sprite into Cells 71, 72, and 73.

6. Set a transition for Castmember 30 to enter and exit. In the Transition Channel, select Cell 70. Double-click to open the Transition settings menu and choose Random Rows, Duration 0.80. Set Affects Changing Area Only. Press OK. This transition will become Castmember 52.

7. Move to Frame 74 of the Transition Channel and double-click to activate the Transition settings menu once again. Select Random Columns, Duration 0.80. Set Affects Changing Area Only. Press OK. This transition will become Castmember 53.

8. In order for this graphic to remain on the screen for a while, set a time delay in the Tempo Channel. The Tempo Channel is the first Channel in the Special Effects Channels. To do this, double-click in Cell 73 in the Tempo Channel. Click on the Wait button and move the seconds option to 3 seconds. Select OK.

To view the results of this Tempo change, move the Playback Head to Frame 60 and press Play in the Toolbar.

Next, a transition needs to be placed at the end of this section.

1. Select the Transition Channel, Cell 76. Open the Transition settings menu and select Wipe Down. Set the Duration to 2.0 and press OK. This transition will become Castmember 54.

Along with this transition, a Script needs to be put in place to tell the Playback Head what to do next.

1. Select Cell 76 in the Script Channel. Double-click to activate a new script window.

2. When the Score Script window appears it should already have a script handler in place. If not, open the Lingo window and select E, then select On exitFrame. Enter the script as shown in Figure E1.31. Close the Score Script 55 window.

3. Move the Playback Head to Frame 65 and press play. When frame 76 is reached, the movie will return to Frame 2. The Playback Head will pause at Frame 2 because of the pause script that is in place.

The Special Effects Channels Icons

Tempo
Palette
Transition
Sound 1
Sound 2
Script

Figure E1.31

Adding Music to the Score

The fundamental concept for the user of this interactive kiosk exercise is to activate a sound file to preview a music sample. So far, only the graphic elements have been added. One of the beauties of multimedia technologies is the ability to expand one media by adding others. In this example, the addition of graphics and animation will greatly enhance the audio presentation. At this point, it is time to add the sound track for this movie.

Before beginning this portion of the exercise, return to the default Score settings by opening the File menu and selecting Preferences, then Score. Deselect the Director 5.0 Style Score Display option.

1. Position the Score window so that it appears as shown in Figure E1.32. This will display the Special Effects Channels.

2. In Sound Channel 1, select Cell 18. Open the Cast Window and drag Castmember 31 directly into Cell 18.

3. Close the Cast window.

4. Since the sound file has no graphic image associated with it, it will not appear on the stage. However, the Sprite will appear in the selected Frame. Position the pointer over this Cell. It should say 31:NewAge.

5. To make the sound file play throughout the duration of the movie, it must be in each cell of this movie. To do this, select the Cell by clicking on it once, press and hold the Opt/Alt key and drag to the right, stopping at Cell 76.

Figure E1.32

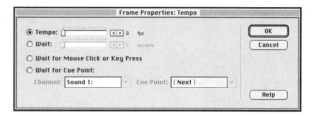

Figure E1.33

Figure E1.34

6. All cells from Frame 18 through Frame 76 will be filled with the sound file. See Figure E1.32.

7. This sound file is only a few seconds long. In order for it to repeat and play through the duration of this sequence it must be looped. Do this by opening the Cast window, and double-click Castmember 31 (NewAge.aif). This will open Castmember Properties. Select the Loop option. The screen should appear as in Figure E1.33. Select OK.

8. Relocate the Playback Head to frame 18 and choose Play from the Control Panel.

The pace of this movie can be changed by modifying settings in the Tempo Channel. To change the tempo, do the following:

1. Select Cell 18 in the Tempo Channel. Double-click on the cell to activate the Tempo settings menu. Set the Tempo settings as shown in Figure E1.34: 8 fps (frames per second). Select OK.

2. With this setting in place in Frame 18, make sure the cell is selected. Press and hold the opt/alt key and drag to the right to Cell 72. Release the mouse.

To complete this portion of the exercise, do the following.

1. In the Marker Channel, click once over Frame 18.

2. The marker is ready to accept a typed entry. Type: NewAge.

The Castmember Properties button. This is located at the top of the Internal Cast Window.

About Markers
By naming portions of your Score window, you can easily recognize sections of your presentation by name. Also, when writing scripts, you can have the script jump to these markers.

Figure E1.35

You can quickly hide or show the Effects Channels by clicking on the Hide/Show Effects Channels icon in the Score.

Markers allow easy visual reference while viewing the Score window, as well as providing a starting point for this section of the presentation.

At the end of this exercise is a copy of the Score window for the New Age section. You can refer to this Score to compare what you have done so far. This will be beneficial if you experience difficulty during the exercise.

Note: This Score window shown at the end of this exercise was captured with the Director 5 Style Score Display option turned on from the Score Preferences menu. This allows you to compare visually the location of each Castmember in the Score. After comparing, make sure to turn this feature off before continuing the exercise.

Developing the Rock Music Portion of the Movie

This portion of the exercise contains an aggressive sound track and an interesting use of Director's special effects.

1. To begin, make sure that your screen is arranged as shown in Figure E1.36. The Score window positioning and the settings displayed in this illustration are important to the beginning of the exercise.

Figure E1.36

Figure E1.37

2. Select Channel 2/Cell 80. With this frame selected, open the Cast window and drag Castmember 32 onto the screen. Place it as shown in Figure E1.36. If you need to free up visual space on your monitor, temporarily close the Score window.

3. In the Score window, open the Ink menu and set the ink effect to Matte.

4. Select the Sprite in Channel 2/Cell 80 by clicking on it once. Next, press and hold the opt/alt key, then select Cell 80 and drag it to the right to Cell 87. Release the mouse button.

5. Select Cell 80 by clicking on it once. The next step is to modify the size of the Guitar. The guitar image currently has a rectangle around it with handles, or small squares, at each corner and in the center of each line. Move the pointer to the handle in the center of the vertical line on the right-hand side. Click on this handle and hold the mouse button down as you drag to the left. Once the image has been reduced horizontally approximately fifty percent, release the mouse button. See Figure E1.37. Note: When a Graphic on the Stage has been modified, such changes are recorded in the Sprite located in the Score.

6. Next, select Channel 2/Cell 87. Press and hold the opt/alt key and drag to the right to cell 91. With Cell 91 still selected, press and hold the shift key, then drag the guitar image to the center of the stage.

7. Select Cell 91. Press and hold the opt/alt key and drag to the right to Cell 99. With Cell 99 selected, open the modify menu and select Sprite, then Properties from the pop-out menu. In the Scale box, type 50. Make sure that Blend is set to 100% and that Main-

As you use the Copy process throughout this exercise, make sure that the item or the window is active before choosing the Copy command.

Figure E1.38

Your location fields may contain different values. These fields refer to the graphic's location on the stage.

tain Proportions is checked. Refer to Figure E1.38 for details. You will immediately see the guitar in the 50% view. Select the guitar image and drag it directly on top of the identical image in the background graphic. See Figure E1.39 for placement of the reduced guitar.

Move the Playback Head over these frames to view the effects.

8. Using the Shift method dicussed earlier, select cells 80 to 99 in Channel 2. Copy these Sprites. With the Sprites selected, open the Modify menu and choose Reverse Sequence. This will reverse the selected sequence, not the copy that is now in the clipboard.

9. Select Channel 2/Cell 100 and choose Paste Sprites. The Sprites copied in Step 8 will now be pasted here.

10. While at this portion of the Score window, reveal the Effects Channels using the Hide/Show Effects Channel button. In the Tempo channel, select Cell 80. Next, double-click the cell to

Figure E1.39

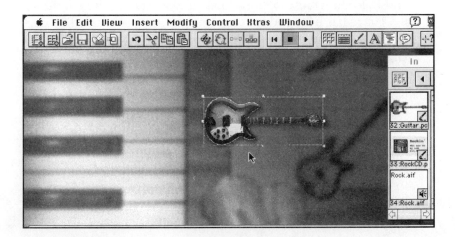

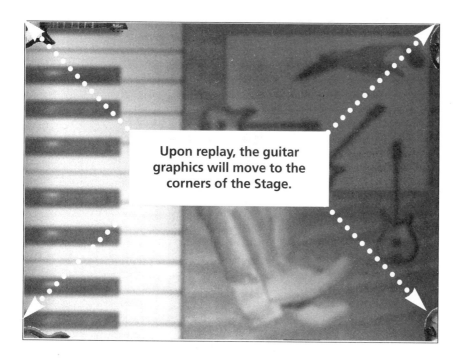

Upon replay, the guitar graphics will move to the corners of the Stage.

Figure E1.40

open the Tempo settings menu. Select Wait then choose 2 seconds. Click OK. This will delay the playback of this portion for two seconds upon entering.

11. In the Marker Channel, click once over Frame 80. Type the title Rock.

12. In the Transition channel, select Frame 80. double-click to open the Transition settings menu. Choose Wipe Right, Duration 0.80. Press OK. This will become Castmember 56.

13. Next, scroll the Score window to the right so that Frames 115 through 170 are revealed. Scroll down so that Channels 1, 2, and 3 are visible.

14. Copy the Sprite in Channel 2/Cell 119. Next, select Channel 3/Cell 119 and choose Paste Sprites.

15. With Channel 3/Cell 119 selected, press and hold the opt/alt key and drag to Cell 134. With Cell 134 selected, move the guitar graphic to the upper-right portion of the Stage. You may want to temporarily close the Toolbar and Cast windows. Move it to the point that it is almost completely off of the screen. Single-click in the middle of the sequence contained in Cells 119 through 134 to select it. With these frames selected, go to the top of the Score window and select the Trails option.

The Trails option allows the image from a previous screen to remain on the Stage. At first, this feature may be confusing. To clear the screen from the multiple images created by using the Trails function, rewind the presentation then return to the frame.

Figure E1.41

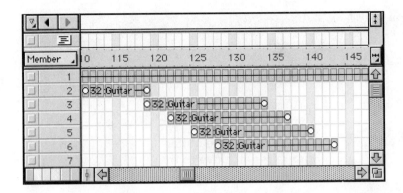

This process will be repeated for Channels 4, 5, and 6. Refer to Figure E1.40 for placement of the Sprites. Instructions for this process are as follows.

16. The Sprite in Channel 2/Cell 119 should still be in the clipboard. Paste it into Channel 4/Cell 122 and extend it to Cell 137. Select Cell 137 and move the guitar to the lower right of the Stage. As previously performed in Channel 3, move the graphic until it is almost invisible, or completely off the Stage. The Trails option should still be selected. If not, make sure the new sequence is selected, then reselect Trails.

17. Paste the clipboard contents again into Channel 5/Cell 125 and extend it to Cell 140. Select Cell 140 and move it to the upper left of the Stage. As previously performed in Channel 4, move the graphic until it is almost invisible or completely off the Stage. Make sure to set the Trails option.

18. Paste the sprite in the clipboard once again into Channel 6/Cell 128 and extend it to Cell 143. Select Cell 143 and move it to the lower left of the Stage. As previously performed in Channel 5, move the graphic until it is almost invisible, or completely off the Stage. Trails should be on.

The Sprites will appear in the Score as shown in Figure E1.41.

Adding the CD Graphic

1. Select Channel 2/Cell 145.

2. Open the Cast window and drag Castmember 33 into this cell. Set the Ink to Not Copy.

3. Select Channel 2/Cell 145. Extend the Sprite to Cell 155.

To make the graphic fade in, add the following:

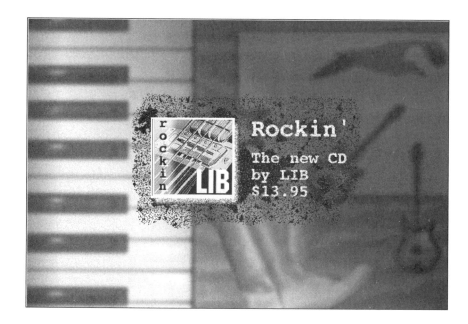

Figure E1.42

4. Select Frame 145 in the Transition Channel. With the Cast window open, locate Castmember 50. Drag the Castmember into Frame 145 of the Transition Channel.

5. Copy this Sprite. Select Frame 149 and Paste. Also Paste the Sprite in Frame 156.

Next, move to the Script Channel. Select Frame 156. In the Sprite Script Pull-Down menu located at the top of the Score window, select script number 55, on exitFrame, go to frame 2. Since this process has already been defined, and used earlier in the movie, it is easy to select and use.

All of the special effects in this section should appear in the Score window shown in Figure E1.43.

Figure E1.43

Setting Tempo

The tempo for this portion of the movie will have a few variations. Tempo settings are ideal for controlling the pace of an on-screen presentation. An example of this is the fact that the first portion of this phase is not as active as the last half. Therefore, the first part could run at a slower frame rate than the last part. Note: This section refers to changes made in the Tempo Channel only.

1. Go to Cell 81, double-click to open the Tempo settings menu. Select Tempo, with a setting of 12 fps. Click OK. Extend the Sprite to Frame 118.

2. Next, select Frame 119. Double-click to open the Tempo settings menu. Change the tempo setting to 30 fps. Click OK. Extend this Sprite to Frame 143.

3. Next, go to Frame 146 in the Tempo Channel and select the cell. Double-click to open the Tempo settings menu. Select the Wait option and increase the seconds option to 5. This will add a pause of five seconds which allows the CD art to remain on the Stage for this amount of time. Click OK.

4. Fill in Frames 147 through 156 with the tempo setting of 12 fps, using the process mentioned above.

Adding the Sound Track

Last, but not least, it is time to add the soundtrack to the movie. In this scenario, two audio tracks will be added.

1. In Sound Channel 2, select Cell 93. Next, open the Cast window and locate Castmember 35. double-click on the Castmember. When the Sound Cast Member Properties window opens, make sure that the Loop option is selected, and press OK.

2. Drag Castmember 35 directly into Sound Channel 2/Cell 93. Extend the Sprite to Cell 119.

3. Next, select the Cast window and locate Castmember 34. Choose the Castmember Properties as done in step 2. Make sure that the Loop option is selected. Select OK. In Sound Channel 1, select Frame 119. Drag Castmember 34 directly into the Cell, then close the Cast window. Extend the Sprite to Cell 149.

4. Return to Sound Channel 2 and fill Cells 150 through 156 with Castmember 35. Remember, Castmembers can be copied from existing Sprites in the Score window. It is not necessary to return to the Cast window each time, if the Castmember is already in the Score window.

This completes the Rock Music portion of the exercise. If you would like to check the contents of the Score window, refer to the end of this exercise and view the completed Score window. Insert the cursor in Frame 80 and press Play to preview this section. If you are using a retail version of Director, save your work now.

The Country Music Section

The Castmember Properties icon.

This part of the exercise will make use of additional animated techniques. This section is designed to be entertaining and light hearted. To begin this portion of the exercise, arrange the Score window so that it appears like the one shown in Figure E1.44.

1. Select Channel 2/Cell162. While selected, drag Castmember 38 onto the Stage from the Cast window. Once the graphic is on the stage, select Matte in the Ink effects menu.

2. Position the boots as shown in Figure E1.45. This graphic is positioned over the same image that appears in the background.

3. In Channel 2 of the Score, copy cell 162 and Paste it into Cell 163.

4. Now, select Channel 3/Cell 163. Open the Cast Window and drag Castmember 40 onto the Stage as shown in Figure E1.46. Choose Matte from the Ink Palette.

 At this point, you may want to rearrange your computer screen to appear as shown in Figure E1.46.

5. Select Channel 4/Cell 163. Open the Cast Window and drag Castmember 39 onto the Stage next to Castmember 40. Select Matte from the Ink menu.

 The next three cells will use these two images. Their location will be modified.

Figure E1.44

Figure E1.45

6. Select Channel 3/Cell 163. Press and hold down the Shift key and select Channel 4/Cell 163. While selected, choose Copy Sprites. Insert the pointer into Channel 3/Cell 164 and choose Paste Sprites. Move to Cell 165, then to Cell 166 and repeat this process until the score looks like Figure E1.47.

7. Select Channel 3/Cell 164. This activates the boot on the left. Hold down the Shift key, select the boot graphic, and drag it upward

Figure E1.46

approximately one inch. Pressing the Shift key before you begin to drag will constrain the movement either vertically or horizontally.

8. Using the same technique as above, select Channel 4/Cell 166 and move this boot approximately one inch upward.

9. Next, using the Shift key select the group of boot Sprites you have just created in the Score and choose Copy Sprites (Cells 163 through 166 in Channels 3 and 4).

10. Once copied, select Channel 3/Cell 167. Next, choose Paste Sprites. This will repeat the entire process just created.

11. Next, select Channel 3/Cell 171. Open the Cast window and drag Castmember 42 onto the stage. Set the Ink to Matte. Position the boot as illustrated in Figure E1.48 (left graphic). Use the background as a visual aid while placing these graphics. Next, while holding down the opt/alt key, extend the Sprite to Cell 178. With Cell 178 selected, move the boot graphic to the right as shown in Figure E1.48 (right graphic).

Figure E1.47

Figure E1.48

This section requires that constrained movement of graphics be performed often. Pressing and holding the Shift key before selecting a graphic on the Stage will allow constrained movement.

Figure E1.49

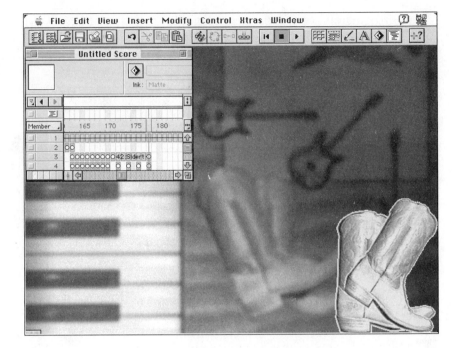

You can move frame by frame through the playback head by using the following keyboard shortcuts:

Macintosh:
 opt+command
 +Arrow keys

Windows:
 Ctrl+Alt
 +Arrow keys.

This will be helpful in comparing boot placement.

Figure E1.50

12. Next, select Channel 4/Cell 171, open the Cast, and drag Castmember 43 onto the Stage. Set the ink to Matte. Place the graphic on top of Castmember 42. Extend this Sprite to Channel 4/Cell 178. With Channel 4/Cell 178 selected, move the boot into position over Castmember 42 in Cell 178. Select the sequence then Edit Sprite Frames from the Edit menu to break down the sequence into individual cells. Next, delete the following Cells in Channel 4: 171, 173, 175, and 177. This will make the boots appear to shuffle across the screen. Use the Playback Head to view.

Figure E1.49 shows how the screen will look when Frame 178 is complete. By utilizing other graphics, the same effects will be applied going a different direction.

13. Select Channel 3/Cell 179. Open the Cast and drag Castmember 37 into the lower right side of the Stage. Set the ink to Matte. Select Channel 4/Cell 179 and drag Castmember 36 onto the Stage, again selecting Matte. Position these graphics in the lower right side of the Stage as shown in Figure E1.50.

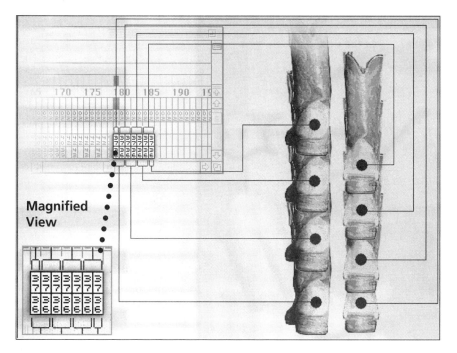

Magnified View

Figure E1.51 This view shows the Castmember numbers in the Score. Use this for reference when placing the Castmembers. However, after moving the boots, be sure to turn this option off before continuing with the exercise.

The process outlined in step 12 will be repeated here in a different format.

14. Select Channel 3/Cell 179. Hold the Shift key and select Channel 4/Cell 179. Choose Copy Sprites. Fill the cells to the right with these two Sprites through Cell 185.

 Now we will make the boots climb up the right side of the screen. The right boot (Castmember 37) remains in the same location in frame 179. The left boot (Castmember 36) remains stationary in both frames 179 and 180.

15. The first step-up occurs with the right boot in Channel 3/Cells 180 and 181. Select these cells in the score. Notice the right boot is selected on the stage. Move this boot up approximately one inch, as indicated in Figure E1.51.

16. The next step-up occurs for the left boot in Channel 4/Cells 181 and 182. Select these cells and move the boot up accordingly.

Complete the remaining four step-ups in the same manner, using Figure E1.51 as a reference.

The next step involves making the boots shuffle across the top of the Stage similar to the way they did at the bottom of the Stage, only with new Castmembers. If Director 5 Style Score Display is turned on, turn it off before proceeding.

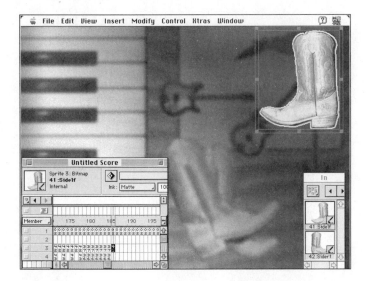

Figure E1.52

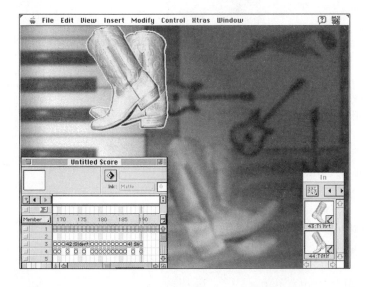

Figure E1.53

17. Select Channel 3/Cell 186. Open the Cast window and drag Castmember 41 onto the Stage. Set the Ink to Matte and position as shown in Figure E1.52. Next, extend the Sprite to Channel 3/Cell 190. With Channel 3/Cell 190 selected, move the boot to the left of the screen (see Figure E1.53).

18. Next, select Channel 4/Cell 186. Open the Cast window and drag Castmember 44 into the upper-right corner of the Stage. Castmember 44 should be positioned on top of Castmember 41. Set the Ink to Matte. Extend the Sprite in Channel 4/Cell 186 to Channel 4/Cell 190.

19. Select Channel 4/Cell 190. On the Stage, drag the boot image to the left side, covering Castmember 41. Select the sequence then Edit Sprite Frames from the Edit menu to break down the sequence into individual cells. Next, delete the following Sprites in Channel 4: 187 and 189. See Figure E1.53 for details. In the Score window, move the playback head to view what you have done.

Next, a sequence will be added to the left side of the Stage.

20. Select Channel 3/Cell 191. Drag Castmember 40 to the upper-left corner of the Stage. Next, select Channel 4/Cell 191 and drag Castmember 39 onto the stage next to Castmember 40. Close, or move, the Cast window. Remember to set the Matte Ink effect for both Castmembers.

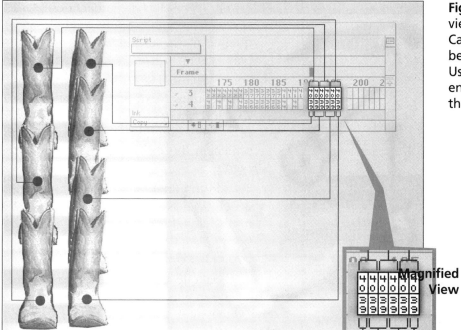

Figure E1.54 This view shows the Castmember numbers in the Score. Use this for reference when placing the Castmembers.

Magnified View

21. With the boots in the upper left-hand corner of the Stage, fill Channel 3/Cell 191 to 196 with Castmember 40, and Channel 4/Cell 191 to 196 with Castmember 39. Develop the placement scenario as shown in Figure E1.54.

 The next process will duplicate what has been done thus far. This is a Copy and Paste function.

22. Select the Cells in Channels 3 and 4 that represent the boot graphic placement done thus far. This is represented by the cells shown in figure E1.55 (Channels 3 and 4 only). Once selected, choose Copy sprites from the Edit menu. Next, move to Channel

Figure E1.55

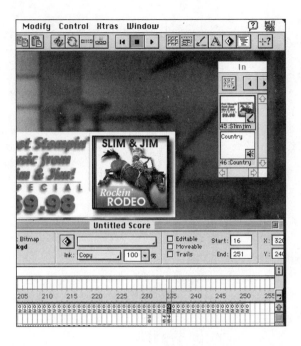

Figure E1.56

3/Cell 197, select it, and choose Paste sprites. This will insert the entire boot sequence in these frames, allowing it to play again.

23. Select Channel 2/Cell 163 and choose Copy sprites. Next, select Channel 2/Cell 231 and choose Paste sprites. This will place the large boot graphic on the screen in the exact location that it was before.

24. To add the final graphic, select Channel 2/Cell 234. Next, drag Castmember 45 into Channel 2/Cell 234. Set the Ink to Copy. Also, Copy this Sprite and Paste it into Cell 235. See Figure E1.56.

Next, special effects will be added to this portion of the movie. Rearrange the Score window so that all of the Special Effects channels are in view.

1. In the Marker Channel, click once over Frame 161, and type in the name Country. This will identify the beginning of this presentation.

2. In the Transitions Channel, drag Castmember 51 into Cell 161. Setting this transition here will make the boots graphic fade in over the background image.

3. Copy this transition and paste it in the two cells immediately to the right of Frame 161. These dissolve transitions will make one set of boots fade out, while the other fades in.

4. With this dissolve transition still in the clipboard, move through the presentation to Frame 231, and choose Paste Sprites. Also, Paste a copy in Frames 232 and 233. This allows the boots to fade in and then out, once again.

5. Next, select the Transition Channel/Frame 234. Double-click to open the Transition settings menu. Select Venetian Blinds, Duration: 1.25 Sec., Affects: Changing Area Only. Press OK. This allows the CD graphic to enter. This will become Castmember 57.

6. Still in the Transition Channel, choose Paste in Frame 236. Castmember 51, Dissolve Pixels, should still be in the computers clipboard. If not, copy it from another location in the score. This will be the final transition of the presentation.

7. In order for the presentation to return to the main screen, which is Frame 2, select Cell 237 in the Script Channel. With this cell selected, open the Sprite Script Pull-Down menu at the top of the Score window. Choose Script 55.

Adding Tempo Settings

If necessary, scroll back to reveal Frame 160 as the left-most part of the Score window.

The following changes will apply to the Tempo Channel only.

1. Double-click in Frame 163 to open the Tempo settings menu. Set the Tempo to 10 fps, and choose OK.

2. Double-click in Frame 164. When in the Tempo settings menu, set the tempo to 4 fps. Select OK. Next, use this tempo setting and fill from Frame 164 to Frame 237. Hold the opt/alt key and extend the Sprite. This will set the tempo for most of this section.

3. There are two locations that demand changes to this tempo. Select the sequence that contains Frame 197. Select Edit Sprite Frames from the Edit menu to break down the sequence into individual cells. Go to Frame 197, select the cell and select Clear sprites from the Edit menu to clear the cell. Next, double-click in the cell to open the Tempo settings menu once again. Select the Wait option. Next, move the slider to the 2 seconds location. Select OK. Doing this will cause a pause at the point that the animated boot segment replays. Without this pause, the presentation will move too fast.

4. Add a 2 second Wait in Cell 231 of the Tempo Channel.

5. The next change in Tempo will affect the CD artwork that appears at the end of the presentation. Go to Frame 235 and clear this Cell. Next, double-click to open the Tempo settings menu. Select Wait, and choose 6 seconds. Press OK.

Adding the Sound Track

As with the other sections of this exercise, this portion seems pretty dull without a sound track.

1. Make sure that the Score window begins with Frame 160 on the left, and have the Special Effects channels open. In Sound Channel 1, click in Frame 162 to select it. Select Castmember 46. Double-click the Castmember. This will open the Cast Member Properties window. When the dialog box opens, make sure that the Loop option is selected. This will ensure that the file will play over and over until completion.

Figure E1.57

2. Drag Castmember 46 directly into Cell 162 of Sound Channel 1. With this Cell selected, press and hold the opt/alt key and extend the Sprite to Frame 237.

3. Insert the cursor in Frame 160 of the Playback Head and choose Play to preview what you have done in this section.

This concludes this portion of the exercise. At this point, the graphics have been put in place for the intro, the New Age, Rock, and Country sections. From here on, the project will be tied together with interactive links from section to section creating the movie interface.

Developing the Interface

In this section, the interface that controls the three independent presentations that have been created so far will be developed.

The goal in this section is to make the keys on the keyboard at the beginning of the exercise link to the corresponding presentations or functions. Before you begin, arrange your screen to look similar to Figure E1.58.

Figure E1.58

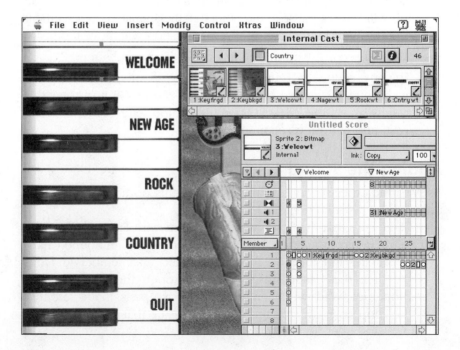

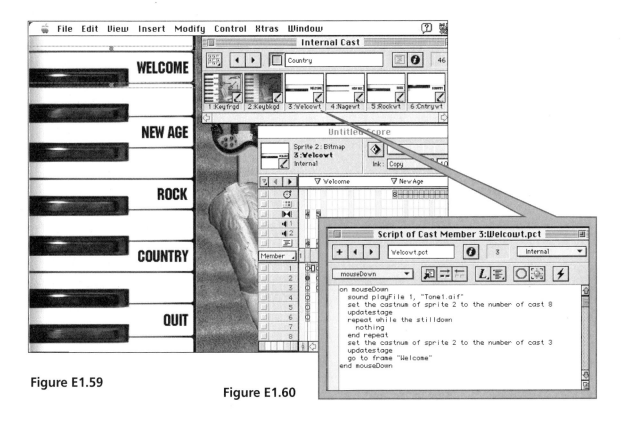

Figure E1.59

Figure E1.60

Scroll back to the beginning of the Score window.

1. In the Score window, insert a Marker in the Marker Channel over Frame 4. Type in the name Welcome. This will identify this portion of the movie.

2. Next, select Channel 2/Cell 2. Notice the Welcome key on the keyboard is highlighted. The highlighting is represented by a rectangle with handles at each corner and in the middle. This indicates that this Sprite is selected in the Score and subsequently on the Stage. It also reflects this Castmember. To develop a Script for this object, open the Cast window. From here, select Castmember. 3. At the top of the Cast window is the Script icon. Click on this icon to open the Script window. To make this key or graphic produce an interactive response, a script must be entered to tell it what to do. Figure E1.60 shows the open Script window.

3. Organize your screen to look like Figure E1.59. When the Castmember 3 Script is open, eliminate the existing Script handler in the Script window and type the script as follows, or as shown in Figure E1.60.

```
on mouseDown
   sound playFile 1, "Tone1.aif"
   set the castnum of sprite 2 to the number of cast 8
   updatestage
   repeat while the stilldown
   nothing
   end repeat
   set the castnum of sprite 2 to the number of cast 3
   updatestage
   go to frame "Welcome"
end mouseDown
```

Close the Script window.

Basically, when you press the mouse button, this script will play a sound, change the graphic appearance of the Welcome key to that of Castmember 8, and move the playback head to the marker Welcome, thus initiating that part of the movie. This same process will apply for all of the named keys on the keyboard.

Other scripts similar to this one will be used in other locations. If you prefer, you can copy this script as a time-saving measure. Insert the cursor in the script, choose Select All from the Edit menu, then choose Copy Text.

Make the Toolbar active. Choose Rewind and press Play. Press the Welcome key. The key should reverse color, play a tone, then advance to the Welcome screen, then pause. While at the Welcome screen, press the Exit button at the bottom of the screen. This should play a click and then a tone, then return to the main screen. If the script does not perform properly, review the script for accuracy. Make sure that it is typed in accurately. When finished, press the Stop key. If needed, close the Toolbar to allow a better view of the Introduction Screen.

The New Age Key

Follow the basic screen preparation steps done in the Welcome Key section.

1. In the Cast, select Castmember 4.

2. Next, select the Script icon to open the Script window.

3. If you didn't copy the Welcome Key's script, enter it as shown on the following page. Otherwise, paste and edit the copied script.

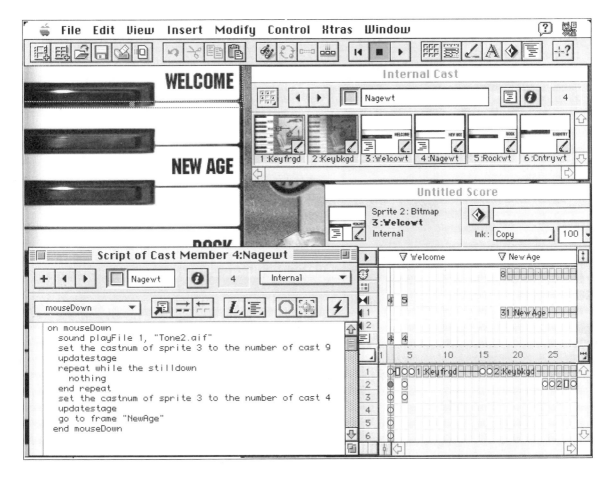

```
on mouseDown
    sound playFile 1, "Tone2.aif"
    set the castnum of sprite 3 to the number of cast 9
    updatestage
    repeat while the stilldown
    nothing
    end repeat
    set the castnum of sprite 3 to the number of cast 4
    updatestage
    go to frame "NewAge"
end mouseDown
```

Figure E1.61

4. As before, test the script by rewinding and selecting Play from the Control Panel. If all works properly, you will advance to the NewAge portion of the movie. It will then play and return to the main screen. When finished, press stop in the Toolbar.

Scripts behave based on the information entered. Accuracy is demanded. Proof all entries carefully.

Figure E1.62

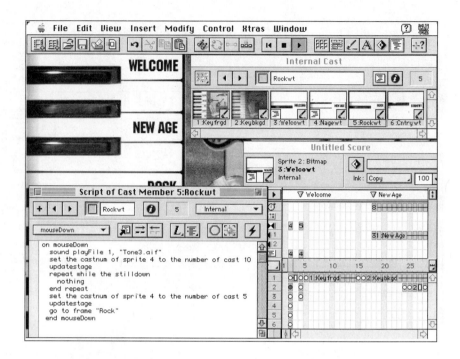

The Rock Key

Organize your screen as shown in Figure E1.62.

1. In the Cast, select Castmember 5.

2. Next, select the Script icon to open the Script window.

3. Enter the following script:

```
on mouseDown
    sound playFile 1, "Tone3.aif"
    set the castnum of sprite 4 to the number of cast 10
    updatestage
    repeat while the stilldown
    nothing
    end repeat
    set the castnum of sprite 4 to the number of cast 5
    updatestage
    go to frame "Rock"
end mouseDown
```

4. Test the script by selecting Play from the Toolbar.

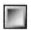

You can Copy and Paste between Script windows. This will save time with repetitive information.

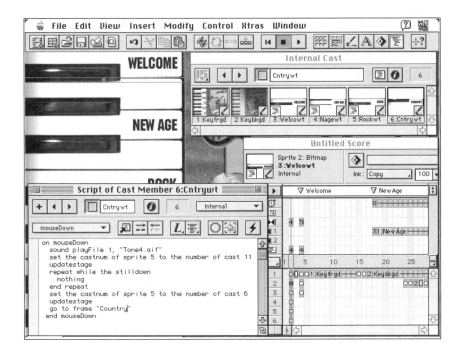

Figure E1.63

The Country Key

1. In the Cast, select Castmember 6.

2. Next, select the Script icon to open the Script window.

3. Enter the following script:

```
on mouseDown
    sound PlayFile 1, "Tone4.aif"
    set the castnum of sprite 5 to the number of cast 11
    updatestage
    repeat while the stilldown
    nothing
    end repeat
    set the castnum of sprite 5 to the number of cast 6
    updatestage
    go to frame "Country"
end mouseDown
```

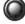

Important Note About Quitting

In the Lingo **Script** shown here, quit has been added. Upon playback, the presentation will quit, and subsequently **close** the Director application. If you are using the **Save-Disabled** version, you will lose your work performed so far. If you wish, you can delete the "quit" from this script.

Figure E1.64

The Quit Key

1. In the Cast, select Castmember 7.

2. Next, select the Script icon to open the Script window.

3. Enter the following script:

```
on mouseDown
    sound playFile 1, "Tone5.aif"
    set the castnum of sprite 6 to the number of cast 12
    updatestage
    repeat while the stilldown
    nothing
    end repeat
    set the castnum of sprite 6 to the number of cast 7
    updatestage
    sound playFile 1, "Tone6.aif"
    go to frame 240
    quit
end mouseDown
```

Figure E1.65

Wrapping Up

The Quit script indicates that the program will pass to Frame 240 before it closes. This allows the screen to dissolve, or fade, to a blank screen before it closes. To make this happen, scroll to Frame 240. Select Cell 240 in the Transition Channel. From the Cast window, drag Castmember 50 into this cell.

To make the background screen black, do as follows:

1. Open the Modify menu.

2. Select Movie, then Properties from the pop-out menu.

3. When the window opens, locate the Stage Color option. Click and continue to hold the mouse button on this chip to open the color palette. Drag down to select the Black color chip in the lower right side of the color palette. See Figure E1.65.

4. Once selected, choose OK.

This completes Exercise 1. Rewind and view your completed movie!

Completed Windows for Exercise 1

These graphics represent the way each segment of the Score window should look upon completion. Use this as a guide through the development process.

Note: These graphics are displayed using the Director 5 Style Score Display. This is done in order for you to check the Castmember location in the score. To proof your work and to compare with these graphics, make sure you have chosen this option from the Score Preferences in the File menu.

Figure E1.66
The Welcome Score

Figure E1.67
The New Age Score

Figure E1.68
The Rock Score

Figure E1.69
The Country Score

Figure E1.70
The Completed Cast Window

Marker Channel

Tempo Channel

Palette Channel

Transition Channel

Sound Channel 1

Sound Channel 2

Script Channel

Playback Head

Sprite Channels

Some of Director 6.0's Key Components

Figure E1.71

Figure E1.72

This is a Frame. Frames run vertically in the Score. A frame contains information about all castmembers that appear on the stage at the same time.

This is a Cell. A Cell is the smallest part of the Score. Each Cell holds information about a Castmember. This information is called a Sprite. A Sprite refers to the placement of a Castmember of the stage. This placement can vary from Cell to Cell.

This is a Channel. A Channel is a row of cells that extends horizontally through the entire movie.

Exercise 2

Electronic Brochure
Media Presentation for Macintosh Only

Today, there are numerous communications options: the phone, mail, print, and more. There is also a growing array of choices available through computer technologies. This arena is without a doubt the area that allows us to communicate with greatest speed to any location in the world. This exercise is designed to focus on the development of self-promotion material that could be distributed via computer media. This distribution process could range from floppy disk to the Internet.

This exercise is simple and uses minimal external multimedia support files. It is designed to demonstrate the user friendly nature of the mPower™ software application. As you work, you will notice that the extendability of this media development environment goes beyond this exercise. This extendability includes the connectivity to external audio and video sources, the ability to create player files that will allow playback on Macintosh and Windows computers, and much more.

Exercise 2 allows you to create an mPower presentation containing a total of fifteen different slides. This short demonstration will provide a feel for the simplicity and effectiveness of this presentation/authoring program. This exercise will guide you through the development of a self-promotional presentation that can be distributed electronically. The concepts learned here will provide hands-on experience with many features of mPower. Though exposed to these features, this software has much more extendabilities and capabilities.

The mPower software on the CD-ROM is a fully operational retail version specially packaged with this book. Any project that you develop can be saved, allowing any portion of an exercise or other project, to be resumed at any time.

What You Will Learn

This exercise will expose you to the following concepts:

- Hot Buttons
- Sound Effects
- Grids
- Timing
- Layering
- Special Effects

On the CD-ROM, open the mPower folder. Read the mPower Installation Instructions, then use the mPower Installer Software to install the proper version on your hard drive. Pay attention to the requirements listed in order to install the program.

Once the installation is complete, it is suggested that you open and view the completed version of this exercise. To do so, double-click the mPower application icon. This will open mPower, but not a presentation. From the main mPower window, select the Open Presentation button. Locate the MEDIA folder on the CD-ROM then select Ex2 file and choose Open. As this presentation opens, the slides should appear as shown in Figure E2.1. Also, Slide Number 1 should

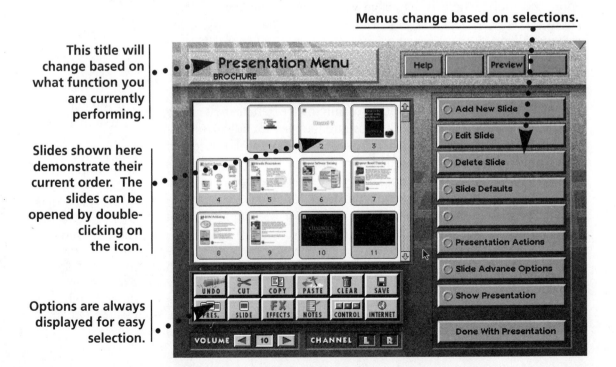

Figure E2.1 The mPower Presentation Menu screen, demonstrating the user interface.

have a red border around it. If it does not, click on the slide once to make it active. Note: When previewing the presentation, the preview will begin with the slide selected in the Presentation Menu (Fig. E2.1). Once open, select the Show Presentation button at the bottom of the screen. This will play the presentation.

Here you can take a look at how it is assembled. Study the effects and implementation in order to develop an understanding of the mPower software and its functioning.

mPower uses menu options shown here that are constantly exposed to the screen and change based on selections made.

Before You Begin

Make sure that you have installed mPower on your computer. Open the mPower folder on your hard disk drive and locate the Backgrounds folder. Open the folder and locate the Custom folder. Drag this Custom folder to the Trash. Once in the Trash, choose Empty Trash from the Special menu. Next, open the MEDIA folder on the CD-ROM. Locate a folder there called Custom. Drag it into the Backgrounds folder on your hard disk drive, thus replacing the original Custom folder.

The purpose of doing this is to add a custom background for this exercise only. When completed with this exercise, the original Custom folder can be placed into the mPower Backgrounds folder to restore the original files.

Slide 1

1. Open the mPower application by double-clicking on the icon, or by selecting the icon and choosing Open from the File menu. When the window opens, select the New Presentation menu. When asked to name this presentation, type in BROCHURE and Save to the Presentations folder. Your BROCHURE document will be located in the Presentations folder contained within the mPower folder.

Importing files from your computer is done by selecting the Computer icon shown here. Creating custom graphic shapes is done by selecting Custom.

2. Select the Add New Slide menu. Notice that as you select this option that the menu selections on the right change. These new menu options reflect choices that can be made to the new slide that was just created.

3. Select the Background menu. When the Backgrounds window opens, click and hold the pull down menu at the top of the window. As the options are displayed, choose Custom. As the Custom Backgrounds option appears it will look blank, as if each

On screen items are arranged in priority in the FX (Effects) menu shown here. The events in this menu can be repositioned by dragging from top to bottom, or vice versa.

option is white. The first rectangle (top left) is actually a background; it is white. Select it, then choose OK. The background of the slide will appear solid white.

4. Click once on the Graphics menu. When the menu topics change, click on the Add New Graphic menu. When the Select a source... option appears, select Computer then press OK. Next, a window will appear asking that you select a file for importation. Navigate to the MEDIA folder on the CD-ROM. Open that folder and select Today.pct. Choose Open. The file will initially be imported and placed in the upper-left corner of the screen. Single-click on the graphic to select it. Then, hold down the mouse button on the image and drag it to the center of the slide. If you select the Position button at the top of the screen, you will go to a full-size screen display and can move the graphic while there. When finished, click on a blank area of the screen. Doing this will return you to the previous screen.

While at this screen, select the FX Effects button below the screen. This will take you to the Special Effects screen. Here is where timing, sequencing, enter, exit, and other effects are set. The Effects set here take place based on the order that they are placed. For the Today.pct graphic, set the effects listed on the next page.

Figure E2.2

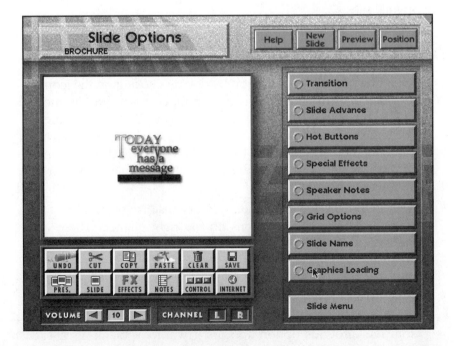

1. Item number 1 in the Effects menu shows that Background Enters is the first event. Next is Graphic 1 Enters. Graphic 1 happens to be the Today.pct file since it was the first graphic entered. It becomes labeled as Graphic 1. When this box is selected, the two options in the lower section indicate No Transition and Immediately. These contain menus which allow other options to be selected. From the No Transition menu, select Fade In. From the Timing menu select After .5s. This translates to "after one half of one second."

2. Next in line in the Effects menu is the Slide Exits selection. This should be moved because Graphic 1 must exit first. Click and hold the mouse button down and drag the Graphic 1 Exits menu above the Slide Exits menu. This will change the order of the Effects.

3. With this box in front of the Slide Exits menu, set the following attributes:

 Transitions: Fade Out Timing: After 1.5s

4. Set the Slide Exits Timing pull-down menu to Immediately.

When complete, the Effects menus should look as shown in Figure E2.3. Select the Done With Effects button at the bottom of the screen.

When you return to the main menu, select the Preview button at the top of the screen. This allows you to preview what you have just done. Upon completion, click once on the screen to return again to the slide menu.

This constitutes the entire first slide. To exit the slide editing menu and to return to the main menu, select the Slide Menu option and then select the Done With Slide button. Your screen will look like Figure E2.4.

Figure E2.3

Each slide in this exercise contains graphics, sounds, or text. The performance of all of these media elements can be affected by making changes in the Effects, or FX, menu. If you desire, as elements are placed on each slide, they can be named for easy reference. This is done as follows: In the FX menu, select the item to be changed by clicking on it once. Once selected, double-click on the title, (ie, Graphic 1 Enters), this will open a window called Object Name. Type in the desired name for the media elements here and choose OK. The object will now be named in the FX window. Also note that as FX menu items are selected, the object on the slide is also selected. This demonstrates that you are making changes to the desired media element. This exercise does not demonstrate or require that these titles be added. This is an optional step.

Figure E2.4 The Presentation Menu demonstrating the slide just created.

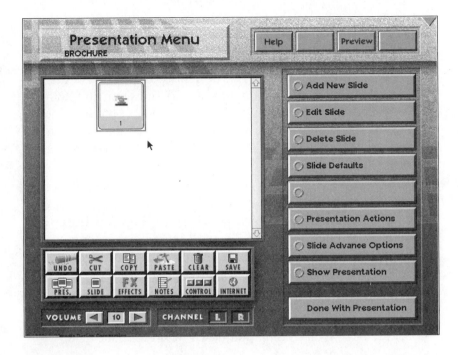

Slide 2

1. Create a new slide by selecting the Add New Slide menu.

2. Select the White background as done previously.

3. Select the Text menu, then the Add New Text menu. A text area will appear on the slide with a blinking cursor.

4. Type the following: *is yours being*

5. Select the text by clicking, and holding the mouse button and dragging across the text. While selected, set the following text attributes from the menus on the right:

 Font: Times
 Style: Bold/Italic/Smoothing
 Size: 48
 Color: Black (the color chip in the lower right of the color palette)
 Justification:Center
 Text Type: Normal
 Once these selections have been made, select Done With Text.

6. Center the text on the screen by using the Grid function. Select Slide Menu, then choose the Slide Options menu. Next choose Grid Options. Set the Grid size to 20, check Show Grid and Snap

As text attributes are being selected, at the bottom of the menu is a Voice option. Macintosh models that have speech recognition software installed can select the Voice option and the text will be spoken. This feature will not be used in this exercise. Therefore, ignore the Voice option when selecting text attributes.

Figure E2.5

Figure E2.6 Using the Grid option to align text on the screen.

to Grid. Press OK. See Figure E2.5. You will notice that the grid did not appear. To see the grid, and to reposition the text, select the Position button at the top of the Screen. Here, the text can be moved into the desired position, or in this case, the center of the screen. The text can be repositioned by clicking and dragging with the mouse, or by selecting the text and using the up or down arrow key on the keyboard. Note: If you click anywhere on the screen but the text, you will return to the previous screen. This is also how you exit when you are finished positioning the text.

The next step is to import additional files.

7. Return to the Slide Menu. Choose Graphics, Add New Graphic, Computer, then import the following in order from the MEDIA folder:

Heard1.pct This will become Graphic 1 in the FX Menu.

Heard2.pct This will become Graphic 2 in the FX Menu.

Question.pct This will become Graphic 3 in the FX Menu.

These files will be placed on the stage on top of each other in the upper-left side of the slide. Some of the files may not be visible due to the fact that they are stacked (see Figure E2.7).

You can preview a slide by using the Preview button at the top of the screen.

Figure E2.7

Figure E2.8 An icon indicating that a sound file has been imported.

Figure E2.9 FX for slide 2.

8. Select Slide Menu then Audio then Add New Audio then Computer. Open the MEDIA folder and select the file BOOM.MOV and choose Open. This will become Audio 1 in the FX Menu. When this sound file opens, a dialog box may open asking if you wish to move this file to the Audio folder. Select No. You will notice that a box with a musical note appears on the slide (see Figure E2.8). This indicates that the sound file has been incorporated into this slide.

Now that these files have been imported, they will be assigned their on-screen performance characteristics in the FX menu.

9. Return to the Slide Menu. Choose the FX Button. Adjust FX window as shown in Figure E2.9. Note: The FX items are in a scrollable window. This means that you can go up or down to view the entire range of items. The light gray items are currently active items, while the items in dark gray are inactive. The inactive items can be made active by clicking and dragging the items to a new location, either in front of or behind another effect, but above the Slide Exits item. This section of the exercise will make use of this technique.

The settings in Figure E2.9 should be set for the items currently on the slide. Drag the appropriate items into position based on Figure E2.10. Basically, all of the objects need to be centered on the slide, with the exception of the question mark. Also, there is no need to rearrange the music icon. This represents that an audio file is in place, but its icon does not appear in the presentation. Note that items that have been removed have simply been dragged into the inactive portion of the FX window. Items that are now active that originally were not active have been dragged into the active portion of the FX window.

Figure E2.10 Graphics in position.

 Notice that as items are selected in the FX window that the corresponding on-screen item is selected. This principle also works in reverse. Make sure that the Graphic, 1, 2, and 3 files in the FX window are positioned on the slide for smooth playback. Use the Preview function while in the FX window to see how changes perform. To exit the Preview screen click on the screen to return to the previous screen.

 Note: During this section, the Audio Enters FX was moved to the inactive section of the FX menu. There is no need for the audio to enter into this slide. The only function of the audio here is for it to play in the designated sequence. This is why the Audio Enters FX was relocated.

 When this portion works satisfactorily, select the Done With Effects button. Check the original file if you need to review the nature of the effects.

Slide 3

1. From the Presentation Menu, select the Add New Slide button.

2. Set the Background to White as done in Slides 1 and 2.

3. From the Slide Menu, select the Graphics button. Next, choose Add New Graphic, then select Custom from the Select a source... menu. Select the Filled Rectangle in the upper-left corner then click OK. Now, you are ready to draw a rectangle. The pointer has changed to a crosshair and is ready to click, drag, and release. Draw a rectangle approximately four and a half inches wide and five and three-quarter inches high. Note: Your actual graphic may vary. Refer to Figure E2.17 for proportions relative to your screen size. As the mouse button is released, the menu on the right will provide Shape and Color options. Choose Color. When the Color Palette opens, choose Black, or the color in the lower-right side of the Palette. Select the Done With Graphic button.

The FX Effects window allows events to be moved. This will affect the associated text, graphic, or sound as to when they enter, exit, or what special effect they will perform.

4. Return to the Slide Menu. Next, select the text menu. Choose Add New Text and type:

Grow in the future using multimedia technologies.

Set the text attributes as follows:

Font: Times
Style: Smoothing
Size: 48pt
Color: White
Justification: Left
Text Type: Normal
Next, select Done With Text

Figure E2.11 The Color Palette.

5. Position the text on the black rectangle. Use the screen image shown in Figure E2.12. When the body of text is selected, the frame around the text can be adjusted using the small box located in the lower right side of the text area. Click and hold in the body of the text and drag it into the desired position. Use the Position button at the top of the screen to enlarge the view of the slide. You can use the arrow keys on the keyboard for precision alignment. Make adjustments to the rectangle as required to match the image shown in Figure E2.12. Note: The dimensions used above are a guide only. Return to the Slide Menu.

The Transition speed pull-down menu appears when any of the "from" options are chosen from the transition pull-down menu.

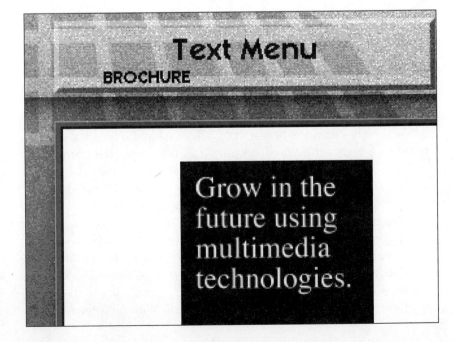

Figure E2.12 Positioning a rectangle on the slide.

Figure E2.13

Figure E2.14

Figure E2.15 The Color Palette.

As you reposition graphics, sometimes they appear to not select or move immediately. Press and hold the mouse on the object for a second to two, then drag the object to the desired location.

6. Next, select the Graphics, then the Add New Graphic menu. Select Custom as the source, then select the Line tool (see Figure E2.13). Draw a horizontal line under the word Grow (see Figure E2.14). When the line is drawn, choose Line Thickness from the menu. In the top row, select the first line option on the left side and choose OK. Next, select the Color menu. When the color palette opens, in the third line from the bottom, select the red chip eight spaces from the left. Press OK. Position as shown then select Done With Graphic.

7. Return to the Slide Menu. Create a new typed entry, select Text, then Add New Text and type the word *CHADWICK*.

 Set the following attributes:

 Font: Times
 Style: Smoothing
 Size: 48pt
 Color: Gray (see Figure E2.15)
 Justification: Left
 Text Type: Normal

8. Return to the Text Menu and choose Add New Text once more and type: *associates*. This will be all lowercase type. The text attributes are as in Step 7 above. Position these text items as shown in Figure E2.16.

9. Return to the Slide Menu and select the Graphic Menu. Repeat the line selection process and draw another line and place it under the word CHADWICK. Once drawn, choose the same

Figure E2.16

Figure E2.17

Save your work on a
regular basis.

attributes as the line from Step #7. Resize and reposition as needed. See Figure E2.17 for placement.

10. From the Slide Menu, select the Graphic menu, then choose Add New Graphic, then select the Computer option. Open the MEDIA folder and locate the file Can-Help.pct. Once imported, place the graphic in the lower right side of the screen (see Figure E2.17).

11. From the Slide Options screen, select FX. When the FX window opens, make the settings as shown in Figure E2.18. Make sure to drag events that are not needed to the inactive section and inactive features needed to the active section.

If the procedure has been followed for the importation and creation of files in Slide 3, then the FX and the sequence in the FX windows should match Figure E2.18. If you need to reference the original file for any reason, save you work now and open the original Ex2 file for review. Remember that only one mPower file can be open at a time. Also remember that this version of mPower is a full retail version, allowing you to save your work.

Figure E2.18

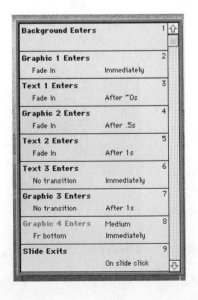

When finished, close the FX window. Navigate back to the Slide Menu and then select Done With Slide. At this point, your screen should look like Figure E2.19. This figure illustrates that there have been a total of three slides developed thus far. They are in chronological order.

Slide 4

Slide 4 will be the main interface screen for the rest of this presentation.

1. Create a new slide with a white background as done in Slides 1, 2, and 3.

2. Select the Text menu, then the Add New Text button. Type: *Navigation Screen*

 Make the type attributes for this text as follows:

 Font: Times
 Style: Smoothing
 Size: 48pt
 Color: Red
 Justification:Left
 Text Type: Normal
 Select Done With Text

Occasionally, graphic and text files will overlap. Select the files that cover these graphics and temporarily move them while repositioning the underlying image.

Figure E2.20

When moving a graphic use the shift key to restrict vertical and horizontal movement.

When previewing a slide, you can exit the preview mode by pressing the "esc" key once or by clicking anywhere on the screen.

3. Return to the Slide Menu. Select the Graphics menu, then choose Add New Graphic. Select Custom and press OK. Select the line option and press OK. Draw a horizontal line under the words Navigation Screen. When finished, choose Line Thickness from the menu. In the top row, select the first line option on the left side and choose OK. From the Color menu select red again. Select the Done With Graphic button. Next, copy the line and paste it into the same position at the bottom of the screen (see Figure E2.20).

4. Using the Add New Graphic menu, add the following graphic files in the order as shown below:

 1. MMPres Icon
 2. Software Icon
 3. CD-ROM Icon
 4. CBT Icon
 5. Kiosk Icon
 6. Exit.pct

5. Add the following text: *Select a Topic for Additional Information*

 Do this by first selecting "Text" from the Slide Menu, then "Add New Text"

 Set the text attributes as follows:

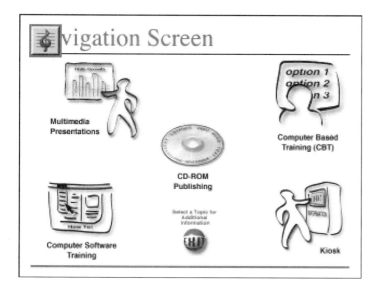

Figure E2.21

Font: Helvetica
Style: Bold/Smoothing
Size: 12pt
Color: Red
Justification:Center
Text Type: Normal
Select Done With Text

Figure E2.22

6. From the Slide Menu select the Audio button. Next, select Add New Audio and then Computer from the Select a source... window. Locate the file Chimes.mov and choose Open. If asked to move this file to the Audio folder, select NO. An icon will appear on the slide screen indicating that the sound file has been placed. This will be adjusted in the FX menu.

 Place the items in step 4, 5, and 6 as shown in Figure E2.21.

 Note: This screen will have interactive links established as the exercise progresses. In order to do this, other slides must be added to establish where these links will advance to. Keep this in mind as the next five slides are developed.

7. Set the FX window for Slide 4 as shown in Figure E2.22.

Slide 5

1. Create a new slide as previously done. Make the background white.

2. Using the Text menus, type the following heading:
 Multimedia Presentations
 This text will become Text 1 in the FX menu.
 Set the type attributes as follows:
 Font: Times
 Style: Smoothing
 Size: 48pt
 Color: Black
 Justification:Left
 Text Type: Normal
 Select Done With Text

 Place the heading in the upper-left corner of the screen.

3. Import the following files in order: These files are in the MEDIA folder.

 1. Chimes.mov (audio file) Audio 1 in FX
 2. Locator1.pct (graphic) Graphic 1 in FX
 3. MMPres.pct (graphic) Graphic 2 in FX
 4. Projectr.pct (graphic) Graphic 3 in FX
 5. Exit.pct (graphic) Graphic 4 in FX

4. Using the Text menus, enter the following text. Reduce the size of your text to 24 pt.

We produce multimedia presentations that mean business. Take advantage of our years of graphic design expertise to deliver your message effectively.

We will show you how to stay successful as well as competitive by using state-of-the-art presentation techniques which will supercharge your audience.

This text will become Text 2 in the FX menu. Text attributes are:
Font: Times
Style: Smoothing
Size: 24pt
Color: Black
Justification:Left
Text Type: Normal
Select Done With Text

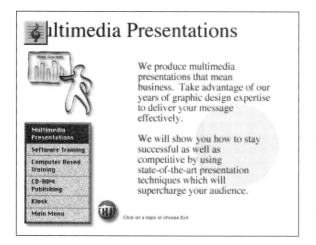

Figure E2.23

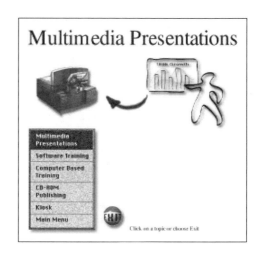

Figure E2.24

5. Using the Graphics menus, draw a filled circle approximately two inches in diameter. The circle does not need to be precise. Color it the lightest gray possible from the color palette. This will become Graphic 5 in the FX menu.

 Position the graphics for this screen as shown in Figure E2.23. Position the graphic files MMPres.pct and Projectr.pct in the same location. Their visibility on the screen during the presentation will be determined by their arrangement in the FX menu. In this case, the projector will be the predominant graphic but the line drawing will appear, then disappear, first.

6. Type the following text to be inserted at the bottom of the screen:

 Click on a topic or choose Exit

 This text will become Text 3 in the FX menu.

 Text attributes are as follows:

 Font: Helvetica
 Style: Bold/Smoothing
 Size: 12pt
 Color: Red
 Justification:Left
 Text Type: Normal
 Select Done With Text

7. The FX window should be set as shown in Figure E2.25. This illustration also demonstrates the graphic placement.

Figure E2.25

Figure E2.26

Slide 6

1. Create a new slide as previously done. Make the background white.

2. Using the Text menus, type the following heading:

 Computer Software Training

 This text will become Text 1 in the FX menu.

 Set the type attributes as follows:

 Font: Times
 Style: Smoothing
 Size: 48pt
 Color: Black
 Justification: Left
 Text Type: Normal
 Select Done With Text

 Place the text in the upper left corner of the screen.

3. Import the following files in order:

 1. Chimes.mov (audio file) Audio 1 in FX
 2. Locator2.pct (graphic) Graphic 1 in FX

While in the FX menu, you cannot use the Position option normally at the top of the screen. Exit FX to have access to the Position function.

3. Software.pct (graphic) Graphic 2 in FX
4. Training.pct (graphic) Graphic 3 in FX
5. Trainlst.pct (graphic) Graphic 4 in FX
6. Exit.pct (graphic) Graphic 5 in FX

Position the graphics as shown in Figure E2.26.

Use the Position feature to have access to a full screen for easy positioning.

4. Type the following text to be inserted at the bottom of the screen:

 Click on a topic or choose Exit

 This will become Text 2 in the FX menu.

 Text attributes are as follows:

 Font: Helvetica
 Style: Bold/Smoothing
 Size: 12pt
 Color: Red
 Justification:Left
 Text Type: Normal
 Select Done With Text

5. The FX window should be set as shown in Figure E2.27.

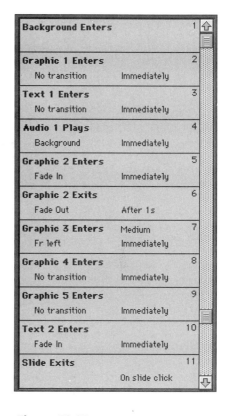

Figure E2.27

Slide 7

1. Create a new slide as previously done. Make the background white.

2. Using the Text menus, type the following heading:

 Computer-Based Training

 This will become Text 1 in FX.

 Set the type attributes as follows:

 Font: Times
 Style: Smoothing
 Size: 48pt
 Color: Black
 Justification:Left
 Text Type: Normal
 Select Done With Text

Figure E2.28

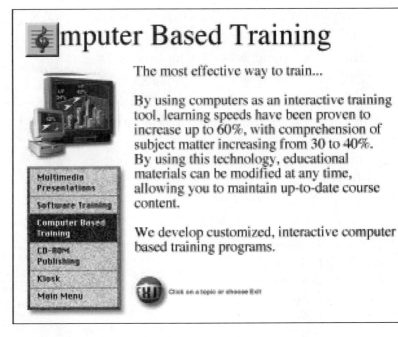

Place the heading in the upper left corner of the screen.

3. Import the following files in order:

 1. Chimes.mov (audio file) Audio 1 in FX

 2. Locator3.pct (graphic) Graphic 1 in FX

 3. CBT.pct (graphic) Graphic 2 in FX

 4. CompTV.pct (graphic) Graphic 3 in FX

 5. Exit.pct (graphic) Graphic 4 in FX

Position the graphics as shown in Figure E2.28. Similar to last time, CBT and CompTV are placed in the same location. Use the Position feature to have access to a full screen for easy positioning.

4. Type the following information:

 The most effective way to train...

 By using computers as an interactive training tool, learning speed has been proven to increase up to 60%, with comprehension of subject matter increasing from 30% to 40%. By using this technology, educational materials can be modified at any time, allowing you to maintain up-to-date course content.

 We develop customized, interactive computer-based training programs.

 This text will become Text 2 in FX.

Text attributes are:

Font: Times
Style: Smoothing
Size: 24pt
Color: Black
Justification:Left
Text Type: Normal
Select Done With Text

5. Type the following text to be inserted at the bottom of the screen:

 Click on a topic or choose Exit

 Text attributes are:

 Font: Helvetica
 Style: Bold/Smoothing
 Size: 12pt
 Color: Red
 Justification:Left
 Text Type: Normal
 Select Done With Text

6. The FX window should be set as shown in Figure E2.29. This illustration also demonstrates the graphic placement.

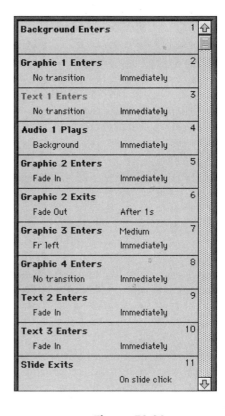

Figure E2.29

Slide 8

1. Create a new slide as previously done. Make the background white.

2. Using the Text menus, type the following heading:

 CD-ROM *Publishing*

 This will become Text 1 in FX.

 Set the type attributes as follows:

 Font: Times
 Style: Smoothing
 Size: 48pt
 Color: Black
 Justification:Left
 Text Type: Normal
 Select Done With Text

 Place this heading in the upper left corner of the screen.

Figure E2.30

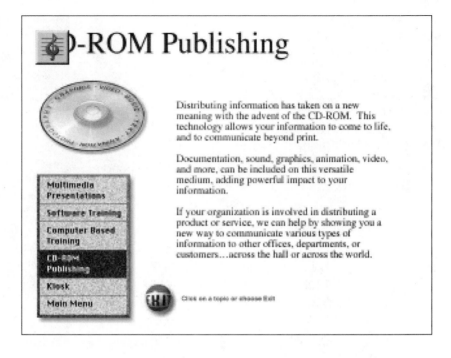

3. Import the following files in order:

 1. Chimes.mov (audio file) Audio 1 in FX
 2. Locator4.pct (graphic) Graphic 1 in FX
 3. CDROM1.pct (graphic) Graphic 2 in FX
 4. CDROM2.pct (graphic) Graphic 3 in FX
 5. Exit.pct (graphic) Graphic 4 in FX

 Position the graphics as shown in Figure E2.30.

 Use the Position feature to have access to a full screen for easy positioning.

4. Type the following information:

 Distributing information has taken on a new meaning with the advent of the CD-ROM. This technology allows your information to come to life, and to communicate beyond print.

 Documentation, sound, graphics, animation, video, and more, can be included on this versatile medium, adding powerful impact to your information.

CD-ROM Publishing

If your organization is involved in distributing a product or service, we can help by showing you a new way to communicate various types of information to other offices, departments, or customers, across the hall or across the world.

Text attributes are:

Font: Times
Style: Smoothing
Size: 18pt
Color: Black
Justification:Left
Text Type: Normal
This will become Text 2 in FX. Select Done With Text.

Note: Make sure that the CD-ROM images are placed on top of each other. They are very similar in appearance; however, one will be in front of the other due to the sequence in which they were imported and the organization in the FX menu. As in previous slides, the first image will appear, then fade. Next, the second image will enter from the left.

5. Type the following text to be inserted at the bottom of the screen:

 Click on a topic or choose Exit

 This will become Text 3 in FX.

 Text attributes are as follows:

 Font: Helvetica
 Style: Bold/Smoothing
 Size: 12pt
 Color: Red
 Justification:Left
 Text Type: Normal
 Select Done With Text

6. The FX window should be set as shown in E2.32. This illustration also demonstrates the graphic placement.

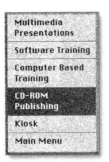

Figure E2.31

Figure E2.32

Figure E2.33

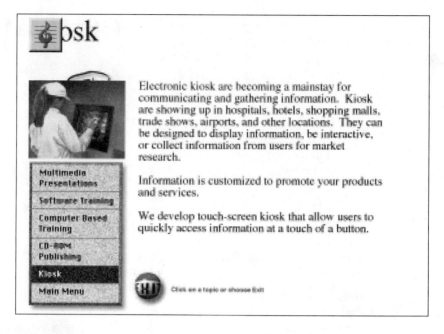

Slide 9

1. Create a new slide as previously done. Make the background white.

2. Using the Text menus, type the following heading: *Kiosk*

 This will become Text 1 in FX.

 Set the type attributes as follows:

 Font: Times
 Style: Smoothing
 Size: 48pt
 Color: Black
 Justification:Left
 Text Type: Normal
 Select Done With Text

 Place the heading in the upper-left corner of the screen.

3. Import the following files in order:

 1. Chimes.mov (audio file) Audio 1 in FX

 2. Locator5.pct (graphic) Graphic 1 in FX

 3. Kioskart.pct (graphic) Graphic 2 in FX

 4. Kiosk.pct (graphic) Graphic 3 in FX

 5. Exit.pct (graphic) Graphic 4 in FX

 Position the graphics as shown in Figure E2.33.

Use the Position feature to have access to a full screen.

4. Type the following information:

 Electronic kiosks are becoming a mainstay for communicating and gathering information. Kiosks are showing up in hospitals, hotels, shopping malls, trade shows, airports, and other locations. They can be designed to display information, be interactive, or collect information from users for market research.

 Information is customized to promote your products and services.

 We develop touch-screen kiosks that allow users to quickly access information at a touch of a button.

 This will become Text 2 in FX.

 Text attributes are:

 Font: Times
 Style: Smoothing
 Size: 20pt (In Edit Text, select Size then choose Other
 Size and type 20)
 Color: Black
 Justification:Left
 Text Type: Normal
 Select Done With Text

5. Type the following text to be inserted at the bottom of the screen:

 Click on a topic or choose Exit

 This will become Text 3 in FX.

 Text attributes are as follows:

 Font: Helvetica
 Style: Bold/Smoothing
 Size: 12pt
 Color: Red
 Justification:Left
 Text Type: Normal
 Select Done With Text

6. The FX window should be set as shown in Figure E2.34. This illustration also demonstrates the graphic placement.

Slide 10

This slide represents the first slide of the closing graphic sequence.

1. Create a new slide by selecting Add New Slide. The background should be black.

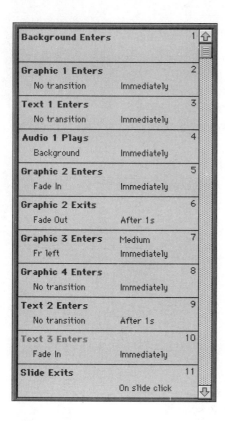

Figure E2.34

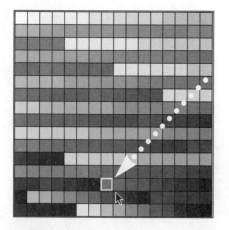

Figure E2.35

2. Select Text, then Add New Text and type the following:

 CHADWICK

 This text should be capitalized. This will become Text 1 in FX.

 Text attributes are as follows:

 Font: Times
 Style: Smoothing
 Size: 72pt
 Color: Gray
 Justification: Center
 Text Type: Normal
 Select Done With Text

3. Select Add New Text. Type in the following:

 associates

 This will become Text 2 in FX.

 Text attributes are as follows:

 Font: Times
 Style: Italic/Smoothing
 Size: 72pt
 Color: Gray
 Justification: Left
 Text Type: Normal
 Select Done With Text

4. Select the Graphics menu and choose Add New Graphics, then Custom and select OK. Click the line tool in the top-right corner and choose OK. Draw a horizontal line under the word CHADWICK. When the line is drawn, choose Line Thickness from the menu. In the top row, select the third line from the left and choose OK. Next, select Color and choose the red as indicated in Figure E2.35, (the third line from the bottom and the eighth block from the left). Choose OK. This will become Graphic 1 in FX.

5. Open the Audio menu. Choose Add New Audio, Computer, then choose FADE.MOV. This sound will play in the background while the red line enters the screen. This effect will be set in the FX menu. This will become Audio 1 in FX.

Figure E2.36

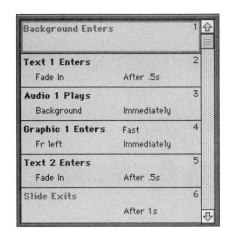

Figure E2.37

6. Position the text and graphics as shown in Figure E2.36.
7. The FX window should be set as shown in E2.37. This illustration also demonstrates the graphic placement.

Slide 11

The purpose of this slide is to simply create a blank black slide that slide 10 will exit to as an interim step to slide 12. This slide will consist of a background only.

1. Select Add New Slide from the Presentation Menu. The background should default to Conservative 1, or black, from the Background menu. If not, select it.
2. While in the Slide Menu, choose the Slide Options button. When this menu opens, select Transition. Next, select Sweeps, then choose the graphic that has an arrow pointing to the right.
3. Open the FX menu and select Slide Exits, Immediately (see Figure E2.38). Choose Done With Effects.
4. From the Slide Options menu, choose Slide Advance and select Go To The Next Slide In Order, then choose OK.
5. Select Slide Menu, then Done With Slide to return to the Presentation Menu.

This completes Slide 11.

Figure E2.38

Slide 12

This slide will introduce a sound and text object.

1. Select Add New Slide from the Presentation Menu. The background should be black as in Slide 11.

2. Select Text from the Slide Menu, then Add New Text.

 Type the following: *multimedia*

 Text attributes are as follows:

 Font: Helvetica
 Style: Bold/Smoothing
 Size: 96pt (select Other Size and type 96)
 Color: Red
 Justification:Center
 Text Type: Normal
 Select Done With Text

3. Select Text from the Slide Menu, then Add New Text.

 Type the following: *for everyone!*

 Text attributes are as follows:

 Font: Times
 Style: Italic/Smoothing
 Size: 72pt
 Color: Red (as in step 2)
 Justification:Right
 Text Type: Normal
 Select Done With Text

4. From the Slide Menu, choose Audio, then Add New Audio. Select Computer and choose OK. Import the file CROWD.MOV. Choose NO if asked to move the file. Arrange the screen and make the FX settings as shown in Figure E2.39.

Figure E2.39

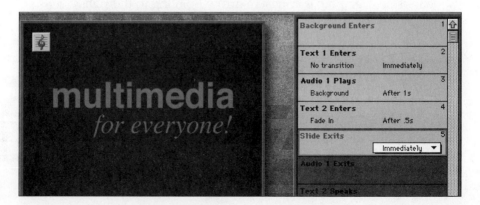

5. When finished with the FX menu, select the Transition button from the Slide Options screen. Select Doors as the transition type, then select the third option from the right in the top row and choose OK.

This completes Slide 12. Before continuing, save your presentation.

Slide 13

This will be another blank slide with a black background. The purpose of this slide is to be used as an in-between slide for effect only.

1. Create a new slide with a background of Conservative 1, or black.

2. Open the FX menu and choose Slide Exits, After 1s. see Figure E2.40. Select Done With Effects.

Figure E2.40

3. Select the Transition button and choose Doors. Next choose the second transition from the right on the top row. Press OK.

4. Select the Slide Advance button and choose Go To The Next Slide In Order.

5. Select the Slide menu then Done With Slide.

Slide 14

1. Create a new blank black slide as done in Slide 13.

2. Add the following text: *For More Information, Call 1-800-000-0000*

 Text attributes are as follows:

 Font: Times
 Style: Smoothing
 Size: 60pt
 Color: White
 Justification:Center
 Text Type: Normal
 Select Done With Text

3. Select Add New Text and type the following: *Click anywhere to quit*

 Text attributes are as follows:

Figure E2.42

Figure E2.41

Font: Helvetica
Style: Smoothing
Size: 18pt
Color: White
Justification:Left
Text Type: Normal
Select Done With Text

See Figure E2.41 for text placement. Note: This graphic is shown reversed for clarity. The background should be black with white text.

4. Open the FX menu and make the changes as shown in Figure E2.42.

5. Close the slide.

Slide 15

1. Create a new slide with a black background as done in Slide 14.

2. Select Slide Options, then Transition. Select Sweeps then the first transition from the left in the top row. Choose OK.

3. Open the FX window and choose: Slide Exits, Immediately. Choose Done With Effects.

4. From the Slide Options menu, choose Slide Advance, then select Go To The Next Slide In Order.

5. Select the Slide Menu then Done With Slide button.

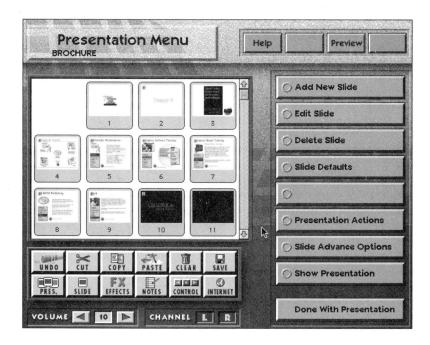

Figure E2.43

The Navigation Screen is where this presentation pauses after the brief introduction. From here, you will be able to go directly to specific topics.

6. Save your presentation.

Your Presentation Menu will look like Figure E2.43. The scroll bar on the right side of the slides allows you to view all of the slides.

Creating Interactivity Using the Hot Button Feature

So far, you have created a presentation that has substance, but no control built in to make it run, or to be interactive. Now that you have developed the content, this phase will show you how to add hot buttons that allow branching to other locations based on where you click, and on instructions you make as to what actions should take place.

The following slides contain hot buttons and describe their link and functioning. At this point, go back through the presentation and assign these buttons as shown in this section. Slide 4 is the main navigational screen, allowing branching to the five main topics in the presentation (see Figure E2.44).

Double-clicking on a hot button will open the Slide Action screen.

Figure E2.44

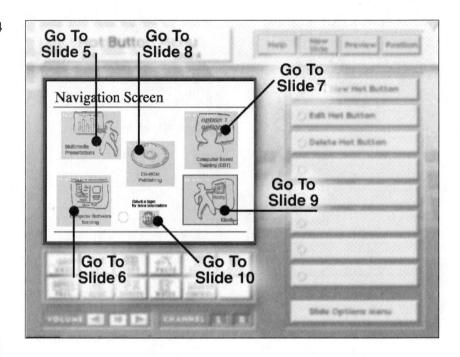

○ Slide Options

○ Hot Button

○ Add New Hot Button

Figure E2.45

This screen will contain the capability to launch to other slides. Likewise, once at other slides, you will have the capability to return to this slide or to other locations.

1. To begin placing hot buttons, double-click on Slide 4. Once the slide is active, select the following sequence of menu options:

　1. From the Slide Menu choose Slide Options

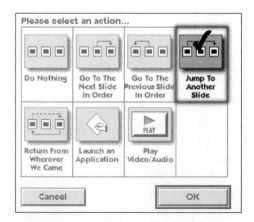

Figure E2.46

Figure E2.47

2. Next, choose Hot Button.

3. From the Hot Button Options, select Add New Hot Button.

4. When you choose Add New Hot Button, a window will open prompting the selection of an action that the button will perform. For this exercise, the Jump To Another Slide option is the only option that will be used. See Figure E2.46.

When this option is selected, the available slides will appear in a reduced view. Choosing a slide and then Select This Slide will make the hot button jump to that slide (see Figure E2.47).

5. When the slide is selected, a green rectangle will appear in the upper-left corner of the screen. This rectangle has a small square in the lower right side. By clicking and dragging in this box, the size of the rectangle can be adjusted to fit over a specified area (see Figure E2.48).

Figure E2.49 demonstrates how to place the hot buttons on the screen and how to position them to cover a desired area. Use this technique to assign all of the links for the Navigation Screen. Refer to Figure E2.44 for placement of the hot buttons on this slide.

Note: In order to test Hot Buttons, you must select the Show Presentation option, not the Preview option.

Using the Position option found at the top of the screen allows you to have a full-screen view. While placing hot buttons, you can also see the instructions for what the button will do.

Figure E2.48

Figure E2.49

Drag Hot Button Into Position

Click Here and Drag To Resize the Hot Button Area

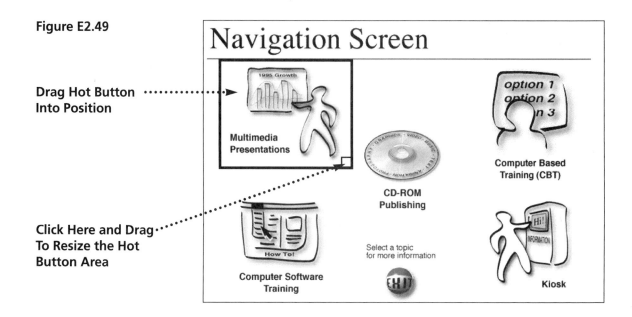

The hot buttons placed on Slide 4 will link to other slides in the presentation. The next section will detail the hot button placement for Slides 5, 6, 7, 8, and 9. This allows for total presentation linking to be established, so that no matter where you are, you can navigate back to almost any screen.

Refer to Figures E2.50 through E2.54 for coordination of how the locator hot buttons are to be assigned. As these menus reflect interactive buttons, make sure that the entire button area is covered with the hot button field. This will ensure that the user can select any portion of the button and have it perform its designated function. Make sure that the links are established for each.

This completes Exercise 2. Save your work, and review what you have done.

Figure E2.50

Figure E2.51

Hot Buttons for Slide 7

- Multimedia Presentations — Jump to slide 5
- Software Training — Jump to slide 6
- Computer Based Training — No Hot Button Here
- CD-ROM Publishing — Jump to slide 8
- Kiosk — Jump to slide 9
- Main Menu — Jump to slide 4

EXIT — Jump to slide 10

Figure E2.52

Hot Buttons for Slide 8

- Multimedia Presentations — Jump to slide 5
- Software Training — Jump to slide 6
- Computer Based Training — Jump to slide 7
- CD-ROM Publishing — No Hot Button Here
- Kiosk — Jump to slide 9
- Main Menu — Jump to slide 4

EXIT — Jump to slide 10

Figure E2.53

Hot Buttons for Slide 9

- Multimedia Presentations — Jump to slide 5
- Software Training — Jump to slide 6
- Computer Based Training — Jump to slide 7
- CD-ROM Publishing — Jump to slide 8
- Kiosk — No Hot Button Here
- Main Menu — Jump to slide 4

EXIT — Jump to slide 10

Figure E2.54

Sales Presentation
Authoring Software:
Adobe Persuasion
Macintosh and Windows

This exercise is designed to provide multimedia exposure in a basic format using presentation software. Here you will use Adobe Persuasion Version 3.0. Persuasion software has grown with great sophistication since its introduction. With the ability to accept graphics, sounds, movies, and other file formats, this program provides a varied exposure toward the preparation of sophisticated presentations.

The material prepared in this exercise allows you to assemble a sales presentation designed to support a speaker as he presents a report to his audience. Presentation graphics in this format provide excellent communication techniques. This presentation will expose you to a vast array of media elements and techniques designed to gain audience attention.

Presentation software offers a variety of multimedia features. Based on your needs, you can develop presentations with various degrees of sophistication. Having the ability to incorporate interactive links, graphics, sound, and video, you can make presentations extremely simple or very complex.

Before beginning this exercise, it will be helpful if you view the completed exercise. This can be done as follows: Using the steps on the following page, load Persuasion 3.0. When the main menu appears select Open presentation.... If you are a Macintosh user, open Ex3 from the MEDIA folder. If you are a Windows user open Ex3.pr3, also from the MEDIA folder. When the file opens select View > Slide show > Show all slides.

In Persuasion 3.0 for Windows, only one presentation can be opened at a time. Therefore, it is recommended that Windows users preview the completed exercise prior to beginning.

Macintosh users: Persuasion for the Macintosh will allow you to open more than one document at a time. This will let you view the completed exercise as needed.

Note: The demo software versions on the CD-ROM are Save-Disabled versions. This means that you will not be able to save your work. The program is fully functional with this exception. Keep this in mind as you work through this exercise.

If you own a copy of Persuasion, and plan to use it for this exercise, then you will be able to save your work during the development process.

Before beginning the exercise, take a minute to familiarize yourself with the Persuasion menus and windows. These are broken down at the end of this exercise.

What You Will Learn

- Layering
- Transition Effects
- Visual Effects
- Autojump
- Animation
- Adding Audio/Video

Installation

Macintosh

To use Adobe Persuasion 3.0 from the CD-ROM:
1. On the CD-ROM, open the folder named Demo Software.
2. Open the Adobe Persuasion™ 3.0 Tryout folder.
3. Double-click on the file Adobe Persuasion 3.0 Tryout.

Recommended Macintosh Installation

For best results, install as follows:
1. Open the Demo Software folder and locate the Adobe Persuasion™ 3.0 Tryout folder.
2. Copy this folder to your hard disk drive. This can be done by dragging the folder over the icon representing your hard disk drive.
3. This folder will consume approximately 6.5MB of disk space.

Windows

To use Adobe Persuasion 3.0 from the CD-ROM:
1. In the Demosoft folder, open the Persuasn folder.
2. From the Persuasn folder, open the file Pr3.exe. This is the Persuasion 3.0 application program.

Recommended Windows Installation

1. In the Demosoft folder, locate the Persuasn folder.
2. Copy the entire folder onto your hard disk drive. This folder will require approximately 9MB of disk space.

Important Note: This exercise requires that the QuickTime extension be installed on your computer.

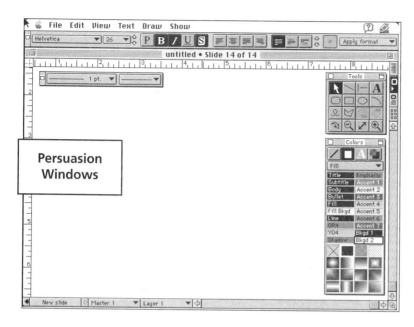

Figure E3.1

The Macintosh and Windows version of Persuasion are fundamentally identical. The graphics used in this exercise have been captured from the Macintosh version. If you are using the Windows version, you will notice some slight variances in some features. This should not hinder the development of this exercise in any way.

Open the Adobe Persuasion 3.0 Tryout version. When the Persuasion window opens, choose the Open presentation... option.

Building the Slide Master

Persuasion 3.0 uses what is called a Master Slide. Any elements added to this slide are automatically included in all subsequent slides. To build this slide use the following steps:

Macintosh

1. Open template.pr3 from the MEDIA folder on the CD-ROM.
2. As this file opens, it will be in the Master Slide.

Windows

1. Open template.atf from the MEDIA folder on the CD-ROM.
2. As this file opens, it will be in Slide 1 of the presentation. In order to change to the Master Slide, first open the View menu. Then select Slide Master > Master 1 from the pop-out menus.

Figure E3.2 The opening screen to Adobe Persuasion Tryout Version.

Figure E3.3
Importing the
presentation
background.

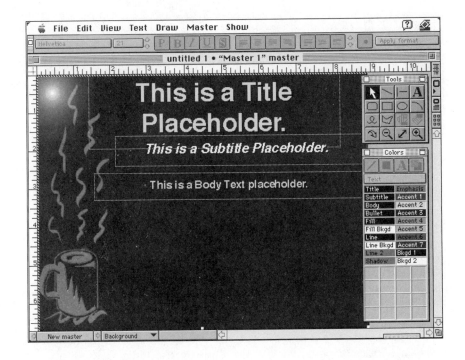

You cannot save
your work unless
you are using a
registered copy of
Adobe Persuasion
3.0.

Graphic files for
Windows users will
have a .tif
extension. Mac users
graphic files have a
.pct extension.

When importing
files in Windows
you must select the
placement area for
the file by single-
clicking the desired
location on the
screen.

A new slide contains
all of the elements
established on the
Master Slide.

3. To import the background for the Master Slide, open the File menu and select Import, then Graphics from the pop-out menu. Open the MEDIA folder, select the file Backgnd.pct (Windows users select Background.tif. See note in margin) and choose Import. This file should be placed on the screen behind the text elements. You can send the graphic to the back by choosing the Draw menu, then Send > To Back. Make sure that the graphic is centered on the screen, covering the entire slide.

The text placement and the background are the foundation for the presentation. They will be contained on each slide. The screen should look like Figure E3.3.

Customizing the Color Palette

Before slides are developed for this exercise it is important that steps be added to make custom color selections easy. Persuasion's color palette can be customized, thus allowing specific colors to be assigned to the palette prior to the development of the presentation. For this exercise, a few colors will be selected and placed in the Color palette at pre-determined locations. This will simplify color selection throughout the remainder of the exercise. The process involves copying custom

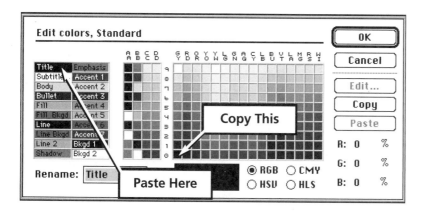

Figure E3.4
Macintosh Users

color-chips to the working palette. To begin, expand your Color palette by selecting the expand/collapse box in the upper-right corner of the palette.

Macintosh

1. Select the Edit... button from the top of your expanded Color palette.
2. When the Edit colors, Standard window comes up select GY0 (black) from the right-most color-chip matrix (see Figure E3.4).
3. Select Copy.
4. Select the top-most, left-hand location in the color palette (Title) and select Paste.
5. Select OK.

Windows

1. While holding the Shift Key down, select the top-most, left-hand location (AA9) in the expanded color palette.
2. Select GY0 (black) by single-clicking on it in the right-most color-chip matrix (see Figure E3.5).

Repeat the previous instructions to add the following colors into the left-hand column of the Color palette (under GY0):

1. GY9 (white)
2. YW4 (yellow)
3. BU4 (blue)
4. YO4 (orange-yellow)
5. OR4 (orange)

Customizing the Windows Color palette is different than customizing the Macintosh's. In Windows the user selects the location, then the color. On the Macintosh the user selects the color, then the location.

Figure E3.5
Windows Users

Figure E3.6
Customized
Macintosh and
Windows Color
Palettes

Your customized Color palette should look similar to Figure E3.6.

Adding Slides

Developing the First Slide

1. In the View menu, select Slide, then from the pop-out menu choose 1 Untitled. The new slide will appear based on the Master Slide and is ready for input. Notice at the top of the screen that Slide 1 of 1 appears, letting you know that you are now in the new slide, and have left the Master slide.

2. With the Text tool selected, click in the title placeholder (Click here for title), to select the text and type: *JoJo Bean Coffee*

3. Click the subtitle to select it and type:

 Annual Sales Meeting

4. In the body text area, click to select all of the text and type:

 The Best in Town! (return)

 The Best in the State! (return)

 The Best in the Nation!

 As you type these three lines, the text will be in the default setting of 21 points. The next step will be to modify the size of the text.

5. The first line of this text will remain at 21. Using the Text tool, click at the beginning of the second line and drag the cursor over this entire line to select it. Release the mouse. Make this line 30. Do this by selecting the size option from the Text Palette. For Macintosh users this is the second pull-down menu from the left in the toolbar. Windows users must select Text > Character > Size then enter 30 in the Size field. Again using the Text tool, select the third line and make this text 36.

As you enlarge the font size, you may find that the text on the third line may be too large to remain on one line. The following step will demonstrate how to reposition the text.

1. Select the Pointer from the Tool Palette. Next, click once on the body text. When the small boxes (handles) appear around the text, select the middle handle on the right side and click and hold as you drag to the right. Do this until the last line, *The Best in the Nation!,* is on one line.

2. Once each line of text is arranged, click and drag the text into position as shown in Figure E3.7.

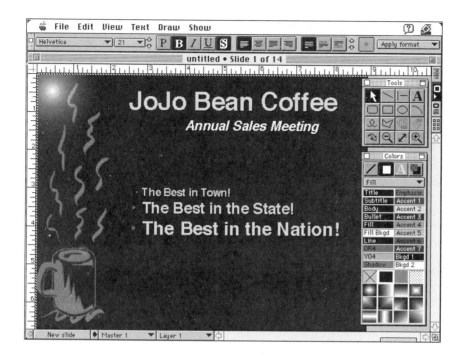

Figure E3.7

The Tools Palette

The Text Tool

Adding Layers

Next, Layering will be added to make this text enter at different times.

Figure E3.8

1. Select the body text with the pointer. From the Draw menu, select Autolayer. When the Autolayer window appears, make the selections as shown in Figure E3.8. This will cause each line to build until they are all displayed.

2. Using the Pointer, select the title text, *JoJo Bean Coffee*. With this selected do the following as outlined on the next page.

On both the Macintosh and Windows versions the Layer option is represented by the following:

The number in brackets represents the layer that the selected object is on. The other number represents the drawing layer number. This is the layer on which the objects are automatically placed. For this exercise, only the number in brackets will be used.

When within the body text area, pressing "return" or "enter" gives you another bulleted line.

Once text is entered on the screen it can be easily moved. Select the Pointer from the Tool palettes, then select the text and move to the desired location.

Figure E3.9

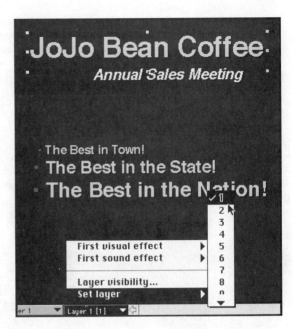

Macintosh

Locate the Set Layer option at the bottom of the screen. Hold this button down to reveal additional options. These options are displayed in Figure E3.9. The Layer set here affects the currently selected object on the screen. Set *JoJo Bean Coffee* to Layer 1 by selecting 1 from the menu shown in Figure E3.9. The hollow number reflects the layer that the selected object is on.

Windows

Locate the Layers option at the bottom of the screen. Hold this button down to reveal additional options. Set *JoJo Bean Coffee* to Layer 1 by selecting 1 from the pop-up menu. The checked number reflects the layer that the selected object is on.

3. Using the technique in Step 2, select the Subtitle (*Annual Sales Meeting*) and set this to Layer 2.

4. Using the previous Layer selection technique, select the Body text, (*The Best*, etc.), and make this Layer 3. Due to the fact that the Autolayer feature was applied to this text, it will consume a total of three layers in the Layer menu. The Layer menu at the bottom of the screen will also show the layer number for the currently selected object. However, it cannot display the layer numbers of objects that use the Autolayer feature.

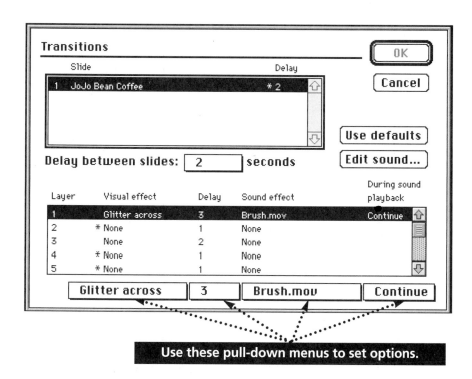

Figure E3.10
The Edit Transitions window

Transitions

1. From the View menu, select Slide Show, then Transitions from the pop-out menu.
2. Slide 1 will automatically be selected because it is the only slide currently in the presentation. In the effects menu below, make the following selections for Layer 1 only (see Figure E3.10):

 Layer 1

 Visual Effect: Glitter Across

 Delay: 3

 Sound effect: Brush.mov

(choose Import, open the MEDIA folder and choose Brush.mov)

 During Sound Playback: Continue

 Delay between slides: 2 seconds

3. In Layer 3, set a delay of 2. Select OK.

At this point, preview the slide. To do this, choose View > Slide Show > Preview Current Slide. When finished with the preview, press the esc key to exit.

To add a sound effect to the pull-down menu open the Transitions window. Select Import from the Sound effects pull-down menu. Locate the file and select Import. Once added, this effect can be chosen over and over again.

To reposition images and text on the screen, use the pointer tool from the toolbox. As you drag to rearrange, an outline of the object will follow.

Prompt text and their boundaries can be turned off by choosing:
Show > Placeholder > then deselect Prompt text or Boundaries.

Palettes are opened and closed in the Show menu.

Slide 2

At the bottom left of your screen is the New Slide button (see Figure E3.11). Click once here to create a new slide. Once selected, you will have a new, blank slide on the screen. Notice that the text place-holders are ready for input.

1. In the Title Placeholder, type: *Where We've Been.*

At this point, you will develop a custom slide by adding photographs and arbitrary text placement.

2. From the File menu, choose Import > Graphics. Open the MEDIA folder and import the following graphics:

 Bldg1.pct Bldg2.pct

 Position them as shown in Figure E3.12. Note: You can temporarily close or reposition any on-screen palettes while placing files.

3. To add text to these elements, do as follows:

 • Select the text tool from the Tools palette.

 • Position the cursor to the right side of the top photo then click and drag to the right to create a new text block.

Figure E3.11 Create a new slide by clicking once on this icon. • • • • • • •

Figure E3.12

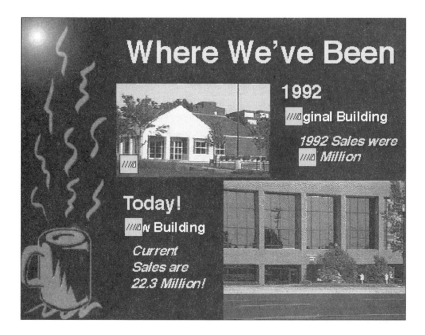

By selecting the A at the top of the Colors palette, you can change the color of the text.

By selecting the blocks, you can change the text shadow color.

The Windows Palette will vary slightly.

- Type in *1992.*
- Make sure the text is selected. From the text palette at the top of the screen, select: Helvetica/Arial-30pt-Bold-Shadow-Align Left.

 While the text is selected we will change its color.
- Select the A from the Colors palette. Choose YW4 from the colors added to the palette in the beginning of this exercise.
- Select the Text Shadow button then Text shadow from the Shadow pull-down menu. Choose GY0 as the shadow color. This will be the text shadow color used throughout the exercise.

 Follow the procedure above to create another text block immediately below that one.
- Type in *Original Building* with the following attributes:

 Helvetica/Arial-21pt-Bold-Shadow-Align Left-Color: GY9

 Next, create another text block immediately below the one above.
- Type in *1992 Sales were 1.5 Million* with these attributes:

 Helvetica/Arial-21pt-Bold-Italic-Shadow-Align Left-Color: YW4

 Using the Pointer tool, position the text blocks as shown in Figure E3.13. Resize the text blocks by selecting one of the handles around the text and dragging to extend the text box.

Based on your Persuasion software configuration, your colors may not match the numbers indicated. If not, simply choose a yellow color for the title and body text, and a white color for the subtitle text. All shadows are to be black.

To make changes to on-screen text, first select the text, then apply the change (bold, italics, etc.).

4. Next, the same styles of text will be developed and placed to the left of the graphic at the bottom of the screen. Rather than going through the steps above to recreate this text, take the following shortcut:

- Select the Pointer from the Tools palette.
- Select one of the three text blocks just created, then press and hold the Shift Key while selecting the other two. (Holding the Shift key allows multiple selections.)
- Choose Copy from the Edit menu.
- Choose Paste from the Edit menu and the new items will be pasted on top of the copied items.
- Drag the Pasted items into the location to the left of the graphic at the bottom of the screen.
- Replace the Pasted text as follows:

Replace *1992* with *Today!*

Replace *Original Building* with *New Building*

Replace *1992 Sales were 1.5 Million* with *Current Sales are 22.3 Million!*

Animation

Next, basic animation features will be added to bring the slide to life.

1. Using the Layer option at the bottom of the screen, and the Layer selection techniques used in Slide 1, set the layers for the graphics on Slide 2 as shown in Figure E3.14.

In this illustration, not only do we want the information to appear at different times, we will also want the information to appear from different directions. By using the Autoanimate feature found in the Draw menu, graphics can be animated in several ways.

2. Choose the Original Building text, then choose Autoanimate... from the Draw menu. Set the attributes to reflect the graphic settings shown in Figure E3.15:

Direction: Enter from Left
Speed: Normal
Play area: Cropped
Set the same Autoanimation attributes for the *1992 Sales were 1.5 Million* text. Next, select the Bldg1.pct graphic, and set the Autoanimation as shown on the next page.

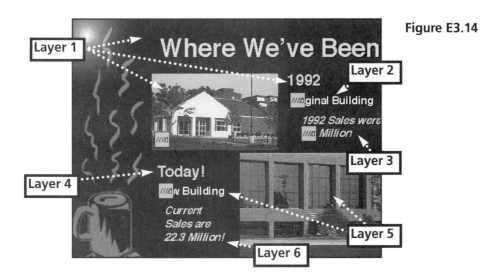

Figure E3.14

Direction: Enter from bottom
Speed: Slow
Play area: Cropped
Set the following for the graphics and text at the bottom of the screen:

Today!	No effect
New Building (text)	Direction: Enter from right
	Speed: Normal
	Play area: Cropped
New Building (graphic)	No effect
Current Sales...	No effect

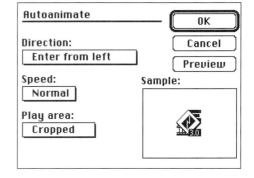

Figure E3.15

Preview the slide Choose View > Slide Show > Preview Current Slide.

Sound Effects and Transitions

Just as Layers and Autoanimation contributed to this slide, sound effects and transitions will add further enhancements.

1. Open the Transitions menu by choosing View > Slide Show > Transitions. Make sure that Slide 2 is currently selected. Make all settings as shown in Figure E3.16. These changes will affect transitions, sound effects, delays, and more.

Preview the slide to see the results.

Figure E3.16
The selection box at the bottom of this screen that contains the Layer, Delay, Visual, Speed, Sound, and Action effects options only displays four Layers at one time. This graphic has been modified to show all six settings for this particular slide.

You can turn on or off the Subtitle and Text blocks that appear on the screen by choosing the following from the Show menu. Placeholder, Prompt Text, Boundaries. Doing this will free the screen of clutter.

 About Badges
Once Autoanimation is set to an object on the screen, a Badge is shown attached to it. Animation attributes can be changed by clicking on the badge. Badges can be turned on or off in the Show menu.

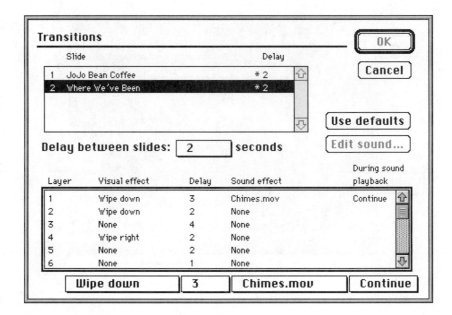

Slide 3

1. Select the New slide icon at the bottom of the screen to add a new slide to the presentation.

2. In the Title Placeholder type *Where We're Going!* Note: If the Placeholder or Prompt text was turned off in the last slide, turn it back on by choosing: Show > Placeholder > Prompt Text/ Boundaries.

3. Select the subtitle section and type *New Directions.*

4. Select the body text area and type:

 Residential(return)

 Franchise (return)

 City (return)

 Mall

5. Select all of this text with the text tool. From the Text menu, select Line Spacing... Set the Line Spacing feature to Fixed and type in 40 in the box (see Figure E3.17).

Figure E3.17

Figure E3.18

Figure E3.19

Figure E3.20

Note: In Windows, this process varies a bit. Select Text > Paragraph > Spacing > Line, then set to 40 points. The screen layout will vary.

6. Import the following graphics by using the following menu selections: File > Import > Graphics...

 House.pct

 Franchis.pct

 City.pct

 Mall.pct

 Position the graphics and text as shown in Figure E3.18.

7. As you will notice during the graphic placement, the Mall graphic is a bit too wide. Select the graphic, then click and hold the mouse button down on the handle in the center of the left side and drag the handle to the right. This will resize the graphic to your specifications. Look at the graphic in Figure E3.19 to determine the proportion of the graphic. Note: Precision is not required here.

8. Using Figure E3.20 as a guide, set the layers for each graphic and text group.

Figure E3.21

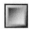

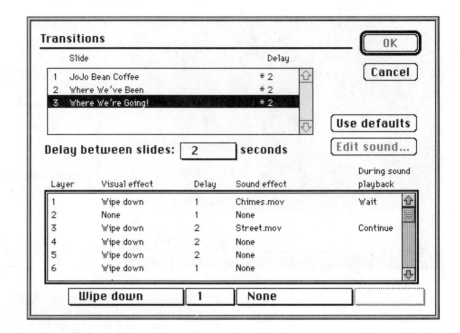

The Layers shown in the Transition menu directly reflect the graphical representation on the slide.

Chimes.mov does not have to be imported again. Simply select it from the Sound effects pull-down menu.

After the Layers are assigned for each object, set the Transitions as illustrated in Figure E3.21.

9. The body text set on Layer 3 must have a Layer effect set in order for it to be revealed incrementally. Select this text and open the Draw menu and select Autolayer. Set the effects as shown in Figure E3.22.

10. Select the Mall graphic, then choose Autoanimate from the Draw menu. Set it to perform as shown on the facing page:

Figure E3.22

Direction: Enter from Right

Speed: Fast

Play Area: Cropped

This completes the effects required for Slide 3. Preview the slide now.

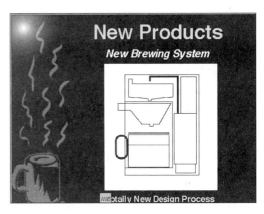

Slide 4

1. Create a new slide as done in Slide 3.

2. In the Title type *New Products.*

3. In the Subtitle type *New Brewing System.* Select the Pointer in the Tool palette, select the type and place in Layer 2.

Figure E3.23

4. In the Body type *Totally New Design Process.* Set Layer to 4. Set the Autoanimate features as follows:

 Direction: Enter from Bottom

 Speed: Slow

 Screen: Full Screen

5. Choose Import Graphics from the File menu. Open the file Maker1.pct. Place it in the center of the screen as shown in Figure E3.23. Set the graphic to Layer 3. Note: You may need to reposition the text at the top of this slide by moving it up. By using the Pointer from the Tool Palette, any on-screen object can be rearranged.

6. Open the Transition Window. Set the attributes as illustrated in Figure E3.24.

Figure E3.24

Preview the slide.

Slide 5

1. Create a new slide.

2. In the Title type *New Products.*

3. In the Subtitle type *New Brewing System.*

4. Choose File > Import > Graphics. Next, open the MEDIA fold-

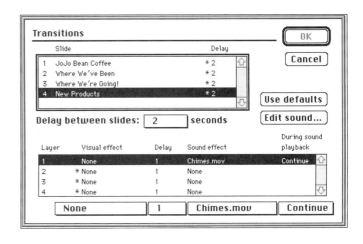

The Diagonal Line Tool

er and open the file Maker2.pct. Place in the center of the screen (see Figure E3.26).

5. Select the text tool and insert in the upper-right side of the coffee pot art. Click once then type *Cold Water In*. The text attributes should be: Helvetica/Arial-21pt-Bold-Shadow-Align Left-Color: YW4. Repeat this process to create a text block for each of the topics shown here. Note: you may wish to take advantage of the Copy and Paste features here.

Warming Tank

Heating Element

Super Heater

Filter System

Fresh Coffee

Figure E3.25

Place these individual text elements as shown in Figure E3.26.

Figure E3.26

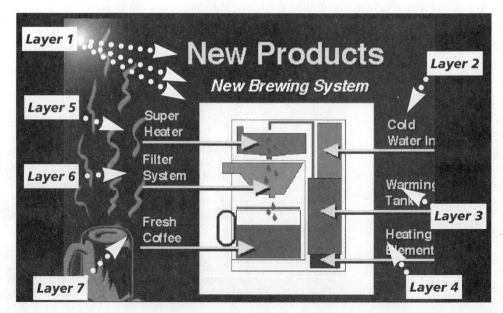

6. When finished placing the text, reduce the excess space around the text. Select the pointer and then click on each text block. Drag the handles around the text to minimize the unnecessary blank space around them.

7. Next, create an arrow to compliment each of these text headings. Follow these steps to create a shaded arrow:

 a. From the Show menu, open the Lines palette.

 b. From the Tools menu, select the diagonal line tool.

Macintosh

 c. From the left pull-down menu in the Lines palette select a 4 point line.

 d. From the right pull-down menu select End.

Windows

 c. Select Edit... from the Lines palette, then enter a 4 into the Point size field.

 d. Under End, select either arrow in the second column.

 e. In the Colors palette, set the arrow color to YW4 by selecting the line button, then YW4.

 f. Draw an arrow under the text *Cold Water In,* as in Figure E3.26.

 g. With the arrow selected, open the Draw menu and select Shadow offset. Set the offset to:

 Macintosh: Below: 5 points

 Right: 5 points

 Windows: Down: 0.1 inches

 Right: 0.1 inches

 Select Show object shadow.

 h. Draw the rest of the arrows as shown in Figure E3.26. As a shortcut, you can use the Copy and Paste, or Duplicate from the Edit menu.

8. Next, each title and arrow should be grouped in order to assign a layer to each. Using the Pointer tool, select one of the text blocks. While holding the Shift key, select its corresponding

Once an arrow is drawn on the screen, it can be modified. With the Pointer tool, you can select the arrow. You will know that it is selected when handles appear at each end. Once selected, you can change colors, line thickness, and other attributes. By clicking on either handle at the end, you can reposition the endpoints of the line. To move the graphic intact, click in the middle of the graphic, then hold the mouse button down and drag to the desired location.

Figure E3.27

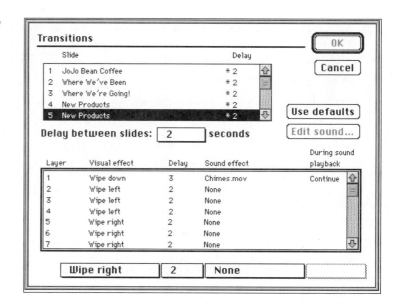

**The
Vertical/Horizontal
Line Tool**

Rectangle Tool

The Zoom-Out Tool

The Zoom-In Tool

arrow. Open the Draw menu and select Group. Perform this task to all six text/arrow groups.

9. Based on Figure E3.26, set the appropriate Layers for each grouped object on the slide.

10. Open the View menu, then Slide Show, then Transitions. Make all settings appear as in Figure E3.27, including all layers.

Slide 6

1. Create a new slide.

2. In the Title type *New Products*.

3. In the Subtitle type *New Brewing System*.

4. Choose File > Import > Graphics. Next, open the MEDIA folder and open the file Maker3.pct. Place this graphic as shown in Figure E3.29.

The next few steps will create a unique animated effect.

5. Select the Zoom-In Tool from the Tool palette.

 Move it over the graphic and click twice so that the view is similar to the illustration in Figure E3.28.

6. With the vertical/horizontal line tool, draw a line from the coffee filter basket to the bottom of the coffeepot. Make the line 4 pts

Figure E3.28

Figure E3.29

wide by making a selection in the Lines palette. Select GY0 as the line color. Set the Shadow offset to zero. With the line selected, choose Autoanimate from the Draw menu. Set the attributes as follows:

Direction: Enter from top

Speed: Slow

Play area: Cropped

Set the Layer to 2.

7. Select the Rectangle drawing tool from the Tools palette. Draw a rectangular shape to almost fill the coffeepot. Select GY0 as both the line and fill color. To set the fill color, Macintosh users select the fill button, then GY0. Windows users select FG, then GY0.

Set the following Autoanimate attributes:

Direction: Enter from bottom

Speed: Slow

Play area: Cropped

Set the Layer to 3.

8. Zoom back out using the Zoom-Out Tool from the Tool palette.

9. Select the text tool then click and drag under the coffeemaker to create a new type area.

Enter the following: *The Deluxe 2000!*

When working with Layers, you may suddenly "lose" some of your text or graphics. This occurs because text or graphics with higher numbers are placed on top of those with lower numbers. In Slide 8, for example, if the map is on a higher number layer than the text or smaller graphics, the map will completely cover them. If this happens, select the larger graphic and adjust the layer accordingly.

If an object is moved unintentionally, select the Undo command immediately.

Set the font attributes as follows:

Helvetica/Arial-36pt-Bold-Shadow-Align Left-Color: YW4.

Set this Layer to 4.

Set Autoanimation for this text as follows:

Direction: Enter from bottom

Speed: Slow

Play area: Full screen

10. Select the text tool and create a new text area.

Type the following: *Ready To Ship!*

Text attributes are: Helvetica/Arial-36pt-Bold-Shadow-Align Right-Color: BU4.

With the Pointer, select the text and select the fill/FG button in the Colors palette. Select the color, YW4.

Make this object Layer 5.

Autoanimate as follows:

Direction: Enter from right

Speed: Normal

Play area: Full screen

In the Transitions dialog box, select Wipe Down for Layer 1. This is the only transition for this screen. Set the Delay between slides at 2.

The completed screen should appear as in Figure E3.29.

Slide 7

1. Create a new slide.

2. In the Title type *New Products.*

3. In the Subtitle type *New Insulated Thermal Container.*

Set the text attributes to:

Helvetica/Arial-36pt-Bold-Italic-Shadow-Align Left

4. Choose File > Import > Graphics. Open the MEDIA folder. Locate the file Thermos.pct and select OK.

Autoanimate the graphic as follows:

Direction: Enter From bottom

Speed: Normal

Play area: Full screen

Figure E3.30 **Figure E3.31**

All objects will remain on Layer 1.

In the Transitions dialog box, select Wipe Down, with a delay of 1 second. Also choose the Chimes.mov for the Sound effect, and Continue. Set the Delay between slides at 2.

The finished slide is shown in Figure E3.30.

Slide 8

1. Create a new slide.

2. In the title type *New Suppliers*.

3. Choose File > Import > Graphics. Open the MEDIA folder. Select the file Map.pct. Move the graphic to the extreme right side of the screen and release. Select the handle on the left/center position of the map graphic and drag toward the center of the screen until it aligns with the column artwork. See Figure E3.31 for positioning.

 Set Autoanimation attributes for the map as follows:

 Direction: Enter From top

 Speed: Fast

 Play area: Cropped

4. Select the Text tool and insert over the map and click to create a new type block. Type *Guatemala,* with the following type attributes: Helvetica/Arial-24pt-Bold-Shadow-Align Left-Color: YW4.

When drawing circles, hold the Shift key as you drag. This will constrain the shape to a circle.

Also, create the following text blocks using the same attributes: *Kenya* and *Columbia.*

5. Use the line tools to create yellow arrows as done in Slide 5.

6. Select the Circle tool and draw a circle in the locations shown in Figure E3.31. Circles have attributes just like lines. Make these circles 4 pt and make the line color YW4 from the Color palette. Make sure you select the Line button on the top of the Color palette in order to change the line color. You can use the Cut and Paste or Duplicate functions here to save time.

Once the text, lines, and circles are in place as shown in Figure E3.31, select the three components that make up each section, the name, arrow, and circle, and choose the Group command from the Draw menu. Do this for each supplier.

Set the layers as illustrated below:

Title: Layer 1

Map: Layer 2 Note: Set this layer last. If not, it will hide the other layers during the development stage.

Guatemala: Layer 3

Kenya: Layer 4

Columbia: Layer 5

Set the sound and delays in the Transitions menu as in Figure E3.32.

Preview the current slide or the entire presentation.

Figure E3.32

Slide 9

1. Create a new slide.
2. In the title type *Providing the Best!*
3. In the subtitle type *Hand Picked Freshness.*
4. In the Tools palette, select the Rectangle tool. Open the Show menu and choose Rulers. Then from the pop-up menu, make sure Show Rulers is selected. With the Rulers on, draw a rectangle four inches high by six inches wide. Fill the rectangle with GY0 from the Colors palette. Set the line to the same. At this point, the Rulers can be turned off.

 Place the rectangle as shown in Figure E3.33. Note: The rectangle shown here has a white border. This is done for definition in this Figure.

 Select the rectangle and set Autoanimation attributes as follows:

 Direction: Enter From left

 Speed: Fast

 Play area: Cropped
5. From the File menu, select Import > Movies. Open the MEDIA folder and select the file JoBean.mov. Once on the slide, center the movie on the 4 x 6 rectangle. Note: The beginning of this

Figure E3.33

Figure E3.34

movie is black, therefore, you will not be able to see an image as it is placed. You will, however, see handles around it as well as an outline that appears as you drag the movie. This will assist as you drag it into place.

6. In the Layers palette, set the following:

Layer 1: Title Text

Layer 2: Subtitle Text

Layer 3: 4 x 6 rectangle (set this Layer last)

Layer 4: Movie

7. In the Transitions palette, set the following for Layer 1 only:

Visual: Wipe Down

Delay: 1

Sound effect: Chimes.mov

During Sound Playback: Continue

Delay between slides: 2 seconds

Select OK.

The completed slide is as shown in Figure E3.34.

Slide 10

1. Create a new slide.

2. In the Title type *Three New Blends.*

3. Hide the Prompt text and Boundaries by choosing

Show > Placeholder > Prompt Text/Boundaries

4. Select the Text tool and type the following as individual text blocks:

Light Roast

Columbia Chocolate

Kenya Dark Roast

Text attributes are as follows:

Helvetica-24pt-Bold-Shadow-Align Left-color: YW4.

5. Draw three lines with arrows at the end. These lines should be 3 pts, with the same shadow offsets as before (5 points/0.1 inches). Select YW4 from the Color palette. Make the shadow GY0. Refer

Figure E3.35

to the illustration for placement. With the lines and text both in place, group each line and text so they can easily be selected for Layering.

6. From the File menu, Import the following three files from the MEDIA folder: Bean1.pct, Bean2.pct, Bean3.pct. See Figure E3.35 for placement.

7. Set the Layers as shown in Figure E3.35.

8. In the Transitions window, set the Layer 1 sound effect to include the Chime.aif sound file. Also, select Continue under the During Sound Playback option. Select 2 seconds as the Delay between slides.

Slide 11

1. Create a new slide.

2. Import the graphic file Chart.pct. This file is a copy of the background art with a chart placed. When it is placed, it will completely cover the background file. Make sure the graphic fills the entire screen.

Polygon Tool

Figure E3.36

3. Since the graphic is covering up the text placeholders, select it, then Send > To back from the Draw menu. Type *Industry Growth* in the title text block.

4. Select the Polygon tool from the Tool menu. In the Lines palette, set the line to 1 point. Draw the arrow shape as illustrated in Figure E3.36. When the beginning and the end of the line meet, Macintosh users double-click to join the lines. Single-click if you are a Windows user. If your first attempt to draw this shape is unsuccessful, delete the shape and try again. Choose YW4 as both the line and the fill color. Next, select the Draw menu then Shadow Offset. Once in the Shadow Offset window, select Object, then:

 Macintosh:

 > Below: 5 points
 >
 > Right: 5points

 Windows:

 > Down: 0.1 inches
 >
 > Right: 0.1 inches

 Select GY0 as the shadow color.

5. Use Copy and Paste to create two more arrow shapes. Select one of the arrows with the pointer tool. Open the Draw menu and select Rotate/Flip then Flip horizontal from the pull-out menus.

6. Select the Type tool and click on the slide.

 Type the following: *Up 34%*

 Give this text the following attributes:

 Helvetica/Arial, 30pt-Bold-Shadow-Center-Color: YW4

 With the Pointer, select the text again. Select the fill/FG button in the Colors palette, and choose the color GY0.

 Select the text block and duplicate it twice. Change the text in the two newly created boxes to read: *Up 23%* and *Up 42%*.

 Arrange the text and graphics as shown in Figure E3.37.

 Set the Layers as shown in Figure E3.37.

7. In the Transitions menu, set the following for Layer 1

Visual effect:	Wipe Down
Delay:	1
Sound effect:	Chimes.mov
During sound playback:	Continue

Custom graphics can be flipped by opening the Draw menu and selecting Rotate/Flip then Flip Horizontal from the pull-out menus.

8. Set Autoanimation attributes for the custom pointers as follows:

 Left and Center Arrows:

 Direction: Enter from left

 Speed: Slow

 Play area: Cropped

 Right Arrow:

 Direction: Enter from right

 Speed: Slow

 Play area: Cropped

 Preview the slide.

Slide 12

1. Create a new slide.
2. In the title text block type *Our Charter.*
3. Select the Vertical/Horizontal line tool. Make sure the arrow option is set to none, and draw a 4 pt line under the words *Our Charter.* Make the line color YW4.
4. In the body text, enter the following:

 Use Only the Best Suppliers (return)

Figure E3.38

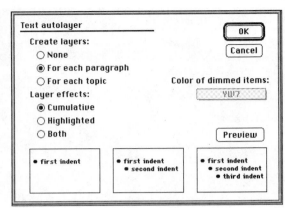

Figure E3.39

Circular gradient

State-of-the-art Facilities (return)

Unique Processing (return)

Prompt Delivery to Customer (return)

SATISFACTION GUARANTEED!

Make the text attributes for this text as follows:

Helvetica/Arial-24pt-Bold-Align Left-Color: YW4

Next, select the Text menu, then choose Line Spacing. Next, locate Fixed and type in the number 40.

Position the text created thus far as illustrated in Figure E3.38.

5. Select the Body Text and set it to Layer 2.

6. Using the Pointer, select the body text and choose Autolayer from the Draw menu. Set the attributes as shown in Figure E3.39.

7. Set the following Transitions for Layer 1 only:

Visual effect: Wipe Down

Delay: 1

Sound effect: Chimes.aif

During sound playback: Continue

Delay between slides: 2 seconds

Preview the slide.

Slide 13

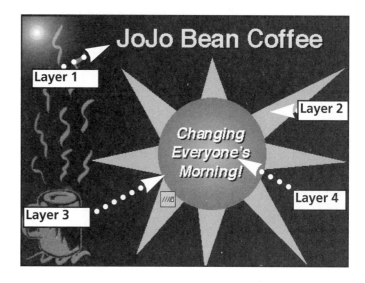

Figure E3.40

1. Create a new slide and type the following in the title block: *JoJo Bean Coffee*

2. Select the Polygon tool in the Tools menu. Draw the shape of the sun rays as shown in Figure E3.40 with a 2 point line. This is done by a point-to-point method. Macintosh users, where the beginning and end of the line meet, double-click (Windows single-click) to join the graphic. Set this graphic to Layer 2.

3. Select the Circle tool in the Tool Palette. Draw a circle approximately 3 inches, also with a 2-point line. Turn on the Rulers if needed. When finished, choose the Pointer and drag the circle to the center of the polygon image.

4. Select the polygon image with the pointer. Set the line color to YO4. Next, in the Colors palette, select the fill/FG button. Macintosh users select Fill from the pull-down menu. Select the YO4 color.

5. Select the circle and set the line color to OR4. Select fill/FG and also choose the color OR4. Next, select Fill background/BG and select YO4. Choose the circular gradient as shown in the sidebar illustration on the previous page.

6. Set the following Autoanimation attributes for the circle:

 Direction: Enter from bottom

 Speed: Slow

 Play area: Full Screen

7. With the Text tool, type the following: *Changing Everyone's Morning!*

 Text attributes are:

 Helvetica/Arial-30pt-Bold-Italic-Shadow-Align Center-Color: GY9

 Center this text in the center of the circle, or the Sun graphic.

8. Set the layers for these graphics as shown in Figure E3.40.

Figure E3.41

9. Set the Transitions as illustrated in Figure E3.41.

Slide 14

To finalize this presentation, a slide will be created that will provide information about how to exit the presentation, as well as how to restart.

1. Create a new slide. This will become Slide 14.

2. In the Subtitle Placeholder, type *To Quit*.

3. In the body text type the following:

 Macintosh: *Type Command + Q.*

 Windows: *Type Alt + F4.*

 Click Here to Restart the Presentation

 Position the text as illustrated in Figure E3.42.

 This screen provides simple information about how to exit or restart the presentation. Here, an Autojump will be established to make the presentation start over based on user interaction.

4. From the Tools palette, select the Autojump tool. Next, click and drag to create a rectangle around the *Click Here to Restart the Presentation* text. As you release the mouse button, the screen illustrated in Figure E3.43 will appear. Select the options as shown

The Autojump Tool

Figure E3.42

Figure E3.43

here from the pull-down menus. Notice that the action will return to the beginning of the presentation.

5. When finished, preview your presentation. When you come to the final slide and drag the pointer over the *Click Here* text, the pointer will change to a hand. As it does, click once on the text and the presentation will replay.

This completes Exercise 3. To view the entire presentation, select View > Slide Show > Show all slides. Warning: Quitting the presentation will quit the program. If you wish to exit the slide show select the Escape Key.

Figure E3.44 Persuasion 3.0 Slide Features • Macintosh

A Identifies the current slide.

B **Text Palette** Allows text attributes to be changed (see Figure E3.46).

C **Toolbox** Contains the pointer, drawing tools, autojump tool, text insertions tool, magnification and positioning tools.

D **Colors Palette** Change the color of text and objects.

Pop-up color palette allows color selections (see Figure E3.48).

E Formats text based on the style defined on the master slide.

F **Lines Palette** Allows line styles to be set and endcaps to be applied.

G **Nudge Palette** Allows the adjustment of the size or

position of objects on the slide.

H Create new slides, select additional master slides, and assign object layers.

Figure E3.45 Persuasion 3.0 Slide Features • Windows

A Identifies the slide currently on the screen.

B **Text Palette** Allows text attributes to be changed (see Figure E3.46).

C **Toolbox** Contains the pointer, drawing tools, auto-jump tool, text insertions tool, magnification and positioning tools.

D **Colors Palette** Change the color of text and objects. Pop-up color palette allows color selections (see Figure E3.47).

E Formats text based on the style defined on the master slide.

F **Lines Palette** Allows line styles to be set and endcaps to be applied.

G Create new slides, select additional master slides, and assign object layers.

Figure E3.46 Detailed Macintosh and Windows Text Palettes

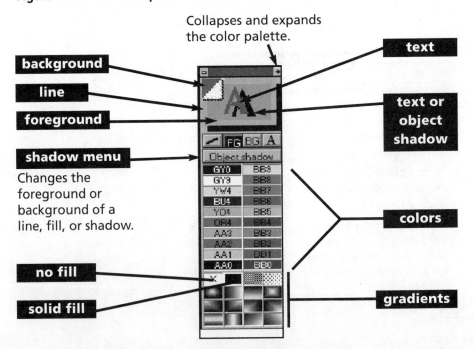

Figure E3.47 The Collapsed Windows Color Palette

Figure E3.48 The Collapsed Macintosh Color Palette

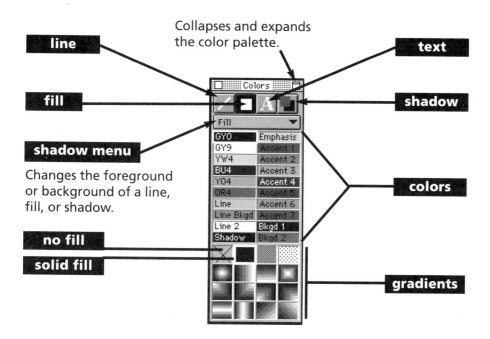

line

Collapses and expands the color palette.

text

fill

shadow

shadow menu

Changes the foreground or background of a line, fill, or shadow.

colors

no fill

solid fill

gradients

Exercise 4

Product Support Simulation
Media Presentation for Macintosh/Windows

Exercise 4 will allow you to simulate a project that you would see on a CD-ROM, a Web page, or perhaps over a corporate intranet. The concept is a manufacturer, in this case a fictitious bicycle company, providing an electronic catalog that allows the user to view information at his own pace. The content categories focus on topics that are critical for this company to communicate to retailers, installers, and end users.

The exercise utilizes Macromedia Director to control the variety of multimedia elements that have been designed for placement into this interactive environment. These elements include graphics, audio, and video. The project will guide you through the creation of multiple screens that provide various informative topics. The purpose of this exercise is to teach the logic of on-screen navigation, information layout, interactivity design, and other essentials.

Predesigned data files are located on the acompanying CD-ROM. These files are located in the MEDIA folder.

What You Will Learn

This exercise will introduce you to the following concepts.

- Interface Screens
- Interactivity
- Scripting Language
- Making Tempo Adjustments
- Controlling Digital Video
- Controlling Digital Audio

Macromedia
Director Save-
Disabled version is
available for your
use as you explore
multimedia
development.

You will learn the following terms:

- Castmembers
- Cells
- Stage
- Tool Palette
- Script Handlers
- Transitions
- Buttons

- Score Sprites
- Frames
- Tempo
- Lingo Scripting
- Tool Bar
- Markers

At the end of this
exercise you will
find completed
screens and Director
key components
that will assist you
during the
development of this
exercise.

Before You Begin

If you plan to perform this exercise using the Macromedia Director software contained on the enclosed CD-ROM, keep in mind that this is a save-disabled version. This means that the software is fully functional, with the exception that you will not be able to save your work. It is important to remember this as you perform this exercise.

If you own a copy of Director and plan to use it for this exercise, then you will be able to save your work during the development process. This allows you to complete the project on an incremental basis.

Remember that the final exercise is saved for your use, regardless of which version you are using. You can use it as a point of reference at any time. This file is named Ex4 and can be found in the MEDIA folder on the CD-ROM. Please note that Director will only allow one document to be open at a time. Before beginning this exercise, it is a good idea to review the completed version. This will give you an idea of what to expect during your personal development process.

The graphic images and figures used in this text have been captured from the Macintosh version of Director. If you are using the Windows version, some screen interface details will vary slightly, but the program details are the same.

If you have installed Director and have performed Exercise 1, then this set-up procedure is not required.

System Requirements

Macintosh

68040 Macintosh or better, System 7.1 or higher, 640 x 480 (13-inch) monitor, 8 MB of application memory (dedicated to Director), more is recommended. For the best on-screen image performance, set your monitor to thousands of colors. 20 MB of hard disk space (minimum), double-speed CD-ROM drive.

Windows

486/66 MHz or better system with at least 8 MB of memory, QuickTime for Windows, 20 MB of hard disk space (minimum), a double-speed CD-ROM drive, 640 x 480 (13-inch) monitor. Set the display to 16-bit (high color). Monitors set at 800 x 600 will provide a larger work area which will be helpful with the palettes associated with Director.

Installation

Macintosh

1. Open the Demo Software folder, then open the Director 6.0 folder.
2. Double-click on the Director 6 Demo Installer icon.
3. When the Install window opens, select the Easy Install button in the upper-left corner of the window.
4. At the bottom of the screen, make your hard drive the Install Location. Note: This demo will require approximately 20MB of disk space. It is recommended that you have at least another 20MB of free space when building this exercise.
5. Select Install. This will install a folder on your hard drive called Director 6.0, Save Disabled.
6. To use the software, open the folder and double-click Director 6.0. When Director opens, a blank, new movie will appear. Director uses the term Movie for the multimedia project you will develop.

Windows

1. Open the Demosoft folder, then the Director folder.
2. Locate the file Setup.exe. Double-click on the icon to open.
3. The installation window appears. Select Next. Read the disclaimer then press Yes.
4. Select Typical Setup.

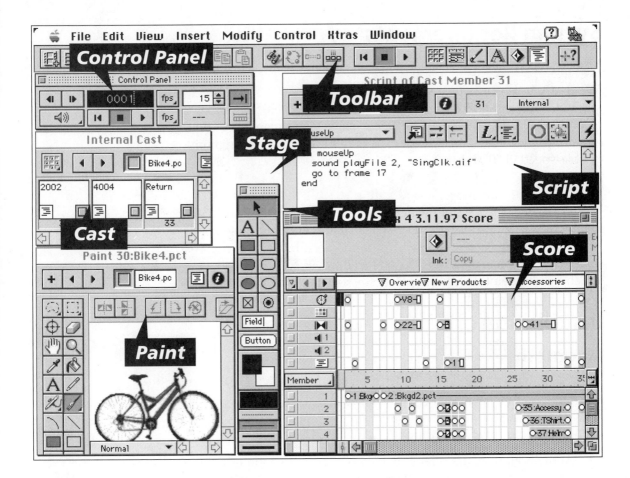

Figure E4.1 In this exercise, the windows shown here will be used extensively.

5. Select Next, then create or select a folder to install the demo as prompted.

6. Select Next, review the settings in this window. If correct, choose Next.

7. Director will begin the installation process and display a Setup Complete window.

8. Press Finish to exit Setup.

9. To use the software, open the Start menu and select Programs. Select the following from the pop-out menus: Macromedia Director 6 Demo > Director 6 Demo. When Director opens, a blank, new movie will appear. Director uses the term Movie for the multimedia project you will develop.

A Word About the Director Interface

Macromedia Director uses a theatre metaphor to describe its components. The main screen is called the Stage. This is where the movie that you are creating appears. The stage is always open and is behind other windows. The Cast window displays the castmembers. These are the files, art, sound, movies, etc., that make up your movie. The Toolbar is made up of short cut icons. Once you become familiar with what the icons represent, this will become a quick and easy way to control your project. The Score keeps track of what castmember is on the stage in each frame of a movie. The score window is also where you control timing, transitions, sound timing, and palettes. The Control Panel is similar to the controls on a VCR. Since Director creations are called movies, the VCR control panel metaphor fits logically. The Script window is where you type instructions to create interactive links and a multitude of other functions. The Paint window is a bitmapped painting program that allows you to create graphics or to modify graphics imported from another program. The Tool Palette contains tools for creating type, graphics, buttons, lines, and colors. Review Figure E4.1.

SingClk.aif is a sound file that is accessed through scripts placed at strategic locations throughout this exercise. Sound files accessed in this way must be located in the same folder as the Director 6.0 application. Unless Exercise 1 has been completed, SingClk.aif is currently located in the MEDIA folder on the CD-ROM. Copy this file to your hard drive, in the Director Save-Disabled folder. Note: If Exercise 1 has been completed, you have already made this adjustment.

Open the Director 6.0 Save-Disabled Version that you have installed on your hard drive. When the blank window opens, you are ready to begin the development of a new Director movie. Select New from the File menu. Then, from the pop-out menu on the right select Movie. This will create a new, blank Director Movie.

To begin this movie, open the Window menu and select Cast to open the Cast window. The Cast window will be used to incorporate the variety of previously prepared files that will be used in the movie. If the Toolbar is not already open, open it as well as the Score window. This is also done by selecting them in the Window menu.

If you are using a registered copy of Director, choose Save As from the File menu, and name the file Ex4New. Save this file in the Director 6 Demo folder.

As you perform this exercise, many keyboard shortcuts are available. As you use the pull-down menus, note the shortcuts and give them a try.

A Sprite is information about a castmember. This information is contained in a cell, as shown here.

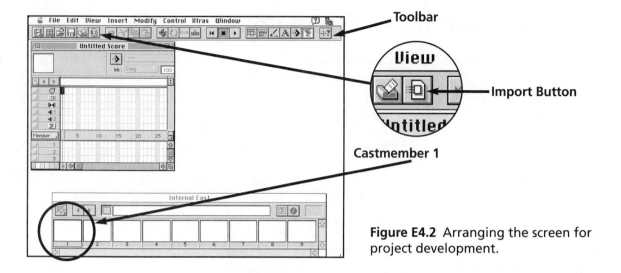

Figure E4.2 Arranging the screen for project development.

If you hold the pointer over icons in the Toolbar, or objects in other windows, a description will pop up letting you know the name of that feature.

Designing the Interface Screen

The first step in just about any type of multimedia presentation is to design the screen that the user will interface with regularly. In this scenario, the main screen will be the backdrop for the entire movie.

1. Position the Cast and Score windows as shown in Figure E4.2. Select Castmember 1 and choose Import from the File menu, or select the Import icon from the Toolbar (see Figure E4.2).

2. Open the MEDIA folder located on the CD-ROM. Locate the file Bkgd1.pct and choose Add. Next, locate the file Bkgd2.pct and select Add. Once these two files are added, choose Import. These two files will be added to the Cast in the order that they were placed, and will become Castmember 1 and 2.

 Macintosh: Make selections as shown in Figure E4.3.

Figure E4.3 Image Options will allow you to select specifics for each imported graphic.

Windows: Select the following settings:

 Color Depth: Stage (16 bits)

 Palette: Dither

Since we are importing more than one file, check the Same Settings for Remaining Images box.

Before adding castmembers to the Score, the Span Duration setting in the Preferences menu must be changed. Do this as follows. From the File menu choose Preferences, then select Sprite. The Sprite Preferences window will appear. At the bottom of this window is an option called Span Duration. Enter a 1 in the Frames field. This will make subsequent Castmembers to be imported into the selected cell only, rather than a sequence of cells.

Figure E4.4

3. Select the Score window. Arrange the window so that Channel 1/Cell 2 is visible (see Figure E4.4). Next, select Castmember 1 and click and hold the mouse button down and drag the graphic into Channel 1/Cell 2. This will place the graphic in the center of the stage.

4. Next, select the sprite in Channel 1/Cell 2. Press and hold the option/alt key down and drag the cursor to the right, extending the sequence from Cell 2 to Cell 6. The background will now fill Cell 2 through Cell 6.

5. Castmember 2, Bkgd2.pct, is the background art that will be on-screen most of the time. Place this art on screen as follows.

 In the Cast window, select Castmember 2. Press and hold the mouse button and drag Castmember 2 into Channel 1/Cell 7 of the Score window. With this Sprite in place, hold the option/alt key down and drag to the right to extend the Sprite to Cell 55.

6. In the Special Effects channels, insert the following.

 In the Tempo Channel: double-click in Cell 2. When the Tempo window opens, select Wait, and set the time for 2 seconds. Select OK.

 In the Transition Channel: double-click in Cell 2. When the Transition window appears, select Dissolve, Pixels, with a Duration of 2 seconds. Select OK. This will become Castmember 3.

Next, interactive features will be assigned to the button graphics that appear at the bottom of the background screen. The goal of this section is to create interactive links over the menu buttons shown at the bottom of the screen. This will be done by writing Scripts with the

Figure E4.5

The Hide/Show Effects Button
Use this button to reveal or close the Effects Channels.

To ensure that your Cast window appears as in Figure E4.6, make the following settings: Open the File menu and select Preferences. Next, choose Cast, then Label:Number:Name option. This will display the number and name of the Castmember under the thumbnail.

Buttons are just graphics unless they have an interactive function. Scripts make buttons behave the way you want them to.

Keyboard shortcuts:
To open and close the Score window:
Macintosh
 Command + 4
Windows
 Ctrl + 4

To open and close the Cast window:
Macintosh
 Command + 3
Windows
 Ctrl + 3

Figure E4.6 Castmembers sometimes are invisible, but still perform a function. Note: This graphic is for placement reference only. The text shown in the figure will not appear on your screen.

Lingo scripting language. These scripts will perform an action once clicked.

Figure E4.5 illustrates the names of the button graphics at the bottom of the screen and the position of the Sprites that control them. These Sprites begin in Channel 10 and go through Channel 16. This is the first occurrence of these Sprites. Once they are developed, they will be used at several locations in the Script.

1. Insert the cursor in Channel 10/Cell 3. It is necessary to ensure that this cell is selected for the success of this exercise.

2. Open the Tool Palette from the Windows Menu. Position the Windows as shown in Figure E4.6 to make the buttons at the bottom of the screen clearly visible. In the Tool Palette, select the Unfilled rectangle. At the bottom of the Tool Palette is a line menu. The top line is a no line pattern. This is illustrated as a dotted line. Select this before drawing the rectangles. This will make the rectangles invisible, while their functioning remains intact.

Draw a rectangle around the Overview button. The rectangle will become Castmember 4.

Figure E4.7

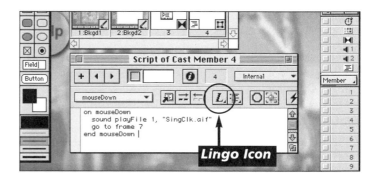

Figure E4.8 The Script window for Castmember 4.

The rectangle becomes Castmember 4 even though it is not visible in the Cast window. Notice in Castmember 4 that there is a small icon in the lower-right corner. This represents the rectangle that you have just drawn. If you double-click in Castmember 4, the Castmember Properties window will appear. This shows that the rectangle is there, but with no line. This is due to the fact that no line was selected. Select OK.

3. With Castmember 4 selected, click once on the Script button in the top of the Cast window (see Figure E4.7).

 With the Script window open, delete any information currently in the window by selecting it, then choosing Clear Text from the Edit menu. Next, select the Lingo icon. Scroll down to the Mo to Move selection. From the pop-out menu, choose on mouseDown (see Figure E4.9). Once this is inserted, type in the two center lines as shown below:

Figure E4.9 A Lingo menu.

Castmember 4 Script:

```
on mouseDown
    sound playFile 1, "SingClk.aif"
    go to frame 7
end mouseDown
```

This script will cause the button, when clicked, to play a sound file that will simulate a mouse click, and then go to another frame in the presentation.

Close the Script window by clicking once in the square box in the upper-left corner of the Script title bar. Note: This will close the script but you can view it at any time by selecting the Castmember then the Script icon in the Cast. At this point, this frame is not active, so the function of this script is not fully operational. The sound file must also be added to the cast. This will fit into place later in this exercise.

Select this icon to access the Lingo menu. When you select a Lingo command, the beginning and end (Script Handlers) are inserted for you. You are responsible for filling in the commands in between.

As you create new elements in your movie, they will become Castmembers, and will automatically be placed in the first available Cast window.

Castmembers can be added to the stage in two ways:

1. Click and drag the castmember directly into a Cell in the Score. This will center the Castmember on the Stage.

2. Click and drag the castmember directly onto the Stage, positioning it as you wish.

4. Repeat this for the rest of the buttons at the bottom of the screen, as well as for the Help button. Prepare them as follows. If there is already a Script Handler in the Script window, make sure to delete it before you start to type a script. A Script Handler is a set of Lingo statements attached to an object. In these scripts, the sound will play when the mouse button is pressed, and the Playback Head will move to the specified frame.

As you add buttons they will be automatically added to the score. When you are done make sure your score window appears as in Figure E4.5. If not, select and drag the sprites to their correct location.

Castmember 5 Script:
```
on mouseDown
sound playFile 1, "SingClk.aif"
go to frame 15
end mouseDown
```

Castmember 6 Script:
```
on mouseDown
sound playFile 1, "SingClk.aif"
go to frame 26
end mouseDown
```

Castmember 7 Script:
```
on mouseDown
sound playFile 1, "SingClk.aif"
go to frame 35
end mouseDown
```

Castmember 8 Script:
```
on mouseDown
sound playFile 1, "SingClk.aif"
go to frame 41
end mouseDown
```

Castmember 9 Script:
```
on mouseDown
sound playFile 1, "SingClk.aif"
go to frame 60
quit
end mouseDown
```

Castmember 10 Script:
```
on mouseDown
sound playFile 1, "SingClk.aif"
go to frame 54
end mouseDown
```

In order for the movie to stop at this screen, a Pause must be inserted to cause the screen to remain visible, thus allowing selections to be made to these buttons. To do this, a Pause script must be prepared for this Frame.

5. In the Score, double-click in Cell 3 in the Script Channel. When the Script window opens, select the text currently in place and delete it. Next, select the Lingo icon and select E (see Figure E4.10). When the pop-out menu appears, select on enterFrame, then release the mouse. When the Script Handler is placed in the Script window, it is ready to accept a typed command. Type the word pause. Close the window.

Figure E4.10
Preparing a pause script.

Next, in the Toolbar, press the Rewind button, then press the Play button (see Figure E4.11). Notice that the Playback Head goes to the first frame, then automatically advances to Frame 3, then pauses. You will notice the background fades in. If your exercise does not function like this, check the Script and make sure it is entered properly.

You may also wish to review all instructions to this point.

As suggested in the scripts above, a sound file called SingClk.aif (short for Single Click) is listed as a file that will play once the mouse is clicked. The next step will add the click to the Cast.

6. Open the Cast window. Select Cast Number 12. Choose Import from the File menu. Locate the file SingClk.aif and choose Import. This file will be used several times in this exercise. This will be Castmember 12.

At this point, the main screen has many elements in place. Some adjustments will be made later in the exercise. Your Score window should look like Figure E4.12.

Designing the Overview Screen

In the Overview section, graphic and audio files will be used to communicate a specific message. Timing and transitions will be added to synchronize this phase.

1. With the Cast window open, activate Cast number 13 by clicking once on it. (Click Cast 13 only once.) With this frame selected, choose Import from the File menu and open the MEDIA folder.

Director 6.0 contains a feature called Sprite Overlay. This feature displays important Sprite information directly on the Stage. This feature is automatically activated in the save-disabled version. This exercise will not refer to this feature. To turn this feature off, from the View menu select Sprite Overlay. Then, from the pop-out menu select Show Info to turn it off. (Remove the check mark to disable this feature.)

Figure E4.11 The Toolbar includes Play, Stop, and Rewind buttons for previewing.

Reviewing your work along the way is extremely helpful. If you desire, you can check your Score and Cast window status with the printed version at the end of this exercise.

Note: You can also use the shortcut from the Toolbar as before. As you add these files in the Import window, use the ADD button. Doing this allows the files to be accumulated before importing into the Cast. Import the following files in order. Once added, choose Import.

Order	File	Castmember Number
1.	cddist.pct	13
2.	30min.pct	14
3.	Updates.pct	15
4.	Systems.pct	16
5.	Intro.mov	17
6.	Video.mov	18
7.	Latest.mov	19
8.	Macwin.mov	20

Figure E4.12

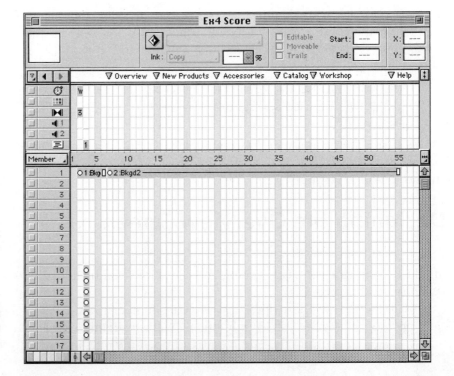

When previewing your presentation, it is important to press the Stop button to exit the Play mode.

The Playback Head

In the Image Options window that will open during the importing process, select the identical setting used previously.

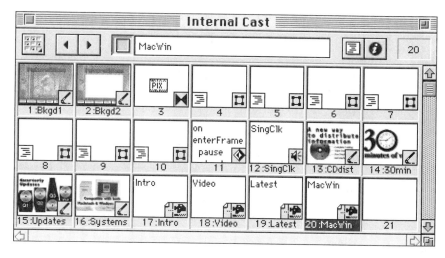

Figure E4.13

After these files have been imported your Cast window and its placement should look like the one shown in Figure E4.13. The combination of these graphic and audio files will make up this section of the movie.

2. Select Castmember 13 and drag it into Channel 2/Cell 9.

 Once this file is on the Stage, position it in the white portion of the screen. This can be done by clicking on the graphic and dragging it into position, or pixel by pixel, with the arrow keys on the keyboard. Do this for each of the following graphics as they are being placed on the Stage.

 Select Castmember 14 and drag it into Channel 3/Cell 10.

 Select Castmember 15 and drag it into Channel 2/Cell 11.

 Select Castmember 16 and drag it into Channel 3/Cell 12.

 Select Castmember 17 and drag it into Channel 8/Cell 9.

 Select Castmember 18 and drag it into Channel 8/Cell 10.

 Select Castmember 19 and drag it into Channel 8/Cell 11.

 Select Castmember 20 and drag it into Channel 8/Cell 12.

 In order for these files to work in harmony, settings must be made in the Tempo Channel. Set the following in order for the sound files to play properly.

3. In the Tempo Channel, Cell 9, double-click the cell to open the Tempo window. Make the following selections:

 Wait for Cue Point: > Channel: 8: Intro > Cue Point: {Next}.

 The Channel: 8: Intro will appear in the Channel: window because it is contained in Frame 9 also. Select OK. Next, press the option/alt key and extend the Sprite to Channel 12.

Castmembers placed on the Stage are actually Sprites. Sprites are only an image of the original castmember

When importing files into the Cast, you occasionally may find a castmember in a different location than specified in this text. If this happens, you can cut and paste the castmembers to place them in the proper position.

Use shortcuts wherever you can.

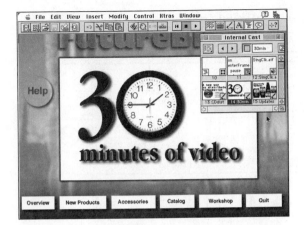

Figure E4.14 Above **Figure E4.15** Below

4. While in the Special Effects section, make the following settings in the Transition Channel.

 Double-click in Cell 7 to open the Transitions menu. Select Wipe Down/Duration 2 Seconds then OK. In Cell 9, set the Transition to Wipe Right/Duration 2 seconds. Copy and Paste this in Cells 10, 11, and 12.

 Next, a Script needs to be added to this portion to tell the Playback Head what to do when the materials have played.

5. In the Script Channel, double-click in Cell 13. When the Script window appears, delete the text that is displayed in its entirety. From the Lingo menu, select E, and then on enterFrame from the pop-out menu. This handler will be added to the Script window. The desired effect here is for the Script to return us to the main screen. To make this happen, type in the following script: *go to frame 3*. Close the Script window. This will become Castmember 23.

 Once you enter this script, you can use it over and over. This will be helpful since Frame 3 will be used as the main screen. Though not formally referred to as such, it is the return point from most other screens.

 To finalize this portion of the design phase, a Marker should be added to identify the Overview section.

6. Click once in the Marker Channel. Move the Marker over Frame 7. Immediately type Overview. This will help visually locate a section in Score window, as well as to enable you to write a Script to return you to this location.

Designing the New Products Screen

```
 4004 
```

Figure E4.16

This section allows the development of additional interactivity.

1. Begin this portion by adding a Marker. Click once in the Marker channel over Frame 15. Immediately type *New Products.* As the Score window becomes more cluttered, this will help distinguish where sections begin.

2. Open the Cast window. At this point, Castmember 24 should be empty. Select Cast member 24, then open the File menu and select Import.

 Import the following files in order. Remember that you can add all files first, then import them all at once.

Order	File	Castmember Number
1.	2002.pct	24
2.	4004.pct	25
3.	NwProd.pct	26
4.	Bike1.pct	27
5.	Bike2.pct	28
6.	Bike3.pct	29
7.	Bike4.pct	30

The Tool Palette

When the Image Options window appears, select the same options used during the previous importing functions.

Select Castmember 28 and drag it into Channel 2/Cell 15.

Select Castmember 30 and drag it into Channel 3/Cell 15

Select Castmember 26 and drag it into Channel 4/Cell 15.

Next, Select Channel 5/Cell 15, and do the following: Open the Tool Palette. Select the Button option. Move to the Stage and click and drag the cursor to the right to create a button. Type in *2002.* Repeat this procedure and type in *4004* (see Figure E4.16). Close the Tool Palette. When you created these buttons, they were automatically added to the Cast window. The 2002 button should have become Castmember 31, and 4004 should be Castmember 32. Check the Cast Window to confirm that this is true. To make them function as a button, a script must be added to each.

Type the following in the Cast Script window for Castmember 31:

```
on mouseUp
   sound playFile 2, "SingClk.aif"
   go to frame 17
end mouseUp
```

Figure E4.17
Positioning the graphics
you have just imported.

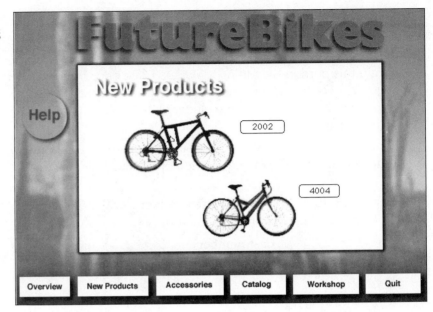

By naming portions
of your Score
window, you can
easily recognize
sections of your
presentation by
name. Also, when
writing scripts, you
can have the script
jump to these
markers by name.

If an unwanted
Marker appears in
the Marker
Channel, click and
drag it to the top or
bottom. This will
delete it.

To change the text
attributes of a
button, double-click
on it in the Cast
Window. This will
bring up an editing
window.

Positioned on-
screen elements can
be repositioned
with the pointer or
with the arrow keys.

Type the following in the Cast Script window for Castmember 32:

```
on mouseUp
   sound playFile 2, "SingClk.aif"
   go to frame 18
end mouseUp
```

3. Close the Cast and Score windows, and position the graphics as shown in Figure E4.17.

 Once in position, reopen the Score window and locate the Sprites in Frame 15 of Channels 2-6. Using the option/alt key, click and drag each of these cells to the right to fill Frame 16.

4. Since you have become familiar with selecting specific cells, and adding Castmembers, add the following:

 Drag Castmember 27 into Channel 2/Cell 17

 Drag Castmember 24 into Channel 3/Cell 17

 Drag Castmember 29 into Channel 2/Cell 18

 Drag Castmember 25 into Channel 3/Cell 18

5. Once these graphics are added, a Return button must be added.

 Make sure that Channel 4/Cell 17 is selected. Open the Tool Palette. Select the Button option. Click on the Stage and drag to the right to create a button approximately one inch wide. Type Return in the button.

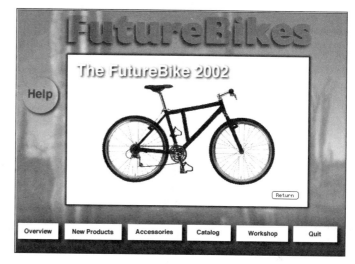

Figure E4.18

Figure E4.19

If you wish, you can change font attributes by selecting the text then choosing font from the Modify menu. This is not necessary for this exercise.

As you created the button, it was automatically entered into the Cast Window. Open the Cast and locate the new button. It should be Castmember 33.

Next, select Castmember 33 by clicking on it once, then selecting the Script icon to open a new script. Enter the following in the Script window:

```
on mouseUp
  sound playFile 2, "SingClk.aif"
  go to frame 16
end mouseUp
```

Close the Script window and the Tool Palette. When finished, select the Sprite in Channel 4/Cell 17 of the Score window. Press and hold the option/alt key and drag the Sprite into Channel 4/Cell 18. The button will perform the same function for both locations (see Figure E4.18).

Move the playback head to Frame 17. Arrange the graphics as shown in Figure E4.19. You may need to close the Cast and Score windows.

Do the same for Frame 18. Position the graphics as shown in Figure E4.20.

Director stores information associated with a Sprite in a Cell in the Score window. This information, for example the position of a Sprite on the Stage, can change from Cell to Cell.

If you click in cells that contain Sprites, you can instantly see the position of the associated Castmember on the Stage. This is good for quick positioning reference.

Figure E4.20

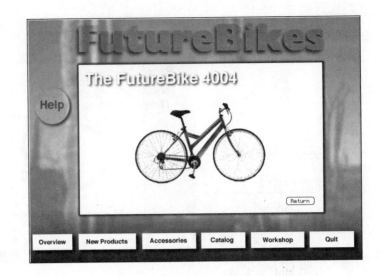

Sprite Script Pull-
Down Menu

When you preview
a file, make sure
you press the Stop
button as shown
here. These buttons
are like the buttons
on a VCR.

Make sure you DO
NOT test the Quit
button at this
juncture—you will
lose your work if
you are working
with a save-disabled
version of Director

Before you test what has been done with these last few steps, it is important to add some features in the Special Effects Channels.

In the Score, copy Cell 2 of the Transition Channel, then Paste it into Cell 15. Next, while pressing the option/alt key, expand the Sprite to Cell 16.

Add the following effects in their respective channels:

Channel: Script

Cell(s): 16, 17, 18.

Setting: Select Cell 16. Choose Script 11 from the Sprite Script pull-down menu. Extend the Sprite to 18. The reason for this is there are several buttons controlling frame-to-frame activity here. The pauses that these Scripts perform allows the user time to invoke an action.

Channel: 8

Cell(s): 15

Add: Import the sound file Newprod.mov into the Cast window, as Castmember 34

Setting: Add Castmember 34 by dragging it into Channel 8/Cell 15

Channel: Tempo

Cell(s): 15

Setting: Wait for Cue Point: > Channel: 8: NewProd,Cue Point: {Next}

To conclude the design of the New Products section, it is important that the buttons at the bottom of the screen be activated.

6. Go to Channel 10/Cell 3 and click once. Next, press the Shift Key and select Channel 16/Cell 3. This will select the range of Sprites from Channel 10 to Channel 16. These Sprites contain information that controls the interactivity of the main screen. Choose Copy. Next, move to Channel 10/Cell 15 and choose Paste. Do the same in Cell 16. Now the buttons at the bottom of the screen are activated for these screens.

It is time to close all windows and test what you have done so far (see the Tip in the sidebar). Be aware that only the Overview and the New Products buttons are functional at this point.

If you are using a registered copy of Macromedia Director, save your work at this time.

Once you have previewed the project, you will still be in the Play mode until you select Stop. Once Stop is selected, you will need to open the Score and Cast windows to continue exercise development.

Figure E4.21

Having completed this section, your Score window should look like the one in Figure E4.21.

Developing the Accessories Section

The Accessories section is a screen that contains an assortment of bicycling accessories.

1. Begin by clicking in the Marker Channel directly over Frame 25. Immediately type *Accessories*. This will mark where the Accessories section will begin in the Score window.

Using Transitions is one way of making changes on the Stage. These affect the way one image advances to the next.

Cutting and pasting techniques work for just about every feature of Director. These features include Casts, Scripts, and Sprites.

When a Cast-member is initially placed into the Score, it is important to position the image on the Stage first, then adjust the Sprites in the Score. As the Sprites in the Score are duplicated, the positioning on the Stage will be as well.

2. Open the Cast window and select Cast 35 , then Import the following in order:

Order	File	Castmember Number
1.	Accessy.pct	35
2.	TShirt.pct	36
3.	Helmet.pct	37
4.	Seatart.pct	38
5.	Glasses.pct	39
6.	Watch.pct	40

Remember to first Add to the Import window, then choose Import when ready to import all files at once. When the Image Options window opens, select the previous settings used earlier in this exercise.

3. Open the Score window and drag Castmember 35 into Channel 2/Cell 26. Arrange this graphic in the upper-left corner of the presentation area. When in position, go to the Score window and extend the Sprite to Cell 33.

4. Next, drag Castmember 36 into Channel 3/Cell27. Position this graphic on the left side of the stage. Once in place, extend the Sprite to Cell 33.

At this point, it is important to view the graphic you are constructing in order to know where to place these items. As items are placed, arrange them as shown in Figure E4.22.

Figure E4.22
Accessory files placed on the Stage.

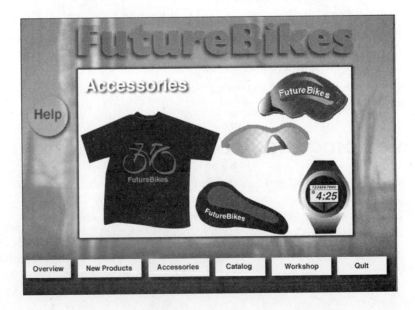

Repeating the same processes, refer to Figure E4.23 and place the rest of the graphics on the Stage:

Drag Castmember 37 into Channel 4/Cell 28

Drag Castmember 38 into Channel 5/Cell 29

Drag Castmember 39 into Channel 6/Cell 30

Drag Castmember 40 into Channel 7/Cell 31

Extend these sprites to Cell 33 also. Make sure to do this after positioning them.

5. Next, add the following transitions in the Transitions Channel:

 Cell 26: Place Castmember 22 here (this is an existing transition you can drag the Cast member directly into Cell 26). Next, select (double-click) Cell 27. Choose the following new transition: Random Columns. Set the Duration to 1.00 seconds. Also, select the Changing Area Only button. Next, click OK. This transition will become Castmember 41. Verify that this is true by checking the Cast window.

6. Once this transition is in place, extend the Sprite to Cell 31.

7. In the Script Channel, select Cell 33 and insert Pause script 11. Simply open the Script pull-down menu at the top of the Score window and select it.

8. To make the interface screen during this segment, placement of the interactive buttons must be done at the beginning and at the end of this section. In the Score window, scroll down to reveal Channels 10 through 16 in Frame 16. Select Channel 10/Cell 16, then press and hold the Shift key and select Channel 16/Cell 16, then choose Copy.

9. Select Channel 10/Cell 26 and Paste. Also, select Channel 10/Cell 33 and Paste again. This last action is necessary because at the end of the effects in this section, the screen will pause. Having these buttons in place allows the user to make a selection at the end as well as at the beginning of this section.

Test what you have done thus far by closing all windows, rewinding and then choosing Play. Remember that only the first three sections are active, therefore, do not press other buttons. Remember, do not quit!

The Score window for the Accessories section should look like Figure E4.23.

Figure E4.23

Figure E4.24

You will notice that the sprites in the graphic below are represented by Castmember numbers. This feature can be turned on by selecting File > Preferences > Score > Compatibility: Director 5 Style Score Display.

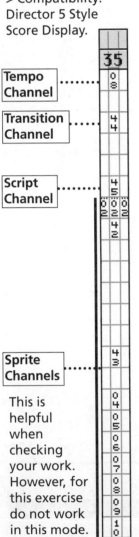

Tempo Channel

Transition Channel

Script Channel

Sprite Channels

This is helpful when checking your work. However, for this exercise do not work in this mode.

Developing the Catalog Section

This screen will be a very simple reference screen, guiding the user to another location to receive additional information about a product or service. All of this activity will happen in Frame 35.

1. Open the Cast window and select Cast number 42. This Cast member should be empty. With the Cast member selected, choose Import. Select the graphic file Catalog.pct to fill Castmember 42, then the sound file Catalog.mov, to fill Castmember 43. Choose the settings as selected previously in this exercise.

2. Drag Castmember 42 into Channel 2/Cell 35. Check to make sure that the graphic is in the center of the white portion of the screen.

3. Drag Castmember 43 into Channel 8/Cell 35.

4. In the Tempo Channel, select Cell 35 and double-click to open. Select Wait for Cue Point: Channel: 8: Catalog, Cue Point: {Next}, then select OK.

5. In the Transition Channel, double-click and set the Transition to Venetian Blinds, duration 2.00 seconds, Affects Changing area only. Press OK. This Transition will become Castmember 44.

6. Next, scroll down to Channel 10. Copy the Sprites in Cell 33 of Channels 10-16. Next, paste a copy in Cell 35. This will make the buttons at the bottom of the screen active.

7. Double-click in Cell 35 of the Script Channel and add the following

```
on exitFrame
    pause
end exitFrame
```
This script should become Castmember 45.

To complete this section, click once in the Marker Channel over Frame 35. Immediately type in the title *Catalog*.

Developing the Workshop Section

This section will introduce a variety of video clips to the presentation. These clips provide "how-to" information that plays upon user interaction.

1. Begin this section by clicking once in the Marker Channel over Frame 41. Next, type in the title *Workshop*.

2. Open the Cast window and select Castmember 46. This should be the first open Cast window available. Next, Import the following files in order:

Order	File	Castmember Number
1.	Wkshop.pct	46
2.	Brake.mov	47
3.	Cleaning.mov	48
4.	Derail.mov	49
5.	Handlebr.mov	50
6.	Pedal.mov	51
7.	Seat.mov	52
8.	Tire.mov	53

Upon import, use the settings as performed previously in this exercise.

3. Drag Castmember 46 into Channel 2/Cell 41. Castmember 46 is the file Wkshop. Clear all windows and position the graphic to the center of the presentation window. Next, extend the Sprite to Cell 52.

 In the next part of this exercise, graphics will be added to specify a part of the bicycle that can be selected, and then linked to a movie file.

4. Open the Tool palette.

Figure E4.25

Importing digital video files is like importing other files, except that they are always linked to the original file or disk. The original digital video file must always be accessible by Director in order to play. Having all files in the same folder is necessary.

Figure E4.26

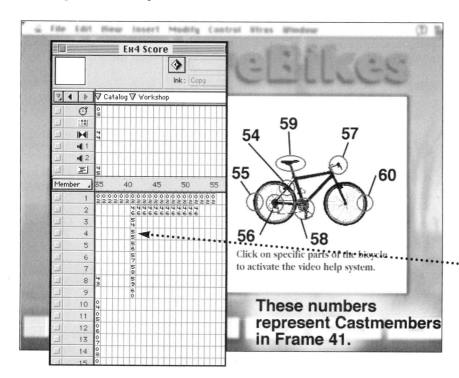

Click on specific parts of the bicycle to activate the video help system.

These numbers represent Castmembers in Frame 41.

Note
Stacking these Sprites will allow them to appear on the screen at the same time.

As you draw ellipses on the screen, holding the Shift key will constrain the ellipse to a circle. Once placed, the arrow keys on the keyboard will allow you to move the shape one pixel at a time.

5. With Cell 41 in Channel 3 selected, select the hollow ellipse tool in the Tool Palette. Next, select the second to last line thickness option in the palette (two-pixel line). Select a red color for the line by holding down the cursor on the top-left color-chip icon and selecting the red color from the pop-out menu, as indicated in Figure E4.25. With Channel 3/Cell 41 still selected, draw the first circle (or ellipse) around the rear brakes as shown as number 54 in Figure E4.26. Repeat this procedure to place the rest of the ellipses as follows:

Select Channel 4/Cell 41: Draw the circle as shown for Castmember 55

Select Channel 5/Cell 41: Draw the circle as shown for Castmember 56

Select Channel 6/Cell 41: Draw the circle as shown for Castmember 57

Select Channel 7/Cell 41: Draw the circle as shown for Castmember 58

Select Channel 8/Cell 41: Draw the circle as shown for Castmember 59

Select Channel 9/Cell 41: Draw the circle as shown for Castmember 60

Important: The illustration shows what Channel and Cell should be selected as each ellipse is drawn. It is important that this be followed strictly!

A sample image is shown in Figure E4.26. As before, use Director 5 Style Score Display to check your work. Do not work in this mode.

Placing Video Files

1. Arrange the Cast window to look like the one shown in Figure E4.27.

2. Open the Score window to reveal the Cells as shown in Figure E4.28.

 Drag the following Cast members into the Score as illustrated: 47, 48, 49, 50, 51, 52, and 53. Note: This screen represents the Director 5 Screen Settings. Use this setting for comparison only.

3. As the video castmembers are dragged into the Score, they will be centered on the screen. With each one, select the video on the Stage and drag it into the black Workshop window. Use the arrow keys for precise alignment (see Figure E4.29).

4. Set the following Scripts for the following Frames.

 Drag Cast member 11 into Cell 41 of the Script channel. Double-click in the Script channel, Cell 42. Write the following script:

```
on exitFrame
   go to frame 41
end exitFrame
```

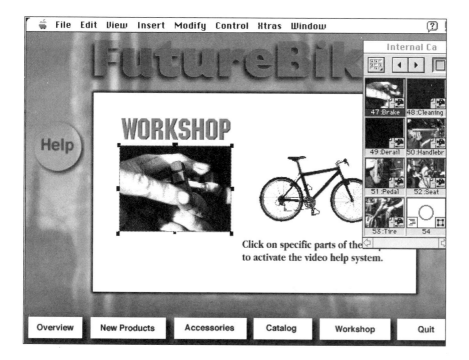

Figure E4.27

Figure E4.28

Figure E4.29

Selecting the Sprite in the Score window will highlight it on the Stage. Once highlighted, then position it.

Once a Cast member has been placed on the Stage, you can use the arrow keys on the keyboard to move it one pixel at a time for precise positioning. To do this, make sure the Cast member is selected and that the stage is active.

Figure E4.30

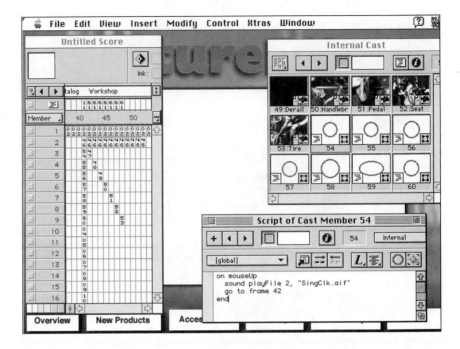

Fill cells 42 through 48 with this Sprite. This Script will make the Playback Head return to the main screen of this section. This will become Castmember 61.

5. Next, Scripts need to be applied to the ellipses/circles that were placed on the bicycle in order for them to play the associated digital video file on demand. To do this, open the Cast Window, locate the specific Castmember, open the Castmember Script, and enter the following Scripts. Arrange your screen as shown in Figure E4.30.

You can use the Copy and Paste function when inserting Scripts that are similar. If you do so, remember to modify the pasted data with the information that changes, in this case, the frame numbers.

Castmember 54 Script:
```
on mouseUp
   sound playFile 2, "SingClk.aif"
   go to frame 42
end mouseUp
```

Castmember 55 Script:
```
on mouseUp
   sound playFile 2, "SingClk.aif"
   go to frame 43
end mouseUp
```

Castmember 56 Script:
```
on mouseUp
   sound playFile 2, "SingClk.aif"
```

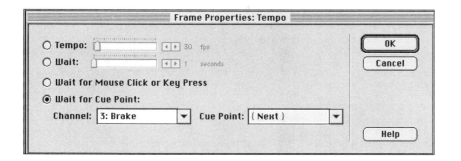

```
   go to frame 44
end mouseUp
```

Castmember 57 Script:
```
on mouseUp
   sound playFile 2, "SingClk.aif"
   go to frame 45
end mouseUp
```

Castmember 58 Script:
```
on mouseUp
   sound playFile 2, "SingClk.aif"
   go to frame 46
end mouseUp
```

Castmember 59 Script:
```
on mouseUp
   sound playFile 2, "SingClk.aif"
   go to frame 47
end mouseUp
```

Castmember 60 Script:
```
on mouseUp
   sound playFile 2, "SingClk.aif"
   go to frame 48
end mouseUp
```

With these Scripts in place, changes need to be made in the Tempo Channel to control the behavior of the video.

6. Go to the Tempo Channel. In Frame 42 set the Tempo settings as shown in Figure E4.31.

 For the following frames set identically except change the Cue Points to the following:

 Frame 43: Cue Point: Channel 4: Cleaning.

 Frame 44: Cue Point: Channel 5: Derail.

 Frame 45: Cue Point: Channel 6: Handlebr.

 Frame 46: Cue Point: Channel 7: Pedal.

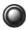

The Tempo settings control how fast your movie will play. Tempos can be used to control the speed in various portions of your movie.

Make sure to test your movie at various intervals.

Figure E4.32

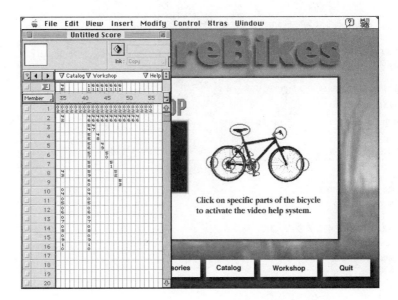

Frame 47: Cue Point: Channel 8: Seat.

Frame 48: Cue Point: Channel 9: Tire.

7. In order for the Workshop screen to contain all the functioning of the other screen, the button Sprites must be copied into Frame 41. Copy the Sprites in Cell 35 of Channels 10 through 16, and paste them into Frame 41 beginning in Channel 10.

The final phase of this section is to add some transitions. These need to be added into the Transition Channel of the Score window, Frames 41 and 42. This allows a transition between each video clip and the main Workshop screen, providing a more pleasing effect.

8. Set the following in the Transition Channel. From the Cast window, locate Castmember 21 and drag it into Frames 41 and again into 42.

At this point, your Score window should look like Figure E4.32.

Assembling the Help Screen

The final graphic portion of this movie involves the assembly of the Help screen. This screen will be developed in Frame 54.

1. Open the Cast window. Select Castmember 62 and choose Import. Select the following three files in order.

Figure E4.33

Order	File	Castmember Number
1.	Help.pct	62
2.	Helptxt.pct	63
3.	Help.mov	64

Use the import options as previously performed in this exercise.

2. Drag Castmember 62 into Channel 2/Cell 54. Center the graphic in the white rectangle. Drag Castmember 63 into Channel 3/Cell 54. Place it into position as shown in Figure E4.33.

3. Next, drag Castmember 64 into Channel 4/Cell 54.

4. In the Tempo Channel, select Cell 54. Double-click to open, and choose Wait for Cue Point: Channel: 4: Help. Select OK.

5. In the Transition Channel, select Cell 54. Double-click to open, and choose Wipe Down, with a Duration of 0.50 seconds. Select OK. This transition will become Castmember 65.

6. Copy the button sprites beginning in Channel 10/Cell 41 to Channel 16/Cell 41. Go to Channel 10/Cell 54, and choose Paste. At this point, the button scripts are in place at every pause in the movie.

7. With the Cast window open, drag Castmember 45 into Cell 54 of the Script Channel. This will add an existing Pause script to the Score rather than creating a new Script.

8. In the Marker Channel, click to create a Marker in Frame 54. Immediately type the word Help.

The Quit Button

This section involves Frame 60 only! To make the movie quit on demand, do as follows:

1. Have the movie fade out by selecting the Dissolve Pixels command in the Transition Channel. Set the Duration to 1.25 seconds. This will become Castmember 66.

2. In the Tempo Channel, select Wait/2 seconds. Press OK.

At this point, the movie will fade out, then quit the presentation.

During playback, as you reach this point, you may not want to press the Quit button. Remember, if you are using the Save-Disabled version of Director 5.0, when you quit, you lose your project. If you wish, you can remove the Quit Script to avoid this step.

This completes Exercise 4. Review your work!

**Figure E4.34
Completed Cast
Window**

Figure E4.35 Completed Score Window

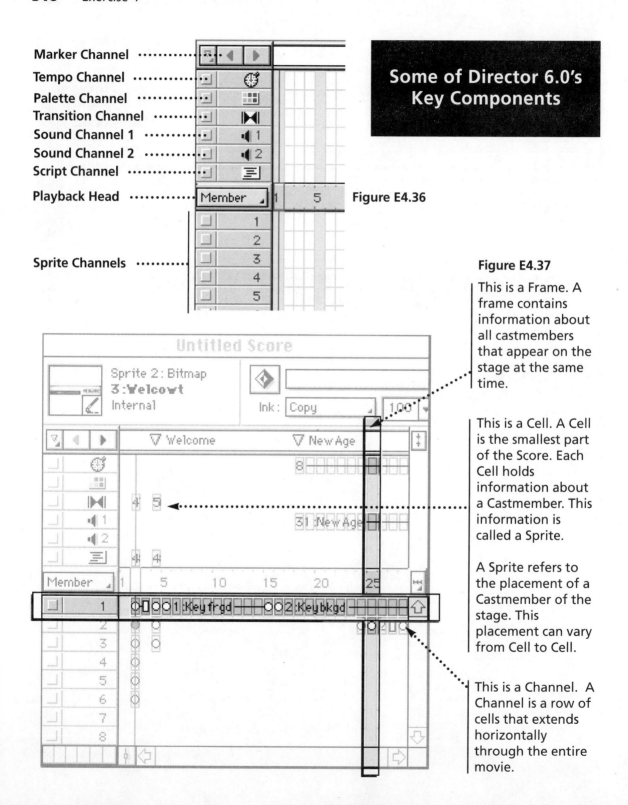

Marker Channel

Tempo Channel

Palette Channel

Transition Channel

Sound Channel 1

Sound Channel 2

Script Channel

Playback Head

Some of Director 6.0's Key Components

Figure E4.36

Sprite Channels

Figure E4.37

This is a Frame. A frame contains information about all castmembers that appear on the stage at the same time.

This is a Cell. A Cell is the smallest part of the Score. Each Cell holds information about a Castmember. This information is called a Sprite.

A Sprite refers to the placement of a Castmember of the stage. This placement can vary from Cell to Cell.

This is a Channel. A Channel is a row of cells that extends horizontally through the entire movie.

Glossary

AIFF—Audio Interchange File Format. A standard audio file format that is supported by applications on both Macintosh and Windows computer systems.

bit—A binary digit. The smallest unit of information that a computer can handle, represented by a single 0 or 1.

buffer—A part of the drive that reads information on the CD and stores it. This allows quick access to the information when you are ready to use it.

bug—An error in a program or a malfunction in a computer system.

bus—The wire or network of wires and circuits that carry signals from one part of a computer to another.

byte—A group of eight bits (representing, for example, a number or letter) that the computer operates on as a single unit.

CD-ROM—Compact Disk, Read-Only Memory. A data storage medium that utilizes laser optics to read or retrieve information. These disk store information in recessed "pits." The information on CD-ROMs is very secure and durable, due to the phyiscal structure of the disk and the plastic coating that protects the information. CD-ROM readers can also read audio CD formats.

CPU (central processing unit)—The main part of a computer. Contains internal memory, an arithmetic/logic unit, and control circuitry. Performs data-processing, timing, and controlling functions.

database—A collection of information organized for rapid search and retrieval.

data transfer rate—The speed associated with the rate that a CD-ROM drive reads data from the disk.

desktop case—The design of the computer housing. A desktop case takes up more space on the desk and usually allows for a monitor to be placed on top of it.

device driver—Software that tells the computer how to communicate with specific hardware devices. Some of these devices are: CD-ROM drives, printers, external speakers, and scanners.

disk drive—A device that rotates a magnetic storage disk that can record and read data.

downsampled sound—A sound originally recorded at a higher setting, then lowered, thus decreasing the size and quality of the original file.

DRAM—Dynamic Random Access Memory. Most graphic cards contain DRAM. It is cheaper than VRAM.

EDO RAM—Extended Data Out RAM is faster than traditional RAM. EDO RAM is recommended for graphic or data intensive applications, such as multimedia. EDO functions at 16 nanoseconds. Standard RAM functions at 70 nanoseconds

EIDE hard drive (Enhanced Integrated Drive Electronics)—The method in which the hard drive is connected to the CPU. Not only does it describe how it is connected, it describes how data is transmitted between the two.

expansion card(s)—Circuit boards, designed for a special purpose, that fit in one of the expansion card slots inside the computer. These cards are usually developed by companies that produce a specific peripheral device. The cards control how the device works. Some of the devices are: Scanners, monitors, sound, graphic accellerators, and audio/video input and output.

expansion slot—A socket inside the computer that will accept the variety of expansion cards.

file formats

> AIFF
> AVI
> BMT
> EPS
> EXPF
> FSSD
> GIF
> MIDI
> Paint
> PCX
> PhotoCD
> PICS
> PICT

PICT2
SND
SFIL
TIFF
TGA
RIFF

floppy disk—A thin flexible plastic disk that stores data in the form of magnetic patterns on its surface. Used primarily in microcomputers.

GUI (Graphical User Interface)—The physical appearance of what appears on your computer screen, usually refering to desktop metaphors, containing such items as trash cans, pull-down menus, icons of files, etc. The user can point and click on icons of folders, files, and applications.

hardware—The physical components of a computer system, such as the chips, disk drives, monitor, and other devices.

icon—A visual symbol of a program, document, or utility, that can be made up of almost any picture or graphic. Icons for application programs and their files usually resemble each other, allowing the user to easily recognize what type of file or application it is.

interface—The hardware and software that enable a user to interact with a computer (called a user interface) or that enable two computer systems to interact.

ISA (Industry Standard Architecture)—An earlier form of computer system architecture. Allows boards to be inserted into the computer on the expansion slots which are a part of the motherboard. Compared to the PSI Bus Architecture, ISA is much slower, and is not workable for video playback.

memory—A storage area in which a computer saves data and from which it retrieves data.

microcomputer—A class of small, general-purpose digital computers built around a microprocessor. Home, personal, desktop, and small business computers are all microcomputers.

microprocessor—A single chip containing all the components found in a computer's central processing unit.

MPC—Multimedia Personal Computer. These are usually IBM-compatible systems that offer built-in equipment, such as: CD-ROM players, speakers, microphones, and large disk drives, in order to play CD-based multimedia titles.

multimedia—The combining of two or more forms of media to effectively create a sequence of events that will communicate an idea in a audible and visual format. Multimedia components consist of animation, graphics, photography, sound, text, and video.

network—A system of computers, terminals, and databases connected by communications lines. Allows users of different types of computers to exchange data and to make use of special programs or very large computers. Scopes range from local-area networks (LANs) to international networks.

OLE—Object Linking and Embedding.

operating system—A linked series of programs that control, assist, and supervise all other programs on a computer system and that allow dissimilar hardware systems to work together.

PCI (peripheral component interconnection) bus architecture—The bus analogy refers to channels that are used to send data to different computer components and back. Bus architecture is a simple reference to the type of bus that your system uses. PCI is a newer technology that is found in IBM-compatible as well as Apple Macintosh systems. PCI Bus Architecture is one of the fastest processes to move information from one location to another.

pipeline burst cache—This cache is designed to take advantage of the PCI architecture. The term pipeline comes from the fact that the cache is connected directly to the PCI slot in the CPU. The term burst comes from the process of information and the retrieval of data is faster due to this improved cache system.

Publish and Subscribe—A feature, available in numerous applications, which allows imported files to be modified in their original state, and to be automatically updated, no matter where they are located. An "edition" file is created as a go-between, to continually update edited materials.

RAM (random-access memory)—A temporary computer memory system in which data can be stored and from which data can be quickly retrieved.

ROM (read-only memory)—A permanent computer memory system containing data and instructions that can be retrieved and used but never altered.

sampling rate—The process of converting analog sound into digital sound. The computer captures many samples from the original

sound source and converts the information into digits that a computer can read.

SCSI (Small Computer System Interface)—A device on your computer that allows the connection to various periepheral devices such as CD-ROM drives, printers, or external disk storage.

SMPTE (Society of Motion Picture and Television Engineers)—SMPTE is also a name associated with a coding method used for videotape in the editing process. A SMPTE timecode has four formats:

1. 30 fps (NTSC)
2. 25 fps (PAL/SECAM)
3. 24 fps (film)
4. 29.97 fps (drop frame)

SMPTE Time Code—Society of Motion Picture and Television Engineers. The SMPTE time code provides an absolute address in hours, minutes, seconds, and frames for video.

sound card—A circuit board installed in a computer that adds sound capabilities to the system. Older systems often do not have sound capabilities. Most current systems are equipped to handle sound.

SoundEdit 16—Sound editing software that allows the user to record, edit, modify, play, and store sound files. SoundEdit supports 16-bit sound recording. SoundEdit 16 is manufactured by Macromedia.

tower case—A tower case refers to the design of a computer housing. This case design is vertical and takes up very little space on the desktop. These cases are also excellent for placing on the floor, totally away from the monitor and keyboard.

VRAM (Video Random Access Memory)—VRAM is more expensive than DRAM, but is faster and greatly improved the overall performance of a video card.

WAVE (.WAV)—A sound standard format for Windows sound files.

Index

f = figure
t = table

Endicott College

Beverly, Mass. 01915